Adobe Photoshop 7.0 for Photographers

In memory of my mother Marjorie Evening

Adobe Photoshop 7.0 for Photographers

A professional image editor's guide to the creative use of Photoshop for the Macintosh and PC

Martin Evening

OXFORD AMSTERDAM BOSTON LONDON NEW YORK PARIS SAN DIEGO SAN FRANCISCO SINGAPORE SYDNEY TOKYO

Focal Press An imprint of Elsevier Science Linacre House, Jordan Hill, Oxford OX2 8DP 200 Wheeler Road, Burlington MA 01803

First published 2002 Reprinted 2003

Copyright © 2002, Martin Evening. All rights reserved

No part of this publication may be reproduced in any material form (including photocopying or storing in any medium by electronic means and whether or not transiently or incidentally to some other use of this publication) without the written permission of the copyright holder except in accordance with the provisions of the Copyright, Designs and Patents Act 1988 or under the terms of a licence issued by the Copyright Licensing Agency Ltd, 90 Tottenham Court Road, London, England W1T 4LP. Applications for the copyright holder's written permission to reproduce any part of this publication should be addressed to the publisher. Permissions may be sought directly from Elsevier's Science and Technology Rights Department in Oxford, UK: phone: (+44) (0) 1865 843830; fax: (+44) (0) 1865 853333; e-mail: permissions@elsevier.co.uk. You may also complete your request on-line via the Elsevier Science homepage (http://www.elsevier.com), by selecting 'Customer Support' and then Obtaining Permissions'

British Library Cataloguing in Publication Data

A catalogue record for this book is available from the British Library

Library of Congress Cataloguing in Publication Data

A catalogue record for this book is available from the Library of Congress

ISBN 0240516907

For information on all Focal Press publications visit our website at: www. focalpress.com

Printed and bound in Italy

Contents

Introduction	xiii
Acknowledgments	xv
Getting started	xvi
What's new in Photoshop 7.0	xvi
Mac OS X and Windows XP support	xvii
File Browser	
Healing brush and patch tool	xviii
Brushes engine	
Interface refinements	
Automation	xix
Auto Color	xix
Filter menu	xx
Web features	xx
Extras	xx
Chapter One – Digital Capture	
Structure of a digital image	
Scanners	
What to look for in a scanner	
Resolution	
Dynamic range	
Bit depth	
Scanning speed	
Software	
Visual assessment	
Purchasing bureau scans	
Kodak Photo CD and Picture CD	
Image quality	
Optimum Photo CDs	
Opening a Photo CD image	
In conclusion	
Digital cameras	
Consumer cameras	
35 mm SLR features	
Hot mirror filters	
Medium format CCD cameras	
Making every pixel count	
Scanning backs	23
Is it time to go digital?	24
Camera software and storage	
Conclusion	27
Chapter Two – Resolution	28
Pixels versus vectors	
Terminology	
Repro considerations	
Inkjet output resolution	
Creating a new document	
Altering the image size	
Practical conclusions	

Chapter Three - Configuring Photoshop	40
Buying a system	
Monitor display	
Video cards	
Extras	
Retailers	
Improving Photoshop performance	
Chip speed	
Chip acceleration	
RAM memory and scratch disks	
Clearing the Photoshop memory	
Configuring the RAM memory settings (Macintosh OS 9)	
Configuring the RAM memory settings (Windows and Mac OS X)	
Photoshop and Mac OS X	
Installing Mac OS X and Photoshop	
Shared and non-shared items	
Windows XP	
Office environment	
System software	54
Chanton Four Color Management	
Chapter Four – Color Management	
The need for color management	
Why not all RGB spaces are the same	
The way things were	
CMYK color management	
RGB devices	
Not all RGB color devices are the same	
ICC profiled color management	
Switching on Photoshop ICC color management	
Monitor profiling	
Monitor calibration	
Mac OS X calibration	
Contrast and brightness	
Neutralizing the color	
Target Gamma	
White point	
Conclusion	
Calibrating a PC monitor with Adobe Gamma	
The value of a calibrated display	
The Photoshop color engine	
The profiled approach	
The versatility of RGB	
Choosing an RGB work space	
Apple RGB	
sRGB IEC-61966-2.1	
ProPhoto RGB	
Adobe RGB (1998)	
The ideal RGB working space	
Photoshop color management interface	
The Color Settings	
Color management policies	
Managing the Color Settings	
Profile conversions Converting to the work space	
Converting to the work space	83

Handling Grayscale	84
Handling legacy files	85
Advanced color settings	87
Blend RGB colors using gamma	88
Desaturate monitor colors	
Customizing the RGB and work space gamma	
RGB to CMYK	90
CMYK setup	91
Advanced CMYK settings	
Conversion options	
Rendering intent	
Black Point Compensation	
Use Dither (8-bit per channel images)	
Creating a custom CMYK setting	
Ink Colors	
Dot gain	
Separation options	
Black generation	
Opening CMYK and Lab files	
Information palette	
The ICC color managed workflow	101
Charter Fire File Management and Output	100
Chapter Five – File Management and Output I	
RGB output to transparency and print	
CMYK output	
Fine art printing	
Inkjet CMYK output	105
Inkjet media	105
The ideal inkjet	106
Photoshop print controls	
Color proofing for press output	
Targeted CMYK printing	
Soft proofing	
Simulate Paper White and Ink Black	
PostScript printing	
Quantity printing	
Stormy waters	
Storing digital files	
Image database management	
The File Browser	
Renaming in the File Browser	
The future of image asset management	
Bureau checklist	
Image protection	123
Chapter Six – The Work Space I	25
Chapter Six – The Work Space	23
Photoshop preferences	
Saving files	
Display & Cursors	
Transparency & Gamut	
Units & Rulers	
Guides, Grid & Slices	
Plug-ins & Scratch Disks	
Memory & Image Cache	134

Image window	135
Title bar proxy icons (Macintosh)	
Preview box options	
Managing document windows	136
Rulers, Guides & Grid	
'Snap to' behavior	138
The Photoshop palettes	138
Palette docking	139
Workspace settings	
File Browser	
Navigator	
Info	
Tool Options bar	
Tool Presets	
Character	
Paragraph	
Brushes	
Brushes palette	
Styles	
Swatches	
Color	
Preset Manager	148
Actions	
History	150
Layers	
Channels	151
Paths	151
Tools palette	152
Selection tools	
Modifier keys	
Lasso: freehand/polygon/magnetic	
Move tool	
Crop tool	
Slicing tools	
The paint tools	
Healing brush/Patch tool	
Brush	
Pencil	
Clone stamp/Pattern stamp	
History brush	
History brush and Snapshot	
History and memory usage	
Non-linear history	169
Art history brush	170
Eraser/background eraser/magic eraser	
The Extract command	173
Gradients	174
Noise gradients	176
Paint bucket	
Focus: blur/sharpen/smudge	
Toning: dodge/burn/sponge	
Pen and path drawing	
Type tool	
Shape tools	
Annotation tools	
Eyedropper/color sampler	181

	Measure	182
	Navigation tools – hand and zoom	182
	Foreground/background colors	
	Selection mode/Quick mask	183
	Screen display	183
	Jump to button	184
Sun	nmary	184

TIFF (Tagged Image File Format)	. 186
EPS	. 188
DCS	. 189
Photoshop PDF	. 189
PDF security Importing multi-page PDF files PICT	. 192
Importing multi-page PDF files	. 192
PICT	. 193
IPEG	. 193
File formats for the Web	. 195
Other file formats for the Internet	. 195
GIF	. 196
Save for Web	. 198
PNG (Portable Network Graphics)	. 203
IVUE	. 204
FlashPix	. 204
Future of electronic publishing	. 204

Chapter Eight – Basic Image Adjustments 205

Cropping	205
Cropping Orientation and canvas	
Precise image rotation	
Big data	
Perspective cropping Image analysis	
Image analysis	
Levels adjustments	
Specular highlights	
Assigning shadow and highlight points	
Unsharp masking	
Sharpening for repro	
Amount	
Radius	
Threshold	
Threshold Selective sharpening	220
Chapter Nine – Color Adjustments	
Hue/Saturation	
Color balancing with Levels	
Variations	227
	227

Auto adjustments	227
Color Balance	229
Variations	229
Curves adjustments	229
Arbitrary Map mode	235
Replace Color	236
Color Range	238

Adjustment layers	
Multiple adjustment layers	
Blending mode adjustments	
16 bits per channel support	
Selective Color	
Chantan Tan Danaining an Incara	244
Chapter Ten – Repairing an Image	
Basic cloning methods	
Retouching a color negative	
Alternative spotting technique using the history brush	
Working with the healing brush	251

working with the healing brush	. 2	51
Patch tool	. 2	55
Healing brush strategies	2	58
Cloning selections		
Restoring a faded image	2	63
Keyboard shortcuts	2	65
Removing moiré patterns	2	66
Scanning halftone images	2	67
Tool applications and characteristics	2	69
Brush blending modes	2	70
Beauty retouching	2	71
Softening the focus	2	75
Rescuing shadow detail	2	76
Dodge and burn	2	78

Selections and channels	280
Summary of channels and selections	282
Selections	282
Quick mask mode	282
Alpha channels	282
Work paths	282
Modifying selections	284
Smoothing and enlarging a selection	284
Anti-aliasing and feathering	
Layers	
Blending modes	289
Masking layers	294
Adding an empty image layer mask	294
Adding an image layer mask based on a selection	294
Viewing an image layer mask in Mask or Rubylith mode	294
Applying and removing image layer masks	
Vector masks	297
Working with multiple layers	
Layer set management	298
Layer sets	299
Advanced blending options	301
Color coding	301
Layer locking	
Transform commands	303
Numeric Transforms	
Repeat Transform	
Transforming selections and paths	
Drawing paths with the pen tool	306
Guidelines for drawing pen paths	306

Pen tool in action	
Montages	
Masking hair	
Clipping groups	
Extract command	
Complex image blending	
Removing a matte color	
Ribblehead Viaduct by Ian McKinnell	
Exporting clipping paths	
Chapter Twelve – Shortcuts	
Efficient running	338
Contextual menus	
Selections	
Window display options	
Moving and cloning selections	
Info and Navigator	
Working with Actions	
Playing an Action	
Recording Actions	
Troubleshooting Actions	
Batch processing Actions	
Automation plug-ins	
Fit Image	
Picture Package	
Contact Sheet II	
Export Transparent Image and Resize Image	
Web Photo Gallery	
Creating a Droplet	
Layers and channels	
Chapter Thirteen – Black and White Effects	
-	
Duotone mode	
Printing duotones	
Full color toning	
Split toning	
SolarizationBlack and white from color	
Infrared film simulation	
Adding a photographic rebate	
Chapter Fourteen – Coloring Effects	
Cross-processing	
Channel Mixer adjustments	
Color overlays	
Retouching with overlays	
Gradient Map coloring	
Chapter Fifteen – Layer Effects	
Layer effects and Styles	
Drop Shadow	
Inner Shadow	
Outer Glow and Inner Glow	
Bevel and Emboss	

Satin	
Gradient Overlay	
Pattern Overlay	
Color Overlay	
Stroke	
Creating Styles	
Applying layer styles to image layers	
Painting effects	
Layer effect contours	
Transforms and alignment	
Shadow effect	
Spot color channels	
Adding type	
Vector output	
Chapter Sixteen – Filters	
Blur filters	
Fade command	
Smart blur	
Noise filters	
Filters for alpha channel effects	
Distortions and displacements	
Liquify	
The Liquify tools explained	
Lighting and rendering	
Clouds and Difference Clouds	
Lens Flare	
Lighting Effects	
Pattern Maker	
3D Transform	
Practical applications	
Appendix	
Adobe ImageReady™ 7.0	
Interface	
Jump to	
ImageReady layers	
Styles	
Actions	
Image resizing	
Cropping	
Color management	
Image slicing	
Slice content	
Optimizing images and image slices	
Image maps	
Rollovers	
Animation	
World Wide Web contacts list	
Index	

Introduction

n 1996, a group of self-proclaimed 'digital' photographers met together at Ian McKinnell's studio in Holborn, London, to discuss the formation of a Digital Imaging Group. At first, this was a small gathering of professional photographers. The one thing we all had in common was a shared interest in using computers and their potential as a photographic medium of the future.

Back then, to edit your photographs digitally was regarded as a very strange business. If nothing else, we were to be marvelled at for our patience, as to manipulate anything bigger than a 10 MB file on a desktop computer could be a notoriously slow process. At worst we were to be distrusted as the harbingers of doom, bringing about the end to photography as we know it. At one point it was seriously suggested by a photographic gallery committee that 'digital' photographs could not be exhibited unless accompanied by a sticker to signify that these pictures were not real photography. Maybe now it is true to say that because of digital technology, the photographic profession never will be the same again. But this has more to do with the way images are being marketed rather than the means by which those images are captured. Photographers are under increasing pressure to sign away their valuable rights and the pressure of competition has never been greater.

When image editing work stations used to cost a cool half million, digital retouching was the preserve of an exclusive elite. Photoshop has played an important role in bringing professional image editing within the reach of many. That is one of the great virtues of Photoshop – almost anyone can have a go now. Photoshop brings the power of professional image editing within the reach of the many. And as I have toured around Britain and the United States presenting seminars, I meet so many

people who are just beginning to get started using Photoshop and discovering for themselves the enjoyment that can be gained from being able to manipulate and control their own photographs up to and beyond the confines of what could once be achieved in the darkroom.

From a technical standpoint, dipping one's toes in the digital stream embodies taking on much more responsibility for the production process. For that reason this book is not solely about Photoshop but also delves into the technical implications surrounding the program's use and working in the digital domain. You are about to venture into new territory. The photographers whose work appears in this book, like myself, came to use Photoshop with no great knowledge of computers. We all had to learn to use this new technology from scratch. So in planning this book I considered carefully what could be packed into 480 pages that would be relevant to someone wanting to use Photoshop as a digital darkroom tool. Techniques which show you how to create 3D type effects and illustration graphics have been deliberately scaled down – there are other great Photoshop books which can service those interests. Presented here is a guide packed with the Photoshop features you'll really want to use and need to become familiar with. One special feature is the inclusion of some of the book tutorials in movie form on the CD-ROM. From my own experience, movies are a helpful way to learn and assimilate Photoshop techniques.

Adobe Photoshop 5.0 for Photographers was first published in October 1998. This and the subsequent Adobe Photoshop 5.5 and 6.0 for Photographers were bestselling Photoshop titles on the Amazon.com book selling lists in the United States and here in the UK. Thank you to all the readers who wrote in with their comments and suggestions. In this updated edition I have been able to increase the size of the book and include extra tutorials relating to Photoshop 7.0 and revise the earlier passages to help the book flow more and take into account recent technical developments in computer hardware. Photoshop 7.0 is bundled with Adobe ImageReady™ 7.0. I felt that ImageReady, although a great program, is not so relevant to photographers. Of course there are quite a few new web features which have been added since version 5.0, and these are all covered in the book. A special ImageReady section has been incorporated in the Appendix. A few people wrote and asked if it would be possible to include the images illustrated in this book on the CD-ROM? I am afraid that this is one wish that is going to be hard to satisfy at present. The majority of the photographs that appear in this book either feature professional models, belong to other photographers or appear by permission of a commercial client. Permission has been obtained for the pictures to be reproduced in the book, but obviously this does not include royalty-free usage on the CD disc. Even if we could have gained such permissions it would not have been possible to achieve within the book's production budget. However, a few of the pictures - the non-commercial shots - are now contained on the CD-ROM and can also be downloaded from the book's website.

I use an Apple Macintosh system to run Photoshop, but have included keyboard equivalents for PC users and special instructions throughout. If you are running the Windows 98 operating system or later, the translation between Mac and PC is not too dissimilar. My advice to anyone is use the computer system you feel most comfortable with. It is a sign of maturity when one can mention the words Macintosh and PC in a sentence without claiming superiority one way or the other. Platform wars and speed comparisons prove very little. When analyzing these differences, Photoshop performance hinges more on the skill and speed of the operator and not the hardware or computer system they use.

Being British born I use UK English spelling in the normal course of my writing. However, Adobe are a US company and the international, English language Photoshop interface uses US spelling. As this book is being distributed throughout many English speaking countries, we settled on the US English spelling conventions throughout. In addition, I believe it is important for everyone that all the interface terms and definitions are used precisely. There are many confusing and incorrect terms in use – like the Photoshop user who on an Internet mailing list described an action called 'Pretzel-clicking'. In Germany apparently, the Apple Command key is also known as the Pretzel key.

Acknowledgments

I must first thank Andrea Bruno of Adobe Europe for her suggestion that I write a book about Photoshop aimed at photographers. I would like to give a special mention to my publishing editors: Marie Hooper, Jennifer Welham, Beth Howard and Jane Read at Focal Press. Also thanks to Adam Woolfitt and Mike Laye who helped form the Digital Imaging Group (DIG) forum for UK digital photographers and all the other DIG and Association members: Julian Calder, Laurie Evans, Jon Gibson-Skinner, Peter Hince, Thomas Holm, Ed Horwich, Bob Marchant, Ian McKinnell, Gwilym Johnston (who compiled and authored the CD-ROM), and in particular Rod Wynne-Powell, who reviewed the final manuscript and provided an enormous amount of help with technical advice and assistance in the production of this book. And I want to give a very special mention to fellow Photoshop alpha tester Jeff Schewe for all his guidance and help over the years.

The following clients, companies and individuals should also be mentioned for the help they gave me: Adobe, Amateur Photographer, Binuscan, Bookings, Steve Broback, Russell Brown, Camera Bits, Clippers, Clipso, Jeremy Cope, Chris Cox, Tom Fahey, Bruce Fraser, Karen Gauthier, Gretag Macbeth, Nick Haddon, Mark Hamburg, Leon Herbert, Imacon – Denmark, Thomas Knoll, Ricky Liversidge, MacUser UK, M&P Models, Models One, Nevs, Marc Pawliger, Pixl – Denmark,

Profile, Clair Rawlings, Herb Paynter, Red or Dead Ltd, Eric Richmond, Andrew Rodney, Schwarzkopf Ltd, Michael Smiley, The Smithsonian Institution, Susanne Sturton, Paul Smith, Martin Soan, Storm, Tapestry, Tresemme, Jim Williams, Russell Williams, Mark Williford and YU salon. And lastly, thanks to friends and family. My late mother for all her love and encouragement and who was always so supportive and proud of my success.

Getting started

I aimed to make this book a comprehensive guide to the use of Photoshop as a photographers' tool. The early chapters introduce important subjects such as how digital images are captured, digital image resolution and the all-important topic of color management. You will doubtless want to refer to this first section when you need to find out more about different file formats and print proofing methods, but it is not absolutely necessary that you begin reading here. If you want to dive in and learn the Photoshop basics, you could easily bypass these early chapters and start at Chapter Six on 'The Work Space'. Here you will be introduced to all the Photoshop 7.0 tools and palettes. Chapter Eight deals with basic image correction controls and from thereon as you progress through the book, you will be shown how to incorporate some of Photoshop's more powerful features and apply sophisticated techniques. But to begin with, here is what you will find that is new in this latest version of Photoshop.

What's new in Photoshop 7.0

Whenever a new full version of Photoshop is released there is a predictable debate over whether the new program justifies being classed as a full upgrade or not. But whatever the pundits and critics like myself write, it is going to be the Photoshop customers who will ultimately decide if Photoshop 7.0 makes the grade or not. Speaking as an alpha tester and someone who has had the opportunity to work closely with the Photoshop engineering team, I can readily acknowledge the hard work and dedication of the Photoshop engineering team that goes into each and every program upgrade. And Photoshop 7.0 is no exception. In preparing this update to the book I counted at least fifty feature additions and tweaks to the program. Admitedly some of these are quite subtle, but nonetheless these have all gone to provide a version of Photoshop that is more versatile and equipped ready to meet the demands of users old and new. What follows is a brief summary of what's new and which features will be of special interest to photographers.

Mac OS X and Windows XP support

For Macintosh users, the Mac OS X support was one of the most eagerly anticipated features of Photoshop 7.0. While at the same time, PC users now have support for the Windows XP operating system, and I'll be writing more about this in Chapter Three. Mac OS X is based on a UNIX core and although UNIX has been around for a long time, the last time it was supported by Photoshop was in version 3.0. So a lot of engineering time had to be devoted to updating the Photoshop 7.0 code in order to achieve this. Photoshop 7.0 has also had to rely heavily on Apple to provide the operating system resources to optimize Photoshop 7.0's performance in OS X. To this end, Mac users will probably want to make sure they are running the very latest update (OS X 1.4 at the time of writing). The Windows XP system is an overhaul of the Windows NT system and like OS X is a very robust OS to run Photoshop on and features a new 'Luna' interface and some nice cool interface features that enhance image file management. But apart from a few nagging issues I have with Mac OS X, the OS X and XP interfaces give Photoshop a nice brand new environment to work within.

File Browser

The File Browser first made its debut in Photoshop Elements and a much enhanced version of the File Browser is now included in 7.0. As far as photographers should be concerned, this is the number one new feature. Gone are the days when we thought ourselves lucky to be able to work on more that one image at a time. And because Photoshop now allows us to process large numbers of images with ease and the number of image files stored on our hard drives increases, we really do need an efficient method of navigating, sorting and managing our photographs. The File Browser is a very welcome addition for Photoshop, as we are now able to quickly see large image thumbnails and previews. Images can be ranked according to preference plus you can rotate and batch rename selected images from within the browser interface. And since Photoshop 7.0 features XMP (eXtensible Markup Platform) support for embedding metadata, you can view all the associated metadata in the File Browser. Metadata use is becoming increasingly important to the future of digital photography and image management and XMP will allow you to manage your files in an automated production workflow. The File Info dialog now automatically includes any of the EXIF metadata present in the file and the XMP data.

Healing brush and patch tool

At first sight the healing brush appears to be a new variant of the clone stamp, but is actually a very powerful retouching tool. The healing brush is able to sample the pixel texture from one source point (which can be image pixels or a pattern texture) and smoothly blend this with the color and luminosity of the pixels you are applying the healing brush to. The healing brush will prove itself to be incredibly useful for all sorts of tricky photographic retouching jobs. The patch tool is an interesting variant of the healing brush that allows you to sample larger, selection-defined image areas and 'patch' these over with pixels sampled from another part of the picture. Or alternatively, you can use the patch tool as an effective means for copying selected areas and smoothly compositing in another portion of the image. The patch tool may sound like yet another gimicky Photoshop feature but this too is a very effective retouching tool.

Brushes engine

The Photoshop paint engine contains a lot of new brush dynamics controls and is able to fully exploit all the different user-variable options of a pressure sensitive tablet such as the Wacom IntuosTM and create natural media painting effects and these can be combined with pre-supplied or any sampled texture. The brushes limit has been increased to 2500 pixels and there are some other subtle improvements, such as the ability to use all layers when you use the blur tool (and also with other tools). The overwhelming variety of brush options may be beyond the basic requirements of photographers. Nevertheless, the visual feedback provided in the brushes palette allows you to explore these various options intuitively and easily should you wish to do so. The supplied brush presets will help you get acquainted with the new possibilities the brushes engine offers. Several new brush and layer blending modes have also been added in Photoshop 7.0.

Interface refinements

You can save as many custom palette configurations as you like via the Workspace settings in the Window menu (previously you only had the choice of saving your last used palette layout, or resetting the palettes to their default positions). You can even record the loading of saved workspace settings as an action and it is also possible to assign hotkeys to switch quickly between different screen layout settings. Macintosh users will be pleased to know that they can now choose to display all their open document windows as a tiled display, just as PC users have been able to before.

Many of the Photoshop tools now have revised options in the Options bar. Custom Photoshop tool configurations can be saved in the Tool Presets palette. This means that you can save or load settings for custom marquee tool proportions or type tool settings using a specific font, font size and alignment. The document window will display the size dimensions in the status box and you can create a new document from a custom preset document size (and create your own document size presets).

Automation

Photoshop 7.0 fully supports automated system scripting. This will enable the geekier users among us to write scripts that operate actions from outside of Photoshop to perform discrete image processing tasks. The Conditional mode change feature in the Automate menu permits you, when recording an action, to selectively perform a color profile change based on a preselected range of color mode options. The Picture Package has been revamped to allow you to select more than one image to place on the page, together with file name or caption information and Picture Package now displays image previews in the dialog. The Contact Sheet II feature at last addresses the problem of the gutters being too wide. Several new preset options are available in the Web Photo Gallery styles – you can now have your email address appear on the pages and there are some new security features too, so if you wish, you can have a copyright notice added to your web gallery images. The text engine includes spell checking and replace text features in multiple languages, plus a new 'Sharp' text anti-aliasing mode.

Auto Color

An Auto Color image adjustment has been added to the Auto Levels and Auto Contrast commands in the Image Adjust menu. Auto Color will attempt to remove color casts by analyzing the darkest and lightest colors in an image and neutralizing them. In the Levels and Curves dialogs there is an additional option to neutralize the midtone color as well. The Levels and Curves auto options allow a suitable element of control over these auto adjustments in case you are worried about introducing too much image clipping. And as with the other auto adjust tools, it can be applied to 16-bit per channel images.

Filter menu

The Adobe filter plug-in previews have all been enlarged to twice their previous size. This will make it easier to evaluate the final outcome before applying a filter and visualize what the image will look like at different filter settings. The Liquify command has been moved to the Filter menu and been improved to provide full zoom and pan control over the image preview, plus a turbulence distort tool, multiple undo and the ability to save and load Liquify mesh distortions. You can load presaved alpha channels for use as a freeze mask and the distorted image can be previewed as transparently overlaying the full composite original or a specific layer in the Liquify dialog.

The Pattern Maker is a curious item. It can be used to generate a fragmented pattern based on a selection from the original picture. It will be useful for web designers who want to produce tiled background images, but the Pattern Maker can also be used to produce interesting pattern tiles that work for larger images as well.

Web features

More web features have been added to Photoshop 7.0 and ImageReady[™] 7.0. In the Photoshop Save for Web dialog you can save customized SFW settings, specify knockout transparency for one or more colors in a web graphics element and create partial transparency effects. You can selectively protect vector art and text layers, preserving these elements in a design using a higher quality JPEG compression setting. The Rollovers palette in ImageReady allows you to manage rollover animations more easily and the Slice tool has a Divide option, enabling you to split a slice into even subsections and you can auto-generate slices based on the Photoshop guides.

Extras

The Canvas size dialog enables you to add extra units of measurement to the canvas 'relative' to the original size. So, for example, you can choose to add 2 cm of canvas top and left of the current canvas. Password protection can be added to limit the access people have to PDF files saved out of Photoshop and restrict the printing options.

There is a website set up to promote this book where you can find active links mentioned in the book and late-breaking news on Photoshop 7.0.

<www.photoshopforphotographers.com>

Chapter One Digital Capture

reckon it is probably fair to say every photographer I know now involved with digital imaging came from the position of being a onetime digital skeptic. The conversion has in some cases been dramatic which was no doubt linked to the speed of changes which took place in our industry during the eighties and nineties. One colleague commented that in the early days he used to tease his retouching bureau that you could see the pixel structure of a digital image. 'When they started working with 200–300 MB images and you saw the grain structure of the film before the pixels – I finally conceded my argument!'

The point is that digital imaging has successfully been employed by the printing industry for over fifteen years now and if you are photographing anything that is destined for print media, one can say with certainty an image will at some stage be digitized. At what point in the production process that digitization takes place is up for grabs. Before, it was the sole responsibility of the scanner operator working at the printers or high-end bureau. The worldwide sales success of Photoshop is evidence that prepress scanning and image editing now takes place more commonly at the desktop level.

So this book commences with the digital capture or digitization of a photographic image. It is self-evident that the quality of your final output can only be as good as the quality of the original. Taking the digitization process out of the hands of the repro house and closer to the point of origination is quite a major task. Before, your responsibility ended with the supply of film or prints to the client. Issues such as image resolution and CMYK color conversion were not your problem, whereas now they can be.

It is worth bearing in mind the end product we are discussing here: digital files that have been optimized for reproduction on the printed page. The media by which the images are processed are irrelevant to the person viewing the final product. Those beautiful transparencies are only ever appreciated by a small audience - you, the art director and the client. Pretty as they might be, transparencies are just a means to an end and it is odd that clients may still insist on digital files being 'proofed' as transparency outputs when a calibrated digital proof would give a better impression of how the job will look in print. I am not knocking film - I happen to be one of those photographers that still shoots using transparency film and scans the selected images. A roll of film has the potential to record and store many gigabytes of data at high quality quickly, and for a very reasonable cost. The majority of my work involves shooting live action. In my opinion, digital cameras and the hardware and software used to preview the images captured have some way to go before they will be able to rival the versatility of shooting and editing with conventional film, although I am sure it will happen one day soon. Digital capture is definitely the way forward for the future of photography the superior image quality speaks for itself.

Scans can be made from all types of photographic images: transparencies, black and white negatives, color negatives or prints. Each of these media is primarily optimized for the photographic process and not for digital scanning. The tonal density range of a negative, for example, is very narrow compared to that of a transparency. This is because a negative's density range is optimized to match the sensitometric curve of printing papers. Therefore the task of creating a standardized digital result from all these different types of sources is dependent on the quality of the scanning hardware and software used and their ability to translate different photographic media to a standard digital form. If one were to design an ideal film with CMYK print reproduction in mind, it would be a transparency emulsion which had a slightly reduced density range and an ability to record natural color without oversaturating the blues and greens (what looks good on a light box is not necessarily the best image to use for print reproduction). A negative emulsion is able to capture a wider subject brightness range than a transparency can, but the problem here is that the subtle negative information can easily be lost unless the scanner is able to record such subtle tonal differences with accuracy.

Structure of a digital image

A digital image is a long string of binary code (like the digital code recorded and translated into an audio signal on your music CDs). It contains information which when read by the computer's software displays or outputs as a full tone image. A digital image is a high-fidelity original, capable of being replicated exactly, any number of times.

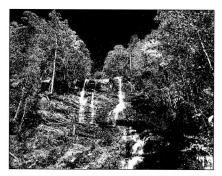

Bitmap image (I-bit)

Figure 1.1 The bit depth of an image is a mathematical description of the maximum levels of tone that are possible, expressed as a power of 2. A bitmap image contains 2 to the power of I (2 levels of tone), in other words, either black or white tone only. A normal Photoshop 8-bit grayscale image or individual color channel in a composite color image can contain up to 256 levels of tonal information. When the three RGB 8-bit color channels are combined together to form a composite color image, the result is a 24-bit color image that contains up to 16.7 million shades of color.

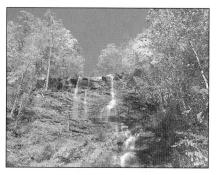

Red channel (8-bit)

Green channel (8-bit)

Combined RGB image (24-bit)

Blue channel (8-bit)

Cha	nnels	$\underline{\}$					0
		RGB				¥-	
		Red				36 1	
	Green				₩2		
	Blue #3			# 3			

Each picture element or 'pixel' is part of a mosaic of many thousands or millions of pixels and each individual pixel's brightness, hue and saturation is defined numerically. To understand how this works, it is best to begin with a grayscale image where there are no color values, just luminosity. Grayscale images are made up of 256 shades of gray – this is what is known as an 8-bit image. A 1-bit or bitmapped image contains black or white colored pixels only. A 2-bit image contains 4 levels (2²), 3-bit 8 levels (2³) and so on, up to 8-bit (2⁸) with 256 levels of gray. An RGB color image is made up of three color channels. Each channel contains 8-bit grayscale information defining the amount of each color component of the full color image. The overlaid color channels mean a single pixel of an RGB color image contains 24-bit color information, which can define up to 16.7 million possible colors.

The scanner you have may be described as being able to capture an RGB image in 30-bit or 36-bit color. Photoshop can support 16 bits per pixel for each channel, so if the scanner is able to capture a greater bit depth than 8 bits per channel it is possible to import a high-bit image and edit it in 16-bit per channel mode (i.e. 48-bit RGB). Photoshop has extended support for 16 bits per channel editing. You can crop, clone, adjust the color and apply certain filters like the unsharp mask when in 16 bits per channel mode.

Scanners

A scanner reads information from an original, which can be a print, negative, transparency or artwork, and converts this to digital information at the preferred output size, and in the preferred color space ready for image editing. High-end drum scanners are the choice of professional bureaux as these produce the best quality. The optical recording sensors and mechanics are superior, as is the software, and of course you are paying a skilled operator who will be able to adjust the settings to get the finest digital results from your original. Desktop drum scanners are available at a slightly more affordable price, but hot on the heels of these are the top of the range flatbeds, in particular the Agfa, Umax and Linotype-Hell models. The reason for this improved performance is largely due to the quality of the professional scanning software now bundled (i.e. Linotype and Binuscan). In fact it has been rumored that these flatbed scanners have for quite a while been capable of improved output. They were hindered from achieving their full potential by software limitations which maintained a division in the market between these and the more pricey desktop drum scanners. It rather reminds me (and I am told this is a true story) of an electrical goods manufacturer in the process of testing their latest budget 'all in one' phono/tuner/cassette and CD player prototype. The sound quality from the CD was no better than phono or cassette, so the CEO suggested adding a few extra components to distort the output from everything but the CD player, after that the CD always sounded superior.

Flatbed scanners work a bit like a photocopying machine. The better models record all the color densities in a single pass and have a transparency hood for transparency scanning. One or two high-end flatbeds use a method of three pass scanning, which provides better color accuracy. Flatbeds fall mostly into the cheap and cheerful class of equipment, but there are professional ranges of flatbed that are gaining popularity in bureaux due to the true repro quality output which can be obtained and the ease of placing images flat on the platen, compared to the messiness of oil mounting on a drum. Heidelberg have a good reputation – they manufacture a broad range of nicely designed flatbed scanners. Even the cheapest scanner in their Linoscan range has an integrated transparency hood. A lot of designers use budget scanners such as these to create what are known as a 'positional' scans for placing in the layout. Although not necessarily designed for repro work, a great many photographers are finding they can nevertheless squeeze quite acceptable scans within the limiting confines of a cheap flatbed.

Flatbeds are generally OK for scanning large format film emulsions. Other CCD (charge coupled device) variants are designed to scan film emulsions at high resolutions. Polaroid, Nikon, Canon and Kodak make good models for scanning from 35 mm and 120 formats. In addition it is worth checking out the Imacon Flextight range of CCD scanners. These CCD scanners offer high optical scanning resolution and a good dynamic range. To my mind the Flextight scanners such as the Flextight Photo (35 mm and 120 films only), Flextight III and Flextight 848 are the best quality CCD scanners around for small and medium format professional scanning and offer excellent value compared to a desktop drum scanner.

With a drum scanner, the image is placed around the surface of a transparent drum. To avoid Newton rings, the transparency is oil mounted – a very thin layer of a special oil ensures perfect contact with the drum surface. Fastening the transparencies in place is quite a delicate procedure, and demands skillful handling of the film originals. High-end drum scanners are often sited in an air-controlled room to minimize on dust. The image on the drum is rotated at high speed and a light source aligned with a photomultiplier probe travels the length of the film. This records the image color densities digitally at very fine detail. Drum scanners offer mechanical precision and advanced features such as the ability to make allowance for microscopic undulations in the shape of the drum and thereby guaranteeing perfectly even focussing. From the bright point light source, the photomultiplier is able to record shadow detail in the densest of transparencies (this is where inferior scanners are usually lacking). Drum scanners offen have a separate photomultiplier (PMT) head to record tonal values in advance of the recording RGB heads and intelligently calculate the degree of sharpening required for any given area (of pixels).

Basically flatbed devices tend to use CCD chips and drum scanners use PMTs. CCD scanners tend not to emphasize dust and scratches the way a drum scanner (used in a normal dusty air environment) would. The reason for this is the light source is much softer in a CCD scanner and it is a bit like comparing a diffuser with a condenser printing enlarger. The latter has a softer light source and therefore doesn't show up quite so many marks. To combat the problem of dusty originals, the Nikon LS 2000 was the first 35 mm CCD scanner to employ ICE image processing. This is a clever filtering treatment which automatically removes dust and scratches, with little softening of the image scan, involving the use of the infrared portion of the data to mask out surface imperfections.

What to look for in a scanner

The following section contains advice on what to look for in a scanner. This will help you weigh up which is the right scanner for you. To summarize, there are three basic types of scanner you can buy. A flatbed is the cheapest option and if you get one with a transparency hood you will be able to scan prints, negatives and transparencies. But only the more expensive flatbeds are able to satisfactorily scan small format films. If that is your goal then you would be better off purchasing a basic 35 mm CCD scanner such as the Nikon Coolscan IV, or if you want to scan 120 films as well and get professional repro quality, manufacturers like Nikon and Polaroid make larger CCD scanners that are near repro quality. For the very best quality consider one of the Imacon Flextight range. The manufacturer's technical specifications can guide you to a certain extent when whittling down your selection. Here are the main things to look for:

Resolution

Specified as pixels per inch, this indicates how precisely the scanner can resolve an image. The Nikon Coolscan IV ED CCD scanner is an affordable 35 mm CCD scanner and has a scanning resolution of 2900 ppi. This means that you can scan a full-frame 35 mm image and get a 32 MB 24-bit file. Higher optical resolutions (4800 ppi) are only possible with drum scanners and high-end CCD scanners. It is the optical resolution that counts and not the interpolated figures. Some manufacturers claim scanning resolutions of up to 9600 ppi when in fact the maximum optical resolution is only 600 ppi. This is a bit like claiming you possess a video of your car breaking the sound barrier and you prove it by playing the tape back at a faster speed. The lowend flatbed machines begin with resolutions of 600×1200 ppi, rising to 3048×3048 for the high-end models like the Heidelberg Linoscan 1800. Flatbed resolutions are

expressed by the horizontal resolution – the number of linear scanner recording sensors – and vertical resolution – the mechanical accuracy of the scanner. My advice when using a flatbed is to set the scanning resolution no higher than the 'optical' resolution and interpolate up if necessary in Photoshop. There is also a good case to be made for scanning at the maximum optical resolution and reducing the file size in Photoshop, as this will help average out and reduce some of the scanner noise pixels which are typically generated by the cheaper flatbed scanners. For critical jobs – scanning detailed line art, for example – it may be worth rotating the page 90 degrees and comparing the quality of the two scans. For the best optical quality, position the original around the center of the platen, known as the 'sweet spot'.

Dynamic range

A critical benchmark of scanner quality is the dynamic range - the ability to record detail across the widest tonal range from the shadows to the highlights. Not every manufacturer will want to tell you about the dynamic range of their scanner, probably because it is not very good! Without a wide dynamic range the scanner will be unable to record the subtle tonal variations in the shadows of a transparency. You may also find that the cheaper flatbed scanners are unable to record subtle highlight detail. You may see highlight tones disappear entirely, where the RGB measured values in Photoshop are blown out to white (R:255, G:255, B:255). If you use a flatbed to scan in prints and have this problem, try making a print to match the recordable density range of your scanner. For example, select a softer grade of printing paper and print the highlights darker than normal and make the shadows slightly lighter than usual. Print several versions from the negative and find which scans best with your equipment. A normal contrast photographic print has a reflectance range of about 2.2 which may be beyond the capabilities of an inferior scanner and when it comes to scanning transparencies the ludicrous density ranges of modern E-6 emulsions can be an even tougher scanning challenge (Ektachrome transparencies have a typical dynamic range of 2.85-3.6). Some photographers are deliberately overexposing a transparency film like Velvia and underprocessing it. This produces weaker shadows that are therefore easier to scan. A good quality repro drum scanner should be able to attain a dynamic range of 3.8, but note that the dynamic range specified by some manufacturers may be a little optimistic and the quoted values could actually be influenced by scanner shadow noise.

Bit depth

If you are scanning from negative originals, then the dynamic range won't be your main problem. But it will be important to capture enough detail within a narrow subject tonal range and expand this to produce a smooth continuous tone output after inverting to make a positive. A scanner that is capable of a higher bit depth means that more levels of tone will be captured in the scan. As was explained in the early pages of this chapter, a 24-bit RGB color image will be made up of three 8-bit image channels and each 8-bit channel can only contain up to 256 levels of tone. If you have a scanner that is only capable of capturing 256 levels per color channel and you want to expand the tonal range of a low contrast scan in Photoshop, when you apply a Levels adjustment you will end up stretching the limited number of levels of tone in each channel. Most of the scanners you come across will be able to scan at 12 bits per channel or higher. A 12-bit per channel scanner (quite common these days) will be able to record up to 4096 levels in each color channel. Therefore a lot more tonal data information is captured and if you apply a levels correction to the shadows and the highlights (either in the scanner software or in Photoshop), you will still end up with enough data points to produce a nice smooth histogram when this is converted to a 24-bit RGB image. Any capture device that produces a file with a greater bit depth than 8 bits per channel will be translated into a 16-bit per channel file when opened in Photoshop (check the Image > Mode menu). I always scan and shoot everything in high bit data and perform all the initial image adjustments in this 16-bit per channel mode. This is especially important when you scan black and white negatives. You will probably have to greatly expand the shadow and highlight points of a negative and also want to apply a curves adjustment to increase the contrast. Editing in 16 bits per channel enables you to maintain ultimate integrity of your data providing the scanner was able to record all the necessary data in the first place.

Scanning speed

It can take a long time to carry out a preview plus make the final scan, so buying a slow scanner could really stall your workflow. The manufacturer's quoted scan times may be a bit on the optimistic side, so do check the latest magazine reviews or the Web for comparative performance times. Do also take into account the time it takes to set up and remove the original and the additional time it might take to scan at higher resolutions or work in a multi-pass scanning mode. I have used a drum scanner for several years now and am very aware of the length of time it takes to mount each transparency, peel these off afterwards and then have to clean everything afterwards.

I A black and white negative will contain a lot of subtle tonal information and it is important that the scanner you use is able to accurately record these small differences in tone.

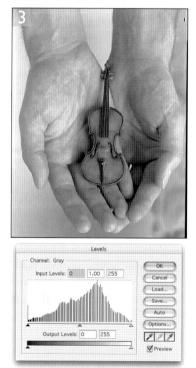

3 If we scan in the standard 24-bit RGB, 8 bits per channel mode and expand the shadow and highlight points, you will see how ragged the Levels histogram appears.

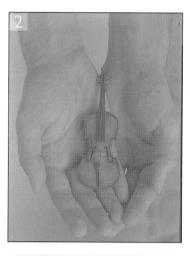

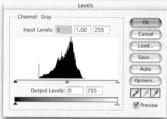

2 A histogram display of the inverted, but otherwise unadjusted negative confirms that you will need to expand the shadow and highlight points in order to produce a full tonal range image in print.

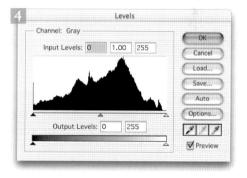

4 If instead we always scan in high-bit (anything greater than 8 bits per channel scanning mode) the image will always open in 16 bits per channel in Photoshop. The histogram after adjusting the Levels will look smooth as shown here, meaning there is no tonal information lost.

Photograph: Eric Richmond

Software

The scanner will be supplied with driver software that controls the scanner. The scanner driver may be in the form of a stand-alone application which will import the image and save as a TIFF file ready to open in Photoshop, or it may come in the form of a plug-in or TWAIN driver designed to be incorporated within Photoshop. The installer will automatically place the necessary bits in the Plug-ins folder. The scanner will then be accessed by choosing File > Import > *name of scanner device*.

A well-designed driver should be easy to use. A good, clear scan preview will help you make adjustments prior to capturing the full resolution scan. The ideal situation is one where the scanning device faithfully captures the original with minimal tweaking required in Photoshop to get an accurate representation in the master file. Modern scanner software should be using ICC-based color management to take care of interpreting the color from the scan stage to opening in Photoshop. Even the 'canned' scanner ICC profiles supplied with every machine regardless of individual characteristics should get you into the right ball park. For really accurate color management you will want to investigate having customized profiles created for you. If your scanner or capture device does not have an ICC color management facility, the instructions in Chapter Four describe how to convert from the scanner color space to the Photoshop color work space.

Visual assessment

All scanners are RGB devices. CCD chips are striped with three or four colored sensors, usually with one red, two green and one blue sensor (the extra green is there to match the sensitivity of the CCD to that of the human eye). When evaluating the quality of a scan, check each individual channel but pay special attention to the blue channel because this is always the weakest. Look for excess noise and streaking. The noise will not always be noticeable with every subject scanned, but if you had lots of underwater pictures or skyscapes to process, this failure would soon become apparent.

Purchasing bureau scans

Low-end scanners are fine for basic image-grabbing work such as preparing scans for a website. But professional photographers should really purchase a repro quality scanner and if you cannot afford to do that, buy bureau scans. The cost may seem prohibitive, but you are getting the best that modern digital imaging technology can offer. It amazes me that people are prepared to spend good money on professional cameras and lenses, yet use the equivalent of a cheap enlarging lens to scan their finest pictures. When buying bureau scans, you need to know what to ask for. First, all scanners scan in RGB color, period. The person you deal with at the bureau may say 'our scanners only scan in CMYK'. What they really mean is, the scanner software automatically converts the RGB scan data to CMYK color (for more information on RGB to CMYK, see Chapter Four on color management). The bureau you are dealing with may normally supply scans to go direct to press, one that is converted to CMYK color and pre-sharpened. If you want to do any serious retouching before preparing the file to go to press you are better off with an RGB scan that can be converted to CMYK and sharpened later. Photoshop editing is best performed using an RGB file without any unsharp masking. You can edit and composite in CMYK, so long as you don't mind not being able to access many of the plug-in filters. The unsharp masking can be a real killer though – make sure you ask them to leave the image unsharpened and apply the unsharp masking (USM) yourself.

Kodak Photo CD and Picture CD

Kodak launched Photo CD in 1992 as a platform-independent storage medium of digitized images for use with desktop computers and for display on TV monitors via a CD player. Although initially targeted at the amateur market, Photo CD soon became popular with a lot of professional users as well.

Labs/bureaux offering the Kodak Photo CD service can supply the processing of a roll of film, transparency or negative plus transfer of all the images to a Master CD disc as an inclusive package. Depending on where you go, it can work out at around a dollar per scan including the film processing, although in addition you will have to purchase the CD disc. A Master disc can store up to 100 standard resolution (18 MB) 35 mm scans, while the Pro disc can store 25 individual high resolution (72 MB max) scans from either 35 mm, 120 or 5×4 films. Pro Photo CD scans can cost anywhere between \$10 and \$30 each plus \$10–\$30 for the Pro Photo CD disc. These charges compare with \$60–\$150 for high-end drum scans.

Image quality

Is it any good? Leading labs/bureaux are prepared to offer Pro Photo CD scans as a cheaper alternative to drum scans. At Tapestry in Soho, London, I was shown examples of CMYK Cromalin proof outputs from both a Hell Color scanner and Kodak Pro Photo CD. There is a perceptible difference between the two when they are compared side by side, but it is hard to fault the Photo CD scans when the printed results are viewed in isolation. Quality is dependent too on the operator who is preparing your scans, but I'll come to this later. Digitized images are written to disc in a

lossless (compressed without loss of detail) proprietary format, making Photo CD an efficient and cheap storage medium for archiving images. Scanned images consume precious disk space, which adds to production costs, especially if you are having to store both original and manipulated versions. With the cost of process + scan package deals being as cheap as they are, one can easily build an archive library of skies, elements and textures etc.

	Kodak PCD Format				
	Source Image				
	Name: IMG0006.PCD				
	Pixel Size: 2048x3072 + Cancel				
	Profile: KODAK Photo CD 4050 E				
	File Size: 36.9 Mb				
	Destination Image				
	Resolution: 300 ppi 🕴				
Image Info	Color Space: RGB 16 Bits/Channel				
Original Type: Color reversal (slide film) Product Type: FilmScanner 404	Orientation: OLandscape Portrait				

Figure 1.2 The Photo CD interface. The Image Info on the left tells you which film emulsion type the photograph was shot on and the type of scanner used. This information will help you determine which source Profile setting to use. This latest, much simplified interface is a great improvement on those found in previous versions of Photoshop. It is now possible to set the pixel resolution you want the file to open at and you can now open a Photo CD file as a 48-bit RGB. This overcomes the previous limitations of bringing files in at 24-bit color. It is claimed that the luminance channel in a YCC file contains 12 bits of information, so bringing a file in at 48-bit RGB will make the most of all the information captured in the original Photo CD scan.

The Photo CD format contains a pyramid structure of five resolutions from Base/16 (used to create the thumbnail index card images), up to 16 Base (18 MB) for output as a 10×8 photographic quality print. The Pro Photo CD disc can also store 64 Base (72 MB) images scanned from any film format up to 5×4 sheet film. The advantage of the Image Pac structure is that you can easily access the appropriate resolution required for any usage without having to open the very largest sized file and resample down. The Kodak software enhancements for opening Photo CD images also optimize the image detail for whichever resolution you choose. Photo CD is device and platform independent. Film originals are scanned at the bureau on a PIW (Photo CD Imaging Workstation) and converted to Kodak's Photo CD YCC storage format. This format stores color information using a method based on the CIE or Lab color

model (see Chapter Four). Almost all the image detail is recorded in the Y (luminance) channel. The two chroma (CC) channels record the color information – these contain little image detail and can be compressed to a smaller size. Finally a hierarchy of resolutions is created which forms the Image Pac.

Optimum Photo CDs

The scanner operator working on the PIW has limited control over the making of PCD scans. Included with every workstation is a Scene Balance Algorithm (SBA) control, which will automatically read an image and make adjustments for incorrect camera exposure or variations in color temperature (just like the automated devices used in optical printers at photo finishing labs). The operator can override or reduce the SBA to taste. Or as is more likely, in the case of handling professionally shot reversal films, stick to using the 'Universal Film Terms'. This will retain the original appearance of the image as it appears on film. To explain this more clearly, the PIW records the information from the film on the basis that it is correctly exposed and has the correct lighting color balance, retaining the original film's unique characteristics.

The aspect ratio of the scanning area is 2:3. Therefore 35 mm or 6×9 cm film formats make best use of the available area. The PIW mask holders will accept any other format up to 5×4 but bear in mind that with 6×4.5 cm or 6×6 cm transparencies where you want to crop to a portrait or landscape format, you will make use of only half the total scanning area. A 35 mm full framed image scanned at standard resolution will yield a maximum image size of 18 MB, while with a 6×4.5 cm image you only get 9 MB of usable data. For these film formats you will certainly only want to have high-res 72 MB Pro Photo CD scans done, which will provide a 36 MB image (less if you want to crop within the full frame).

Opening a Photo CD image

The standard Photoshop installation will install all the plug-ins needed to open an image from a PCD disc (also check these extensions have not been temporarily switched off or disabled). First, go to the extensions manager (Mac system) and check to see that all the KODAK PRECISION and CD-ROM extensions are switched on. If not, do so now and reboot the computer. The easiest mistake Macintosh users can make is to go to the folder marked 'PHOTOS' and open the files directly in Photoshop. These PICT format images (for TV monitor display) are not suited for reprographic output as the highlight tones tend to be clipped.

- Insert the Photo CD disc into the CD-ROM drive.
- With Photoshop loaded, open the image required via the File > Open menu.
- Click to select desktop and open the PCD icon.
- Go to the 'Photo_CD' folder. Open the folder marked 'IMAGES'.
- Check the indexed print on your CD for the image number and click 'Open'.

The dialog box which now appears offers several choices. Go to Pixel Size and choose the resolution size for output, i.e. 2048×3072 which will yield a file size of 18.4 MB. Where it says Profile, choose the one which closely matches the film type of the original and the scanner model used. The Image Info section on the left will remind you of the film emulsion and the scanner type used. Pro Photo CD scans use the 4050 profiles and standard Photo CD scans use the 'Universal' profiles. The color negative profile is common to all Photo CD scanners. Selecting the correct Input profile will improve the quality of the imported image, particularly in the shadow detail of reversal films. You have a choice of opening the Photo CD image in either YCC (Photoshop Lab) mode or as an RGB. Since the advent of Photoshop 5.0, the risk of clipping when opening a Photo CD in RGB has diminished. If you select RGB, the file will automatically convert and open to whatever is your current default RGB space. Note you can also choose to open a Photo CD image in 16 bits per channel color to produce a 48-bit RGB file.

In conclusion

Photo CD is a well-established service for the digitizing and storage of photographs. When weighing up the cost of buying a decent scanner, it is worth calculating the comparative cost of Photo CD scans, taking into account the costs of archiving all the data likely to be accumulated. On the downside, the Kodak profiles are in my opinion not really precise enough. Some intervention will nearly always be required to get a perfect color match. The Kodak website (see link below) contains lots of useful extra information. One of the recent developments introduced by Kodak includes a 30 MB CMYK TIFF scan output either to a general standard or to your custom printer specifications. This service is supplied at specialist bureaux only and is costed at the same price as a Pro Photo CD scan. A more recent innovation is Picture CD and this should not be confused with Photo CD, as Picture CD is simply a CD containing JPEG compressed files. All you have to do is check the appropriate box and a CD will be included when you go to collect your prints. Picture CD will supply a folder of JPEG scanned images on a disk.

Photo CD website: www.kodak.com/US/en/digital/products/photoCD.shtml

Digital cameras

Silver film has been with us for over 150 years. We know it works well because the manufacturers are continuing to refine the film emulsions we use today. But digital capture technology has improved so much over recent years that it won't be long before digital cameras become the main method of capturing a photograph. We have seen an incredible rise in the interest among the consumer end of the market. Digital capture has become popular because you get to see the results immediately, you can email pictures to friends and more importantly, it's fun!

Professional photographers are similarly adopting digital capture because of the immediacy and also because the approved image is the final file. All that waiting for labs to collect the film, process it and you sending the edited results by courier to the client are a thing of the past. The client can leave the studio with the finished result burnt to a CD disk. The client not only saves time, they can save money on film, processing and scanning costs as well.

Consumer cameras

There are plenty of cameras to choose from that are all priced under \$1000. The file capture sizes used to be quite small, but now you can typically expect to purchase a camera capturing between 2 and 6 megapixels in this price bracket. The image quality from these cameras is not going to match a professional camera - the spectral response can be uneven, especially when capturing certain shades of green. But nevertheless the results will compare well to mini lab prints. Once you have bought the camera there is no more film and processing to pay for and all you will need is a computer to download the images to. The memory cards supplied with these cameras will usually be quite small, so it is worth buying something larger and they are not too expensive. If you set the camera to capture at the highest quality JPEG compression, you will be able to fit a lot of pictures on a card and the image quality will be fine for web or email use. Depending on the megapixel size of the camera you should be able to make decent inkjet prints from the files, and that is all that most users really want. The higher priced cameras within this category are suitable for a limited number of professional applications. The Nikon Coolpix 5000 is a good example - it has great optics combined with 5.24 megapixel capture and manual override of the controls. So, for example, you can set the exposure manually or link to an external flash unit. These models are really amateur cameras but with professional aspirations. What really limits them is the awkward way they perform professional

tasks and their limited battery life and card size. There can also be an annoying delay between pressing the shutter and the image being captured, which is not much use when you are trying to capture a moving subject.

35 mm SLR features

If you want to buy something that feels more like a proper SLR camera there are several models on the market. The Fuji FinePix 6900 (which is priced well under \$1000 at the time of writing) takes astonishingly good pictures for its class. If you can stretch the budget to \$2000, take a look at the Olympus E-10, or the latest E-20N). These cameras have fixed lenses, which is somewhat limiting even though you can buy specially designed wide angle lens adaptors. The Fuji FinePix S1 and Canon D30 offer entry level 35 mm system digital capture. And although the D30 is not promoted by Canon as a professional camera, it offers lots of desirable pro features. The Fuji FinePix S1 is the most affordable digital true SLR camera, being based on a Nikon 35 mm camera body that accepts most Nikon system lenses. The chip has a high ISO rating of 320° to 1600° ISO which is fine for location work and low light conditions, but is unsuitably high for use with studio flash.

The cameras in this class are (like the consumer type cameras) one-shot devices that use a striped CCD chip to record a full-color digital image. The CCD is coated with an RGB pattern of filters so that each grayscale pixel records either red, green or blue light. Nearest pixel interpolation software determines all intermediate values and the color information is recorded in a single exposure.

Canon announced the new Canon 1D camera at Photo Plus East in New York in the Fall of 2001. This is a fine improvement on the D30 camera and shows that Canon are now serious about competing with the Kodak and Nikon 35 mm SLR bodies for the professional market. The Canon 1D, Kodak DCS 760 and Nikon D1X and D1H offer professional quality capture, fast burst rates and instant capture response. All this at an affordable pro price. I would say that all these cameras are suited to a wide range of applications such as social photography, news reporting and portraiture. The Nikon D1 and Kodak DCS 760 are both based on the Nikon F5 camera body. The Canon 1D, which like the D30 has the EOS-1 body, looks set to become popular among professional shooters. The D1X is a good, solid camera, but I have a preference for the slightly more expensive Kodak DCS 760. Although both cameras capture an identical number of pixels, the Kodak chip is physically larger. It measures 85% the size of a 35 mm frame and is the only camera in this class to do so. Some 35 mm body digital cameras have a chip that is about half the 35 mm frame area in size. This means an effective doubling of the 35 mm lens focal lengths in

terms of the angle of view. On such cameras, a 50 mm standard lens effectively becomes a 100 mm equivalent telephoto and the wide angle 24 mm equivalent to a standard lens.

Because of the rapid capture and burst rates the above three cameras are the first to appear in this class that can realistically be used for fashion and portraiture work. A 15–18 MB size RGB capture file has ample pixels to fill a magazine page. However, because of the way the sensor captures the one-shot image using a striped chip, there will be a limit as to how much you will be able to crop a picture and still enlarge it to fill the page. If you want the smoothest possible digital capture, you are going to have to be extra nice to the bank manager!

Hot mirror filters

The spectral sensitivity of many CCDs matches neither the human eye nor color film and extends awkwardly into the infrared wavelengths. This is partly inherent in their design and partly due to their original development for military uses. To overcome the extreme response to the red end of the spectrum, Kodak advise the use of hot mirror filters. Nikon cameras have this filter built in behind the lens. These high quality glass filters are made by Tiffen in the USA and are costly and inconvenient, since each lens used will require one, unless the photographer is happy to spend time fitting it to each lens in turn prior to shooting – unlikely at a football match. The EOS and Nikon lens systems have about four common filter sizes (52, 62, 72 and 77 mm) so at over \$150 each, these filters alone will cost much the same as a low-end digital camera. Kodak's newest chip technology delivers a dramatic improvement in color response and purity in the blue channel and a much more controlled response at the red end of the spectrum. Despite this the Kodak software retains the option to process files as either 'product' shots or 'portraits'.

And as a further precaution Kodak fit a hot mirror filter immediately inside the throat of the camera body. This filter, which is very thin and fragile, serves not only to reduce still further the infrared wavelengths reaching the CCD but also to reduce the color noise generated by high contrast fine detail in the image. This aliasing noise is generated by interference between fine detail and the mosaic of color filters applied to the chip. It is most visible in fabric textures or fine detail such as print. The Kodak anti-aliasing filter works by very slightly unsharpening the image, but a better method may be to use software such as Quantum Mechanic from Camera Bits. Other camera manufacturers overcome the infrared problem by fitting a hot mirror type filter to the face of the CCD itself, but within the engineering confines of the existing Canon and Nikon bodies; this option is not available to Kodak.

Medium format CCD cameras

Until recently, digital photographers were a small exclusive club of pioneers who had to work hard to convince clients of the benefits of going digital. Now it seems that it is the clients who are driving the demand, aware of the cost-saving benefits that digital photography can bring as well as the high image quality. However, many people underestimate some of the potential pitfalls of switching to a digital workflow, especially those for the unwary or inexperienced digital photographer. All too often photographers and their clients have rushed into switching from an analog to a digital workflow without paying serious attention to important issues such as maintaining an image archive and color management. Worse still, mistakes made by ill-prepared newcomers risk jeopardizing the confidence of everyone else in the desktop publishing industry.

Four or five years ago the professional-level digital options were rather limited and hideously expensive. Some of the early digital cameras looked more like CCTV security cameras: a brick with a lens stuck on the front. The egg heads who designed these had perhaps spent too much time looking the wrong way down the lens as these cameras had no viewfinder and you were forced to preview directly off the screen (this was about as useful as replacing a car's steering wheel with a mouse). Manufacturers such as Leaf, Phase One and Dicomed began producing digital backs that could easily fit on the back of conventional professional camera systems. The initial interest in digital photography came mainly from the repro companies who were soon seen building their own in-house photographic pack shot studios and taking business away from the old analog photographers who specialized in that market. Fortunately this trend has stalled as it was discovered that photography was not as easy to do as had first been thought.

The very first multicapture backs used grayscale CCDs to capture three sequential exposures through a rotating wheel of red, green and blue filters. As the new generation of mosaic CCD arrays were being designed it was realized that moving the CCD in one pixel increments gave similarly good results. The CCD chip is moved between three or four exposures by a piezo crystal that can be made to expand or contract in exact increments whenever a small voltage is applied. The piezo crystals shift the single grayscale chip, repositioning it by fractional amounts. In multishot mode such cameras are only suitable for shooting still-life subjects. Some multishot backs are also able to capture a single shot image keeping the chip still and capturing a single exposure.

Leaf, Sinar, Phase One, Kodak and Imacon all make single and multishot backs. Most of these cameras are built round the outstanding Philips $2K \times 3K$ chip capturing 6 MB of raw pixel information in each color channel to produce finished files of

18 MB RGB or 24 MB CMYK. Kodak launched the DCS ProBack in 2001, which features their own Kodak designed 38 mm \times 38 mm, 4K \times 4K Tin Indium Oxide CCD. Phase One are looking to implement the Kodak chip in their H20 back and Imacon have already used the Kodak chip in the Flexframe 4040. The Flexframe can capture a single or multishot 48 MB image in 24-bit color or a 192 MB 24-bit RGB image in the 16 exposure micro step mode.

At this level the photographer can expect quite superb image quality, exceeding that of film. It is sharper, has no grain structure to interfere when images are resized, and offers more precise control of color over a greater dynamic range – typically 10–11 f/stops, between shadows and highlights (color negative film manages 6–7 f/stops, while transparency film can only manage 4–5 f/stops). In nearly all these cameras, special attention has been paid to reduce the electronic noise, which can be particularly evident in the red or blue channels. In some cases the chip is cooled to improve performance, or the electronics are put to sleep, awakening milliseconds before the

Figure 1.3 The above picture was taken by Jon Gibson-Skinner using the Leaf digital camera back.

Figure 1.4 Photograph taken on a Hasselblad camera, using Fuji Velvia emulsion, scanned at 2600 ppi with a ScanMate 5000 scanner to produce a 100 MB RGB 24-bit color file. Image displayed at 100%.

Photograph by Paul Webster.

Making every pixel count

The optimum ratio of an image's pixel resolution to the printer's line screen is close to $\times 1.5$. If you were to make an RGB scan, to fill an A4 magazine page using a 133 lpi screen, you would need a raw RGB image that measured A4 and with a pixel resolution of 200 ppi. This would then be converted to produce a CMYK file of 15.5 MB. If you allow a little extra for the bleed, you need at least a 12 MB RGB file to produce an A4 output. All the professional cameras mentioned in this feature are able to capture at least 12 MB of RGB 8-bit per channel data. But most of the professional digital cameras mentioned in this feature are by no means limited to producing A4 output. The file capture is so smooth that you can realistically interpolate the files up to reproduce at bigger sizes and without incurring any perceivable loss of image quality as you would if you were to interpolate up a scanned image.

One of the reasons why we have been conditioned to work with large scans is due to the grain structure inherent in the film. When a film original is scanned, the scanner records the density of all the minute grain clusters that make up the photograph. The grain structure can cause the scanner to record sharp variations in pixel values from one pixel to the next. This is especially noticeable when you examine an area of pure color. Even on a low resolution scan, the pixel fluctuation caused by the grain can still be visible. At higher resolutions you actually see the grain clusters. If you increase the size of a file through image interpolation, the pixel fluctuations become even more magnified. There is no fluctuation in a professional digital camera capture file, so therefore it is possible to interpolate a file upwards in size without generating unpleasant image artifacts. The high-end digital cameras also cool the capture chip. This prevents digital noise from appearing in the shadows, especially in the blue channel. None of this comes cheap of course, but the purity of the pixel image obtained from a

Figure 1.5 Digital capture using a Phase One LightPhase back, 48 MB RGB 24-bit color file interpolated up by 66%. Image displayed at 100%.

professional digital camera sets it apart from anything else you will have seen before, including the best drum scans made from film. The image details shown here compare the output from a LightPhase with a drum scan made from a transparency. The output files are not as large as those produced by the scanning back. The CCD chip in the Leaf DCB camera produces a 4 MB sized rectangular scanned image. An RGB composite is therefore 12 MB. This does not sound very impressive, but with digital cameras you have to think differently about the meaning of megabyte sizes or more specifically pixel dimensions and the relationship with print output file size. Digitally captured images are pure digital input, while a high-end scanned image recorded from an intermediate film image is not. Good as drum scans may be, the latter are always going to contain some electronic or physical impurity, be it from the surface of the film, the drum or grain in the film image. The recommended resolution for scanned images prepared for print output is double the printing screen frequency or sometimes 1.5:1 is recommended as the optimum ratio. In either case the film image must be scanned at the correct predetermined pixel resolution to print satisfactorily. If a small scanned image file is blown up, the scanning artifacts will be magnified. Because digital files are so pure and free of artifacts, it is possible to enlarge the digital data by 200% or more and match the quality of a similar sized drum scan.

It's hard to take on board at first, I know. It came as a shock to me too when I was first shown a digital picture: an A3 print blowup from a 4 MB grayscale file! Not only that, but digital images compress more efficiently compared to noisy film scans. The full-frame Leaf I2 MB image will compress losslessly to around a few megabytes (less with high quality JPEG) and transmit really quickly by ISDN or fast modem. Catalog and product shot studios prefer to have the Leaf back attached to something like the Fuji GX68 III camera, because it provides a limited range of movements in the lens plane and can reasonably handle the same type of photography tasks as monorail plate cameras.

exposure is made and then going back to sleep again. As you might expect, the chip sensor is extremely delicate and is also the single most expensive component in a digital camera. If it becomes damaged in any way there may be no alternative but to have it replaced. Pay special attention to using the manufacturers' correct cleaning methods and take every precaution when removing dust from the sensor surface. Insurance policies against accidental damage are also available for the more expensive digital cameras – a wise step to take considering how fragile the sensor is.

Only a few years ago, medium format camera backs would cost a small fortune to purchase, requiring serious analysis in order to calculate the financial benefits of digital over film capture. And since a lot of professional photographers were then

Figure 1.6 The CCD sensor found in most one shot digital cameras will contain a mosaic grid of RGB sensor elements arranged in a 2×2 pattern like the diagram shown here, with two green sensors and one red and one blue. The Fuji SI camera uses hexagonal shaped elements that are able to gather more light than conventional designs and therefore has a faster ISO rating.

Figure 1.7 The Foveon designed chip features a revolutionary new design whereby the color sensors are able to overlap each other and let light pass through each sensor layer. The first chips to emerge have demonstrated an ability to make smooth captures and less problems with moiré and edge artifacting. Although this is still a 'prosumer' level product, it may hold the key to professional one shot digital camera design.

buying into digital imaging for the first time they would often have to factor in the cost of a computer imaging work station and perhaps a new camera body system as well. In 2001, Leaf announced the C-Most camera back at a revolutionary low price. At the time of writing you could purchase this camera back for just under \$10,000 (check the current pricing with your nearest dealer). In future this may well have an impact on the pricing of other products within this category. It almost certainly heralds another step towards digital capture becoming the preferred method of working in professional photography.

Scanning backs

These record a scene similar to the way a flatbed scanner reads an image placed on the glass platen. A row of light sensitive elements travels in precise steps across the image plane, recording the digital image. The digital backs are designed to work with large format 5×4 cameras, although the scanning area is slightly smaller than the 5×4 format area. Because of their design, daylight or a continuous light source must be used. HMI lighting is recommended because this produces the necessary daylight balanced output and lighting power. Some manufacturers of flash equipment like the Swiss firm Broncolor, now make HMI lighting units which are identical in design to the standard flash heads and accept all the usual Broncolor lighting adaptors and accessories. Many photographers are actually able to use quartz tungsten lighting, providing the camera software is able to overcome the problem of light flicker. The other thing to be careful of here is that lower light levels may require a higher ISO capture setting and this could lead to increased blue shadow noise. Sometimes bright highlights and metallic surfaces can leave bright green streaks as the CCD head moves across the scan area. This is known as blooming and looks just like the effect you often saw in the early days of color television. It might have appeared cool in a TV recording of a seventies glam rock band, but it is really tricky to have to retouch out in a stills photograph. Some scanning back systems contain anti-blooming circuitry in the equipment hardware.

The exposure time depends on the size of final image output. It can take anything from under a minute for a preview scan to almost 10 minutes to record a 100 MB+ image. The latest Betterlight scanning back can now scan a high-resolution image in just a few minutes. Everything has to remain perfectly still during exposure. This limits the types of subject matter which can be photographed. You can use a scanning back on location, but sometimes you get unusual effects similar to the distortions achieved with high-speed focal plane shutters.

One of the first photographers to adopt digital capture was Stephen Johnson, who shoots fine-art landscape photographs, using a Betterlight scanning back attached to a 5×4 plate camera which he takes on location. When Stephen Johnson began testing a prototype Betterlight scanning system in January 1994, he simultaneously shot a sheet of 5×4 film and made a digital capture of a view overlooking San Francisco using the Betterlight. He made a high resolution scan of the film and compared it with the digital capture. He was blown away by what he saw. The detail captured by the scanning back was incredibly sharp when compared side by side with the film scan. This was the moment when Stephen Johnson declared 'Film died for me on that day in 1994.' Since then, everything he has photographed has been captured digitally (you can visit his gallery website at: <www.sjphoto.com>). It wasn't just the sharpness and resolution of the images that appealed. The Betterlight scanning

back system is able to discern a much greater range of tonal information between light and shade than normal film ever can. The digital sensors are able to see deep into the darkest shadows and retain all the highlight detail. The color information can also be made to more accurately record the scene as it really appeared at that time of the day.

Figure 1.8 Photograph by Stephen Johnson. Copyright © 1994 by Stephen Johnson. All rights reserved worldwide. www.sjphoto.com

Is it time to go digital?

These are exciting early days, when high resolution digital image capture has become a reality. There are still a few obstacles to overcome before digital cameras can match the versatility of film cameras, but for many professional setups digital cameras are able to fulfil a useful role in the studio and on location. Digital cameras have arrived at a time when digital press technology is well and truly established. Film scanners have had to be designed to cope with the uneasy task of converting continuous tone film originals of different types to a standard digital output. Digital camera design has been invented from the ground up and digital camera development has therefore been very much designed to meet the specific needs of repro. A really important benefit of running a digital studio is increased productivity. When a client commissions a photographer to shoot digitally, they have an opportunity to see the finished results straight away. It is possible for the client to attend a shoot, approve the screen image after seeing corrections, then the picture can be transmitted by ISDN to the printer (or wherever) and the whole shoot be 'signed off' the same day. Because of the huge capital outlay involved in the purchase and update of a digital studio camera system, it is not unreasonable for a photographer to charge some sort of digital premium, in the same way as the cost of studio hire is normally charged as an expense item. Digital capture is all too often being promoted as an easy solution and unfortunately there are end clients who view the advantages of digital photography purely on the basis of cost savings: increased productivity, fast turnaround and never mind the creativity. Some clients will look for the material savings to be passed on to them regardless, but there are clients who are willing to accept this, as they will still be able to save themselves time and money on the film and processing plus further scanning costs. And as photographic studios are getting involved in the repro process at the point of origination, there is no reason why they should not consider selling and providing an extra menu of services associated with digital capture, like CMYK conversions, print proofing and image archiving.

Camera software and storage

In the rush to 'go digital' many photographers (and clients) have overlooked some of the obvious workflow differences with a digital shoot. In a traditional, analog workflow, clients received transparencies or contact sheets and once the final picture had been selected and approved, the photographer's responsibility ended there. But now there are a lot more things for you to consider.

For example, how are you going to preview and edit the pictures? If you are present while the photographs are being taken, then it will be easy to approve the results there and then and walk away with a finished CD. If you or the final client wish to approve the pictures remotely, then you need to work out a method of getting the pictures to them. The Web Photo Gallery in Photoshop is a very easy-to-use automated plug-in. A photographer can quickly build a web gallery of images, upload these to a server and share the results of a day's shoot with anyone who has Internet access. And what if the client does not have a computer? You can use the refined Contact Sheet II feature to produce printed contact sheets with identifying file names below each image. These and other capture-related subjects will be discussed later on in the book (see Chapter Twelve, Shortcuts).

There remain a few major problems with a digital workflow that are yet to be resolved. The hardware is really good, but in some cases the supplied camera software is inadequate for professional use. The only hindrance to the all-digital process is the time it takes to review and edit pictures captured digitally. How long does it currently take to scan through a contact sheet or roll of transparencies, compared to the time it takes to open and close an equal number of digital captures? On the other hand, what price the immediacy of having your photograph instantly displayed on the computer and ready to send off to print? Why should a photographer be expected to wait over 30 seconds to preview an 18 MB RGB image, when Photoshop can open a file this size in less than 3 seconds? This was one of the complaints I had when reviewing the otherwise excellent Nikon D1X camera system in the summer of 2001. Some camera manufacturers are recycling old computer code that by today's standards is poorly optimized. And why do we need a stand-alone application to replicate what Photoshop can do not only better but faster? There are alternatives. You can use third party software such as FotoStation as the equivalent of a 'light box' to preview the camera files quite quickly. Or with certain raw camera files you can use the File Browser in Photoshop 7.0. To do this efficiently you will need a camera file format plug-in and that is going to require some cooperation from the camera manufacturers to reverse engineer this. As these become available the File Browser will enable you to bypass the camera manufacturer's software completely. Photoshop 7.0 can then interface directly with the raw camera files, and that is going to be big news for digital photographers who have felt unnecessarily encumbered by current digital workflows.

How many 18 MB exposures would it take to fill up your computer's hard disk? Seventy-two frames (two rolls of film) would occupy about a gigabyte. If you are still inclined to get carried away shooting lots of photographs, where are you going to save all your images to and how are you going to archive them? Forty exposures could be fitted onto a recordable CD, but think how long it would take to transfer and record all that data? Maybe it won't be necessary to shoot so many exposures once we have the approved image 'in the bag' so to speak. But suppose you were to shoot a dozen captures on the new Imacon Flexframe 4040? You would need to burn a whole CD in order just to store the equivalent of a roll of 120 film. It is going to be very important that you maintain a cataloged archive of all your digital images - this is something the photographer should be able to do using an image database program like ImageAXS. But clients will probably want to build their own database record too. I know of an art director who told his photographer to go back to shooting film, because he wasn't able to cope with the growing pile of CDs and he could never locate an image quickly enough! In Chapter Five I will be going into more detail the ways photographers can manage their files and archive them securely.

Conclusion

Digital photography has become firmly established as the way of the future. But making the transformation from analog to digital can be a frightening process. The photographer is rightly anxious to keep their customers happy and often compelled to invest in digital camera equipment because they will otherwise lose that client. Meanwhile clients want to see better, faster and cheaper results. But they also wish to avoid the scary disasters brought about through digital ignorance. For photographers this is like a replay of the DTP revolution that saw a massive shake-up in the way pages were published. For newcomers, there is a steep learning curve ahead, while for experienced digital pros there is absolutely no going back!

Resolution

Chapter Two

This chapter deals with the issues of digital file resolution, and two of the first questions everyone wants answered – how do you define it and just how big a file do you really need? When we talk about resolution in photographic terms, we normally refer to the sharpness of the lens or fineness of the emulsion grain. In the digital world, resolution relates to the number of pixels contained in an image. Every digital image contains a finite number of pixel blocks that are used to describe the tonal information, and the more pixels, the finer its resolving capacity. The pixel dimensions of a digital image are an absolute value: a 3000 × 2400 pixel image could be output as 12" × 15" at 200 pixels per inch and the megabyte file size would be 20.6 MB RGB or 27.5 MB CMYK. A 3500 × 2500 pixel image could reproduce as an A3 or full bleed magazine page printed at the same resolution of 200 pixels per inch and megabyte file size would be about 25 MB RGB (33.4 MB CMYK).

The pixel dimensions are the surest way of defining what you mean when quoting digital file size. If we have a digital image where the dimension along one axis is 3000 pixels, these pixels can be output at 10 inches at a resolution of 300 pixels per inch or 12 inches at a resolution of 250 pixels per inch. This can be expressed clearly in the following formula: number of pixels = physical dimension × (ppi) resolution. In other words, there is a reciprocal relationship between pixel size, the physical dimensions and resolution. If you quote the resolution of an image as being so many pixels by so many pixels, there can be no ambiguity about what you mean. Digital cameras are often classed according to the number of pixels they can capture. If the CCD chip contains 3000×2000 pixel elements, it can capture a total of 6 million pixels, or for shorthand, is described as a 6 megapixel camera. And if you multiply the 'megapixel' size by three you will get a rough idea of the megabyte size of the

RGB image output. In other words, a 6 megapixel camera will yield an 18 MB RGB file. Quoting megabyte sizes is a less reliable method of describing things because document file sizes can also be affected by the number of layers and alpha channels present and whether the file has been compressed or not. Nevertheless, referring to image sizes in megabytes has become a convenient shorthand when describing a standard uncompressed, flattened TIFF file.

Pixels versus vectors

Digital photographs are constructed with pixels and as such are resolution-dependent. You can scale up a pixel image, but as you do so, the finite information can only be stretched so far before the underlying pixel structure becomes apparent (see Figure 2.1). Adobe IllustratorTM is an example of a vector-based program. Objects drawn in Illustrator are defined mathematically, so if you draw a rectangle, the proportions of the rectangle edges, the relative placement on the page and the color it is filled with can all be expressed using mathematical expressions. An object defined using vectors can be output at any resolution, from the display on the screen to a huge poster. It will always be rendered as a crisply defined shape (see Figure 2.2). Photoshop is mainly regarded as a pixel-based graphics program, but it does also now have the capability to be a combined vector and pixel-editing program because it also contains a number of vector-based features that can be used to generate im-

Figure 2.1 In this diagram you can see how a digital image that is comprised of a fixed number of pixels can have its output resolution interpreted in different ways. For illustration purposes let's assume that the image is 40 pixels wide. The file can be printed big (and more pixelated) at a resolution of 10 pixels per cm, or it can be printed a quarter of the size at a resolution of 40 pixels per cm.

ages such as custom shape tools and layer clipping paths. This raises some interesting possibilities – with Photoshop you can create various graphical elements like type, shape layers, layer clipping paths which are all resolution-independent. These 'vector' elements can be scaled up in size in Photoshop without any loss of detail, just as you can with an Illustrator graphic.

Figure 2.2 Digital images are constructed of a mosaic of pixels. Because of this a pixel-based digital image always has a fixed resolution and is said to be 'resolution-dependent'. If you enlarge such an image beyond the size at which it is meant to be printed, the pixel structure will soon become evident, as can be seen in the right-hand close-up below. But suppose the picture shown opposite was created not as a photograph, but as an illustration in a program like Adobe Illustrator[™]. If the picture is drawn using vector paths, the image will be resolution-independent. The mathematical numbers used to describe the path outlines shown in the bottom left example can be scaled to reproduce at any size: from a postage stamp to a billboard poster.

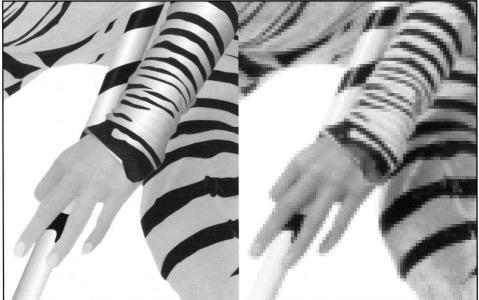

Photograph: Eric Richmond.

Terminology

Before proceeding further let me help clarify a few of the confusing terms used and their correct usage when describing resolution.

ppi: pixels per inch. Describes the digital, pixel resolution of an image. You will notice the term dpi is often inappropriately used to describe digital resolution. Scanning devices are sometimes advertised with their scanning resolution expressed in dots per inch. Strictly speaking, this is an incorrect use of the term 'dpi', because input devices like scanners produce pixels and only output printers produce dots. However, it's fallen into common parlance and unfortunately only added to the confusion. Photoshop always refers to the input resolution as being in pixels per inch or pixels per centimeter, and so should you. Monitor resolution is also specified in ppi: Macintosh monitors have a resolution of 72 ppi, whereas PC monitors are usually 96 ppi. One of the reasons for the Macintosh default resolution of 72 ppi (which dates back to the era of the first Apple Macs) is that it helps graphic designers get a better feel for the weight of their fonts when laying out a page.

lpi: lines per inch. The number of halftone lines or 'cells' in an inch, also described as the screen ruling. The origins of this term go back way before the days of digital desktop publishing. To produce a halftone plate, the film exposure was made through a finely etched crisscross screen of evenly spaced lines on a glass plate. When a continuous tone photographic image was exposed this way, dark areas formed heavy halftone dots and the light areas, smaller dots, giving the impression of a continuous tone image when printed on the page and viewed from a normal distance.

dpi: dots per inch. Refers to the resolution of a printing device. An output device such as an imagesetter is able to produce tiny 100% black dots at a specified resolution. Let's say we have an imagesetter capable of printing at a resolution of 2400 dots per inch and the printer wished to use a screen ruling of 150 lines per inch. If you divide the dpi of 2450 by the lpi of 150, you get a figure of 16. Within a matrix of 16×16 printer dots, an imagesetter can generate a halftone dot varying in size from 0 to 255, which is 256 print dots (see Figure 2.3). It is this variation in halftone cell size (constructed from the combined smaller dots) which gives the impression of tonal shading when viewed from a distance. Desktop inkjet printers produce an output made up of small dots at resolutions of between 360 and 2880 dots per inch. Remember, an inkjet output is not the same as the reprographic process – the screening method is quite different.

Above all you need to understand that an image displayed on the screen at 100% does not represent the actual physical size of the image, unless of course your final picture is designed for screen use only, such as for the Web or CD-ROM display.

I The halftone screen shown here is angled at zero degrees. If the pixel resolution were calculated at $\times 2$ the line screen resolution, the RIP would use four pixels to calculate each halftone dot.

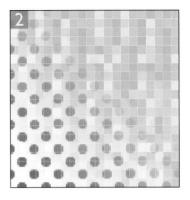

2 To reproduce a CMYK print output, four plates are used, of which only the yellow plate is actually angled at zero degrees. The black plate is normally angled at 45 degrees and the cyan and magenta plates at less sharp angles. Overlay the same pixel resolution of $\times 2$ the line screen and you will notice that there is no direct relationship between the pixel and line screen resolutions.

The pixel resolution (ppi) is the number of pixels per inch in the input digital image.

The line screen resolution (lpi) is the frequency of halftone dots or cells per inch.

4 Each halftone dot is rendered by a PostScript RIP from the pixel data and output to a device called an imagesetter. The halftone dot illustrated here is plotted using a 16×16 dot matrix. This matrix can therefore reproduce a total of 256 shades of gray. The dpi resolution of the image setter, divided by 16, will equal the line screen resolution. 2400 dpi divided by 16 = 150 lpi screen resolution.

3 There is no single empirical formula that can be used to determine the ideal 'half toning factor'. Should it be $\times 2$ or $\times 1.5$? The black plate is the widest at 45 degrees and usually the black plate information is more prominent than the three color plates. If a halftoning factor of $\times 1.41$ (the square root of 2) were used, the pixel resolution will be more synchronized with this angled halftone screen. There is no right or wrong halftoning factor – the RIP will process pixel data at any resolution. If there are too few pixels, print quality will be poor. Having more than the optimum number does not necessarily equate to better output, it is just more pixels.

Repro considerations

You can see from the previous description where the term 'lines per inch' originated. In today's digital world of imagesetters, the definition is somewhat archaic, but is nonetheless commonly used. You may hear people refer to the halftone output as dpi instead of lpi, as in the number of 'halftone' dots per inch, and the imagesetter resolution be referred to as having so many spi, or spots per inch. Whatever the terminology I think we can all logically agree on the correct use of the term pixels per inch, but I am afraid there is no clear definitive answer to the mixed use of the terms dpi, lpi and spi. It is an example of how the two separate disciplines of traditional repro and those who developed the digital technology chose to apply different meanings to these terms.

The structure of the final print output appearance bears no relationship to the pixel structure of a digital image. A pixel in a digital image does not equal a cell of half-tone dots on the page. To explain this, if we analyze a CMYK cell or rosette, each color plate prints the screen of dots at a slightly different angle, typically: Yellow at 0 or 90 degrees, Black: 45 degrees, Cyan: 105 degrees and Magenta: 75 degrees. If the Black screen is at a 45 degree angle (which is normally the case), the (narrowest) horizontal width of the black dot is 1.41 (square root of 2) times shorter than the width of the Yellow screen (widest). If we extend the width of the data creating the halftone cell, then multiplying the pixel sample by a factor of 1.41 would mean that there was at least a 1 pixel width of information with which to generate the black plate. The spacing of the pixels in relation to the spacing of the 45 degree rotated black plate is thereby more synchronized.

For this reason, you will find that the image output resolution asked for by printers is usually at least 1.41 times the halftone screen frequency used, i.e. multiples of \times 1.41, \times 1.5 or \times 2. This multiplication is also known as the 'halftone factor', but which is best? Ask the printer what they prefer you to supply. Some will say that the 1.41:1 or 1.5:1 multiplication produces crisper detail than the higher ratio of 2:1. There are also other factors which they may have to take into account such as the screening method used. Stochastic or FM screening, which, it is claimed, permits a more flexible choice of ratios ranging from 1:1 to 2:1.

Image size is therefore determined by the final output requirements and at the beginning of a digital job, the most important information you need to know is:

- How large will the picture appear on the page, poster etc.?
- What is the screen frequency being used by the printer how many lpi?
- What is the preferred halftone factor used to determine the output resolution?
- Will the designer need to allow for page bleed, or want to crop your image?

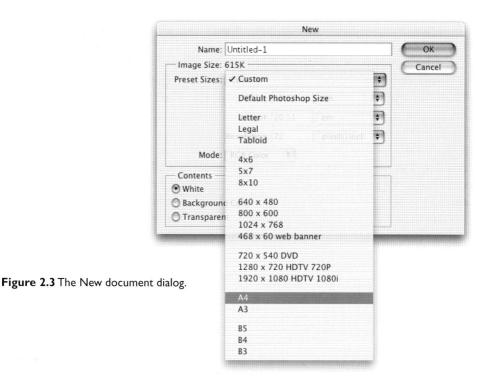

Ideally this information needs to be known before the image is scanned (or digitally captured). Because if you calculate that only 10 MB worth of RGB data will actually be required, there may be no point in capturing more image data than is absolutely necessary. If the printer's specification is not available to you, then the only alternative is to scan or shoot at the highest practical resolution and resample the image later. The downside of this is that large image files consume extra disk space and take longer to process on the computer. If a print job does not require the images to be larger than 10 MB, then you'll want to know this in advance rather than waste time and space working on unnecessarily large files. On the other hand, designers like to have the freedom to take a supplied image and scale it in the DTP layout to suit their requirements. Use the $\times 2$ halftone factor, and there will be enough data in the supplied file to allow for a 20% scaling without adversely compromising the print quality.

Inkjet output resolution

I said earlier that the pixel resolution of an image should be clearly specified using the numbers of pixels per inch (ppi) so as to avoid confusion when using the number of dots per inch (dpi) to describe the imagesetter output resolution (although sometimes dpi is used to refer to the number of halftone cells per inch). Inkjet printers also use the term

'dots per inch' to describe the output resolution of the printer. The dpi output of a typical inkjet will range from 360 to 2880 dpi. And although this is a correct usage of dpi, in this context the dpi means something else yet again. Most inkjet printers use similar methods to lay down a scattered pattern of tiny dots of ink that accumulate to give the impression of different shades of tone, depending on either the number of dots, the varied size of the dots, or both. The principle is roughly similar to the halftone process, but it is not really the same. If you select one of the finer print resolutions such as 1440 or 2880 dpi, you should see smoother print outputs when they are viewed in close-up. The optimum pixel resolution should ideally be the printer dpi divisible by a whole number. The following pixel resolutions could be used: 144, 160, 180, 240, 288, 320, 360. To make large inkjet prints for viewing at a greater distance, use a low pixel resolution. For smaller sized portfolio prints I normally use a 240 ppi pixel resolution. I doubt very much you will notice any improvement in print quality if you choose a resolution that is higher than this.

Creating a new document

If you want to create a blank new canvas in Photoshop, go to the File menu and choose New... This will open the dialog shown in Figure 2.3. In Photoshop 7.0 you can select a new preset setting. This will automatically configure the physical size dimensions for your new image. However, Photoshop will not adjust the resolution for you, this must be entered manually. Advanced users can create their own custom document size presets by going to the Presets folder and following the instructions in the New Doc Sizes.txt document and editing the values for the height, width and units.

Altering the image size

The image size dimensions and resolution can be adjusted via the Image Size dialog, shown in Figure 2.4. By default the dialog will open with the Resample image box checked. This means that you can enter new pixel dimension values to increase or decrease the image size. Or if you enter new physical dimensions, or change the image resolution, you can also increase or decrease the image size (and you will see the pixel dimensions adjust simultaneously). Remember the rule I mentioned earlier: the number of pixels = physical dimension × (ppi) resolution. You can put that rule to the test here and use the Image Size dialog as a training aid to help understand better the relationship between the pixels, dimensions and resolution. The constrain proportions checkbox links the horizontal and vertical dimensions, so that any adjustment is automatically scaled to both axis. Only uncheck this box if you wish to squash or stretch the image when adjusting the image size. Any adjustment made to the image will not alter the total pixel size. If you adjust the dimensions the resolution value will adjust to compensate and vice versa.

When Resample Image is checked the image can be enlarged or reduced by making the number of pixels in the image greater or smaller. This resampling is also known as interpolation and Photoshop can use one of three methods when having to assign (approximate) values for any new pixels that are generated. The interpolation options are located next to the Resample Image checkbox. Bicubic interpolation provides the best image quality when resampling continuous tone images. Photoshop will read the values of neighboring pixels, vertically, horizontally and diagonally to calculate a weighted approximation of each new pixel value. In other words, Photoshop guesses the new pixel values, but does so with a modicum of machine intelligence. Bilinear is a less sophisticated form of interpolation, reading only the horizontal and vertical, neighboring pixels. Nearest Neighbor is the simplest interpolation method and yet I use this quite a lot, such as when I want to enlarge a screen grab of a dialog box for this book by 200% and I don't want the sharp edges of the dialog boxes to appear fuzzy.

		Image Size			
Pixel Dimen	sions: 11.7M	(was 29.8M)	1	ОК	
Width:	1629	pixels	÷78	Cancel	
Height:	2500	pixels	÷®	Auto	
Document S	Size:				Auto Resolution
Width:	8.144	inches	•]	Screen: 133	lines/inch 🗘 OK
Height:	12.5	inches	•	- Quality -	Cancel
Resolution:	200	pixels/inch	+	O Draft	
Constrain Proportions				 Good Best 	
Resample	e Image: Bi	cubic	•		

Figure 2.4To change the image output resolution without altering the physical size, check the Resample Image box and enter a new resolution. To change image output dimensions without altering the resolution, leave the Resample box unchecked. Auto resolution will help you pick the ideal pixel resolution for repro work based on the line screen resolution.

I consider 'interpolating up' an image in Photoshop to be preferable to the interpolation methods found in basic scanner software. Digital files captured from a scanning back or multishot digital camera are extremely clean, and because there is no grain present, it is usually possible to magnify a digitally captured image much more than you would to a scanned image of equivalent size. There are other programs like Resolut and ColorShop which are used to good effect when interpolating digital capture files. Interpolation works most effectively on a raw scan – one that has not already been pre-sharpened. Unsharp masking should always be applied last as the file is being prepared for repro. Interpolating after sharpening will enhance the image artifacts introduced by the sharpening process. If you need to apply an extreme image resize either up or down in size, I suggest you consider resizing the image in stages rather than all in one go. Increase or decrease the resolution by 50 ppi at a time. For instance, start with an image at 300 ppi (or make it 300 ppi in the Image Size dialog box, with Resample Image checked) and reduce to 250 ppi, then 200 ppi, till the pixel dimensions get close to the desired number. This is not something I recommend you must do with every picture. I will probably only use this method when sampling down a large image that is destined to appear prominently on a web page.

T	What is t	What is the desired print size of the image?				
	Width:	8	inches	• •]@	
THE MELS	Height:	4.79	inches	•) -].	

Figure 2.5 If Image Size is proving too confusing, the Resize Image assistant is on hand to help guide you. This wizard is located in the Help menu and can be used to resize images both for print and for the Web.

Once an image has been scanned at a particular resolution and manipulated there is no going back. A digital file prepared for advertising usages may never be used to produce anything bigger than a 35 MB CMYK separation, but you never know - that is why it is safer to err on the side of caution – better to sample down than have to interpolate up. It also depends on the manipulation work being done - some styles of retouching work are best done at a magnified size and then reduced. Suppose you wanted to blend a small element into a detailed scene. To do such work convincingly, you need to have enough pixels to work with to be able to see what you are doing. For this reason some professional retouchers will edit a master file that is around 100 MB RGB or bigger even. Another advantage of working with large file sizes is that you can always guarantee being able to meet clients' constantly changing demands. Although the actual resolution required to illustrate a glossy magazine double-page full-bleed spread is probably only around 40-60 MB RGB or 55-80 MB CMYK. Some advertising posters may even require smaller files than this, because the print screen on a billboard poster is that much coarser. When you are trying to calculate the optimum resolution you cannot rely on being fully provided with the right advice from every printer. Sometimes it will be necessary to anticipate the required resolution by referring to the table in Figure 2.7. This shows some sample file size guides for different types of print job.

				Inches	Centimeters	Inches	Centimeters
Pixel size	Megapixels	MB (RGB)	MB (CMYK)	200 ррі	80 ррс	300 ррі	120 ррс
1600 × 1200	2	6 MB	7.5 MB	8 x 6	20 x 15	5.5 x 4	13.5 x 10
2400 × 1800	4.3	12.5 MB	16.5 MB	12 x 9	30 x 22.5	8 x 6	20 x 15
3000 × 2000	6	17.5 MB	23.5 MB	15 x 10	37.5 x 25	10 x 6.5	25 x 17
3500 × 2500	8.75	25 MB	33.5 MB	17.5 x 12.5	44 x 31	11.5 x 8.5	29 x 21
4000 × 2850	11.4	32.5 MB	43.5 MB	20 x 14	50 x 36	13.5 x 9.5	33.5 x 24
4500 × 3200	14.4	41 MB	54.5 MB	22.5 x 16	56 x 40	15 x 10.5	37.5 x 27
5000 × 4000	20	57 MB	76 MB	25 × 20	62.5 x 50	16.5 x 13.5	42 x 33.5

Figure 2.6 The above table shows a comparison of pixel resolution, megapixels, megabyte file size and output dimensions at different resolutions, both in inches and in centimeters.

Output use	Screen ruling	x1.5 Output resolution	MB Mono	МВ СМҮК	x2 Output resolution	MB Mono	МВ СМҮК
A3 Newspaper single page	85 lpi	130 ppi	3	12.5	170 ррі	5.5	21.5
A3 Newspaper single page	120 lpi	180 ррі	6	24	240 ррі	10.5	42.5
A4 Magazine mono single page	120 lpi	180 ррі	3	na	240 ррі	5.3	na
A4 Magazine mono double page	120 lpi	180 ррі	6	na	240 ррі	10.6	na
A4 Magazine single page	133 lpi	200 ррі	3.7	14.8	266 ррі	6.5	26.1
A4 Magazine double page	133 lpi	200 ррі	8	29.6	266 ррі	13	52.2
A4 Magazine single page	150 lpi	225 ррі	4.7	18.7	300 ррі	8.3	33.2
A4 Magazine double page	150 lpi	225 ррі	9.4	37.4	300 ррі	17	66.4

Figure 2.7 Here is a rough guide to the sort of file sizes required to reproduce either a mono or CMYK file for printed use. The table contains file size information for output at multiples of $\times 1.5$ the screen ruling and $\times 2$ the screen ruling.

Practical conclusions

Amid all the conflicting opinions on how large a digital file should be, I find the guidelines given by some of the photographic picture libraries instructive. Photographers who submit digital work are asked to supply digital files of around 40–50 MB RGB. The thinking is that for the vast majority of picture purchases, these file sizes will be ample and in fact the majority of pictures purchased are probably printed using 20 MB of RGB data or less anyway. You can be sure that in any magazine publication you care to look at, it does not matter how large the original scans were, the same amount of digital information was eventually used to make the halftone separations on each page you are looking at. There are photographers and also clients who insist nothing less than a high resolution scan from a 5×4 or 10×8 sheet of film will provide good enough quality for advertising work. I do believe an overobsession with 'pixel correctness' gets in the way of appreciating just how good the technical output quality can be from smaller format cameras or what can be created on a modern computer desktop setup in the hands of a talented artist.

In theory the larger a picture is printed, the further away it is meant to be viewed and the pixel resolution does not have to alter in order to achieve the same perception of sharpness. There are limits though below which the quality will never be sharp enough at normal viewing distance (except at the smallest of print sizes). It also depends on the image subject matter – a picture containing a lot of mechanical detail will need more pixels to do the subject justice and reproduce successfully. If you had a picture of a softly lit cloudy landscape, you could quite easily get away with enlarging a small image through interpolation, beyond the normal constraints.

An enormous industry was based around photographers supplying films to clients, who made positional scans for layout purposes. They in turn then sent the film for repro scanning at the bureau to make the final separations. Along comes a photographer armed with his or her computer loaded with Photoshop, offering to cut out a large chunk of the repro process, supplying repro quality digital files themselves. Tread on somebody's toes once and they won't like you very much. Stamp all over them and they begin to squeal (loudly), especially if they believe you don't have a clue what you are talking about. Obviously, repro specialists should know best when it comes to getting the best printed results, but remember they have a vested interest too in keeping the likes of you out of the equation. This leads to occasional 'spoiling' tactics, designed to make you look foolish in front of the end client, but I reckon companies with attitudes like these are dying out now. The smart businesses recognize the digital revolution will continue apace with or without them and they have to continually adapt to the pace of modern technology and all its implications. Besides, repro companies have been getting into the supply of digital photography themselves and the boundaries between our industries are constantly blurring.

Configuring Photoshop

Chapter Three

n order to get the best performance out of Photoshop, you need to ensure that your computer system is well optimized for image editing work. When I first began writing my *Photoshop for Photographers* series of books, it was very necessary to guide readers on how to buy the most suitable computer for Photoshop work and what hardware specifications to look for. These days I would suggest that almost any computer you can buy is capable of at least running Photoshop at a basic level and capable of being upgraded to run it faster.

As always, I try to avoid making distinctions between the superiority of the Macintosh or PC systems. If you are an experienced computer user, you know what works best for you and I see no reason to evangelize my preference for using a Mac. Throughout my computer career, it's what I have grown up with and it feels like home. The same arguments apply if you're a Windows PC user and apart from anything else, once you have bought a bunch of programs, you are locked into that particular system. If you switch, it means facing the prospect of buying your favorite software packages all over again. And apart from anything else, the battle of the operating systems is such a bore. Comparing like for like between the two systems may reveal marginal speed benefits one way or the other as one system leapfrogs another, but the cost of buying all the hardware for a Macintosh or PC system is going to be about the same these days, especially since many computer peripherals share the same interface connections. One of the key features of Photoshop 7.0 is that it has been adapted to run on Windows XP and Mac OS X systems (more of which later). But first let's look at the basic hardware components of a computer system, what they do and how they can be customized or upgraded to provide improved Photoshop performance.

Buying a system

As I say, almost any new computer system you buy will be capable of allowing you to run Photoshop. If you require state-of-the-art performance, then you will still have to fork out big bucks. My main buying advice for beginners remains the same. If you are new to computing and Photoshop, don't splash out on a top of the range system just yet. If you later decide image editing is not for you, then at least you can make use of your computer for general purpose office use, linking to the Internet or shooting down rogue asteroids. In a year or two you can either upgrade your current system or purchase a machine that will probably be at least twice as fast as the most powerful computers around today. And besides, even a basic system can include a pretty good-sized monitor and plenty of opportunities for expansion. If you purchase a new machine in a year or two, it will probably be at least twice as fast as the most powerful computers that are around now.

Today's entry level computer will contain everything you need. For example, take the Apple 500 MHz iMac. At the time of writing, this entry level iMac features a fast G4 processor, has the CRT equivalent of a 17" resolution monitor, runs the Radeon video card and has 128 MB of on-board RAM which can be upgraded to a maximum of 512 MB. It's got a fast 20 GB hard drive and the video performance is provided by an ATI Rage 128 graphics card. Personally, I would probably want to add another 128 MB of RAM at the time of purchase and I would prefer working with a larger screen, but otherwise it's got quite enough to get you started. If you purchased the basic 733 MHz Quicksilver G4 Macintosh, then this too has excellent specifications for Photoshop work and its processor can be upgraded. Again, I would want to add at least another 128 MB of RAM to take the memory up to 256 MB total. On the PC side there are many more choices and I would say that without being able to pinpoint any particular model, nearly all the basic packages will (like the iMac and the G4) be able to satisfy all your basic Photoshop requirements. I shall be dealing with the specifics shortly but I would assume that at the very least your entry level computer should have the following: a fast Pentium III processor, 10 GB hard drive and 128 MB of RAM that can be expanded to at least 256 MB. If you are able to get all of this and more, then you have yourself the beginnings of a powerful image editing system. If you have acquired an old computer system (which in computer terms means more than four years old!) you may encounter various problems such as a lack of compatibility with the latest peripherals and find yourself with limited expansion opportunities. Even so, converter devices are available to connect USB devices via older SCSI or SDB ports. And you will also need a later version of the operating system software. For example, Photoshop 7.0 will only run on Mac OS 9.04/9.1, Mac OS X, or Windows 98, NT, ME, or Windows XP.

Monitor display

The monitor is the next most important part of your kit. For Photoshop work, a multiscan Trinitron or Diamondtron cathode ray tube (CRT) is best. I would advise getting a 20"–22" sized screen, but there are also plenty of affordable 17" monitors of this type on the market. I would not recommend you get anything smaller than this. I am currently working with a 22" LaCie Blue screen monitor. This has a good sized screen display and is supplied with a dark hood to help shield the surface of the screen from extraneous light hitting the surface of the screen. The Barco Calibrator is an expensive display screen, but it does feature sophisticated self-calibrating features that ensure impeccable, consistent viewing conditions, which is very important for good color management. This will be explained more thoroughly in the following chapter.

Flat panel TFT type screens are also becoming more popular. The latest flat screen displays are extremely comfortable to work with and the cost of these has come down considerably in recent years. A major benefit of these is that they are physically smaller in size and therefore occupy less desk space. But the problem with TFT screens is they are mostly nigh on impossible to calibrate for consistent color output. The color and brightness of the display can vary enormously as you adjust your angle of view relative to the screen. Someone jokingly suggested that monitor calibration of a TFT screen could be possible, so long as you were prepared to wear a head brace that locked your head position relative to the screen! There are exceptions though. The Apple 22" Cinema display does have a fairly consistent screen output at a range of viewing angles. Silicon Graphics have also had a similar type of TFT screen, designed for prepress work, on the market for a few years now. You cannot attach a normal calibrator device with suckers to the delicate surface of a TFT screen but it is possible to get special TFT screen calibrators that use a simple cantilever device to allow gravity to gently press the calibrator against the angled surface of the display.

If you are able to run two monitors from your computer, then you might want to invest in a second, smaller screen and have this located beside the main monitor and use it to display the Photoshop palette windows and keep the main screen area clear of palette clutter. To run a second monitor screen you will need to buy an additional PCI card that can provide a second video port. The drawback of second monitors is one of calibration. Since both monitors will share a single monitor profile, the profile used can only be correct for one monitor only.

Video cards

If Photoshop is accused of being slow, in comparison to dedicated high-end image editing systems that is not so much a fault of the software, but rather the architecture of the computer used to run Photoshop. You have to realize that desktop computers are designed to perform all types of tasks. This jack-of-all-trades compromise is one thing which separates the desktop computer from other dedicated high-end systems. However, most modern desktop computers have PCI expansion slots on the motherboard. These allow you to add dedicated cards to the basic computer, and these allow you to convert it to a customized workstation for broadcast video editing, 3D modeling or professional image editing.

The view output on your monitor display is processed by a graphics card in your computer. An accelerated graphics card will enable your screen to do several things. It will allow you to run your monitor at higher screen resolutions, it will allow you to view your display in millions of colors and it will also hold more image screen view data in memory. When more of the off-screen image data remains in memory the image scrolling is enhanced and provides generally faster screen refreshes. In the old days, computers were sold with a limited amount of video memory. If you were lucky you could just about manage to run a small monitor screen in millions of colors. If you buy a computer today the chances are that it will already be equipped with a good, high performance graphics card, easily capable of doing all of the above. These cards will contain 32 MB (or more) of dedicated memory. If you need added video performance, a PCI graphics card will fit in an empty PCI slot on a Mac or PC computer. The Matrox Millennium, ATI Rage and the Formac ProFormance cards are recommended good buys.

Extras

An internal 24× or faster CD-ROM drive is standard issue these days. Other things to buy could include a second hard drive to use as a scratch disk plus a removable media storage device such as the Iomega Zip drive or a CD writer. You need these to back up your main hard disk and store all your image documents (the hard disk should be kept as empty as possible). Removable media disks are ideal for transferring documents to a bureau for printing. Bureaux should be able to satisfactorily read Mac and PC format files. If you are going to continue using any SCSI devices, check to see if you need to install a SCSI card interface. If you are buying from scratch then you need not worry about SCSI, as it is not going to be supported any more as standard. USB and FireWireTM (IEEE 1394) are the latest connection standards for peripheral devices. You can have up to 127 USB devices linked to a single computer and you can plug and unplug USB devices while the machine is switched on, which you were most definitely advised not to do with SCSI. USB data transfer rates are rather slow though and USB is best for connecting control devices such as the mouse, Wacom tablet and printer. FireWireTM has the potential to provide fast data transfer rates of 100 MB+ per second. So use FireWireTM wherever possible to connect devices that rely on fast data transfer such as hard drives, CD writers, digital cameras and scanners.

A digitizing pad or graphics tablet is highly recommended. It replaces the mouse as an input device, is easier to draw with and is pressure responsive. Bigger is not necessarily better. Some people use the A4-sized tablets, others find it easier to work with an A5 or A6 tablet like those in the Wacom IntuosTM range, which feature a cordless mouse and switchable pens. You don't have to move the pen around so much with smaller pads and these will therefore be easier for painting and drawing. Once you have experienced working with a pen, using the mouse will seem like trying to draw while wearing a pair of boxing gloves. Wacom recently introduced the Cintiq, which is a combination of an LCD monitor and digitizing pen pad. This radical new design will potentially introduce a whole new concept to the way we can interact with the on-screen image. I don't know if it is going to be generally seen as the ideal way of working for photography work, but early reports suggest that it makes painting and drawing a more fluid experience and that could be of significance to those who are interested in making use of the new paint engine in Photoshop 7.0.

Retailers

Mail order companies are hard to beat on price, although in my experience the customer service ranges from excellent to appalling. Always try to find out if anyone else has had a bad experience with a particular dealer before parting with your money. Under UK consumer law, any claim on your warranty will require you take up the matter via the company which sold the equipment to you. Legally your consumer rights are protected. For extra protection, use your credit card to make mail order purchases. In practice, these suppliers are working in a very competitive market and they make small margins on all equipment sold from the warehouse. Consequently, you can expect little in the way of technical support and the procedures for handling complaints can be very slow. If you do have a problem, and wish to ensure your complaint is dealt with swiftly, be patient, be polite, but above all be methodical in pursuing your complaint - note down dates and times of any calls you make. Computer trade shows are a good place to find special offers, but again check who you are dealing with. Remember prices are always dropping - the system you buy today could be selling for half that price next year (assuming it is still manufactured). Your capital investment is not going to hold its value. Businesses that rely on their equipment to be working every day

of the week will choose to buy from a specialist dealer – someone who will provide professional advice and equipment tailored to their exact needs and, most important of all, instant backup in case things go disastrously wrong.

Improving Photoshop performance

Keep the imaging workstation free of unnecessary clutter – when more applications and files are loaded, the machine will soon slow down. It is best to have a separate computer to run the office software Internet/modem connections and games etc. Switch off non-essential extensions, this will reduce startup times and improve overall operating speed. Make sure you understand what you are doing and can correctly identify what each extension does (you'll need to refer to a system book). Some extensions are essential to run software and external drives but most you don't really need. Photoshop can run without any extensions at all, but you will definitely want to have things like ColorSync, hard drive extensions, CD-ROM and High Sierra access etc. Although in the case of Mac OS X, there are no longer extensions.

Chip speed

Microchip processing speed is expressed in megahertz, but performance speed also depends on the chip type. A 500 MHz Pentium II is not as fast as a 500 MHz Pentium III chip. Speed comparisons in terms of the number of megahertz are only valid between chips of the same series. Some of the latest Pentiums and NT computers are enabled with twin processing. And Apple have only just begun to make multiprocessor computers once more. To take full advantage of multiprocessing, the user must run enabled software. Adobe have designed Photoshop to run on multiprocessor computers, but you won't necessarily feel the benefits if working in OS X (see later on in this chapter). The latest Macintosh Motorola G4 processor includes AltiVec, that is also described as a 'velocity engine'. This helps in providing several instructions per clock cycle to enabled programs such as Photoshop, and is claimed can boost performance speeds of certain operations by at least a third. Windows machines use a similar speed enhancer which is known as MMX.

Another factor is bus speed. This refers to the speed of data transfer from RAM memory to the CPU (the central processing unit, i.e. the chip). High performance computers (read more expensive) have faster bus speeds and are therefore better for Photoshop work, where large chunks of data are always being processed. CPU performance is nearly always restricted by slow bus speeds.

Chip acceleration

Upgrading the processor chip is the most dramatic way you can boost a computer's performance. But not all computers will allow you to do this. If you have either a daughter card slot or some other processor upgrade slot then you will be able to upgrade your old computer and give it a new lease of life. The upgrade card will probably also include an increase of backside cache memory to further enhance performance. The cache memory stores frequently used system commands and thereby takes the strain away from the processor chip allowing faster performance on application tasks.

RAM memory and scratch disks

The amount of RAM memory you have installed is a key speed-determining factor for image editing in Photoshop. A minimum of 35 MB application memory is recommended for Photoshop 7.0, but I doubt you would want to run with anything less than 64 MB specifically allocated to the program. Ideally, when you buy a computer you will want to install as much RAM memory as the computer will allow. Most PCs and Macs use DIMMs (Dual Inline Memory Modules). The specific RAM memory chips may vary for each type of computer, so check carefully with the vendor that you are buying the right type for your machine. RAM memory used to cost a small fortune, but these days the price of RAM is almost inconsequential. If you have three RAM slots on your machine, you should easily be able to install 3×512 MB RAM chips, especially now that Photoshop is able to recognize when you have more than a gigabyte of RAM installed. The speed boost gained from having the maximum amount of RAM installed in your machine will be very significant.

The general rule used to be that Photoshop requires available RAM memory of 3–5 times the image file size to work in real time. That will still hold true except under certain circumstances where the History options are set to allow a great many multiple undos and you are performing global changes, with each operation affecting the entire image, like applying a series of filters to the whole image. If you do that the memory requirements will soon escalate to many times the document file size. If, for example, you are editing a 30 MB RGB image in Photoshop, you will need around 90 MB to 150 MB of RAM memory beyond the amount of RAM used by the system and Photoshop itself, to edit the picture in real time. And that is assuming you have no layers added to the image, in which case the RAM memory requirements will be even greater. To get round this memory devouring problem, Photoshop utilizes free hard disk space as an extension of RAM memory. It uses all the available free hard disk as 'virtual memory'. In Photoshop terms, this is known as a 'scratch disk'.

The Apple Macintosh and Windows operating systems are able to pull off a similar trick with their own virtual memory management systems. It used to be the case that you would be advised to turn these off. This is no longer valid and you should leave the operating system virtual memory left switched on. The Windows VM file should be set to at least 1.5 times your physical memory size. There are some software utilities that claim to double your RAM – these will conflict with Photoshop's virtual memory and should not be used. Certain calculations like Photoshop filters always work best in real RAM. If you are making extensive use of scratch disk space in place of real RAM, you will see a real slowdown in performance.

The free hard disk space must be at least equivalent to the amount of RAM allocated for Photoshop. To use an extreme example, if you have 200 MB of free RAM allocated to Photoshop but only 100 MB of free disk space on the drive allocated as the primary scratch disk, Photoshop will use only 100 MB of the real RAM. For optimal image editing, at least 2 GB of free hard disk space is recommended. Under these conditions, Photoshop will use all the available free RAM for real-time calculations (mirroring the actual RAM on the scratch disk) and when Photoshop runs out of real memory, it uses the extra space on the scratch disk as a source of virtual memory.

Green: MO disk; Red: ZIP disk; Blue: External AV HD; Black: Internal AV HD; Cyan: RAID SCSI 3 drive

Figure 3.1 The above chart shows a comparison of hard disk sustained data transfer rates measured using the ATTO Performance Utility. The test results show data transfer speed on the vertical axis against increasing data block sizes on the horizontal axis. The slowest test result was for a Magneto Optical media disk. The ZIP proved slightly faster. The internal AV hard disk demonstrates a faster sustained speed, while the RAID performance figures dwarf everything else.

Photoshop is designed always to make the most efficient use of real RAM memory. There are slight differences between the way this works on Windows PC and Macintosh systems respectively, but essentially the program tries to keep as much RAM as possible free for memory intensive calculations. Low level data like the 'last saved' version of the image are stored in the scratch disk memory giving priority to the current version and last undo versions being held in RAM. Photoshop continually looks for ways to economize the use of RAM memory, writing to the hard disk in the background, whenever there are periods of inactivity. Scratch disk data is also compressed when not in use, unless the optional extension that prevents this has been loaded at Startup.

With all this scratch disk activity going on, the hard disk performance of your scratch disk plays an important role in enhancing Photoshop speed. Most modern Macs and PCs have IDE, ATA or ATA 160 drives as standard. A fast internal hard disk is adequate for getting started. But for better performance results, you should really install a second hard drive, and have this dedicated as the primary scratch disk (assign it as the primary scratch disk in the Photoshop preferences). Most likely your computer will have the choice of a USB or FireWire[™] connector for linking external devices. USB is about as fast as an old SCSI 1 connection. FireWire™ (IEEE 1394) is the latest connection standard and has many advantages over the older SCSI interface. First of all FireWire™ is a lot faster and second, it will allow you to hot swap a drive between one computer and another. This is particularly useful when you wish to shuttle very large files around quickly. Although the promised FireWire™ data transfer speeds of 100+ MB sounds impressive, most external FireWire™ drives are not actually any faster than the SCSI drives they replaced. But with the advent of the Oxford (Bridge) Chipset, FireWire[™] is now approaching the promised speed. FireWireTM drives are still IDE drives with a bridge to the FireWireTM standard, and the Oxford Chipset came out to enhance the throughput closer to the theoretical limit. An old external SCSI port is usually of a SCSI 1 standard and is suited for connecting all types of SCSI devices. Internal SCSI connections are often SCSI 2, which provides a quicker data transfer standard (data transfer not data access time is the measure of disk speed to look out for).

Until we see fast data transfer rates provided with FireWire[™] drives, you really need to look at using a wide array RAID disk connected via a SCSI accelerating PCI card like a SCSI 3 standard. Specifications vary according to the drives and the PCI card, but Figure 3.1 quite clearly shows that the sustained performance of a 25 MB per second RAID system is a huge improvement over a standard internal drive. But whichever type of drive you allocate as a scratch disk, you should ensure that it is a separate, discrete hard drive and is not shared with the disk which is running either Photoshop or the operating system. There is provision in Photoshop for as many as

four scratch disks. Each individual scratch file can be a maximum of 2 gigabytes. Should the primary scratch disk run out of room to accommodate all the scratch files during a Photoshop session, it will then start writing scratch files to the secondary scratch disk and so on. This makes for more efficient and faster disk usage.

Clearing the Photoshop memory

Allocate most of the RAM available to Photoshop and ideally run the application on its own – this is because Photoshop wants all the memory it can get. Whenever you perform a Photoshop task that uses up a lot of program memory, you can see this in the document status box <u>ser 109M/204.1M</u> in the lower left window display or in the Status bar of a PC. The right-hand figure shows the amount of memory available and the left, the amount used so far. Photoshop stores data such as recent history states and clipboard data in its memory on the scratch disk. Copying a large selection to the clipboard also occupies a lot of memory. Should you experience a temporary slow down in performance you might want to purge Photoshop of any excess temporarily data held in the memory. To do this, choose Edit > Purge > Undo, Clipboard, Histories or All.

Configuring the RAM memory settings (Macintosh OS 9)

In the Finder desktop, go to the Apple menu and choose 'About this Macintosh'. The dialog box will show you how much RAM is used by the system and how much application RAM remains – see Largest Unused Block. Next, find the unopened application icon and choose File > Get Info from the desktop menu. Change the Preferred Size setting to the largest unused block figure minus 10–20 MB. This is the largest amount of RAM you can safely allocate to Photoshop.

Configuring the RAM memory settings (Windows and Mac OS X)

When you first install Adobe Photoshop 7.0, 60% of all available system RAM is automatically allocated for Photoshop use (50% on Windows). You can improve upon this memory allowance by increasing the partition. For example, if you are running Mac OS X and have a gigabyte or more of RAM memory, you can increase the memory allocation in the Memory and Image Cache preferences to 90% or higher. But on a Windows system, do not go higher than 75–85%, as this percentage does not take into account the percentage used by the operating system. If you want to run other programs simultaneously with Photoshop, then lower the percentage of RAM that is allocated to Photoshop. In either case, you have to quit and relaunch Photoshop for these changes to take effect.

Photoshop and Mac OS X

Macintosh System 10 (or Mac OS X as it is more commonly known) is a brand new Apple operating system. Because OS X is based on the UNIX operating system, the Adobe engineers had to rewrite a lot of the existing program code. This was certainly an enormous challenge, but for all that, many Macintosh users are still going to be frustrated by the end result. Any third-party plug-ins or device drivers that are non-OS X compliant will simply not show up in Photoshop 7.0 whenever it is run in the native, Mac OS X environment. Basically it will be down to the third party developers to rectify this and Macintosh users are bound to discover that certain peripherals (such as old inkjet printers) will also have to be replaced with a newer device, or wait until the manufacturer releases OS X driver updates (see below: Installing Mac OS X and Photoshop).

Photoshop 7.0 is able to run in both Classic and native OS X operating system environments. If you are new to Mac OS X, you will notice that the OS X system loads much faster than before and is more stable. Mac OS X features memory protection, which will prevent any application-level memory leaks from affecting another open application, resulting in fewer system-level crashes. While OS X may be a more stable operating system, it is unlikely that Photoshop 7.0 will actually run any faster in OS X compared with OS 9. If you are in the habit of running several applications simultaneously on the same computer, then you will undoubtedly gain a benefit from working in OS X mode. But if you are a power user running Photoshop on its own and use lots of third-party plug-ins and devices, you may find it better to stick to running in OS 9. Remember also that the OS X system will require at least 128 MB of RAM memory to run the operating system and consequently there will be less memory available to run Photoshop. And the symmetric multiprocessing under OS X maximultiprocessor Macintoshes.

And that's not all. The OS X system itself will at times devour a sizeable chunk of the processor's resources. For example, the anti-aliasing engine that produces the rounded corners on the windows and the transparency support will place extra demands on the processor chip. The OS X throbbing buttons alone can consume up to 10% of the processor's resources! On a G3 computer OS X can appear to be noticeably slow compared to running OS 9. But if you are running a more recent twin processor G4, these high overhead demands on the processor are much less noticeable. In my opinion OS X is a very smart looking operating system that in many ways is ahead of its time. Sure, the interface lacks some of the refinements and niceties of Classic OS 9, but this is a promising start. But above all do not expect OS X to run Photoshop any faster. Mac OS X demands you run it on a fast G4 and it is much to the credit of the Adobe engineers that despite everything, Photoshop can

actually run almost as fast in OS X as it can in Classic. It may also help to know that the Photoshop team have lobbied Apple hard to get the necessary extra OS support built into OS X 1.3, which is the minimum OS X install that Photoshop 7.0 should be run on. Among other things, OS X 1.3 (the latest version is OS X 1.4) provides improved support for the brushes engine.

Installing Mac OS X and Photoshop

In OS X operating mode all OS X compliant applications and utilities will be able to operate within this native system environment. The standard Aqua blue interface is rather too colorful for my taste, but you can easily switch to using the Graphite look instead via the system preferences. Any non-OS X compliant program can be run from native OS X, but it will do so by launching the Classic OS 9 operating system from within OS X (you basically end up with a classic window appearing within the OS X operating system). The Mac OS X software package contains clear guidance on how to install the OS X and the Classic OS. I have a G4 Macintosh with the main hard drive divided into two partitioned drives. The first partition is 8 Gigabytes (the recommended maximum) and I installed Mac OS X onto this partition first. I then installed OS 9.2 on the secondary partition.

Install Photoshop 7.0 while running OS X and the program will automatically open in the OS X system environment (as shown in the dialog screenshots illustrated throughout this book). Photoshop users typically rely on the use of third-party plugins such as filters and import/export plug-ins to add functionality to the program. If any of your plug-ins are not OS X compliant, they will not function within OS X. Photoshop 7.0 will still launch OK, but the non-compliant items will fail to appear in the program menus. And sadly this is all too likely going to be the case for a lot of Photoshop users, until more third-party plug-ins are updated for OS X. In the early days of OS X there were not even any OS X compliant drivers for the majority of inkjet printers or pressure sensitive tablets. But this situation should be successfully addressed by the time Photoshop 7.0 hits the shelves.

In the meantime you will want to do the following: install Photoshop 7.0 on the OS X system drive. Install any plug-ins that you require as before. If you can manage without the use of plug-ins that are non-OS X compliant, then operate Photoshop in OS X. For those times when you do need the full use of these plug-ins, you can instruct Photoshop to launch in the Classic environment. Locate and highlight the Photoshop application icon and choose File > Show Info and check the 'Open in the Classic environment' checkbox. To revert to Aqua mode again, uncheck this box in the File Info window. Running Photoshop 7.0 in Classic mode from within OS X will probably help you to run non-OS X filter plug-ins, but it may still not be possible

to get Photoshop to recognize all non-OS X input and output devices. Professional Photoshop users like myself will have customized their computer systems with addons such as Ultra Wide SCSI RAID drives plus high-end drum scanners, digital cameras and print devices. Some of these are old SCSI devices and because there may never be any drivers available for OS X, there will be no other option but to bypass OS X completely and restart the computer using the OS 9 partition instead. Photoshop 7.0 will then readily open up in OS 9 mode.

If you have a scanner or printer that is not supported by an OS X driver yet, it is always worth checking the manufacturer's website or enquiring if and when such a driver will become available. This is one of those unfortunate situations where everyone in the Mac support industry is waiting for everyone else to make the first move. It will probably have helped that Microsoft released Office for Mac OS X first and this will have encouraged the inkjet manufacturers in particular to get the ball rolling. But I suspect a lot of manufacturers will be holding out on updating drivers for all these graphics devices until they see that Photoshop 7.0 is about to ship. Even then, the OS X Mac kernel is still in its infancy and new driver updates are likely to be more buggy.

In my bureau office setup I have two Macintosh computer workstations. One of them operates mainly in Classic mode and handles all the scanning and output work, plus general office application work. This is connected via a high-speed Ethernet link to the other Mac, where I happily do most of my Photoshop retouching running Mac OS X.

Shared and non-shared items

To summarize, you only need to install one version of Photoshop 7.0 and I recommend that you do this using the OS X partition drive. Photoshop 7.0 can open in OS X either as a native classic application, or it can be made (via the File > Get Info dialog) to open in Classic mode. If you startup from the OS 9 partition, Photoshop 7.0 will only open in Classic. So you have one program but with two ways of running it. While some items are shared, such as the plug-ins folder and Preset folder contents, other things such as the preference settings are not. So if you configure the scratch disk preferences in Classic mode, these will not be recognized in OS X mode and you will have to make a separate configuration.

Windows XP

While Apple were bringing out OS X, Microsoft were busy developing the Windows XP operating system. Like OS X, Windows XP has radically abandoned the previous Windows interface design. The standard Windows XP interface design is known as

Luna. The dark blue color featured in Luna is rather distracting for Photoshop work and so I would advise you to dump the Luna interface and choose the 'Silver' theme instead. Both OS X and XP feature advanced operating systems, and are more reliable and not prone to regular crashing, like their predecessors. Or if a program does crash, at least it does not disrupt the system and freeze the whole computer. Photoshop users will be interested to know that Windows XP does have a neat way of displaying image folder information, which in a way complements the Photoshop 7.0 file browser. The XP file navigation system can enable you to browse the images contained in a folder as a slide show, which is very cool.

Adapting to a new system can be a slow learning process. Fortunately, Windows XP features the ability to revert to a previous system configuration. This is particularly useful if you were to install a driver that proved troublesome. You simply revert to earlier system setup. Windows XP is a much refined version of the Windows NT operating system, so it has a good solid legacy. Although OS X is based on a UNIX core, and has a great Aqua interface, much of OS X is very recent and there are a number of neat features from the OS 9 system that are sadly missing in OS X, like the ability to grab and drag a document window from one of the sidebars.

Office environment

Your computer working area matters. Even if space is limited there is much you can do to make your work space as comfortable as possible to work in. Choose a comfortable operator's chair, ideally one with arm rests and adjust the seating position so that your wrists are comfortably resting on the table top. The monitor should be level with your line of view or slightly lower. Lighting levels should be consistent throughout the day and any artificial lights should be daylight balanced. Make sure no direct light hits the screen and that the walls are painted with a neutral color. Once you start to build an imaging workstation, you will soon end up with lots of electrical devices. While these in themselves may not consume a huge amount of power, do take precautions against too many power leads trailing off from a single power point.

External sound speakers must be shielded, unless they are placed at a distance from the computer monitor. Cathode ray tube monitors are vulnerable to damage from the magnets in an unshielded speaker or the electrical motor in an inkjet printer. Just try not to position any item other than the computer too close to a CRT monitor screen. Interference from other electrical items can cause problems as well. I recently noticed all my monitors were flickering after moving to a new office and consequently had to consider shielding the computer monitors with a special material. This was all because of assorted cables contained behind the office wall. To prevent damage or loss of data from a sudden powercut, place an uninterruptible power supply unit between your computer and the mains source. These devices will also smooth out any voltage spike surges in the electricity supply.

System software

A computer that is in daily use will after a month noticeably slow down unless you do some housekeeping. You should regularly rebuild the desktop file by holding down the Command and Option keys (Mac OS 9) simultaneously at startup. This maintenance operation makes it easier for the computer to locate files (just as when you tidy up your own desk). PC users should search for temporary files while no applications are running, using the Find command and entering '*.tmp', to search for any files that have the .tmp (temporary) file extension. These should then be deleted. With Mac OS X you can also purge the cache, which has a similar effect to rebuilding the desktop in OS 9. Norton Utilities is a suite of programs that add functionality. Image files continually read and write data to the hard disk, which leads to disk fragmentation. Norton's Speed disk (which has to be run from a separate startup disc), will defragment files on the main hard disk or any other drive. Windows users should also look out for a program like Windows Disk Defragmenter. This is essential on the drives you allocate as the scratch disks in Photoshop. If you're experiencing bugs or operating glitches and want to diagnose the problem, run Norton's Disk Doctor. This will hunt out disk problems and fix them on the spot.

On the subject of Norton, Rod Wynne-Powell has this extra advice to offer: I have never read it in print or in Norton's literature, but an essential procedure for running Norton is that you run it more than once, if you find that it reports any error at the end. On the second or subsequent runs you may ignore the search for bad blocks, as if they occur you have more than a simple glitch, but in this way you find out whether any 'fixed' item has caused any other anomalies. If you are unlucky enough to have 'bad blocks' do not assume that their reallocation has solved the problem; it may well have reassigned the faulty block, but it could be that the data present in that area is now invalid, and could be a vital system component, which will now start to corrupt more of your disk. The advice is simple, and not welcome; the hard disk must be reformatted, and the system and applications all reloaded. If bad blocks recur the drive needs replacing. And another thing to note is this. Of late Apple has gone against its own advice and introduced files that are preceded by a period (files such as .FS). It should be noted that these must *not* be changed, yet Norton throws these up as damaged. The consequence of this is that currently you will always receive a 'Minor problems' warning at the end of your session.

Chapter Four Color Management

Photoshop 5.0 was justifiably praised as a ground-breaking upgrade when it was released in the summer of 1998. The changes made to the color management setup were less well received in some quarters. This was because the revised system was perceived to be extremely complex and unnecessary. Some color professionals felt we already had reliable methods of matching color and you did not need ICC profiles and the whole kaboodle of Photoshop ICC color management to achieve this. The aim of this chapter is to start off by introducing the basic concepts of color management – the first part will help you to understand the principles of why color management is necessary. And as you will discover, there are some important historical reasons why certain Photoshop users feel they have no need to use ICC profiled color management. We will be looking at the reasons for this and then go on to consider the advantages of an ICC profiled workflow and lastly, how to optimize the Photoshop Color Settings interface.

The need for color management

An advertising agency art buyer was once invited to address a meeting of photographers for a discussion about photography and the Internet. The chair, Mike Laye, suggested we could ask him anything we wanted, except 'Would you like to see my book?' And if he had already seen your book, we couldn't ask him why he hadn't called it back in again. And if he had called it in again we were not allowed to ask why we didn't get the job. And finally, if we did get the job we were absolutely forbidden to ask him why the color in the printed ad looked nothing like the original transparency! That in a nutshell is a problem which has bugged us all our working lives. And it is one which will be familiar to anyone who has ever experienced the difficulty of matching colors on a computer system with the original or a printed output. Figure 4.1 has two versions of the same photograph. One shows how the Photoshop image is previewed on the monitor and the other is an example of how a printer might interpret and reproduce those same colors. Why can there be such a marked difference between what is seen on the screen and the actual printed result? The computer monitor will have manual controls that allow you to adjust the brightness and contrast (and in some cases the RGB color as well), so we have some element of basic control there. And the printer will also probably allow you to make color balance adjustments, but is this really enough though? And if you are able to get the monitor and your printer to match, will the colors you are seeing in the image appear the same on another person's monitor?

Why not all RGB spaces are the same

Figure 4.1 The picture on the left shows how you would see the Photoshop image on your screen and the one on the right represents how that same image will print if sent directly to a proofing printer without applying any form of color management. This is an actual simulation of what happens when raw RGB data is sent without any form of compensation being applied to balance the output to what is seen on the screen.

You might think it is merely a matter of making the output color less blue in order to successfully match the original. Yes, that would get the colors closer, but when trying to match color between different digital devices, the story is actually a lot more complex than that. The color management system that was first introduced in Photoshop 5.0 will enable you to make use of ICC profiles and match these colors from the scanner to the screen and to the print proofer with extreme accuracy.

Client: Clipso. Model: Sheri at Nevs.

Figure 4.2 All digital devices have individual output characteristics, even if they look identical on the outside. In a TV showroom you will typically notice each television displaying a different colored image.

What you have just witnessed illustrates why color management is so important. It is all very well getting everything balanced to look OK on your monitor and knowing how to tweak your printer settings to look right. But there is a better way, one that will allow you to mix and match any number of digital devices. Go into any TV show room and you will probably see rows of televisions all tuned to the same broadcast source but each displaying the picture quite differently. This is a known problem that affects all digital imaging devices, be they digital cameras, scanners, monitors or printers. Each digital imaging device has its own unique characteristics. And unless you are able to quantify what those individual device characteristics are, you won't be able to communicate effectively with other device components and programs in your own computer setup, let alone anyone working outside your system color loop.

The way things were

What follows is a brief summary of working practices in the repro industry, but keen amateurs might also be interested to learn about some of the background history to color management. Ten years ago, most photographers only used their computers to do basic administration work and there were absolutely no digital imaging devices to be found in a photographer's studio (unless you counted the photocopier). At the end of a job we would supply transparencies or prints to the client and that was the limit of our responsibilities. Our photographs then went to the printer to be digitized using a high-end drum scanner to produce a CMYK file. The scanner would be configured to produce a CMYK file ready to insert in a specific publication. If color corrections were required, the scanner operators carried this out themselves on the output file. These days a significant number of photographers, illustrators and artists are now originating their own files from digital cameras, desktop scanners or directly within Photoshop. This effectively removes the repro expert who previously did all the scanning and matching of the colors on the press. Imagine for a moment what would happen if our traffic laws permitted a sudden influx of inexperienced and unaccompanied teenage learner drivers on to our roads? This will give you some indication of the 'printer rage' that ensued when Photoshop users began delivering digital files instead of transparencies. There is no getting away from the fact that if you supply digital images to a printer, you will be deemed responsible should any problems occur in the printing. This may seem like a daunting task, but with Photoshop it is not hard to color manage your images with confidence. It need only take a few minutes to calibrate your monitor with the Adobe Gamma control panel and to configure the Photoshop Color Settings. But we'll come to that later on.

CMYK color management

Printers naturally have an 'output-centric' view of color management. Their main concern is getting the CMYK color to look right on a CMYK press. Accordingly, you will hear an argument that suggests you don't need ICC profiles to get accurate CMYK color. In fact, if you know your numbers, you don't even need a color monitor. In this respect you can say they are right. These proven techniques have served the printing industry well for many years. But most Photoshop users and especially those who are photographers, face a far more complex color management problem, because we don't all have the luxury of managing the one scanner linked to a single press. We quite often have to handle digital files sourced from many different types of RGB devices such as: digital cameras, desktop scanners, Photo CD, picture libraries etc.

RGB devices

If your production workflow is limited to working with the one high-end scanner and a known press output, then the number of variables in your workflow is limited and it would not be difficult to synchronize everything in-house. But this is not the experience of an average Photoshop user. Instead of handling color between a few known digital devices in a fixed loop, you are faced with files coming from any number of unknown digital devices. If we all worked with the same few pieces of digital capture devices (like in the old days when there were only a handful of highend scanner devices) the problem would be not so bad. But in the last decade or so the numbers of different types of capture devices has grown enormously. When you take into account all the different monitors that are in existence and other Photoshop users who supply you with files of unknown provenance, and well, you get the picture! Since the explosion of new desktop scanners and digital cameras arriving on the market, the publishing industry has been turned on its head. This is a relatively new phenomenon and the old way of doing things no longer holds all the answers when it comes to synchronizing color between so many unknown users and digital devices. On top of this our clients may expect us to output to digital proofing devices, Lambda printers, Pictrographs, Iris printers, web pages, and ultimately a four-color press. An appreciation of CMYK printing is important, but in addition to this, you will possibly have to control the input and output between many different RGB color devices before a file is ready to go to press.

Not all RGB color devices are the same

Consider for a moment the scale of the color management task. We wish to capture a full color original subject, digitize it with a scanner or digital camera, examine the resulting image via a computer screen and finally reproduce it in print. It is possible with today's technology to simulate the expected print output of a digitized image on the screen with remarkable accuracy. Nevertheless, one should not underestimate the huge difference between the mechanics of all the various bits of equipment used in the above production process. Most digital devices work using RGB color and just like musical instruments, they all possess unique color tonal properties, such that no two devices are identical or will be able to reproduce color exactly the same way as another device can. Some equipment is capable of recording colors that are beyond the limits of human vision. Nor is it always possible to match in print all the colors which *are* visible to the human eye. Converting light into electrical signals via a device such as a CCD chip is not the same as projecting pixels onto a computer screen or the process of reproducing a photograph with colored ink on paper.

ICC profiled color management

We are all familiar with magazine reviews of digital cameras. At some point the magazine may print a spread of photos where a comparison is made of all the different models and the results achieved from photographing the same subject. The object of this exercise being to emphasize the difference in the capture quality of each camera when each file is brought directly into Photoshop, without any compensation being made. If you could quantify or 'characterize' those differences then it should be possible to accurately describe the color captured by any camera or scanner.

The International Color Consortium (ICC) is an industry body representing the manufacturers of imaging hardware and software who devised a common method of interpreting color between one device and another. The ICC profiling system has been adopted in a number of guises, such as Apple's ColorSync[™]. All ICC systems are basically able to translate the color gamut of the source space via a reference space and accurately convert these colors to the gamut of the destination space. The color conversion processing is carried out by the Color Matching Module or CMM. In Photoshop you have a choice of three CMMs: Adobe Color Engine (ACE), Apple or Heidelberg. Figure 4.8 shows a graphical illustration of a CMM at work.

So let's imagine a scenario where everyone is working in a profile-free, digital workflow. Who would have the hardest job of managing the color? The printer can color correct a CMYK image 'by the numbers' if they wish. Take a look at the photograph of the young model in Figure 4.3. Her Caucasian flesh tones should at least contain equal amounts of magenta and yellow ink with maybe a slightly greater amount of yellow, while the cyan ink should be a quarter to a third of the magenta. This rule will hold true for most CMYK press conditions. The accompanying table compares the CMYK and RGB space measurements of a flesh tone color. Unlike CMYK, there are no set formulae to describe the RGB pixel values of a flesh tone. If you were to write down the flesh tone numbers for every RGB device color space, you could in theory build an RGB color space reference table. And from this you could feasibly construct a system that would assign meaning to these RGB numbers for any given RGB space. This is basically what an ICC profile does except an ICC profile will contain maybe several hundred color reference points. These can be read and interpreted automatically by the Photoshop software.

CMYK ink values	Cyan	Magenta	Yellow	Black
Euroscale Coated v2	09	28	33	0
3M Matchprint Euroscale	07	25	30	0
US Web uncoated (SWOP)	08	23	29	0
Generic Japan pos proofing	07	28	33	0
RGB pixel values	Red	Green	Blue	
RGB pixel values	Red	Green	Blue	
	100000000000000000	Ø. 0100092009000000900000000		
Adobe RGB	220	190	165	
	220 231	190 174	165 146	
Adobe RGB Pictrograph 3000 Lambda				

Figure 4.3 The above tables record the color readings for a flesh tone in RGB and CMYK color spaces.

Figure 4.4 This is an example of a Kodak color target which is used to construct a color ICC profile. Thomas Holm of Pixl in Denmark sent me five separate files, including the one above. Each file was opened in Photoshop without any color conversion and the file was sent directly to the printer, again without any color modification. The print outputs, which contained over 800 color reference swatches, were then sent back to Pixl. They then measured all the color data information using an X-Rite spectrophotometer and from this constructed an accurate profile for my Pictrograph printer using Kodak ColorFlow 2.1 software and emailed the profile back to me.

<email@pixl.dk>

Figure 4.4 shows an example of a Kodak test target which is used to build an ICC profile. A target like this can either be scanned or photographed with a digital camera and the input color values compared using special software. In this case, I printed out the targets without using any color management – this gave a picture of how the printer would reproduce raw digital data directly from Photoshop. The printed targets were then measured using a spectrophotometer, the results evaluated and used to build a color profile for the color printer. As you can see, the profiling method will tell us so much more about the characteristics of a digital device like a camera or a scanner than could ever be achieved by just tweaking the monitor RGB gamma values to match the color balance of a specific output.

All RGB device spaces are different and without an accompanying profile, the RGB number values will lack specific meaning. Without profiles, the only way to compensate the color between different RGB devices was to adjust the monitor to reflect the color of the print output. This is like profiling, but is using only the midrange color balance to adjust the color. The 'mess up the monitor to look like the print' approach is seriously flawed and if you take a look at the examples in Figure 4.5 you will see why. If you plot the color gamut of a device as a 3D shape, you will notice

Figure 4.5 The above photographs have been reproduced without any color management being used. This illustrates not only how the color reproduction ends up being different from each color space, the gamut map of each space is also very different in character.

that the gamuts of these devices and edit spaces have their own distinctive signature shapes. It is not a simple a matter of making the screen a little more red to match the reddish print. Color managing your images in this way can be about as successful as hammering a square peg into a round hole!

In Daniel Defoe's book, Robinson Crusoe faced something of a furniture management problem. He tried to make the legs of his table stay level by sawing bits off some of the legs. As soon as he had managed to even up two or more of the legs, he found that one of the others would now be too long. And the more he attempted to fix the problem with his saw, the shorter the table became. A similar thing happens when you try to color manage through adjusting the monitor settings. You may be able to obtain a good match for the skin tones, but if your subject is wearing a blue suit, the color might be way off and if you then compensate successfully for the blue clothing, the skin tones will no longer be true or some other color will reproduce incorrectly. You will not be able to achieve consistently matching results using this method of color management.

Switching on Photoshop ICC color management

A profile is therefore a useful piece of information that can be embedded in an image file. When a profile is read by Photoshop and color management is switched on, Photoshop is automatically able to find out everything it needs to know in order to manage the color correctly from there on. Note that this will also be dependent on you calibrating your monitor, but essentially all you have to do apart from that is to open the Photoshop Color Settings from the Edit menu and select a suitable preset such as the US Prepress Default setting. Do this and you are all set to start working in an ICC color managed workflow. Think of a profile as being like a ZIP code for images. For example, the address label shown in Figure 4.6 was rather optimistically sent to me at 'Flat 14, London', but thanks to the ZIP code it arrived safely! Some bureaux have been known to argue that profiles cause color management problems. This I am afraid is like a courier company explaining that the late delivery of your package was due to you including a ZIP code in the delivery address. A profile can be read or it can be ignored. It will certainly not be harmful to anyone who is using a non-ICC workflow.

Figure 4.6 Even if you have never been to London before, you know it's a fairly big place and 'Flat 14, London' was not going to help the postman much to locate my proper address. However, the all-important ZIP code or postcode was able to help identify exactly where the letter should have been delivered. An image profile is just like a ZIP code, it can tell Photoshop everything it needs to know about a file's provenance.

Martin Evening Flat 14	
LONDON	
NI ITG	

Monitor profiling

The first step to making color management work in Photoshop is to calibrate the monitor screen. There are several ways of doing this. As a minimum step towards monitor calibration and profile making, you are now advised to utilize the monitor calibration utilities provided by the Macintosh or use the Adobe Gamma control panel on a PC system to calibrate the screen and build a basic monitor profile. A

better solution, if you can afford it, is to purchase a hardware calibration device and software package. Some monitors like the Apple ColorSync and Barco feature builtin internal calibration. All these methods are doing the same thing – they optimize the monitor contrast and brightness, neutralize the color balance of the display and build a monitor profile. The aim is to standardize the monitor display and provide a report in the form of an ICC monitor profile. As shall be explained later, the monitor profile will then be automatically used by Photoshop to accurately display on the screen all profiled color files.

People often ask 'How can I be sure that the color I see is the same as what someone else is seeing?' How reliable are an individual person's eyes when it comes to determining how to neutralize the display? There are several factors which can determine color perception, not least the health of a person's eyes. As you get older the color vision of your eyes will change, plus some people are color blind and may not even be aware of this. For the most part, younger people in their twenties and with healthy vision will perceive colors more consistently and with greater precision. Then there is also the question of how we interpret color – human vision is adaptable and we tend to accommodate our vision to changes in lighting and color temperature and can be influenced by the presence of other colors around us.

Monitor calibration

Before you carry out any monitor calibration, the monitor should be left switched on for at least half an hour to give it a chance to warm up and stabilize. You should get rid of any distracting background colors or patterns on the computer desktop. You should ideally have a neutral gray desktop background and this is especially important when you are calibrating the screen by eye. One way to achieve this is to open an image up in Photoshop and set the screen display to full screen mode with the gray pasteboard filling the screen. Consider also the impact of lighting conditions and the viewing environment. The walls of the room you are working in should be a neutral color and the light levels kept low throughout the day. This will help to preserve the contrast of the monitor and lessen unwanted reflections from the screen.

With the advent of Photoshop 7.0, Adobe is no longer bundling a version of Adobe Gamma with the Macintosh package. It is assumed that ColorSync will handle everything in the Mac OS X, and leaves the field wide open for third parties to develop products for Mac OS 9.x. But the Adobe Gamma control panel is still available in the Goodies folder on the master CD, should you wish to continue using it. The following steps show you how to neutralize a cathode ray tube (CRT) monitor and create a monitor profile on the Mac OS X system.

Mac OS X calibration

To launch the Display Calibration Assistant, click on the Displays icon in the System preferences and click on the Calibrate button. The opening screen introduces the calibration utility and steps to create a monitor profile. Check the Expert Mode button at the bottom of the screen.

Introduction
Welcome to the Apple Display Calibrator Assistant! This assistant will help you calibrate your display and create a custom ColorSync profile. With a properly calibrated display, software that takes advantage of ColorSync can better display images in their intended colors. Image: Software that takes advantage of ColorSync can better display, software that takes advantage of ColorSync can better display. Image: Software that takes advantage of ColorSync can better display. Image: Software that takes advantage of ColorSync can better display. Image: Software that takes advantage of ColorSync can better display. Image: Software that takes advantage of ColorSync can better display. Image: Software that takes advantage of ColorSync can better display. Image: Software that takes advantage of ColorSync can better display. Image: Software that takes advantage of ColorSync can better display. Image: Software that takes advantage of ColorSync can better display. Image: Software that takes advantage of ColorSync can better display. Image: Software takes advantage of ColorSync can better display. Image: Software takes advantage of ColorSync can better display. Image: Software takes advantage of ColorSync can better display. Image: Software takes advantage of ColorSync can better display. Image: Software takes advantage of ColorSync can better display. Image: Software takes advantage of ColorSync can better display. </th
Click the right arrow below to begin.

Contrast and brightness

You will then be asked to adjust the monitor brightness control so that the gray circle inside the larger box just becomes visible and the two darker halves of the square appear to be a solid black. This step optimizes the monitor to display at its full dynamic range and establishes the optimum brightness for the shadow tones.

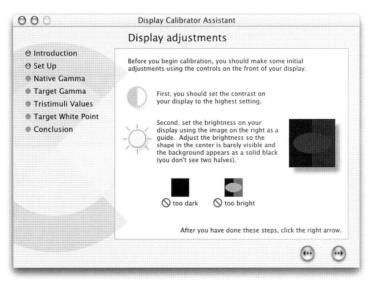

Neutralizing the color

If you are using a cathode ray tube (CRT) monitor the calibration assistant will display the following dialog with the red, green and blue squares. This will allow you to adjust the gamma of the individual red, green and blue monitor colors. Squint your eyes as you adjust the individual color gamma sliders, so that the patterned stripes in the boxes appear to blend with the solid Apple logo in the middle.

000	Display Calibrator Assistant
	Determine your display's current gamma
 e Introduction e Set Up Native Gamma Target Gamma Tristimuli Values Target White Point Conclusion 	Your display's actual gamma is affected by contrast and brightness settings and other characteristics of your display. For each of the three colors below, move the slider until the shape in timay help to squint or step back from the display.

Target Gamma

if you have a flat screen monitor connected to your computer or you have already installed a thirdparty monitor calibration utility, the Calibration Assistant will recognize this and bypass the previous dialog, to display the target gamma screen. If you are using a Macintosh computer, select the Mac Standard 1.8 gamma.

000	Display Calibrator Assistant
	Select a target gamma
 ⊖ Introduction ⊖ Set Up ⊖ Native Garma ⊖ Target Garma ● Tristimuli Values ● Target White Point ● Conclusion 	Select the gamma setting you want for your display. (Watch the picture on the right to see the effect as you move the slider.)
	Target Gamma = 1.80 After you have done this step, click the right arrow.

White point

Now we come to the white point settings. I would advise choosing a white point of 6500 K. You might be guided to choose a white point of 5000 K, because this is the color temperature of a calibrated, proofing lightbox, but the screen will look rather dull and have a slightly yellow cast, so stick to using a 6500 K white point.

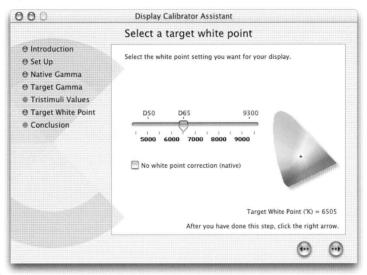

Conclusion

Name the new monitor profile and click on the Create button. You will have created an ICC profile that describes the current characteristics of the monitor and which Photoshop will automatically recognize. Photoshop will utilize this profile information in the color management process without further intervention. You have just successfully calibrated your monitor's brightness, contrast and color balance.

 Set Up Native Gamma Target Gamma Tristimuli Values Target White Point Conclusion 	Cive your profile a name. Calibrated Profile (the name must be 31 characters or less) Profile Summary: Native Gamma: 2.20 Target Gamma: 1.80 Chromaticities x y Red Phosphor: 0.63 0.34 Green Phosphor: 0.29 0.61 Blue Phosphor: 0.29 0.61 Blue Phosphor: 0.15 0.07 Native White Point: 0.28 0.30 Target White Point: 0.28 0.30
---	---

Calibrating a PC monitor with Adobe Gamma

The Adobe Gamma control panel should be located in the Program files/Common files/Adobe/Calibration folder which can be easily accessed on a PC by going to My Computer and selecting Control Panels. Adobe Gamma will now work with most PC computers, providing the video card will allow Adobe Gamma to interact with the monitor tube. Do not use the older Gamma control panel which shipped with Photoshop 4.0 or earlier. This older control panel must be discarded.

When you launch Adobe Gamma, you have a choice of using it in either Control Panel or Step By Step (Assistant) mode. Select the Assistant radio button and click Next. If you already have a monitor profile, such as a canned profile supplied by the manufacturer, click the Load... button, locate this profile and use that as your starting point. Any existing monitor profiles should be found in the ICM Color Profiles folder. If not, any will do as a starting point here. You will be asked to set the monitor contrast to maximum. The single gamma display box will only allow you to adjust the relative brightness. But since you will want to neutralize the color as well, uncheck the View Single Gamma Only box and adjust the three color boxes as outlined in the Mac OS X calibration routine.

The Windows default gamma is 2.2 and this is the best monitor gamma setting for most Windows graphics cards. The white point should be 6500 K, if unsure, try clicking on the Measure... button and following the on-screen directions. The next screen asks if you want to work with a different white point other than that entered in the previous screen. Unless you have a particular need to alter the white point, leave this set to Same as Hardware.

Figure 4.7 If you are using a thirdparty method of profiling the monitor on the Macintosh, other than a system utility, you may be required to manually load this profile next to where it says Display Profile in the ColorSync Control Panel (OS 9), in the ColorSync System preference (Mac OS X), or in the Displays: Color System preference (Mac OS X 10.2). On a PC, you will probably need to carefully consult the instructions which came with the calibration device. These should guide you through the intricacies of how to configure the Windows system setups.

	0	6 🔄 😣		
Show All Display:	s Sound N	letwork Startup Disk Classic		
	Device	Profiles Document Profiles	CMMs	
		specify the primary device or	profile for each	
stand	ard device	class.		
	Input:	Generic RGB Profile	•	
	Display:	PhotoCal Profile	•	
	Output:	Default printer	•	
	Proof:	Generic RGB Profile		
		orkflow Expo	rt Workflow	

The value of a calibrated display

If you follow the steps just described, you will now have yourself a calibrated monitor. On the Macintosh, the profile should be saved in the System/ColorSync Profiles folder. On a PC machine, save to the Windows/System/Color folder. A standard calibration utility like the one just shown is the simplest way of checking that your screen is neutral and is making full use of the display contrast to fully render the shadow and highlight tones correctly. This will get you on the right track with regards being able to open up an image in Photoshop and seeing it with the same brightness and color neutrality as seen on someone else's calibrated system.

The display calibrator utility just shown is effective, but it is still rather basic. There are other, better monitor profiling solutions you might consider using. A hardware calibration device combined with a dedicated software utility will be able to build a much more accurate monitor profile. The LaCie bluescreen prepress monitors can be sold with an optional Blue Eye calibrator device. ColorVisions <www.colorcal.com> make several calibration units, starting with the very affordable Monitor Spyder and PhotoCal software bundle. For really accurate monitor calibration consider the X-Rite DTP 92 with OptiCal software or the very versatile Eye-One devices from Gretag Macbeth, which can be used to build profiles of almost everything in your studio. Monitor profiling devices are attached to the screen via rubber suckers. As I said in Chapter One, most LCD type screens cannot be profiled, apart from certain devices such as the Apple, Wacom and Formac displays. A normal calibrating device will easily damage the delicate screen surface, so a special calibrator must be used. These calibrators have a strap with a weight on the other end and are hung over the top of the screen and will gently rest the calibrator against the screen surface. The calibration software will display a series of color patches on the screen and these are read by the calibrating device and the information is used to build a profile. If you have a third-party device or a built-in monitor calibration system, always use this in preference to anything else. If you still have Adobe Gamma installed, disable it and do not try to use both systems. The performance of the monitor will fluctuate over time as well as on a daily basis. It is therefore important to check and calibrate the monitor at regular intervals. Remember, monitor calibration plays an essential part in establishing a first link in the color management chain.

The Photoshop color engine

Let's put all the pieces together – the diagram in Figure 4.8 illustrates the ICC color management route for handling ICC profiled files coming into Photoshop. It shows the different types of RGB input sources such as desktop scanner files or Photo CD images being brought into Photoshop. If an ICC profile is embedded in the file,

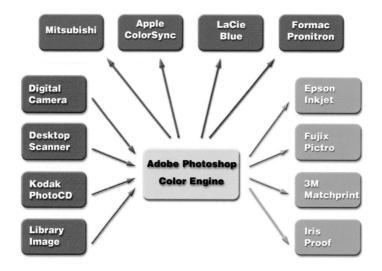

Figure 4.8 Photoshop's ICC color management system revolves around the use of profile information which will ideally accurately describe the characteristics of each digital device used in the chain from capture to print. In the above example, Photoshop can read or make use of the profile relating to any type of input source (the devices listed in the red boxes) and apply a conversion to the destination or output (the devices listed in the green boxes) and maintain consistent color throughout. Profiling the monitor (such as one of the monitors listed in the blue boxes at the top), using a third-party measuring device ensures accuracy of the display of the color data on screen.

Photoshop will recognize this and know how to correctly interpret the color data. The same thing applies to profiled CMYK files as well. Photoshop uses the monitor profile information to render a color correct preview on the monitor screen. It helps to understand here that in an ICC color managed workflow in Photoshop, what you see on the monitor is always a color corrected preview and you are not viewing the actual file data. This is what we call 'device-independent color'. When an image is in Adobe RGB and color management is switched on, what you see on the screen is an RGB preview that has been converted from Adobe RGB to your profiled monitor RGB. The same thing happens when Photoshop previews CMYK data on the screen. The Photoshop color management system calculates a conversion from the file CMYK space to the monitor space. Photoshop therefore carries out all its color calculations in virtual color spaces. For example, the RGB color space you edit within can be exactly the same as the work space set on another user's Photoshop system. If you are both viewing the same file, and your monitors are correctly calibrated and profiled, you should be seeing near enough the exact same colors on the screen in Photoshop.

The profiled approach

To output a file from Photoshop in a color managed workflow, you will need to carry out a further profile conversion from the current work space or file space, to the printer's color space. We will be looking at color managed file outputs in deservedly more detail later on in Chapter Five. In the meantime, Figure 4.9 reexamines the problem encountered at the beginning of this chapter where the skin tones in the original image printed too blue. The profile created for this particular printer describes the variance. The (normally hidden) color shifting which occurs during the profile conversion process will compensate by making the skin tone colors more red, but apply less color compensation to other colors. The result is an output that more closely matches the original. That is a simple illustration of the ICC-based color management system at work. All color can be managed this way in Photoshop from capture source to the monitor display and the final proof.

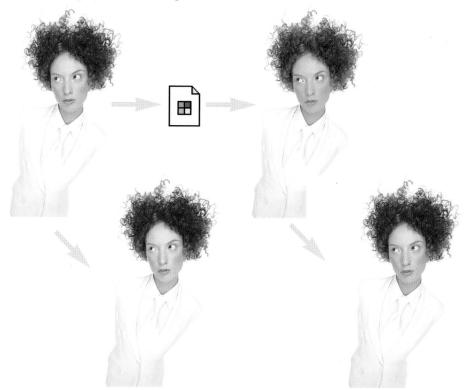

Figure 4.9 As was shown in Figure 4.1, sending the color data direct to the printer without applying any compensation will produce an incorrect color result. But applying a profile conversion with a custom profile for the proof printer will invisibly convert the colors to compensate for the specific characteristics of the printer and thereby produce a much more representative print of the original. The bright red 'profile converted' image will compensate for the color space deficiencies of the output device.

The versatility of RGB

There are those who remain critical of the introduction of ICC-based color management in Photoshop. They look at the needs of their own setup and figure that what works well for them has got to be right for everyone else. I travel quite a lot and once I was driving off the normal tourist track and needed to find a decent road map, but couldn't find any local gas stations that sold one. When I enquired why, I was told 'Because we all know where everything is around here!' It seemed the locals had no need to accommodate lost strangers around those parts.

You could say the same of some bureaux and printers because they work exclusively at the final stage of the print process. If your main area of business revolves around the preparation of CMYK separations for print, then I do recommend you invest in a training course or book that deals with CMYK repro issues. I can highly recommend the *Real World Photoshop* series by Bruce Fraser and David Blatner. Conversely, photographers are mainly involved in the RGB capture end of the business. This is one of the reasons why I devote so much attention to the managing of RGB color, here and elsewhere in the book. But nevertheless, if any work you create is intended for print, the issue of RGB to CMYK conversion must be addressed at some point.

The proliferation of Photoshop use and the advent of high quality digital cameras is also another important factor to consider. If photographers are more likely to want to supply a digital file at the end of a job, how will this fit in with existing workflows? Printers have argued in the past that they would prefer the digital files turned back into transparencies, so they can maintain the opportunity to scan it again themselves. Most of their work is currently handled using original transparency film and therefore this is more convenient for them (and of course they maintain the scanning business). But at what cost to the client? Since digital capture has clearly taken off in a big way, that option will no longer exist. One way or another the RGB to CMYK issue will have to be resolved. The early adopters of digital camera systems were repro houses and they are therefore having to investigate ways and means of handling RGB files and the use of independent hardware/software solutions to carry out the conversion to CMYK. If, as has been proved, professional quality digital cameras become more widely used, photographers will either be turning those digital files back into transparencies to be scanned again by the printer, or supplying digital files direct. As I see it, the latter is the only viable option and the real issue is whether the files should be converted to CMYK by the originator or the printer.

A major advantage of working in RGB is that you can access all the bells and whistles of Photoshop which would otherwise be hidden or grayed out in CMYK mode. Mixed final usage also needs to be taken into account - a photograph may get used in a variety of ways and multiple CMYK separations will need to be made to suit several

publications, each requiring a slightly different CMYK conversion because CMYK is not a 'one size fits all' color space. High-end retouching for advertising usage is usually done in RGB mode and a large format transparency output produced. That transparency can be used as an original to be scanned again and converted to CMYK but the usual practice is to use the transparency output for client approval only. The CMYK conversions and film separations are produced working directly from the digital file to suit the various media usages. When you think about it, a transparency proof for all its glory is actually quite useless considering the end product is to be printed on paper. The ideal proof should be a CMYK output printed to match the expected output of the final publication. At the same time, the RGB original can and should be preserved in RGB mode as a master archive image.

There is life beyond CMYK. Hexachrome is a six-color ink printing process that extends the range of color depth attainable beyond conventional limitations of CMYK. This advanced process is currently available only through specialist print shops and is suitable for high quality design print jobs. Millions have been invested in the presses currently used to print magazines and brochures, so expect four-color printing to still be around for a long time to come, but Hexachrome will open the way for improved color reproduction from RGB originals. Photoshop supports six-color channel output conversions from RGB, but you will need to buy a separate plug-in utility like HexWrench. Spot color channels can be added and previewed on screen – spot color files can be saved in DCS 2.0 or TIFF format. Screen publishing is able to take advantage of the full depth of the RGB color range. If you are working in a screen-based environment for CD, DVD and web publishing RGB is ideal, and with today's browsers color management can be turned on to take advantage of the enhanced color control they now offer.

Choosing an RGB work space

Although I highly recommended that you switch on the color management settings in Photoshop, you cannot assume that everyone else will. There are many other Photoshop users and bureaux running outputs from files who will have Photoshop color management switched off and probably not bothering to calibrate their monitors properly. If you are using Photoshop 6.0 or later it matters less individually which RGB color space you choose in the RGB setup, as long as you stick to using the same space for all your work. Photoshop can safely convert between RGB spaces with minimal loss of data, but the space you plump for does matter. Once chosen you should not really change it, except when preparing images to go on the Web. Whichever color work space you select in the RGB color settings, you will have to be conscious of how your profiled Photoshop RGB files may appear on a non-ICC savvy Photoshop system. What follows is a guide to the listed RGB choices.

Apple RGB

This is the old Apple 13" monitor standard. In the early days of Photoshop this was used as the default RGB editing space where the editing space was the same as the monitor space. If you have legacy images created in Photoshop on a Macintosh computer using a gamma of 1.8, you can assume Apple RGB to be the missing profile space.

sRGB IEC-61966-2.1

sRGB was conceived as a multi-purpose color space standard that consumer digital devices could all standardize to. It is essentially a compromise color space that provides a uniform color space that all digital cameras and inkjet printers and monitors can match to. sRGB aims to match the color gamut of a typical 2.2 gamma PC monitor. Therefore if you are opening a file from a consumer digital camera or scanner and there is no profile embedded, you can assume that the missing profile should be sRGB. It is an ideal color space for web design but unsuitable for repro quality work. The sRGB space clips the CMYK gamut and you will never get more than 75%–85% cyan in your CMYK separations.

ColorMatch RGB

ColorMatch is an open standard monitor RGB space that was implemented by Radius. ColorMatch has a gamma of 1.8 and is favored by certain Mac users as the RGB working space. Although not much larger than the gamut of a typical monitor space, it is a known standard and more compatible with legacy, 1.8 gamma Macintosh files.

ProPhoto RGB

This is a large gamut RGB space that is suited for image editing that is intended for output to photographic materials such as transparency emulsion or taking full advantage of the color gamut of photo quality inkjet printers. Any image editing in a wide gamut space should ideally only be done using 16 bits per channel mode.

Adobe RGB (1998)

Adobe RGB (1998) has become established as the recommended RGB editing space for RGB files that are destined to be converted to CMYK. For example, the Photoshop prepress color settings all use Adobe RGB as the RGB working space. Adobe RGB was initially labeled as SMPTE-240M which was a color gamut proposed for HDTV production. As it happens, the coordinates Adobe used did not exactly match the actual SMPTE-240M specification. Nevertheless, it proved a popular space for prepress editing space for repro work and soon became known as Adobe RGB (1998). I have adopted Adobe RGB as my RGB working space, because it has a larger color gamut that is particularly suited for RGB to CMYK color conversions.

Figure 4.10 The CD-ROM accompanying the *Adobe Photoshop 7.0 for Photographers* book contains a short movie which helps to explain the RGB space issue by graphically comparing some of the main RGB spaces.

The ideal RGB working space

If you select an RGB work space which is the same size as the monitor space, you are not using Photoshop to its full potential and more importantly you are probably clipping parts of the CMYK gamut. Select too wide a space, like Wide Gamut RGB, and there will be large gaps in color tone between one data point and the next, as each color channel can only represent up to 256 data points. Although you can safely use a wide gamut space as long as you are editing in 16 bits per channel mode. But for 24-bit image editing I advise you don't use anything larger than Adobe RGB.

Figure 4.11 A CMYK color space is mostly smaller than the monitor RGB color space. Not all CMYK colors can be displayed accurately due to the physical display limitations of the average computer monitor. This screen shot shows a continuous spectrum going through shades of cyan, magenta and yellow. The image was then deliberately posterized in Photoshop. Notice how the posterized steps grow wider in the Yellow and Cyan portions of the spectrum. This sample gradient pinpoints the areas of the CMYK spectrum which fall outside the gamut of a typical RGB monitor.

Photoshop color management interface

By now you should be acquainted with the basic principles of Photoshop ICC color management. Since Photoshop 6.0 it has become relatively easy to configure the Photoshop system. At the most basic level all you have to do is run the system monitor calibration utility, following the instructions about adjusting brightness and contrast and then go to the Photoshop Color Settings and select an appropriate prepress setting. This will switch on the color management policies.

The Color Settings

The Color Settings command is located in the Photoshop or Edit menu (depending on which operating system is used). This Color Settings interface is more or less identical to that found in Illustrator 9.0 or later and Figure 4.12 shows the basic dialog controls and options. The first item you will come across is the Settings popup menu. Photoshop helpfully provides a range of preset configurations for the color management system. These can be edited (see Managing the Color Settings, page 80) if you wish them to meet your own specific requirements. The default setting

	Color Settings	
Settings	U.S. Prepress Defaults	ОК
Advance	l Mode	
- Working	Spaces	Cancel
RGB :	Adobe R3B (1998) 🗘	<i>C</i>
CMYK:	U.S. Web Coated (SWOP) v2	Load
Gray:	Dot Gain 20%	Save
Spot:	Dot Gan 20%	Preview
– Color Ma	nagement Policies	
RGB :	Preserve Embedded Profiles	
CMYK:	Preserve Embedded Profiles	
Gray:	Preserve Embedded Profiles	
	natches: 🗹 Ask When Opening 🛛 Ask When Pasting Profiles: 🗹 Ask When Opening	
– Descript U.S. Prepre the U.S.	ion ss De faults : Preparation of content for common press conditions in	
– Descript U.S. Prepre	ion	

Figure 4.12 The Photoshop Color Settings. All the Photoshop color settings can be managed from within this single dialog. Photoshop conveniently ships with seven preset settings which are suited to various publishing workflows. As you move the cursor pointer around the Color Settings dialog, help messages are provided in the Description box area below – these provide useful information which will help you learn more about the Photoshop color management settings and the different color space options.

will say 'Web Graphics Default'. If you want to edit your photographs with a view to outputting color separated CMYK files for prepress in Europe, you would select the Default Prepress – Europe setting from this list. A prepress color setting will also be an ideal starting point for any type of color managed workflow. That is all you need to concern yourself with to start with, but if you wish to make customized adjustments, then you can select custom settings in the Working Spaces section below. Refer back to the section on RGB spaces for guidance on selecting the most appropriate RGB space here. The CMYK and Grayscale settings shall be covered later.

Color management policies

Now when a document is opened, Photoshop checks to see if an ICC profile is present. If so, the default policy is to preserve the embedded profile information. So whether the document has originated in sRGB, Adobe RGB or ColorMatch RGB, it will open in that RGB color space and after editing be saved as such (although with these default settings the opening profile mismatch dialog offers you a chance to convert to the current work space or discard the profile). You can have several files open at once and each can be in an entirely different color space. If you have only got accustomed to the Photoshop 5.0 and 5.5 way of doing things, this might take a little getting used to. A good tip is to set the Status box to show 'Document profile' (on the Mac this is at the bottom left of the image window; on the PC at the bottom of the system screen palette). This will give you a constant readout of each individual document's color space profile.

The default policy of Preserve Embedded Profiles allows Photoshop users to use the ICC color management system straight away, without confronting a puzzling 'Convert Colors' dialog all the time. So long as there is a profile tag embedded in any file you open, Photoshop will give you the option to open the file in that same color space without converting it. So if someone asks you to open their Apple RGB file, the default choice offered to you upon opening is to open it in the Apple RGB color space and after saving it, the file will remain in and be tagged with this same Apple RGB color space. This is despite the fact that your default RGB work space might in fact be Adobe RGB. Photoshop will automatically adjust the monitor display to take into account the monitor ICC profile created with Adobe Gamma (or other selected monitor profile). There is no Display Using Monitor Compensation button to check or uncheck in this version and a good thing too! So many people innocently played around with the RGB settings in Photoshop 5.0 and ended up with bizarre configurations which only served to confuse matters (these are still accessible, but are safely hidden away under the Advanced settings). Now, you simply choose an appropriate RGB color work space and that's it. There is no Gamma or Primaries option to meddle with. You are given access to only the necessary range of options.

If you select the Convert to Working RGB policy, then Photoshop will behave more like Photoshop 5.0 and 5.5. If the incoming profile does not match the work space, then the default option will be to ask Photoshop to carry out a profile conversion from the embedded profile space to your current work space. The same policy rules apply to CMYK and grayscale files. When Preserve Embedded Profiles is selected, Photoshop will read the CMYK or Grayscale profile, preserve the numeric data and not convert the colors. And the image will remain in the tagged color space – this is going to be the preferred option when editing incoming CMYK files. You normally do not want to change the CMYK colors, a CMYK file may already be targeted for a specific press output and you don't really want to alter those CMYK numeric color values. When the incoming profile matches the current RGB, CMYK or grayscale work space, there is of course no need to convert the colors.

1	The document "White_suit/01.psd" has an embedded color profile that does not match the current RGB working space.
O	Embedded: sRGB IEC61966-2.1
	Working: Adobe RGB (1998)
	How do you want to proceed?
	• Use the embedded profile (instead of the working space)
	Convert document's colors to the working space
	O Discard the embedded profile (don't color manage)

Figure 4.13 If Preserve Embedded Profiles is selected as the RGB color management policy, the above dialog will appear, asking if you want to use the embedded profile. This happens whenever a profile mismatch occurs and you have checked the Profile Mismatch: Ask When Opening box in Color Settings (see Figure 4.15). If the color management policy is Convert to Work space color, the second radio button will be highlighted in this dialog, asking if you wish to convert the colors to the current work space. In Photoshop 7.0 the file name is now identified in this dialog.

_	The source data's color profile does not match the destination document's color profile.
	Source: sRGB IEC61966-2.1
	Destination: Working RGB - Adobe RGB (1998)
	How do you want to treat the data?
	Convert (preserve color appearance)
	O Don't convert (preserve color numbers)

Figure 4.14 If you attempt to paste image data from a document whose color space does not match the destination space, the above dialog warning will appear, providing the Profile Mismatch:Ask When Pasting box in the Color Settings dialog is checked (see Figure 4.12).

The third option is Color Management: Off. With this configuration, Photoshop will not attempt to color manage incoming documents. If there is no profile embedded, then it will stay that way. If there is a profile mismatch between the source and work space, the profile will be removed (with a warning alert, pointing out that the embedded profile information is about to be deleted). If the source profile matches the work space, there is no need to remove the profile, so in this instance the profile tag will not be removed (even so, you can still remove the ICC profile at the saving stage).

The default settings make it easy for users to select an appropriate combination of color setting configurations with a single mouse-click. Also, the default color management policy will allow you to open up documents which, if they do not match your current work space, you can still continue to edit in that source space and save them with the original profile accurately intact. A newcomer does not necessarily have to fully understand how Photoshop color management works in order to successfully start working in an ICC color managed workflow. They can open up legacy files tagged in sRGB (or any other space), edit and save them as such, even though the work space is Adobe RGB. And if they choose to convert the colors on opening, the file will be converted and saved with the new profile. This really makes the system far more foolproof - it is adaptable enough to suit the individual user's Photoshop skill level. Whichever option you select – convert or don't convert – the saved file will always be correctly tagged. The simplified Color Settings dialog gives you everything you need to get started and hides all the controls which could trap the unwary. The advanced settings can only be reached by clicking on the Advanced mode checkbox.

If you have previously only used Photoshop 5.0, you will probably have to spend a little time adjusting to what the color management policies mean as these now replace the Profile Setup settings in 5.0. As a Photoshop 5.0 user you will probably find yourself opening existing, tagged Photoshop 5.0 files with no problems or unexpected warnings other than a reminder to say 'would you like to carry on editing in that space or convert now?' to say that the file is in a color space other than your default work space.

The ability to save and load custom settings is a smart feature. You can clearly configure Photoshop to suit any workflow you require and save and name this setting for future projects which require you to use the same press settings. If you look again at the default color settings, you will notice how the list includes options such as 'Web Graphics Defaults' (the default setting on installation) and 'Emulate Photoshop 4'. The Color Settings interface is a logical progression from the first Photoshop 5.0 implementation of ICC color management and in my opinion, all users will find the system in Photoshop 6.0 and 7.0 to be a definite improvement.

Managing the Color Settings

As your knowledge increases you will be able to customize and create your own color settings. You might want to start by loading one of the presets present in the Color Settings menu and modify this for a given job and customize the CMYK settings to match the conditions of your repro output. As was mentioned earlier, Adobe RGB is pre-chosen as the default work space. The CMYK setups are fairly similar to the previous CMYK setup defaults, except there are now two CMYK separation options available in the CMYK work space options for Euro and US printing: one for coated and another for uncoated print stock – these default setups in Photoshop are a pretty good starting point. The minimum you need to know is which of these listed color settings will be appropriate for the work you are doing. And to help in this decision, you should read the text descriptions which appear in the Description box at the bottom of the Color Settings dialog.

Figure 4.15 Custom color settings can be loaded or saved via the Color Settings dialog. The relevant folder will be located in the System/Application Support/Adobe/Color/Settings folder (Mac OS 9), Library/Application Support/Adobe/Color/Settings folder (Mac OS X), Program Files/Common Files/ Adobe/Color/Settings folder (PC). When you save a custom setting it must be saved to this location and will automatically be appended with the '.csf' suffix. When you save a color settings file can be shared between some Adobe applications and with other Photoshop users. The Mac OS X location can be 'user' specific, in which case the route would be: Users/username/Library/Application Support/Adobe/ Color/Settings folder.

To save a new color setting, configure the settings to suit your intended workflow and click on the Save... button. Locate the System/Application Support/Adobe/Color Settings (Mac OS 9), Library/Application Support/Adobe/Color Settings (Mac OS X), Program Files/Common Files/Adobe/Color/Settings folder (PC) and name the setting. The file will be appended with a .csf suffix. Enter any relevant comments or notes about the setting you are saving in the text box (see Figure 4.15). This information will appear in the Color Settings dialog text box. You might name the setting something like 'Internal annual report' and the note you write to accompany this might say 'Use this setting for editing and separating the digital photographs to go in the company's annual report'. The saved setting will now appear listed in the main menu the next time you visit the Color Settings dialog.

Profile conversions

One problem with having multiple color spaces open at once concerns the copying and pasting of color data from one file to another. The Profile Mismatch: Ask When Pasting box in the Color Settings (see Figure 4.12) should ideally be checked. When you attempt to paste color data from one document to another (or drag with the move tool) and a profile mismatch occurs, the dialog shown in Figure 4.13 will appear, asking you if you wish to convert the color data to match the color appearance when it is pasted into the new destination document. If you select Convert, the appearance of the colors will be maintained when pasting between the two documents.

If you decide to use the Preserve Embedded Profiles policy and with the Profile Mismatch warning set to Ask When Opening, you will always be given the option of choosing whether to convert to the current work color space or continue editing in the document's own color space. If you choose to continue editing in the document's color space, this is fine if you wish to maintain that document in its original profiled space. There are very good reasons for always keeping CMYK files in their original color space (because if the file has been targeted for a specific press output, you don't want to go changing this), but with RGB files, you will often find it more desirable to convert everything to your default RGB work space. The 'Convert to RGB' Color Settings policy will do this automatically. In the Image > Mode menu in Photoshop 5.0 there used to be an item called Profile to Profile. That has been replaced with the Convert to Profile command. Even when you choose to preserve the embedded profile on opening, you may still want to have the means to convert non-work space files to your current work space. I much prefer the Preserve Embedded Profile option, because it allows me the freedom to open up any document straight away, regardless of the space it is in, without converting. If I want to carry on editing but eventually save the file in the current work space, I can do so at the end, using the Convert to Profile command.

		Convert to Profile		
- Source S Profile:	Space Adobe RGB (1998)			OK Cancel
- Destinat	tion Space ———			✓ Preview
Profile:	Evening.Pictro.cf.	cm	•	
- Convers	ion Options			
Engine:	Adobe (ACE)	*		
Intent:	Perceptual	÷		
🗹 Use Bla	ack Point Compens	ation		
🗹 Use Di	ther			
🛄 Flatter	i Image			

Figure 4.16 Convert to Profile is similar to the old Profile to Profile command in Photoshop 5.0. Photoshop 6.0 and 7.0 color management is different in that you don't need to carry out a profile conversion in order to correctly preview a file in Photoshop. It is nevertheless an essential command for when you wish to convert color data from one profile color space to another profiled space, such as when you want to convert a file to the profiled color space of a specific output device.

Let's suppose I was to open a photograph which had been captured digitally and it was tagged with the profile of the camera's color space. I can open this digital photograph immediately without a conversion, do all the RGB editing in this space and yet still be able to preview a color managed image on the screen. If I carry out a Convert to Profile command, I can instruct Photoshop to convert the image from the tagged camera RGB space to the current work space, or indeed, to any other color space. Convert to Profile is also useful when you wish to output to a printer for which you have a custom-built profile but the print driver does not recognize ICC profiles. You can have such a custom profile built for the printer by a color management service provider and choose this profile as the space you wish to convert to. The profile conversion will convert the color data to match the space of the output device, but at the same time Photoshop's color management system will convert the colors on-the-fly to produce a color managed screen preview. You will probably see only a slight change in the on-screen color appearance. Photoshop also attaches a warning asterisk (*) after the color mode in the title bar to any document that is not in the current work space. A Convert to Profile is just like any other image mode change in Photoshop, such as converting from RGB to Grayscale mode and it is much safer to use than the old Profile to Profile command in Photoshop 5.0. However, if you use Convert to Profile to produce targeted RGB outputs and overwrite the original RGB master, be warned. Photoshop will have no problem reading the embedded profiles and displaying the file correctly and Photoshop 5.x will recognize any profile mismatch (and know how to convert back to the original work space), but as always, customized RGB files such as this may easily confuse other non-ICC savvy Photoshop users (see Figures 4.18 and 4.19 on page 86). If you find yourself in a situation where you know the profile of an opened file to be wrong, then you can use the Image > Mode > Assign Profile command to rectify the situation. Let's suppose you have opened an untagged RGB file and for some reason decided not to color manage the file when opening. The colors don't look right and you have reason to believe that the file had originated from the Apple RGB color space. Yet, it is being edited in your current Adobe RGB work space as if it were an Adobe RGB file. The Assign Profile command can assign correct meaning to what the colors in that file should really be. By attaching a profile, we can tell Photoshop that this is not an Adobe RGB file and that these colors should be considered as being in the Apple RGB color space. You can also use Assign Profile to remove a profile. Some digital cameras don't embed a profile, yet the EXIF metadata will misleadingly say the file is in sRGB color mode. There is an Ignore EXIF Color Space plug-in you can download from the Adobe website to disable this behavior.

Converting to the work space

If you choose either the Preserve Embedded Profiles or the Convert to Work Space policies, you should have the Ask When Opening boxes checked, to provide a warning whenever there is a profile mismatch or a missing profile. When the Missing Profile dialog shown in Figure 4.17 appears on screen while you are opening a file, you can assign the correct profile and continue opening. Click on the pop-up menu and select the correct profile. Then check the box immediately below if you also want to convert the colors to your current work space. These settings will be remembered the next time a mismatch occurs and individual settings will be remembered for each color mode.

		Missing Profile	
	The RGB document	"Picture 1.tiff" does not have an embedde	d color profile.
10	— How do you war	nt to proceed?	
Y	🔘 Leave as is (do	n't color manage)	
	O Assign working	g RGB: Adobe RGB (1998)	
	Assign profile:	sRGB IEC61966-2.1	
		and then convert document to workin	a RGB
		Cancel	ОК
			ОК
	Color Manageme	nt Policies	ОК
	RGB : Preserv		ОК
	RGB : Presen CMYK : Presen	nt Policies ve Embedded Profiles	ОК

Figure 4.17 If the Preserve Embedded Profiles or Convert to Work Space option is checked in the Color Settings, Photoshop will allow you to assign a profile for the file being opened and follow this with a conversion to the current work space.

Handling Grayscale

Grayscale image files are also managed via the Color Settings dialog. If you intend creating grayscale images to be seen on the Internet or in multimedia presentations, choose the Default Web Graphics color setting. The Grayscale work space will then be set to a 2.2 gamma space, which is the same gamma used by the majority of PC computer screens. The truth is, you can never be 100% sure how anybody who views your work will have their monitor calibrated, but you can at least assume that the majority of Internet users will have a PC monitor set to a 2.2 gamma. This is a darker setting than the default 1.8 gamma used on the Macintosh system.

It is important to note that the Grayscale work space settings are independent of the settings entered in the CMYK setup. The Photoshop prepress Grayscale work spaces should correspond with the dot gain characteristics of the press. If you examine the Grayscale work space options, you will see that it contains a list of dot gain percentages and monitor gamma values. For prepress work select the dot gain percentage that most closely matches the anticipated dot gain of the press. Figure 4.29 shows a range of dot gain values that can be used as a guide for different types of press settings. This is a rough guide as to which dot gain setting you should use on any given job. When the Advanced color settings option is checked you can enter a custom gamma value or dot gain curve setting (see 'Dot gain' later on in this chapter, page 96). The color management policy can be set to either Preserve Embedded Profiles or Convert to Grayscale work space and again, the Ask When Opening box should be checked. If the profile of the incoming grayscale file does not match the current grayscale work space, you will be asked whether you wish to use the tagged grayscale space profile, or convert to the current grayscale work space. If there is no profile embedded, you will be asked to either: 'Leave as is' (don't color manage), assign the current grayscale work space or choose a grayscale space to assign to the file and if you wish, convert from this to the grayscale work space.

Here is a test you can easily try yourself. Make a screen capture of something that is in grayscale, like a plain dialog box or a grayscale image. When Photoshop opens this screen grab, it will recognize it as a grayscale file with a missing profile. In the absence of a profile and the color management policy is set as described above, ask yourself which option should be used. Do you want to assign the current grayscale work space as the missing profile? No, because you would be assigning a prepress profile that takes into account dot gain. This is a raw screen grab and not a prepress file. You therefore want to assign a grayscale profile that matches the space it originated in - i.e. the monitor space. And if the monitor space has a gamma of 1.8, then choose that as the profile to assign to this grayscale screen grab. After opening, compare the color managed grayscale with the original screen image to see if the two both look

the same. If you want to know how any existing prepress grayscale image will look like on the Web as a grayscale image, select the View > Proof Setup and choose Windows RGB or Macintosh RGB and adjust the image levels accordingly.

Handling legacy files

When you adopt an RGB space such as Adobe RGB as the preferred work space for all your image editing, you have to take into account that this might cause confusion when exchanging RGB files between your machine operating in a color managed workflow and that of someone who, for example, is using Photoshop 4.0, where the RGB they use is based on a monitor RGB space. Figure 4.18 shows screen shot examples of how a profiled RGB file will be displayed on another monitor if this change in working procedure is not properly thought through. If you are sending an RGB file for someone else to view in Photoshop, then one of six things could happen.

- They open the file in Photoshop 6.0 or 7.0 with the RGB Color Settings set to Preserve Embedded Profiles. The file can be opened and color managed correctly even if their RGB work space is not the same as yours.
- They open the file in Photoshop 6.0 or 7.0 with the RGB Color Settings set to Convert to RGB. If a profile mismatch occurs, the colors can be correctly converted to their RGB work space.
- They open the file in Photoshop 5.0/5.5 with the RGB Color Mismatch Settings set to the default of Convert Colors on Opening. The file will be color managed correctly.
- They open the file in Photoshop 5.0/5.5 with the RGB Color Mismatch Settings changed to Ask on Opening and they click Convert Colors.
- Before sending, you convert RGB image to Lab mode in Photoshop. This does not lose you any image data and is a common color mode to both programs. The end user will need to convert back to their RGB.
- You convert the RGB image in Photoshop from the RGB work space to match the RGB profile of the other user (if known) before saving. Go Image > Mode > Convert to Profile... and select the appropriate destination RGB space from the pop-up list. This could be something like Apple RGB. This is the profile which will be embedded when you save.

Figure 4.18 A Photoshop (5.0 or later) image (left) opened in Photoshop 4.0 (right). If the RGB work space selected in Photoshop is wider than the basic monitor RGB space in Photoshop 4.0, then the latter will interpret a Photoshop (5.0 or later) file as being like any other 4.0 legacy file. The RGB colors will appear compressed and desaturated in version 4.0. The only way round this is to convert the RGB image in Image > Mode > Convert to Profile to the monitor RGB color space used in Photoshop 4.0.

Figure 4.19 An untagged Photoshop 4.0 image opened in Photoshop with color management switched off. If the RGB work space selected in Photoshop is going to be wider than the monitor RGB work space used in Photoshop 4.0, then Photoshop will expand the RGB color space as shown here, *unless* you have the Color management switched on and the Policy settings set to Preserve Embedded Profiles or Convert to Working RGB and the Profile Mismatch Ask When Opening box is checked.

The last two examples take into account the limitations of Photoshop 4.0 (and earlier versions of Photoshop) not being able to understand and interpret a profiled Photoshop RGB file and displaying the RGB data directly on the monitor without compensation. When you save a profiled RGB file, enclose a Read Me file on the disk to remind the person who receives the image that they must not ignore the profile information – it is there for a reason! If you are designing images for screen display such as on the Web, then convert your images to the sRGB profile using Image > Mode Convert to Profile. There are potential pitfalls when opening a legacy file in Photoshop but this

will only happen if you turn all the color management settings to 'Off', without appreciating how doing so will impact on the way the color data is going to be displayed within Photoshop. There are specific instances where you will find it necessary to switch color management off, but you must know what you are doing. The safe way to turn color management off is to select Emulate Photoshop 4 from the Color Settings menu. This will configure Photoshop to exactly match the earlier Photoshop color setup.

Advanced color settings

The advanced settings will normally remain hidden. If you check the Advanced Mode box, you will be able to see the expanded Color Settings dialog shown in Figure 4.20. The advanced settings unleash full control over the Photoshop color management system. Do not attempt to adjust these expert settings until you have fully understood the intricacies of customizing the RGB, CMYK, Gray and Spot color spaces. Read through the remaining section of this chapter first before you consider customizing any of these settings.

	Color Settings	
Setting	s: U.S. Prepress Defaults +	OK
🖌 Advance	d Mode	
— Working	Spaces	Cancel
RGB :	Adobe RGB (1998) *	Load
CMYK:	U.S. Web Coated (SWOP) v2	Load
Gray:	Dot Gan 20%	Save
Spot:	Dot Gan 20% 🗧	Preview
— ColorM	anagement Policies	
RGB :	Preserve Embedded Profiles 📫	
CMYK:	Preserve Embedded Profiles	
Gray:	Preserve Embedded Profiles	
	matohes: 🗹 Ask When Opening 🛛 🗹 Ask When Pasting g Profiles: 👽 Ask When Opening	
- Con vers	ion Options	
Engine:	Adobe (ACE)	
htent:	Relative Colorimetric 📫	
🗹 Use Bl	ack Point Compensation 🛛 🗹 Use Dither (8-bit/channel images)	
- Advance	ed Contro Is	
🔲 Desati	urate Monitor Colors By: 20 %	
Blend	RGB Colors Using Gamma : 1.00	
— Descrip U.S. Prepri the U.S.	tion ess De faults : Preparation of content for common press conditions in	

Figure 4.20 The Photoshop Advanced Color Settings dialog. Switching to the advanced mode unleashes full control over all the Photoshop settings. The remaining sections of this chapter will show how you can customize the advanced color management settings.

Blend RGB colors using gamma

This item provides you with the potential to the override the default color blending behavior. There used to be an option in Photoshop 2.5 for applying blend color gamma compensation. This allowed you to blend colors with a gamma of 1.0, which some experts argued was a purer way of doing things, because at any higher gamma value than this you would see edge darkening occur between contrasting colors. Some users found the phenomenon of these edge artifacts to be a desirable trapping effect. But Photoshop users complained that they noticed light halos appearing around objects when blending colors at a gamma of 1.0. Consequently, gamma compensated blending was removed at the time of the version 2.5.1 update. But if you understand the implications of adjusting this particular gamma setting, you can switch it back on if you wish. Figure 4.21 illustrates the difference between blending colors at a gamma of 2.2 and 1.0.

Figure 4.21 In this test a pure RGB green softedged brush stroke is on a layer above a pure red background layer. The version on the right shows what happens if you check the Blend RGB Colors Using Gamma 1.0 checkbox – the darkening around the edges where the contrasting colors meet will disappear.

Engine : Adobe (ACE)	htent:	Relative Colorimetric	*	
Use Black Point Compensation Vuse Dither (8-bit/channel images) Advanced Controls Desaturate Monitor Colors By: 20 Nend RGB Colors Using Gamma: 1.00		1	*	
Advanced Contro Is Desaturate Monitor Colors By: 20 % Blend RGB Colors Using Gamma: 1.00	🗹 Use Bla	**************************************		
Desaturate Monitor Colors By: 20 % Blend RGB Colors Using Gamma: 1.00		ok Point Compensation 🛛	🖌 Use Dii	ther (8-b it /ch annel images)
Blend RGB Colors Using Gamma: 1.00	- Advance	i Controls		
	📃 Desatur	ate Monitor Colors By:	20	8
- Description	Blend R	GB Colors Using Gamma :	1.00	
	— Descripti	on		

Desaturate monitor colors

The desaturate monitor colors option enables you to visualize and make comparisons between color gamut spaces where one or more gamut space is larger than the monitor RGB space. Color spaces such as Adobe RGB and Wide Gamut RGB both have a gamut that is larger than the monitor space is able to show. So turning down the monitor colors saturation will allow you to make a comparative evaluation between these two different color spaces.

Customizing the RGB and work space gamma

Expert users may wish to use an alternative custom RGB work space instead of the listed RGB spaces. If you know what you are doing and wish to create a customized RGB color space, you can go to the Custom... option in the pop-up menu and enter the information for the White Point, gamma and color primaries coordinates. My advice is to leave these expert settings well alone. Do avoid falling into the trap of thinking that the RGB work space gamma should be the same as the monitor gamma setting. The RGB work space is not a monitor space.

	Custom RGB		
	Save RGB	Cience Stationers	
Settings	Other	Осток	
🗹 Advance	Monitor RGB - electr22b3 ColorSynic RGB - Generic I	The second se	2
Working RGB: •	Adobe RGB (1998)	Cancer	2
CMYK:	App le RGB	Load	
Gray:	ColorMatch RGB ProPhoto RGB	Custom I	RGB
Spot:	sRGB IEC61966-2.1	Name: Bruce RGB	ОК
Cobr M RGB :	bruce_rgb CIERGB ekctr22b3	Gamma	Cancel
CMYK:	Evening.Epson.cf.icm	Gamma: 2.20	
Gray: Profile Mis	Evening.Pictro.cf.icm Generic RGB Profile NTSC (1953)	- White Point: 6500°K (D65)	
Missing	PAL /SEC AM	x y	
Con vers Engine	Photo Cal Profile SMPTE-C sRGB Profile	White: 0.3127 0.3290	
ntent :		Primaries: Custom	•]
		xy	
		Red: 0.6400 0.3300	
		Green: 0.2800 0.6500	
		Blue: 0.1500 0.0600	

Figure 4.22 The Custom RGB dialog. Use this option to create a custom RGB work space. The above settings have been named 'Bruce RGB', after Bruce Fraser who devised this color space as an ideal prepress space for Photoshop.

Adobe RGB is a good choice as an RGB work space because its 2.2 gamma provides a more balanced, even distribution of tones between the shadows and highlights. These are the important considerations for an RGB editing space. Remember, you do not actually 'see' Adobe RGB. The Adobe RGB gamma has no impact on how the colors are displayed on the screen, so long as Photoshop ICC color management is switched on. In any case, these advanced custom color space settings are safely tucked away in Photoshop and you are less likely to be confused by this apparent discrepancy between monitor gamma and RGB work space gamma.

RGB to CMYK

The RGB color space is very versatile. An RGB master can be repurposed for any number of uses. As we are mostly concerned with four-color print reproduction, it is always very important to keep in mind the limitations of CMYK reproduction when editing in RGB. Digital scans and captures all originate in RGB but they are nearly always reproduced in CMYK. Since the conversion from RGB to CMYK has to take place at some stage, the question is, at what stage should this take place and who should be responsible for the conversion? We shall now look at how you can customize the CMYK setup.

There are some people who will tell you that in their expert opinion, Photoshop does a poor job of separating to CMYK. And I bet if you ask them how they know this to be the case, they will be stumped to provide you with a coherent answer. Don't let anyone try to convince you otherwise. Professional quality CMYK separations *can* be achieved in Photoshop, you *can* avoid gamut clipping and you *can* customize a separation to meet the demands of any type of press output. The fact is that Photoshop *will* make lousy CMYK separations if the Photoshop operator who is carrying out the conversion has a limited knowledge of how to configure the Photoshop CMYK settings. As was demonstrated in the earlier sections, a wider gamut RGB space such as Adobe RGB is better able to encompass the gamut of CMYK and yield CMYK separations that do not suffer from gamut clipping. This is one big strike in favor of the Photoshop 5.0+ color system. But CMYK is not a one-size-fits-all color space. CMYK needs to be tailor-made for each and every job.

CMYK setup

The CMYK separation setup settings must be established first before you carry out a conversion. Altering the CMYK setup settings will have no effect on an already-converted CMYK file. Note that in Photoshop 6.0 and 7.0, altering the CMYK setup will not affect the on-screen appearance of an already-opened CMYK file or cause the wrong profile information to be embedded when you save it. However, the profile setting selected here will be the CMYK space that all future CMYK conversions will convert to and will also be the default space to soft proof files when you chose View > Proof Setup > Working CMYK.

If you examine the US Prepress default setting, the CMYK space says U.S. Web Coated (SWOP). This setting is by no means a precise setting for every US prepress SWOP coated print job, but is at least closer to the type of specification a printer in the US might require for printing on coated paper with a web press setup. If you mouse down on the CMYK setup pop-up list, you will see there are also US options for web uncoated, as well as sheetfed press setups. Under the European prepress default setting, there is a choice between coated and uncoated paper stocks. And more importantly, you can choose Custom CMYK... where you can create and save your custom CMYK profile settings to the System/ColorSync profiles folder (Mac OS 9), Library/ColorSync folder (Mac OS X), WinNT/System32/Color folder (NT/2000), Windows/System/Color folder (PC). The Custom CMYK dialog is shown is Figure 4.26.

Advanced CMYK settings

That's really all you can do with the standard CMYK settings – you can make a choice from a handful of generic CMYK profile settings or choose Custom CMYK... This is an improvement upon the preexisting single CMYK setup found in Photoshop 5.5 or earlier. If you check the Advanced options box, you will readily be able to select from a more comprehensive list of CMYK profile settings in the extended menu, depending on what profiles are already in your ColorSync folder.

Conversion options

You have a choice of four Color Management Modules (CMM): the Adobe Color Engine (ACE), Apple ColorSync, Apple CMM or Heidelberg CMM. The Adobe color engine is reckoned to be superior for all RGB to CMYK conversions. For example, the Adobe engine uses 20-bit per channel bit-depth calculations to calculate its color space conversions.

Figure 4.23 This example illustrates an RGB image which was acquired and edited in RGB using the Adobe RGB space. A CMYK conversion was carried out using an ICC profile conversion from Adobe RGB and the Perceptual (Images) rendering intent.

Figure 4.24 The image was assembled with a gradient chosen to highlight the deficiencies of sRGB. The master RGB file was then converted to fit the sRGB color space. A CMYK conversion was made. sRGB is weaker at handling cyans and greens. There is also a slight boost in warmth to the skin tones.

CMYK Info	Α	В	С	CMYK Info	Α	В	С
Cyan	97	75	95	Cyan	84	72	75
Magenta	10	6	9	Magenta	18	7	10
Yellow	96	8	5	Yellow	80	8	6
BlacK	0	0	0	BlacK		0	0

Figure 4.25 Each RGB image will have its own signature color space. In this example, imagine a scene with some blue sky and bright green colors going out of gamut. The middle example shows you the effect of a Relative Colorimetric conversion, which without some manual intervention may clip the out-of-gamut colors. A perceptual rendering will squeeze the out-of-gamut colors to fit the CMYK space, while preserving the relationship between the out-of-gamut colors. This rendering intent may produce a less vibrant separation.

Rendering intent

Perceptual (Images) rendering is an all-round rendering method that can also be used for photographic images. Perceptual rendering compresses the out-of-gamut colors into the gamut of the target space when colors are out of gamut, while preserving the visual relationship between those colors, so they do not become clipped. More compression occurs with the out-of-gamut colors, smoothly ramping to no compression for the ingamut colors. Figure 4.25 illustrates how these different rendering methods work.

The Saturation (Graphics) rendering intent preserves the saturation of out-of-gamut colors at the expense of hue and lightness. Saturation rendering will preserve the saturation of colors making them appear as vivid as possible after the conversion. This is a rendering intent best suited to the conversion of business graphic presentations where retaining bright, bold colors is of prime importance.

Relative Colorimetric has always been used as the default rendering intent in the manual built-in CMYK setup in Photoshop 4.0 and earlier versions, and is the default rendering intent utilized in the Photoshop color settings. Relative Colorimetric rendering maps the colors that are out of gamut in the source color space (relative to the target space) to the nearest 'in-gamut' equivalent in the target space. When doing an RGB to CMYK conversion, an out-of-gamut blue will be rendered the same CMYK value as a 'just-in-gamut' blue. Out-of-gamut RGB colors are therefore clipped. This can be a problem when attempting to convert the more extreme range of out-of-gamut RGB colors to CMYK color and it is advisable that you consider using the soft proofing view of the space you are converting to, in order to check for possible gamut clipping. While in RGB mode, an image can be manually color adjusted to improve the quality of the final RGB to CMYK conversion.

Absolute Colorimetric maps in-gamut colors exactly from one space to another with no adjustment made to the white and black points. This rendering intent can be used when you convert specific 'signature colors' and need to keep the exact hue saturation and brightness, like the colors in a commercial logo design. This rendering intent is seemingly more relevant to the working needs of designers than photographers. However, you can use the Absolute Colorimetric rendering intent as a means of simulating a target CMYK output on a proofing device. Let's say you make a conversion from RGB to CMYK using either the Relative Colorimetric or Perceptual CMM and the target CMYK output is a newspaper color supplement printed on uncoated paper. If you use the Absolute Colorimetric rendering intent to convert these 'targeted' CMYK colors to the color space of the proofing device, the proofer will reproduce a simulation of what the printed output on that stock will look like. For more about targeted proofing, see the following chapter on file management and outputs.

Black Point Compensation

This will map the darkest neutral color of the source RGB color space to the darkest neutrals of the destination color space. When converting RGB to CMYK, it is recommended you always leave this item checked. If you happen to be using Photoshop 5.x, it can pay to experiment with BPC on and BPC off when you test a new profile – some RGB to RGB profile conversions may be adversely affected and you can end up with weak, muddy blacks. These Black Point Compensation issues have been corrected in versions 6.0 and 7.0.

Use Dither (8-bit per channel images)

Banding may occasionally occur when you separate to CMYK, particularly where there is gentle tonal gradation in bright saturated areas. Banding which appears on screen does not necessarily always show in print and much will depend on the coarseness of the screen used in the printing process. However, the dither option will help reduce the risks of banding when converting between color spaces.

Creating a custom CMYK setting

If you wish to make precision separations, you can generate your own custom CMYK profile in the Color Settings in either the standard or advanced mode. Choose Custom CMYK... from the CMYK Work Space menu. Figure 4.26 shows the Custom CMYK dialog. This is better known as the familiar 'Classic' Photoshop CMYK setup. You can enter here all the relevant CMYK separation information for your specific print job. Ideally you will want to save each purpose-built CMYK configuration as a separate color setting for future use and label it with a description of the print job it was built for.

Once the CMYK setup has been configured, the View > Proof Setup > Working CMYK and the View > Gamut Warning (for the CMYK space selected in the Proof setup) will enable you to pre-adjust an image to ensure the out-of-gamut colors are manually brought into gamut while still in RGB mode and before making a conversion. If this CMYK preview suggests that the CMYK conversion is not going to give you the best color rendering of some of the image colors, you have the opportunity to override this. For example, while the master image is in RGB mode, you can choose Working CMYK in the Proof setup (or any other CMYK color space in the list) and make an image color adjustment to bring these out-of-gamut RGB colors into CMYK gamut. See Chapter Nine for more detailed advice on how to do this. See also Chapter Five for more information on the Photoshop soft proofing options.

	Custom CMMK	******	
Settings	Color Settings Load CMYK Save CMYK	1	
Advance	Other		ОК
Working RGB :	ColorSynic CM11K - Generic CM11K Profile	n	Cancel
CMYK:	Euroscale Coated v2	ā	Load
Gray:	Euroscale Uncoated v2 Japan Standard v2	5	Save
Spot:	U.S. Sheetfed Coated v2	9	Preview
CobrMk RGB:	U.S. Sheetfed Uncoated v2 U.S. Web Coated (SWOP) v2 U.S. Web Uncoated v2		
CMYK : Gray : Profile Mis Missing	341 Matchprint ColorHatch 3.01 ~SWOP hk, Sheetfed, Coated Generic CHMK Profile Photoshop 4 Default CMMK Photoshop 5 Default CHMK		
Con vers	Photoshop book 2a		
htent:	adobe (ACE) Belathe Colorimetric I‡ k Point Compensation [v] Use Dither (8-bit,&hannel images)		
	Controls Ite Monitor Colors By 20 %		

Figure 4.26 Select the Custom CMYK... option at the top of the pop-up menu list. This opens the dialog box shown opposite, where you can enter the specific CMYK setup information to build a custom targeted CMYK setting. When the advanced mode box is checked, you can choose from a wider range of pre-loaded CMYK profile settings. The various CMYK setup options are discussed in this chapter.

Custom CMYK	
Name: SWOP (Coated), 15%, GCR, Medium	ОК
Ink Options	Cancel
Ink Colors: SWOP (Coated)	
Dot Gain: Standard 🕴 15 %	
Separation Options	
Separation Type: 💿 GCR 🔘 UCR Gray Ramp:	
Black Generation: Medium 🗘	
Black Ink Limit: 90 %	
Total Ink Limit: 300 %	
UCA Amount: 5 %	

Ink Colors

Where it says Ink Colors, you should choose the setting recommended by your press for the paper stock to be used. For example, European Photoshop users can choose from Eurostandard (coated), (uncoated), or (newsprint). These generic ink sets will do fine for most print jobs. If your printer can supply you with a custom ink color setting, then select Custom... from the Ink Colors menu, this will open the dialog shown in Figure 4.27. Figure 4.27 The Custom Ink Colors dialog. For special print jobs such as where non-standard ink sets are used or the printing is being done on colored paper, you can enter the measured readings of the color patches (listed here) taken from a printed sample on the actual stock that is to be used.

Dot gain

Dot gain refers to the spread of ink on the paper after it is applied and is very much de-

	Y	x	У	ОК
C:	26.25	0.1673	0.2328	Cancel
M:	14.50	0.4845	0.2396	Caricer
Y:	71.20	0.4357	0.5013	
MY:	14.09	0.6075	0.3191	
CY:	19.25	0.2271	0.5513	
CM:	2.98	0.2052	0.1245	
CMY:	2.79	0.3227	0.2962	
W:	83.02	0.3149	0.3321	
K:	0.82	0.3202	0.3241	
-	a*b* Coo timate O			

pendent on the type of press and the paper stock being used. The dot gain value entered in the CMYK setup will affect the lightness of the color films generated from the CMYK file which will be used to make the final plates. The higher the dot gain, the lighter the film needs to be, this is because less ink needs to be laid down to produce the correct sized halftone dot. So therefore a high dot gain value, such as

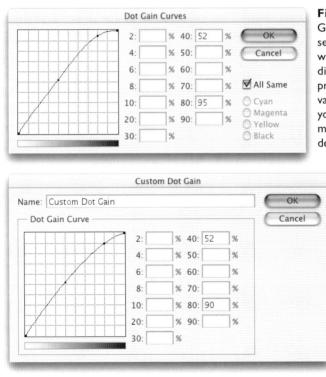

Figure 4.28 If you select Dot Gain: Curves... from the CMYK setup shown in Figure 4.30, you will open the Custom Dot Gain dialog shown opposite. If your printer is able to provide dot gain values at certain percentages, then you can enter these here. Dot gain may vary on each ink plate. If you deselect the All Same box, you can

> enter the dot gain for each individual plate. Note that when you select Custom Dot Gain... from the Grayscale work space menu, a similar dialog appears. If you are preparing to save a color setting designed for separating prepress CMYK and grayscale files, you will want to check that the black plate dot gain setting is consistent. Note that dot gain can vary for each plate and that the black plate dot gain may be slightly different.

that used for newsprint, will cause the CMYK conversion to produce light-looking films. A lower dot gain value such as that used for a coated paper stock will mean that the films will look darker.

The dot gain value will not affect the way the image appears proofed on the screen. This is because Photoshop's color management system will always use the information entered in the CMYK setup to calculate the screen appearance and to provide you with an accurate soft proof of the expected output. But as was pointed out, if you were to compare the outputted films from the previous two examples, the films would actually have very different densities. Dot Gain Curves enable you to input more precise information about the dot gain (choose Curves from the pop-up menu next to Dot Gain). If you select the Dot Gain Curves option, you can enter custom settings for the composite or individual color plates. In the preparation of this book I was provided with precise dot gain information for the 40% and 80% ink values (see Figure 4.28).

Separation options

This controls what type of separation will be used and the total ink limits permitted. The default Photoshop setting is GCR, Black Generation: Medium, Black Ink Limit 100%, Total Ink Limit 400% (which is way too high), UCA Amount 0%. If you ask your printer what separation settings they use and you are quoted the above figures, you know they are just reading the default settings to you from an (unconfigured) Photoshop machine and they either don't know or don't want to give you the answer. If you are creating a custom CMYK setting it is more likely you will want to refer to the table in Figure 4.29 for guidance here. Or if you prefer, stick to using the prepress Adobe CMYK setting that most closely matches the output (US Sheetfed/Web Coated/ Uncoated).

UCR (Undercolor Removal) is said to be the preferred separation method in use today and a lot of commercial printers will use this separation method on their systems. UCR replaces the cyan, magenta and yellow ink in just the neutral areas with black ink. The UCR setting is also favored as a means of keeping the total ink percentage down on high-speed presses, although it is not necessarily suited for every job.

Low key subjects and high quality print jobs are more suited to the use of GCR (Gray Component Replacement) with a small amount of UCA (Undercolor Addition). GCR separations remove more of the cyan, magenta and yellow ink where all three inks are used to produce a color, replacing the overlapping color with black ink. The use of undercolor addition will add a small amount of color back into the shadows and is useful where the shadow detail would otherwise look too flat and lifeless. The percentage of black ink used is determined by the black generation setting (see next heading). In the case of Photoshop conversions, you are better off sticking with the default GCR, a light to medium black generation with 0-10% UCA. This will produce a longer black curve and improved image contrast.

Black generation

This determines how much black ink will be used to produce the black and gray tonal information. A light or medium black generation setting is going to be best for most photographic images. I would advise leaving it set on Medium and only change the black generation if you know what you are doing. As a matter of interest, I always use a maximum black generation setting when I separate all the dialog boxes which appear printed in this book. When I separated the screen grab shown in Figure 4.27, a Maximum black generation separation was applied, so the black plate only was used to render the neutral gray colors. Consequently any color shift at the printing stage will have no impact whatsoever on the neutrality of the gray content. I cheekily suggest you inspect other Photoshop books and judge if their palette and dialog box screen shots have reproduced as well as the ones in this book!

Opening CMYK and Lab files

CMYK files should not be converted back and forth to RGB. I always prefer to keep an RGB master and convert to CMYK using a custom conversion to suit each individual press requirement. Converting from one CMYK space to another is not normally recommended but in the absence of an RGB master, this will be the only option available. Photoshop makes the process of CMYK to CMYK conversion easier to accomplish. Just specify the CMYK profile to convert to in the Convert to Profile dialog box. The Preserve Embedded Profiles policy means that incoming tagged CMYK files can always be opened without converting, thus preserving the numbers, while providing you with an accurate soft proofed screen preview. I do ensure that all my files have an ICC profile embedded, except when I am preparing images for the Web. In the case of the Lab color mode, if a Lab file is missing an ICC profile, it will open without interruption. Lab color mode is therefore assumed to be a universally under-

Separation settings	Ink colors	Separation method	Dot gain	Black generation	Black ink limit	Total ink limit	UCA
US printing							
Sheetfed (coated)	SWOP coated	GCR	10–15%	Light/Medium	95%	320–350%	0–10%
Sheetfed (uncoated)	SWOP uncoated	GCR	15-25%	Light/Medium	95%	260–300%	0–10%
Web press (coated)	SWOP coated	GCR	15–20%	Light/Medium	95%	300–320%	0–10%
Web press (uncoated)	SWOP uncoated	GCR	20–30%	Light/Medium	95%	260–300%	0–10%
Web press (newsprint)	SWOP newsprint	GCR	30-40%	Medium	85–95%	260–280%	0–10%
European printing							
Sheetfed (coated)	Euroscale coated	GCR	10–15%	Light/Medium	95%	320–350%	0–10%
Sheetfed (uncoated)	Euroscale uncoated	GCR	15–25%	Light/Medium	95%	260–300%	0–10%
Web press (coated)	Euroscale coated	GCR	15–20%	Light/Medium	95%	300–320%	0–10%
Web press (uncoated)	Euroscale uncoated	GCR	20–30%	Light/Medium	95%	260–300%	0–10%
Web press (newsprint)	Euroscale newsprint	GCR	30-40%	Medium	85–95%	260–280%	0–10%

Figure 4.29 These separation guidelines reflect a typical range of settings one might use for each type of press output. These are guidelines only and reflect the settings you will already find in Photoshop for each of the above. For precise settings, always consult your printer.

stood color space, and it is argued by some that saving in Lab mode is one way of surmounting all the problems of mismatching RGB color spaces. But one of the problems with using Lab as a master space is that it is so large and there can be a lot of gaps between one color and the next when you save in Lab mode using 8 bits per channel.

Information palette

Given the deficiencies of the color display on a monitor, such as its limited dynamic range and inability to reproduce colors like pure yellow on the screen, color professionals will often rely on the numeric information to assess an image. Certainly when it comes to getting the correct output of neutral tones, it is possible to predict with greater accuracy the neutrality of a gray tone by measuring the color values with the

Figure 4.30 This and Figure 4.31 show a typical use of profiled, RGB workflow. The original subject is shot using daylight. The digital camera used to capture this scene has its own color characteristics and the gamut of the captured image is constrained by what colors the camera is able to capture in RGB. Photoshop is able to read the embedded ICC camera profile tag and converts the colors to the Adobe RGB work space. This RGB file can now be shared directly with other Photoshop 5.0+ users editing in Adobe RGB color.

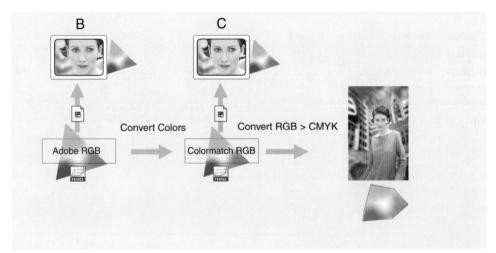

Figure 4.31 The Adobe RGB work space is a virtual space – you cannot actually see it. The monitor profile is generated by the Adobe Gamma control panel. This profile converts the Adobe RGB data 'on-the-fly' to render the monitor screen image. The monitor RGB space is smaller than the Adobe RGB space. Using the monitor alone as your guide, you may not be able to see all the colors that end up in print. Nonetheless, they are preserved in the Adobe RGB edit space. Another Photoshop 5.0+ user may be using a different RGB space, like ColorMatch RGB. No matter, Photoshop converts with high precision from one space to another. When the RGB to CMYK conversion occurs, it is made from an RGB file which has been carefully color managed throughout. In this example, CMYK gamut clipping is avoided, because the limiting monitor RGB space has been taken out of the equation.

eyedropper tool. If the RGB numbers are all even, it is unquestionably gray (in a standard/linearized RGB editing space such as Adobe RGB). Interpreting the CMYK ink values is not so straightforward. When printing a neutral gray, the color is not made up of an even amount of cyan, yellow and magenta. If you compare the color readout values between the RGB and CMYK Info palette readouts, there will always be more cyan ink used in the neutral tones, compared with the yellow and magenta inks. If the CMY values were even, you would see a color cast. This is due to the fact that the process cyan ink is less able to absorb its complementary color – red – compared to the way magenta and yellow absorb their complementary colors. This also explains why a CMY black will look reddish/brown, without the help of the black plate to add depth and neutrality.

The ICC color managed workflow

Now that you have read through to the end of this chapter, see if the diagram of a typical workflow shown in Figure 4.30 makes sense. This represents one possible route an image file might take from the point of digital capture through to the CMYK conversion. If you assume everyone who handles such a file is using an ICC color managed workflow, the image data only has to be converted twice: once from the RGB camera space to the RGB work space and then from the RGB work space to the CMYK output space. In the Figure 4.31 example, an additional RGB to RGB conversion takes place because another Photoshop user receiving the Adobe RGB file is working in an alternative RGB work space. But as you can see, the Photoshop color management system makes it possible to accurately preview the colors on screen and minimize the number of color conversions that have to take place to get the most reliable and fullest gamut color reproduced in the final printed image.

File Management and Output

Chapter Five

The preceding chapter considered the issues of color management and how to maintain color consistency between digital devices. This section though will deal with the end process of converting digital files into a form of tangible print output and this can be broken down into several categories: proof prints, or composites which are intended to emulate the final printed output and are used for checking color and gaining client approval; high-end continuous tone, final art outputs such as Fuji Pictrographs, fine art Iris or transparency; and repro printing. This chapter is titled File Management because we will also be looking at how one can go about organizing and archiving an ever growing collection of digital image files.

The standard of output available from digital continuous tone printers has improved enormously over recent years. Many people find they in fact prefer the print quality of a digital inkjet over conventional silver color prints. I see two reasons for this: the ability to finely control the color output yourself on the computer using Photoshop and the wider range of paper bases available, compared to the usual choice of plastic matt or plastic glossy. There are so many print methods and printer models to choose from, so it is therefore important to understand what the strengths and weaknesses are of each. To start with you need to consider your main print output requirements. Are you looking for speed or a high quality final art finish? Do you require your print output to form the basis of a repro contract print? I know of no single printing device that is able to satisfy all of these requirements.

RGB output to transparency and print

Many photographers prefer to work in RGB throughout and supply an RGB output as the final art, the same way as one would normally supply a transparency or print. Writing to transparency film is quite a slow, not to mention expensive process, but is one means of presenting work to a client where money is no object. Such an output can either be scanned again or used as a reference for the printer to work from the digital file. A CMYK proof is regarded as a better reference in these situations, but nevertheless the transparency output is one that some photographers may feel more at home with.

Transparency writers use a scanning laser beam or LEDs to expose the light sensitive silver emulsion. The same technology is employed to make RGB photographic prints, particularly large blowups for exhibition display with print writers such as the Durst Lambda, CSI Light Jet 5000 and Gretag Sphera PW30 and PW50. As with the transparency writers, these machines are intended to be installed in labs/bureaux, where they can replace the enlarger darkroom. After scanning in a negative or transparency, such printers are capable of outputting from any film format to any size of photographic print (up to 48 inches wide with the Lambda service). Tip: before sending a Photoshop for transparency output, check with the bureau for any specific compatibility problems. I know of at least one instance where the embedding of an ICC profile can trip up some film writers to not read the image data.

The Fujix Pictrography printers are capable of producing a true photographic print finish. A single pass exposure (as opposed to the three or four passes involved with dye-sublimation) is made with a thermal laser diode onto silver halide donor paper, followed by a thermal development transfer to the receiving print. This, Fuji claim, has all the permanence of a conventional color photograph. Admirers of the New York-based photographer Raymond Meier, may be interested to know that he has used a Pictrography machine to supply editorial clients with Pictrographs as finished artwork. Fashion photographers in particular like using Pictrograph outputs, maybe because of the current popularity of supplying C-type prints made from color negatives. I myself have owned a 3000 Pictrograph printer for many years and can vouch for the benefits of superb color and speed of print output at under two minutes. The latest 4000 machine prints at resolutions from 267 to 400 ppi in sizes ranging from A6 to A3. The results are very crisp and the smooth glossy surface will cause no problem when scanned from again and the only chemical solution required is purified water! My only gripe is that Fuji have yet to produce a driver interface sophisticated enough to recognize ICC color space profiles although canned profiles may soon become available for the Pictrograph printers (check the Fuji websites for the latest information). US and European machines have different specifications, but if you can get a custom ICC profile built for your machine you will see a dramatic improvement in the quality of color output produced. Use the Image > Mode > Convert to Profile command and convert from your current RGB space to that of the Fuji Pictrograph profile prior to printing.

CMYK output

If the fast print time, A3 output size and price tag sound appealing then the Pictrograph might be an affordable proposition for a small studio business. However, this is still essentially an RGB printer and it has the potential to reproduce colors beyond the restrictive gamut of CMYK. Pictrographs are beautiful as portfolio prints or final art proofs, but do not help when communicating with a printer who has the job of making CMYK separations from a supplied digital RGB file or matching an image supplied as a CMYK. What they want you to supply ideally is a proof printed using CMYK inks showing near enough how you see the colors being reproduced.

Fine art printing

Inkjet printers use CMYK liquid inks which are finely sprayed onto the paper surface at a typical resolution of 1440 dpi. The best of these has to be the Scitex Iris inkjet where the paper is mounted on a drum which revolves at high speed and the print head passes across the surface in a linear fashion (like a drum scanner in reverse). It is prints made on the standard paper are ideal as repro proofs, but that's not all. There are no limitations to the type of paper which can be used. You can load up paper stock to match that used on the print job. I know of an advertising photographer who owns his own Iris printer and keeps a wide range of paper stocks, so he can proof to any surface required. The very best results are obtained on archival fine art paper - I was quite stunned by the beauty of the first prints I saw produced this way. Iris proofing on art paper has taken off in the US as a medium for exhibiting and selling art photography – whether manipulated or not. In the UK renowned photographer printers such as Max Ferguson have switched from the darkroom to an alldigital setup, supplying clients with Iris art prints. The standard Iris service is comparable in price to other forms of proofing. The inks used are sensitive to sunlight and not guaranteed to last more than a few years. UV protected inks are available for archival printing, but the colors are quite different to the normal inks. Switching from one ink to the other requires flushing out the system and calibrating the printer again. Bureaux will offer one type of service or the other, standard or fine art output, but not both unless running at least two machines.

Inkjet CMYK output

Desktop inkjet printers are probably the most popular type of CMYK proofing device that photographers will use. In the print industry, Cromalins still have the edge – the aforementioned Iris system is a leading product in the bureau end of the market. The two principal manufacturers of desktop proofing inkjets are Epson and Hewlett Packard. These budget-priced printers are cheap to buy and the quality of print output is outstanding. Most of the lower-end models are able to produce a photo-realistic print on to an increasingly wide range of paper stocks.

The inkjet printers work by spraying very fine droplets of ink as the head travels back and forth across the receiving paper. For the most part, the different tonal densities are created by varying the number of individual, evenly sized droplets and dithering their distribution. Hence the illusion of a lighter tone is represented using sparsely scattered ink dots. The later Epson printers are able to produce variable sized droplets. The Epson Photo Stylus models use six color inks and these are capable of producing an even smoother continuous tone output. The six color inkjets use additional light cyan and light magenta inks to render the paler color tones (yellow is light enough already). The print output is still CMYK, but looks smoother because you have less obtrusive dot dithering in the highlight regions. The print times are also slower than the non-Photo Stylus models.

Inkjet media

If you regularly produce lots of prints, then you'll soon spend many times the cost of the printer buying in ink and paper supplies. The ColorSync color matching system will only work when the correct manufacturer's ink is used (and to some extent the media too). This does lock you into always buying their branded inks, but there is more flexibility in the choice of papers, many of which will match the specifications of Epson glossy paper and glossy film. It has to be said that the canned Epson profiles are good, but they are not that brilliant and may produce slightly darker results than expected. It is possible to contact private vendors who will be able to produce a custom profile for your printer (see Chapter Four, Figure 4.4).

Thicker papers require extra head clearance – there should be a lever on your printer where the head height can be adjusted. You can print on to a variety of papers including fine art papers within certain thickness limitations. At this stage the automated color management using the standard Epson profile will fall down and you will definitely need to have a custom profile made. Do this and the results can look very impressive.

Poster inkjet plotters are also capable of printing up to A0 size. These outputs are suitable for all commercial purposes – printing either Photoshop files or vector-based artwork. The latest inks are more colorfast and can be guaranteed to last longer than was the case before. Even so, the prints produced are only intended for economical short-term sales display on a gloss or matt paper surface.

The ideal inkjet

Promises of photo-realistic quality have inevitably led some purchasers of desktop inkjets to make direct comparisons with normal photographic printing. Why can't we have true photographic quality prints that last for ever as well? Why not indeed. And while we are about it, wouldn't it be nice if one could buy a beer that doubled as a slimming aid and hangover cure? In all seriousness, I think we have to be a little more realistic in our expectations and ignore some of the hype surrounding what constitutes photo-realistic output. I would prefer the description 'near photographic quality', because I genuinely believe the quality of output from an inkjet can be good enough for exhibition, use in a professional portfolio, or as CMYK aim prints to supply a printer. With the basic Photo Stylus printers costing around \$200–\$300 to buy and the unit print costs, including ink and media, costing around \$1 each per A4, that's still a pretty good deal.

If it is your intention to sell photographic prints, your customers will naturally enough expect the prints you sell to match the longevity of a traditional print. Inkjet printers are primarily proofing devices. They are designed to produce an accurate color proof quickly and cheaply. If you require archival quality results, there are now third-party inks made by the likes of Lysonic that are compatible with certain Epson desktop inkjets. These inks are customized to resist fading when exposed to ambient daylight for a long time. The catch is that these are not especially designed as color matching inks, so the settings used will probably have to be different and you may not be able to reproduce the full color range of a normal inkjet output. Prompted by the success of third-party ink supplier Lysonic, Epson have now responded by bringing out a new range of printers, inks and papers to offer archival quality color. But if your clients expect real photographs then use a Pictrograph printer. I know the hardware is more expensive to buy, but it is still a lot cheaper than equipping a mini-lab, which after all is the benchmark standard you are trying to emulate. Lysonic also manufacture grayscale ink cartridges for desktop inkjet printers. These will print overlaying inks of varying gray lightness in place of the usual CMYK inks. The end result is a rich-toned fine art print output with smooth blacks that can be output on a variety of paper surfaces.

Photoshop print controls

There are four Print dialogs in Photoshop: The Page Setup, the 'System' Print dialog, a Print with Preview (which used to be known as the Print Options in Photoshop 6.0) and Print One Copy dialog. In the default configuration, Command/Ctrl-P will open the Print with Preview dialog and Command/Ctrl+Option/Alt-P will open the traditional System Print dialog. If you prefer the old setup, go to the Photoshop General preferences and switch the Print Key settings so that Command/Ctrl-P will open the Print dialog instead. The dialog appearance will vary depending on which printer device you have selected. On a Macintosh running OS 9, go to the Chooser to select the printer driver. For Mac OS X go to the Applications folder, open the Utilities and launch the Print Center application. On a PC, choose File > Print and click on the Setup button to select the printer driver. Use The Page Setup to establish the paper size, page orientation and the percentage scaling of the print output.

Figure 5.1 The Print with Preview command will open the above dialog. You can use this interface to accurately position the image on a page and alter the scale at which the Photoshop image will be printed. Under the Show More Options, you can add print information such as calibration bars, captions and crop marks. Or you can select Color Management in order to configure the Source and Print spaces. If a selection is active before you select Print Options and Print Selected Area is checked, the selected area only will be printed.

Settings:	Page Attributes	•
Format for:	SP 1290(USB)	*
	EPSON Stylus Pho	oto 1290
Paper Size:	A4	*
	8.27 in. x 1	1.69 in.
Orientation:	tê te	12
Scale:	100 %	
?		Cancel OK

Figure 5.2 The Page Setup dialog.

The Print with Preview dialog shows how the Photoshop document will print in relation to the page size. When the Center Image box is deselected, you can position the image anywhere you like, by dragging the preview with the cursor. Or you can position and resize within the specified media chosen, using the boxes at the top. You cannot resize the actual number of pixels via this Print dialog. Any changes you make to the dimensions or scaling will be constrained to the proportions of the image. In the Output options below that, click on the Background... button to print with a background color other than paper white. For example, when sending the output to a film writer, choose black as the background color. Click on the Border button to set the width for a black border. On the right, you can select whether or not to print the following: Calibration Bars, which will print an 11-step grayscale wedge on the left and a smooth gray ramp on the right. In the case of CMYK separations, tint bars will be printed for each plate color. The registration marks will help a printer align the separate plates. The crop marks indicate where to trim the image (the Bleed button option lets you set how much to indent these crop marks). Checking the Caption box will print any text that was entered in the File > File Info box Caption field. Check Labels to print the file name.

Color proofing for press output

If you are looking for a fail-safe method of supplying digital files for repro, then you will want to obtain all the relevant information about the press. If the printer is cooperative, they will be able to supply you with a proofing standard ICC profile or printing inks and other specifications for the press. Enter these in the Edit > Color Settings > Working Space > CMYK > Custom CMYK dialog, as described in Chapter Four. Convert your RGB file to CMYK and save it as a TIFF or EPS file and

supply this with a targeted CMYK print proof which shows the printer how the enclosed file should be expected to print within the gamut of the specific CMYK print process. You could also supply an RGB file tagged with an ICC profile, as well as the proof. This will work if it is understood beforehand and accepted that the recipient will be carrying out the conversion to CMYK and using the CMYK proof as a guide. If you send RGB files to printers, be careful to label RGB folders as such and make every effort to avoid any potential confusion down the line. Even a layered Photoshop format file is now placeable in an Adobe InDesignTM layout, flattening on-the-fly, with the ability to recall the layered original for editing.

The print dialogs reproduced here show the Epson inkjet printer settings. The interface and main control will be fairly similar for other makes of inkjet printers. What follows is an easy route to producing a color print output, using the printer profiles that were automatically loaded when you installed the printer driver. In the Print with Preview dialog shown in Figure 5.1, click on the Show More Options section. Go to the Color Management section and make sure that the Source space is set to Document and that the Print Space Profile is set to 'Same as Source'. The Intent can

	Print
Printer: (SP 1290(USB)
Presets:	Standard 📫
Print Settings	
Media Type:	Premium Glossy Photo Paper
Ink:	🖲 Color 💮 Black
Mode:	 Automatic Custom Advanced Settings Print Quality: Photo - 1440dpi MicroWeave High Speed Flip Horizontal Finest Detail
	Help
)	Preview Cancel Prin

Figure 5.3 The Print settings section of the Print dialog window. Here you need to select the media type to be used. Some third-party glossy papers will work best with the Glossy Film media setting. Check the Color ink button, select the Advanced Settings and choose a print resolution. 1440 dpi or higher will produce the smoothest results.

be set to Perceptual. When you click on the Print... button you will be taken to the System Print dialog settings. The Copies & Pages and the Layout sections are fairly easy to understand. Ignore the Save as File option in the Output option. Use the Print Settings section to describe the paper media you are using (which in effect is selecting the correct print output profile). For the very best quality, choose a high print resolution and the best dithering settings. In the example shown in Figure 5.3, I selected a 1440 dpi print resolution on photo quality glossy paper, using MicroWeave diffusion dithering. Remember it will take longer to produce a print at the very highest quality setting. Finally, go to the Color Management options shown in Figure 5.4 and click on the ColorSync radio button. You are now ready to click on the Print... button to make your print.

	P	rint			
Printer: SP 129	90(USB)			•	
Presets: Standa	ard			•	
Color Management	•				
 Color Controls ColorSync No Color Adjustment 		Gamma	1.8	9	
Mode: P	hoto-real	istic		Ð	
Brightness	0		0	-	
Contrast	0		\diamond		
Saturation	0		\diamond	-	
Cyan O	0 -		\diamond	-	
Magenta 🔍	0		Ò	-	
Yellow O	0		Ò	1	
				(Help
)	Pre	view	Can	cel (Print

Figure 5.4 After selecting the Print Output settings, go to the Color Management print settings option and click on the ColorSync radio button. Do this and the printer color management will automatically know how to produce a print on the media type you selected in Figure 5.3.

Although these are CMYK printers, they work best when fed RGB data. The Epson driver will process the RGB data and carry out its own conversion to the CMYK space of the printer. Good results are obtained when printing directly from Photoshop RGB files, especially if you are working in a larger prepress RGB space like Adobe RGB. Inkjets are therefore good for portfolio work and short-term exhibitions. If a

folio print fades, then all you have to do is make a replacement print. The inkjet technology is most ideal for producing excellent quality CMYK output destined to be used as either an 'aim' print or contract proof by the printer. The term 'aim' print most justly describes the appropriateness of a standard Epson inkjet output, when used as a guide for the printer who is determining how to reproduce your image using CMYK inks. The term contract proof is used to describe the same type of thing, except it refers to a more precise form of CMYK proof, one that has been reproduced by an approved proofing device. These include the Rainbow and Kodak dye-sub printers, the Epson 5000 inkjet (with RIP) and prepress bureau service proofs like the Dupont Cromalin[™] and 3M Matchprint.

Targeted CMYK printing

When you supply a CMYK proof you are aiming to show the printer how you envisage the picture should look in print. Because a proof has to be produced using CMYK inks or dyes, you are working within the same color gamut constraints as the halftone CMYK process and therefore the printer now has a realistic indication of what they should be able to achieve. The contract proofing devices benefit from having industry-wide recognition. It is safer to supply a digital file together with a proof which has such a seal of approval. The printer receiving it knows that the colors reproduced on the proof originated from a contract device and were printed from the attached file. Their job is to match the proof, knowing that the colors in the proof are achievable on the press.

It is possible to produce a targeted CMYK print from an inkjet print. You can do this using the supplied printer profiles, but to do it properly you will most likely want to have a custom profile made for your particular printer and paper type. As was mentioned in Chapter Four, you can employ a color management service such as Pixl in Denmark <www.pixl.dk> to build such a profile for you.

To simulate the restricted CMYK gamut of the press output on your printer, you will want to set the source space as being either a CMYK file that is already in the output CMYK space (in which case you select Document), or use the current Proof Setup as the source space (the following section describes how to configure the Proof Setup in Photoshop). In the Figure 5.5 example, I have an Adobe RGB image open that is currently being previewed in a document window that has been configured in the Custom Proof Setup to be displayed using a 3M Matchprint CMYK proofing profile. I therefore want to set the source space to use the Proof color space. Because I wanted to use the custom profile that was made for my printer and the paper I was using, I selected this custom profile space as the printer space and I selected Relative Colorimetric as the rendering intent, because I wanted the print output to be restricted to the gamut of the target CMYK space. After clicking the Print... button you will be

111

taken to the System Print dialog. It is important to disable any further color managing options, because the source and destination profile spaces have already been specified and you do not want to color manage everything twice! Go to the Color Management dialog shown in Figure 5.4 and click on the No Color Adjustment radio button.

			Print			
P	9	Positio	on —			Prin
		Top:	0.92	(cm	*	Can
	100	Left:	0.67	[cm	*	Do
	2		🗹 Center Image			
	1 million	Scaled	Scaled Print Size			
	An Je	Scale:	100%	Scale to	Fit Media	7
ĮĮ	Cellin .	Height:	26.07	Cm	*	- 8
	1 the second	Width:	19.015	cm	•	
	X/III		🗹 Sho	w Bounding Bo)X	
6			🛄 Prir	nt Selected Are	a	
how More	Options					
Color Man	agement 😫					
Source Sp	ace:					
Oocument:	O Document: Adobe R	GB (1998)				
Decel	Proof Setup: 3M Mat	chprint				
Proof:						
Proof: Print Spac	:e:					
Print Spac	e: Evening.Epson.cf.icm					7
Print Spac Profile:						9

Figure 5.5 This shows you how to customize the color management settings to simulate a CMYK proof and utilize a custom built profile for your printer. Under the Show More Options, select Color Management and select 'Document' to print direct from the current document color space. If you want to simulate a CMYK proof based on your current Proof Setup (see Figure 5.6), select 'Proof Setup' to use the current Proof Setup as the source color space. Select the profile of your inkjet printer as the Print Space Profile and set the Intent to Relative Colorimetric. When you hit the Print... button you will be taken to the standard Print dialog. In the Color Management print options you must select No Color Management instead of the ColorSync option.

Soft proofing

When you carry out a color mode conversion or a Convert to Profile command, the color data is converted to the destination/device color space. When the file is in this new space, Photoshop will continue to color manage the image. If you are converting an RGB master to the working CMYK space, Photoshop will simulate the CMYK

print output appearance on the monitor after the file has been converted to CMYK. This is known as 'soft proofing'. A real proof is a hard copy print produced by a contract standard proof printer – soft proofing is therefore a term that is applied to using the monitor as a proofing device. The monitor will never be as accurate when it comes to showing how every CMYK color will reproduce, but it is usually close enough for carrying out all the preparation work, before reaching the stage where a final contract proof is demanded.

If you want to preview the outcome of a color mode conversion, you do not have to convert the color data. Instead, Photoshop is able to calculate a screen preview only, while keeping the color data in its original space. The Photoshop color management system therefore enables you to simulate any CMYK or RGB print output (i.e. Pictrograph or a film writer) without having to carry out a mode conversion first.

If you are editing an RGB master and go to the View > Proof Setup menu and select Working CMYK (which is the default setting), you can preview how the colors will look if you convert from RGB to the working CMYK color space. If you choose the Custom... option you can select any profile space you want from the pop-up list. Name and save the custom proof setting as a '.psf' file in the System\Application Support\Adobe\Color\Proofing folder (Mac OS 9), Users\username\Library\Application Support\Adobe\Color\Proofing folder (Mac OS X), or the Program Files\Common Files\Adobe\Color\Proofing folder (PC). This saved proof setting will then be appended to the bottom of the list in Proof Setup. When a proof setting is selected in the Proof Setup, you can preview the colors in this space by choosing View > Proof Colors. Command/Ctrl-Y is the keyboard shortcut and this will toggle the preview on and off, making it very easy for you to switch from normal to proof viewing mode. The document window title bar will also display the name of the proofing space after the color mode: RGB/Working CMYK.

Each new window view can preview a different proofing setup. You can create several new window views of the same document and use the monitor screen to compare the results of outputting to various types of press output. The Proof Setup is not just limited to CMYK output. You can use the Proof Setup to preview how a prepress grayscale file will appear on a Macintosh or Windows RGB monitor.

Simulate Paper White and Ink Black

Checking these options will modify the final conversion of the preview made from the Proof Setup space to the monitor, so that you can more accurately soft proof how a file might actually reproduce after it has been converted to CMYK and printed. In more detail, when you select Proof Colors, Photoshop takes the current screen preview

Proof Setup	•	✓ Custom		Figure 5.6 Use th		
✓ Proof Colors Gamut Warning	፠የ 쇼೫የ	Working CMYK Working Cyan Pla	ite	to select the devi proof with, when Proof Colors cor	ever y	ou select t
Zoom In	ℋ+	Working Magenta	a Plate			
Zoom Out	Ж-	Working Yellow P	late	Ctrl-Y). Under the		
Fit on Screen	ж0	Working Black Pla	ate	can select the prof	ile of	your printe
Actual Pixels	72#0	Working CMY Pla	tes	in this case, the Fuji	i Pictro	ograph. Che
Print Size				ing the Preserve (
✓ Extras	жн	Macintosh RGB		will show you what		
		Windows RGB				
Show	•	Monitor RGB		look like if it is not	0101	managed.
Rulers	₩R	Simulate Paper W	/hite			
Snap	ፚ ቘ:	Simulate Ink Blac	k			
Snap To	•					
				Proof Setup		
Lock Guides	℃% ;	- Setup: G	Custom	÷1		
Clear Guides		Durela	U.S. Web Coated	1 (01100) -2	-	(ок)
New Guide		Profile:	·			Cancel
Lock Slices			Preserve Color			Load
Clear Slices		Intent:	Relative Colorim		•	Save
			Use Black Poir	nt Compensation		
		Simulate:	Paper White			Preview
			V Ink Black			

only, and converts it on-the-fly to the destination color space selected in the Proof Setup. The data is then converted back to the RGB monitor space to form a preview using the relative colorimetric rendering intent and with black point compensation switched on. In the custom Proof Setup dialog, Simulate: Black Ink will disable the black point compensation and simulate on screen the actual black density of the printing press. Simulate: Paper White will use an absolute colorimetric rendering to convert the proof color space data to the monitor space, simulating the paper white and black ink colors. Simulate: Paper White and Ink Black will take into account the limitations of the black ink reproduction and how bright the paper white will really be. It can be rather scary to see the on-screen image preview deteriorate in front of your eyes this way. Photoshop Color expert, Bruce Fraser, advises that you try looking away from the screen at the moment you check these settings!

PostScript printing

When your computer is instructed to print a document, graphic or photograph, the data has to be converted into a digital language that the printer can understand. RGB image files can successfully be output on the Macintosh using Apple's proprietary Quickdraw – the same language that describes how documents appear on the monitor screen. To print out a page that combines text and images together, Quickdraw will only print the way the data appears on the screen. If you print from a page layout

program, it reproduces the screen image only. The text will be nice and crisp and TIFF images will print fine, but placed EPS images will print using the pixelated preview. PostScript is a page description language developed by Adobe. When proofing a page layout, the image and text data in the layout are processed separately by a RIP (either on the same machine or a remote computer) and once the data has been fully read and processed it is sent as an integrated pixel map (raster) file to print in one smooth operation. This process is known as Raster Image Processing (RIP). For example, you'll notice many proofing printers come supplied with PostScript (level 2 or later). Normally a prepared CMYK image is embedded in the PostScript file of a page layout program and then converted in the RIP. The RIP takes the PostScript information and creates the pixelmap line of dots for each separation to be output to film or plate. The Photoshop image data is likely to be in either TIFF or encapsulated PostScript (EPS) form in the file created by the page layout program and it is this which is passed along with the original vector images and fonts to be rasterized. Printing speed is dependent on the type of print driver software the printer uses and the amount of RAM memory installed in the server machine. Too little memory and either the document will take ages to process or won't print at all.

There are many desktop PostScript printers to choose from for less than \$10 000 – which one you should go for depends on the type of color work you do. Laser printers are useful to graphic designers where the low cost of consumables such as paper and toners is a major consideration. A setup including a laser printer and dedicated RIP server is ideal for low cost proofing and short run color laser printing. I am thinking here of the Efi Fiery RIP server linked to a color laser printer such as a Canon copier or the recent QMS MagiColor 330GX. The Epson 5000 inkjet system can be purchased with a dedicated RIP which costs roughly three times the price of the printer. Even so, this is probably the best value professional CMYK contract proofer available for proofing A3 page layouts. It outputs to the Dupont Cromalin[™] approved standard.

Quantity printing

If you are faced with a large print order there are some bureau solutions to consider. The Sienna printing process supplied by the photographic company Marrutt can produce low cost C-type prints in large quantities and at a reasonable cost. The aforementioned laser light writers such as the Lambda process are always going to be that bit more expensive. Beyond that, one should look at repro type solutions. The technologies to watch are computer to plate (CTP) or direct digital printing: Chromapress, Xericon and Indigo. These are geared for fast, repro quality printing from page layout documents, containing images and text. They make short print runs an economic possibility.

Stormy waters

Color management plays an important role in ensuring that all the prepress activity hangs together as smoothly as possible. For this reason, the profiling of RGB devices as described in the preceding chapter is very important. In today's rapidly changing industry, a digital file may take a very convoluted trip through the world of prepress. The aim of Photoshop ICC color management is to maintain consistency through this part of the process. In an 'all-digital' environment this is eminently doable. But once a digital file has been separated and converted to make the plates, it is down to the printer who is running the press to successfully complete the process.

Color management (even non-ICC profiled color management) is controllable and should be maintained within the digital domain, but once you leave that digital world and enter the press room, the operation takes a completely new direction. Fretting over how a proof print may have faded 0.3% in the last month is kind of out of balance to the bigger picture. The printer may be satisfied to keep the whole print job to within a 5% tolerance, although many manage to keep within even tighter tolerances. Imagine, for example, a large volume magazine print run. A printer may use up paper stocks from 17 different sources and make 'on-the-fly changes' to the press to accommodate for changing dot gain and other shifts which may occur during the run. The proof is like the printer's map and compass.

Successful repro is as much dependent on the printer exerting their skills as it is reliant on the supplier of the digital file getting their side of the job right. Good communication can be achieved through the use of an accepted color proof standard. It is a mistake to think that one can accurately profile the final press output. The best we can hope to achieve is to maintain as accurate an RGB workflow as is possible and to this end, accurate profiling is very important. Once a file has been accurately proofed to a CMYK proofer that is the best we can do – after that it is off to the stormy, choppy waters of repro!

Storing digital files

There used to be a problem trying to work out which removable media to choose for the archiving and transferring of digital files. Iomega ZIP drives are probably the most popular, but these are still fairly limited in storage capacity. The one universal standard is CD-ROM as every computer should be sold with a CD-ROM player (and more often a CD/DVD recorder) these days. The CD drives that can read and record to CDR discs are not that expensive to buy and the media costs have tumbled to ridiculously low prices. The only problem with a CD is that if it gets damaged you lose everything and that might be a hefty chunk of valuable data. Make an extra backup copy of important data and archive this separately – this is always a sensible precaution. You can also get re-recordable CD media and DVD, which will compact even more data on a single disc. Jaz disk systems are the ZIP disk's big brother, store either 1 GB or 2 GB of data and the read/write access times are comparable to a standard internal hard disk. Jaz is useful for handling large amounts of data quickly as a temporary storage medium before archiving to CD or tape. I had a client who recently complained that his removable disk system was not storing his images properly – they would reopen, but with signs of file corruption having occurred. The fault lay not in the drive but the unwisely long chain of SCSI cables.

Image database management

I know of a photographer who was asked to 'go digital' by his main client. So he bought all the necessary kit, investing a small fortune in digital hardware. However, after a few months, the client said he wanted to go back to the old days, when he had piles of transparencies to flip through. This was all because the client had a hard time tracking down specific images from the growing pile of CD-ROMs. This anecdote highlights a great potential weakness in professional digital capture workflow. If you don't manage your images efficiently, you will find it incredibly difficult to track them down later from your growing digital archives. Sifting through a disorganized pile of films is not an ideal solution either of course, but at the end of the day, images must be archived. But the argument can be made that once you do put in the effort to archive and manage your digital files properly, the rewards are that you can retrieve your pictures far more easily than with a conventional film-based archive.

From your own experience you will appreciate the importance of keeping track of all your office work files by saving things to their correct folders just as you would keep everything tidy inside the filing cabinet. The task is made slightly easier on the computer in as much as it is possible to contain all your word processing documents on the one drive (and a single backup drive). Digital files are by comparison too large to store on a single disk and need to be archived on many separate disks or tapes. One disk looks pretty much like another and without diligent marking, cataloging and storing, fast forward a year or so and it will take you forever trying to trace a particular picture. I only have to look at my collection of video tapes to appreciate the wisdom of indexing - I know there are movie masterpieces in there somewhere, but am damned if I can find them when I want to. If you are looking for a sophisticated archival retrieval system then consider purchasing an image database such as Image AXS (a demo version is provided on the CD-ROM). A good image cataloging program will do more than provide a contact sheet of images, which are obviously better than icon previews, but also allow indexing with field entries to aid searching. Basically these are database programs designed for efficient image retrieval.

The File Browser

One of the major new features in 7.0 is the File Browser. Right from the beginning, I was pretty excited about the potential for this new feature, even if it does not do everything I would like yet. There are of course other programs that enable you to preview your images in a lightbox fashion and open them up bigger on the screen, but the significant difference between these and the File Browser is that the File Browser can enable you to do all this within Photoshop. For example, I find it much handier to edit all the JPEG photos I have captured digitally using the File Browser in Photoshop 7.0 than was the case using the stand-alone camera software.

The File Browser is contained within a tab in the Options bar palette well by default, but can be accessed by other means: the Window menu, choosing File > Browse... or the Command/Ctrl-O shortcut. The File Browser might be regarded as a Photoshop palette, but its behavior is more like a document window (it will always disappear behind the other palettes). I usually keep the File Browser docked to the palette well in the Options bar. I can then open the browser window by simply clicking on the tab. When you open the File Browser, the first thing you notice is the list tree view in the upper left pane area, which you use to navigate your disk volumes and hierarchy of folders. You can refresh the list view by Control/right mouse-clicking and selecting 'Refresh', or use the F5 keyboard shortcut. When you highlight a folder in the list tree view, all the image files in that folder will be displayed as icons in the main thumbnail pane area on the right. Note that Photoshop will only be able to create a preview of image files it already understands or has a file import plug-in for. As this is happening, Photoshop will write a folder cache of all these image thumbnails to the hard disk, which will be stored within the Application Support\Adobe\File Browser folder. The saved cache will save time displaying the thumbnails whenever you revisit that folder. Incidentally, it can be considered advantageous to switch on the backward compatibility option in the preferences as this will speed up the writing of the thumbnail cache file. The thumbnail images can be displayed at different sizes or using the 'Details' view, which will show the thumbnail along with some of the more useful file metadata. There are two cache-related options in the File Browser fly-out menu. You can purge the current folder cache or export it, so that a cache is also saved in the same folder heirarchy. This is useful if you are preparing a folder of images to burn to a CD. The exported cache can then readily be accessed by another Photoshop 7.0 user.

When you highlight a thumbnail, a preview will appear in the Preview pane on the left, which is scalable in size if you drag the pane dividers to make the preview area larger or smaller. You can rank the files displayed in the thumbnail pane to indicate their priority or importance. Control/right mouse-down on a thumbnail and select a ranking option from A to E from the contextual menu. File ranking can be displayed in the Large with Rank and Details thumbnail views and you can then use the file

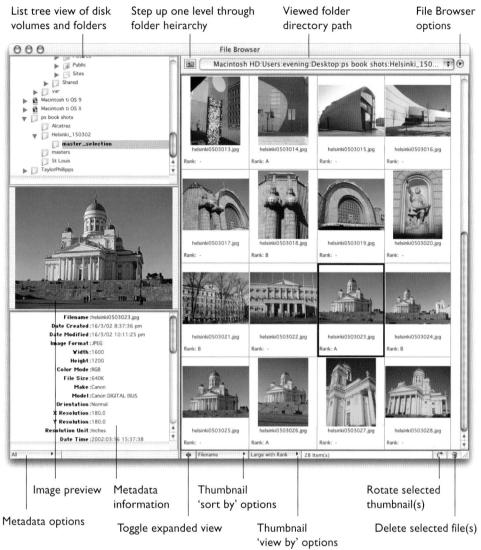

Figure 5.7 The File Browser interface.

ranking to determine the order of how the thumbnails are arranged. The Sort By options allow you to order the images by ascending or descending order using various criteria. Also in the contextual menu is an option that will reveal the highlighted file's folder location in the finder and open this up on the desktop. To delete a file or selection of files, click on the delete file button at the bottom of the palette. This will send the selected files directly to the trash. Click on the rotate button (next to the delete file button) to rotate the thumbnails clockwise. Option/Alt-click to turn counterclockwise. This action will rotate the thumbnail only, save this instruction to the cache and only rotate the master file when it is opened in Photoshop.

Photoshop 6.0 and 7.0 are both able to preserve any metadata that is written into a file, such as the EXIF metadata that many of the digital cameras automatically embed in a file at the time of capture. You will find it very interesting to read all the EXIF metadata that is contained in your digital camera files. It will tell you things like what lens setting was used when a photo was taken and the serial number of the camera. This could be useful if you were trying to prove which camera was used to take a photograph when there were a lot of other photographers nearby trying to grab the same shot and also claiming authorship. The use of metadata will play an extremely important role in the future of digital photography and the way images are managed. In a lot of cases this will happen automatically, thus saving end users' time and money, when cataloging their image databases. The lower left pane in the File Browser can either display all metadata in a selected image or the EXIF metadata only.

	Batch Rename		
- Destination Folder			ОК
Rename in same folder			Cancel
O Move to new folder			
Choose			
File Naming			
Example: helsinki0503001.	gif		
helsinki	+ mmdd (date)	+	
3 Digit Serial Number	+ extension	+	
	* +	(*)	
	(†) +	\$	

Figure 5.8 The Batch Rename dialog.

Renaming in the File Browser

To rename an image in the File Browser, double-click the file name and enter a new name. If you select two or more thumbnail images in the File Browser, you can select the Batch Rename command from within either the File Browser fly-out or contextual menus. This will enable you to rename the selected images any way you like (see Figure 5.8). You can rename the files in the same folder or rename and move them to a new (specified) folder. It would have been more useful to have had a Copy to new folder option. So suppose you want to copy the selected images before renaming them. Create a new folder, and Option/Alt-drag the selected thumbnails across to the new location (Option/Alt will create a duplicate file). It would also be nice if we had had the ability to export selected images from the File Browser. But you can if you create a new folder on the desktop that is always designated as the Source folder within the Web Photo Gallery and Contact Sheet II. Just copy-drag (Option/Alt-drag) the selected images to this folder in the list tree view.

The future of image asset management

At Seybold in San Francisco in the Fall of 2001, Adobe announced XMP (eXtensible Metadata Platform), which to quote Adobe: 'will establish a common metadata framework to standardize the creation, processing and interchange of document metadata across publishing workflows'. Adobe has already integrated the XMP framework into Photoshop 7.0, Acrobat 5.0, InDesign 2.0 and Illustrator 10.0 and it is inevitable that other Adobe products will follow.

XMP is based on XML (eXtensible Markup Language) which is the basic universal format for using metadata and structuring information on the Web. Adobe has also made XMP available as an open-source license, so it can be integrated into any other system or application. Adobe's enormous influence in this arena means that XMP will doubtlessly become a common standard in the publishing and imaging industry. One can anticipate that Adobe and also third-party companies will want to exploit the potential of XMP to aid file management on a general level and for specific needs such as scientific and forensic work.

Where do I see the use of metadata specifically helping artists and designers? Mike Laye recently wrote an interesting article on digital asset management for PDN magazine in New York, where he describes how the metadata information in a file can be used to greatly automate production workflows and preserve the crucial author information in an image. Mike used the analogy of a message in a bottle. It is quite scary to consider the number of freely distributed digital images out there that contain no information about the contact details of the person who created it. So, imagine a scenario in the future where metadata can be used to embed important information about usage rights. Imagine also that a third-party developer could service a website that allowed interested purchasers to instantly discover what specific exclusive usages were currently available for a particular image? You could even embed a self-generating invoice in the image file. If someone tried to strip out the metadata, you could even use an encrypted key embedded in the file to re-import the removed metadata, and/or update specific metadata information. I predict that the use of metadata will offer tremendously powerful advantages to individual image creators who wish to distribute their creative work more securely over the Internet and profit from legitimate image rights purchases.

Image management is something we all need to have. Consider the way we can catalog our music files in a program such as iTunes. Although the music files are all lumped together in a single folder, we are used to accessing our music files not by a folder heirarchy, but by the meta information that separates our music into categories by album title or musical genre – we will also find it useful to apply a similar logic to the way in which we want to manage our image files.

There can be no doubt that the quality of file capture from today's professional digital cameras can outstrip film, yet I have not yet fully made the transition myself to shooting all digital. I still mainly shoot using film and use the Imacon 848 Flextight scanner to scan in the selected images. This is because of speed issues. I want the ability to capture lots of pictures in a very short space of time and also have the ability to process and edit these pictures quickly on a lightbox. If I was to shoot digitally it would currently take ages to archive and backup the same number of digital captures to CDR media. These are mainly technical issues to do with the processing power of today's computers still not being quite fast enough yet to meet my heavy demands and more crucially the space limits of CD-ROM and speed limits of recording to DVD media. I use as a benchmark how long it takes me to shoot five or six rolls of film and edit these on a lightbox, compared with how long it takes to process a similar number of digital files and back these up to disk.

These technical limitations will be overcome in the next few years I am sure, but in the meantime, the File Browser in Photoshop 7.0 is an important first step towards greater productivity and the ability to preview and sort images directly within Photoshop. As additional tools become available for making use of metadata to automate the so far missing parts of the process, we will all reap the benefits of being able to better manage our image resources. You can of course append your own image information within the Photoshop program itself. The File > File Info... dialog box provides a comprehensive list of options for annotating an image with metadata to meet with the NAA/IPTC standard, as used in the newspaper industry. It is even possible to record the inputting of metadata information in the File Info as a Photoshop action, which in turn can be assigned a hotkey or turned into a droplet (see page 356). There used to be no way to export the metadata information from Photoshop until the Pixel Genius crew (of which I am a member) created a metadata and File Info text export plug-in for Photoshop. You can find out more about MetaReader[™] and download the freeware plug-in from our Pixel Genius website at: <www.pixelgenius.com>.

Bureau checklist

Make sure you have everything fully checked before you send that disk. Some bureaux supply their customers with guidelines, others assume you know enough about digital imaging to understand the basic requirements. The preferred image file format is usually a TIFF, that is uncompressed and saved using Mac byte order. Bureaux also prefer you to remove any masking channels and paths from the final output file. Removing unwanted alpha channels from a TIFF will economize on the stored file size. Only leave paths when saving a clipping path with an EPS or TIFF file.

Check that you are supplying your file at an appropriate resolution for the print process, the image dimensions are correct and always make allowance for the extra bleed dimensions (which is usually 3 mm along each edge) if the photograph is to fill the page. There are limits as to how much one can 'interpolate up' a digital image. Apply unsharp masking as necessary. A lot of sharpness gets lost in the repro process and therefore apply a little more unsharp masking than looks correct on the monitor screen (see Chapter Eight). Make sure you supply your images in the correct color mode – either RGB or CMYK. Some service providers, like those outfits who produce the Iris art prints, may use their own color conversion hardware to work from your RGB files.

Image protection

Anyone who fully understands the implications of images being sold and transferred in digital form will appreciate the increased risks posed by piracy and copyright infringement. The music industry has for a long time battled against pirates duplicating original discs, stealing music and video sales. Digital music recordings on CD made this problem even more difficult to control when it became possible to replicate the original flawlessly. The issue of piracy is not new to photographers and image makers, but the current scale of exposure to this risk is. It includes not just us Photoshop geeks who are going to be affected, but includes anyone who has their work published or is interested in the picture library market.

To combat this problem, the first line of defence had been to limit the usefulness of images disseminated electronically by (a) making them too small in size to be of use other than viewing on a screen and (b) including a visible watermark which both identified the copyright owner and made it very difficult to steal and not worth the bother of retouching out. The combination of this two pronged attack is certainly effective but has not been widely adopted. The World Wide Web contains millions of screen sized images few of which are protected to this level. The argument goes that these pictures are so small and degraded due to heavy JPEG compression, what possible good are they for print publishing? One could get a better pirated copy by scanning an image from a magazine on a cheap flatbed scanner. Shopping is now replacing sex as the main focus of interest on the Internet, so screen sized web images therefore do now have an important commercial value in their own right. Furthermore, the future success of digital imaging and marketing will be linked to the ability to transmit image data. The technology already exists for us to send large image files across the world at speeds faster than ISDN. Once implemented, people will want to send ever larger files by telecommunications. The issue of security will then be of the utmost importance.

In recognition of this market need, software solutions are being developed to provide better data protection and security, giving suppliers of electronic data the means to warn, identify and trace the usage of their intellectual property. From a user's point of view, the requirements are to produce an invisible 'fingerprint' or encrypted code, which does not spoil the appearance of the image but can be read by the detection software. The code must be robust enough to work at all usage sizes – screen size to high resolution. They must withstand resizing, image adjustments and cropping. A warning message should be displayed whenever an image is opened up alerting the viewer to the fact that this picture is the property of the artist and a readable code embedded from which to trace the artist and negotiate a purchase.

Two companies have produced such encryption/detection systems - SureSign by Signum Technology and Digimarc by the Digimarc Corporation. Both work as plugins for Photoshop. They will detect any encrypted images you open in Photoshop and display a copyright detection symbol in the status bar alongside the file name. The Digimarc plug-in has been included free since Photoshop 4.0. To use Digimarc to encrypt your own work, you have to pay an annual usage fee to Digimarc to register your individual ID (check to see if free trial period offers are in operation). Anyone wishing to trace you as the author, using the Photoshop Digimarc reader plug-in, will contact their website, input the code and from there read off your name and contact number. Here is the main difference between the two systems - the Digimarc code is unique to each author/subscriber while SureSign provide a unique author code plus transaction number. In my opinion, the latter is a more adaptable system. Anyone contacting me with regard to image usage can quote the transaction number which would relate to a specific image. As for pricing methods, with Digimarc the software is free but you have to pay an annual fee to register your code. At the time of writing, SureSign also sell the software with an annual fee.

Both systems work effectively on digital originals (you can compare them for yourself, a Signum Technology demo is available on the CD-ROM). There is no guarantee that a fingerprint will remain intact when scanned from a halftone printed image, yet Signum report that one client was able to detect the SureSign code from a scanned newspaper page! These programs herald an important step forward for the secure distribution of copyright protected data.

The detection business is very important if fingerprint type encryption is to become trusted as a valuable method of copyright protection. Detection software will also help people searching for a particular image, whether encrypted or not. New Mexico Software and Signum Technologies recently joined forces with C E Heath and Beazley, a Lloyd's insurance syndicate, who are providing an insurance cover plan to enforce copyright protection and recover damages where ownership can be proved using the encryption detecting software.

Chapter Six The Work Space

Before moving on to the practical Photoshop techniques, let's first look at the Photoshop interface. If you switch between using current versions of Photoshop, Illustrator and InDesign, the Adobe interface and keyboard command conventions will remain fairly consistent. For example, the zoom tool shortcut in all these programs is Command/Ctrl+Spacebar. Apart from a few necessary deviations, the transition between all Adobe graphics programs is fairly seamless. The Photoshop 7.0 interface illustrations shown in this book have all been captured using the new Apple Macintosh OS X interface. There should be few problems locating your favorite tools other than adjusting to the 'apparent' disappearance of the magnetic pen and airbrush tools and menu differences introduced in OS X. After that you will soon notice some of the new Photoshop 7.0 tool options have been extended in this version. The following pages give an account of the basic Photoshop working area and introduce you to the new tools, while the keyboard shortcuts are all summarized later on in Chapter Twelve. Use this chapter as a reference as you work through the remainder of the book.

Photoshop preferences

The Photoshop preferences are located in the Edit menu in Windows and Mac Classic and under the Photoshop menu in OS X. You can use the preference dialogs to customize the various Photoshop functions and update the *preference file* which is stored along with other program settings in the system level Preferences folder (Mac) or Registry folder (PC). A new preference file is generated each time you exit Photoshop. Deleting or removing this file will force Photoshop to reset all its preferences. Macintosh users should note that the Photoshop program preference settings are not shared between the Mac Classic and OS X operating systems. Should you switch between the two Mac OS systems and you will have to configure separately the two system operating modes of Photoshop 7.0. Saved settings such as the Actions and Preset manager settings will also be unique to the specific operating system in which you are running Photoshop.

Open the Preferences dialog from either the Edit menu (PC/Mac OS 9) or Photoshop menu (OS X) and choose: Preferences > General (Command/Ctrl-K). I would leave the Color Picker set to Adobe – this is the picker referred to throughout this book (unless you have a strong attachment to the system Color Picker). Leave the interpolation option set to Bicubic. If you need to override this setting then you can do so in the Image > Image Size dialog. The Redo Key option offers you a choice of having Command/Ctrl+Z either successively undo an image or toggle between the current and last used version. Print Keys is a new option that is used to assign the print command behavior. You can have Command/Ctrl+P follow the conventional behavior of opening the normal operating system print dialog, or you can have Command/ Ctrl+Option/Alt+P open the Photoshop Print preview dialog or vice versa. Unchecking the Export Clipboard box saves time when exiting Photoshop to launch another program. If you really need the ability to paste clipboard contents to another program, then leave it on, otherwise switch it off. Check the Keyboard Zoom Resizes Windows, if you want the image window to shrink to fit whenever you use a keyboard zoom shortcut like Command/Ctrl-minus or Command/Ctrl-plus. If you are going to be jumping between Photoshop and ImageReady, then you may want to check the Auto-update open documents option. Otherwise, Photoshop will remind you anyway when you jump applications. The Mac OS X system broke some of the once hallowed rules about not implementing keyboard shortcuts that might conflict with shortcuts in an

		Preferences	
General	**		ОК
Color Picker:	Adobe	•	Cancel
Interpolation:	Bicubic (Better)	•	
Redo Key:	Cmd+Z (Toggles Unde	Prev	
Print Keys:	Cmd+P: Print with Pre	view / Cmd+Opt+P: Print 🗘	Next
- Options			
Export Clip	board	🗒 Beep When Done	
Show Tool	Tips	Dynamic Color Sliders	
Keyboard 2	Zoom Resizes Windows	Save Palette Locations	
Auto-upda	te open documents	Show Font Names in English	
Show Asia	n Text Options	Use Shift Key for Tool Switch	
🗏 Use System	n Shortcut Keys	🗹 Use Smart Quotes	
	Reset All Warn	ing Dialogs	

Figure 6.1 The General preferences dialog.

application designed to run on the Mac system. For as long as I can remember, Command-H should toggle hiding and showing extras in Photoshop. But in Mac OS X, Command-H will hide an application. This could be very confusing when working in Photoshop, which is why you should leave the Use System Shortcuts unchecked and preserve the conventional behavior for all your Photoshop shortcuts. In Mac OS X 10.2, Command-~ (tilde) will now cycle between displaying open documents. This overrides the Photoshop keyboard shortcut used to display the image composite in the Channels palette. To disable this behavior, download the OS X Keyboard Shortcut Fix plug-in from the Adobe website and install in the Plug-ins: Adobe Photoshop Only: Extensions folder. You can check the Beep When Done box, if you want Photoshop to signal a sound alert when tasks are complete. The Dynamic Color Sliders option ensures that the colors change in the Color palette as you drag the sliders - keep this selected. If you would like Photoshop to always remember the last used palette layout, check the Save Palette Locations box (the Reset Palette Locations to Default option is located under the Window menu, as are the new saved Workspace settings). The Show Font Names in English option is of more significance for non-English language users, who will see instead an option for displaying font names in the native language of their localized version of Photoshop (the same applies for the Show Asian Text Options box). The Use Shift Key for Tool Switch answers the needs of users who wish to disable the Shift key modifier for switching tools in the Tools palette with repeated keyboard strokes. See Figure 6.28 for more information about the redo key preference options. The Reset All Warning Dialogs will reset things like the profile mismatch warning messages. These dialogs contain a Don't Warn Me Again checkbox - if you had pressed any of these at any time, and wished to restore them, click here. The Reset All Tools in the Options bar will reset the tool behavior.

Saving files

You will normally want to include image previews when you save a file. It is very useful to have image thumbnail previews in the Open dialog boxes although the File Browser is capable of generating large thumbnails regardless of whether a preview is present or not. There are times though when you don't need previews. Web graphic files should be uploaded as small as possible without a thumbnail or platform specific header information (Save for Web defaults to removing previews). I usually upload files to my server in a raw binary format, which strips out the previews and other file resource information anyway. If you are working on a Mac, you can choose to save a Windows and Macintosh thumbnail with your file, to allow for cross-platform access. Appending a file with a file extension is handy for keeping tabs on which format a document was saved in. It is also very necessary when saving JPEG and GIF web graphics that need to be recognized in an HTML page. If you are exporting for the web, you probably want to check the Use Lower Case box for appending files.

Photoshop PSD files created in Photoshop 7.0 are never going to be 100% compatible if read by someone using an earlier version of the program. This has always been the case with each upgrade of Photoshop. The Always Maximize Backwards Compatibility for Photoshop (PSD) Files option will allow you to always include a flattened version of the image in a saved Photoshop file and a safe solution is to keep this checked. For example, the new layer blending modes in 7.0 will not be interpreted correctly if read by Photoshop 6.0. So if a Photoshop 7.0 file contains a layer element that is unrecognizable in Photoshop 6.0 or earlier, this will trigger opening the flattened composite version instead. However, checking this option will lead to slower saves and bigger Photoshop format files. Once I update to a new version of Photoshop, I never need to go back to using a previous version and I am not in the habit of allowing anyone else access to my layered, Photoshop version-specific files. I have no need to maximize backward compatibility, so I prefer to switch this option off and keep the file size down and save times shorter. But by doing so, I am losing out when I use the File Browser, because the Browser can utilize the flattened composite layer version to more quickly write a preview of the image to the File Browser cache. Although it may take longer to cache the PSD files, once the cache is written, it is stored in the individual volume's File Browser cache folder and will be instantly available the next time I visit that folder, unless I have edited the image in between.

A TIFF format file created in Photoshop 6.0 or 7.0 is able to contain Photoshop layered information but in the case of TIFF a flattened composite is always saved. If you save a TIFF file with layers, the additional layered information should be completely ignored and have no impact when you place such a TIFF in a page layout that will be later converted to go to print. Some people argue that there are specific instances where a layered TIFF might trip up a print production workflow. And more importantly, they argue that you do not want unnecessarily bloated TIFF files slowing down transmission times. So it might be safer to never save a TIFF with layers. When the Ask Before Saving Layered TIFF Files option is checked, Photoshop will present you with the option to either flatten or preserve the layers when you save a layered image as a TIFF. Some page layout programs such as Adobe InDesign allow you to place Photoshop PSD files in the layout. The idea is that this enables you to 'round trip' an image placed in the layout. Using a single file in a PSD format you can modify it in Photoshop and the image will immediately be updated in InDesign. That way you don't run the risk of losing synchronization between a PSD master that is used for Photoshop edits and a TIFF or EPS version of the same image that is used solely for placing in the layout. This is another argument in favor of always maximizing compatibility - a flattened composite has to be present in the PSD file to make this work. In my opinion if you want to adopt such a workflow, then the TIFF file format is preferable to use. In the Photoshop preferences you have the option to be reminded when you save a TIFF to retain or discard the layers (if unselected, layers will be saved regardless). To summarize: a TIFF file will always save a flattened composite and if layers are enabled you have the option of being able to 'round trip' a single, layered file from page layout to Photoshop and back again. This approach is also more versatile as any page layout application can recognize a TIFF. But again the downside is that layered TIFFs mean bloated files, slower saves and slower data transmission, although you may be able to safely apply file compression such as JPEG, or ZIP (which is lossless) in the TIFF format options without causing any glitches at the print rendering stage.

		ОК
Image Previews:	Always Save 😫	Cancel
	🗹 Icon 🔲 Full Size	
	Macintosh Thumbnail	Prev
	🗹 Windows Thumbnail	Next
Append File Extension:	Always 🗘	
	🗹 Use Lower Case	
- File Compatibility		
🗹 Ask Before Saving Lay	ered TIFF Files	
🗐 Always Maximize Con	npatibility for Photoshop (PSD) Files	
🗹 Enable Workgroup Fi	unctionality	
When Opening Managed	Documents	
Check Out from Server:	Ask 🗘	
Update from Server:	Always 🛊	

Figure 6.2 The Preferences dialog boxes for file handling.

Display & Cursors		ОК
– Display Color Channels in Color		Cancel
Use Diffusion Dither		Prev
Use Pixel Doubling		Next
Painting Cursors	Other Cursors	
-		
Standard	Standard	
O Precise	Precise	
Brush Size		

Figure 6.3 The Preferences dialog for Display & Cursors.

The Enable Workgroup Functionality options relate to the use of Web Distributed Authoring and Versioning (WebDAV) server technology. This is supported in Photoshop and will allow you to connect to a WebDAV server so that you can have your files shared with other Photoshop users. When a user 'checks out' a file, only he or she can edit it. The other users who are sharing your files will only be able to make edit changes after the file has been checked back in again. This precautionary behavior ensures that other users cannot overwrite your work while it is being edited.

The Recent file list refers to the number of image document locations remembered in the Photoshop 7.0 File > Open Recent submenu. The default number is 4, which I find to be too low – you might want to consider increasing this number.

Display & Cursors

The display Color Channels in Color option is a somewhat redundant feature as this does not really help you to visualize the channels any better. If anything it is a distraction and is best left unchecked. The Use Diffusion Dither option is a legacy from the days when people were trying to run Photoshop on an underpowered system with an 8-bit color monitor displaying only 256 colors. The Use Diffusion Dither option uses a dithered pattern to approximate the in-between colors to produce a smoother looking if not completely accurate color display. It is important to realize that the screen drawing code for Photoshop was revised around the time of Photoshop 5.0, such that the screen display you see is more accurate, but may appear slower than before when performing image adjustments. The Use Pixel Doubling option will temporarily convert the image preview to display a quarter as many pixels when you are making an image adjustment with, say, Levels or Curves or moving a pixel selection or layer on screen. Pixel Doubling will greatly improve screen refresh times, but is not really all that necessary with today's Macs and PC computers.

The Painting cursor displays an outline of the brush shape at its actual size in relation to the image magnification. This is the default setting, although you could choose the cursor to display with a precise cross-hair or with the standard tool icon. The latter cursor display happens to be the default setting under Other Cursors. This is fine when starting to learn Photoshop but for precision work I suggest changing the Other Cursors setting to Precise. Depending on how you configure the Display & Cursor options, the Caps lock key will toggle the cursor display. When the standard paint cursor is selected, the caps lock will toggle between standard and precise. When the precise or brush size paint cursor option is selected, the Caps lock will toggle between precise and brush size. When standard cursor mode is selected for all other cursors, the Caps lock key will toggle between the standard and precise cursor.

Transparency & Gamut

The transparency settings determine how image transparency is represented on screen. For example, if a layer contains transparency and is viewed on its own with the background layer visibility switched off, the transparent areas are normally shown using a checkerboard pattern. The display preferences let you decide how the checkerboard grid size and colors are displayed.

If you are working in RGB or Lab color mode and choose View > Gamut Warning, you will be alerted as to which colors are out of gamut. Photoshop represents these with a color overlay, which can be a solid or specified percentage color.

Transparency & Gamut 🗧 —		ОК
- Transparency Settings		Cancel
Grid Size: Medium +		Prev Next
 Use video alpha (requires hardware Gamut Warning 	support)	
Color:	Opacity: 75 🕅 %	

Figure 6.4 The transparency display settings are editable. You have a choice of transparency display settings: none, small, medium or large grid pattern as well as a choice of different grid colors. Should you so desire to customize the interface.

Units & Rulers

Use this preference to set the Ruler measurement (inches or centimeters etc.) and type units used. The measurement units can also be changed via the Info palette submenu or by Control/right mouse-clicking a ruler to open the contextual menu. Double-click the ruler bar as a shortcut for opening this preference window. The New Document Preset Resolution options allow you to decide what pixel resolution should be the default for screen display or print output work when you select a Preset size from the File > New Document dialog.

Units & Rulers		ОК
- Units		Cance
Rulers: inches 🛟		
Type: points 🛟		Prev
- Column Size		Next
	ts 🛊	
Gutter: 12 point	ts 🛊	
New Document Preset Resolutions		
Print Resolution: 300 pixel	s/inch 🗘	
Screen Resolution: 72 pixel	s/inch 😫	
Point/Pica Size		
PostScript (72 points/inch)		
Traditional (72.27 points/inch)		

Figure 6.5 Ruler units can be set in pixels, inches, cm, mm, points, picas or as a percentage. The percentage setting is ideal for recording Actions that you wish to apply proportionally at any image size.

Guides, Grid & Slices

There are a choice of colors and two line styles to choose from and you can customize the grid appearance, such as the number of Grid subdivisions, to suit whatever project you are working on (the use of the Guides & Grid is discussed in one of the following sections). The Slice options include Line color style and whether the Slice numbers are displayed or not.

Guides, Grid & Slices	+	ОК
Guides		Cance
Color: 🔲 Light B	lue 🗘	
Style: Lines	*	Prev
Grid		Next
	*	
Style: Lines	*	
Gridline every: 1	inches 🗘	
Subdivisions: 4		
Slices		
Line Color: 🔲 Light B	lue 🗘	
Show Slice Numbers		

Figure 6.6 The preference settings governing the appearance of the Guides, Grid & Slices.

Plug-ins & Scratch Disks

The Plug-ins folder will automatically be recognized by Photoshop so long as it resides in the same application folder. You can also choose an additional plug-ins folder that may be located in another application folder (such as Adobe Photoshop Elements) so these can in effect be shared with Photoshop. Click the Browse... button to locate the additional folder. If you install any third-party plug-ins that predate Photoshop 7.0, these may possibly incorporate a hidden installation process that looks for a valid Photoshop serial number in the older style, consisting of letters and numbers. If that is the case, enter your old Photoshop serial number in the Legacy Serial Number box.

Cancel
Prev
Next

Figure 6.7 Specify the Plug-in folder to use (which may be shared with another application). Up to four scratch disks are supported by Photoshop.

Specify the primary and spill-over scratch disks below. The scratch disk choice will only take effect after you restart Photoshop and the primary scratch disk should ideally be one that is separate to the disk running the operating system and Photoshop. Partitioning the main disk volume and designating an empty partition as the scratch disk serves no useful purpose, as the disk drive head will simply be switching back and forth between different sectors of the same disk as it tries to do the job of running the computer system and providing scratch disk space. If you hold down the Command/Ctrl + Option/Alt keys at the beginning of the startup cycle, you can choose the location of the additional Plug-ins folder first then hold down the same key combination again and then choose the scratch disks. Up to four scratch disks can be specified. Holding down Command/Ctrl + Option/Alt + Shift during startup will delete the current Photoshop preferences.

Memory & Image Cache

The image cache settings affect the speed of screen redraws. Whenever you are working with a large image, Photoshop uses a pyramid type structure of lower resolution, cached versions of the full resolution picture. Each cached image is a quarter scale version of the previous cache level and is temporarily stored in memory to provide speedier screen previews. Basically, if you are viewing a large image on screen in 'fit to screen' display mode, Photoshop will use a cache level that is closest to the fit to screen resolution to provide a screen refresh view of any edit changes you make at this viewing scale. The cached screen previews can provide you with faster screen redraws and larger images will therefore benefit from using a higher cache level. A higher setting will provide a faster screen redraw, but at the expense of sacrificing the quality of the preview. This is because a lower resolution cache preview is not as accurate as viewing the image at Actual Pixels. You may sometimes notice how the layered Photoshop image on screen is not completely accurate at anything other than the 100% magnification – this is the image cache at work, it is speeding up the display preview at the expense of accuracy. Note also that the number of cache levels chosen here will affect the structure of a 'Save Image Pyramid' TIFF file.

The PC Windows and Mac OS X memory management allocation is set as a percentage of the total RAM available. Photoshop starts with a default setting of 75%. If more applications are required to run simultaneously, this percentage may need to be lowered, but this then means that Photoshop will not run quite as fast. The ideal solution is to run Photoshop entirely on its own and allocate the highest percentage of RAM memory to

Photoshop that will reasonably allow you to run both the operating system and Photoshop. I normally have over a gigabyte of RAM memory on my computers and leave the percentage set at 85%.

Image window

The document window displays extra information about the image in the two boxes located in the bottom left corner of the image window (Mac) or at the bottom of the screen (PC). The left-most displays the zoom scaling percentage, showing the current zoom factor. You can type in a new percentage of any value you like from 0.2% to 1600% up to two decimal places and hit Return to set this as the new viewing resolution. In the middle is the Work Group Server button, which you can use to check in or check out a document that is being shared over a WebDAV server. Next to this is the Preview box. Mousing down on the Preview box will display an outline box of how the image will be scaled relative to the current Page Setup paper size. The preview reflects the image dimensions at the current pixel resolution. The resolution can be checked by holding down the Option/Alt key while you mouse down. This will display both the dimensions and image resolution. Command/Ctrl + mouse down shows the image tiling information can be changed by mousing down on the arrow next to the box to select one of the following:

Document Sizes displays the current document size. The first figure is the file size of a flattened version of the image. The second, the size if saved including all the layers.

Document Profile displays the current profile assigned to an open document.

Document Dimensions displays the physical image dimensions, as would currently be shown in the Image Size dialog box.

Scratch Sizes – the first figure displays the amount of RAM memory used. The second figure shows the total RAM memory after the system and application overhead available to Photoshop. The latter figure remains constant and only changes if you quit Photoshop and reconfigure the memory partition. The amount of RAM memory consumed can be minimized if you avoid making too many global changes in a row to an image.

Efficiency summarizes the current performance capability of Photoshop. Basically it provides a simplified report on the amount of Scratch Disk usage. Low percentages warn that it may be advisable to purge the clipboard or undo memory (Edit > Purge > Clipboard/Undo).

Timing times Photoshop operations. It records the time taken to filter an image or the accumulated timing of a series of brush strokes. Every time you change tools or execute a new operation, the timer resets itself.

Tool Selection displays the name of the tool you currently have selected. This is a useful aide-mémoire for users who like to work with most of the palettes hidden.

Title bar proxy icons (Macintosh)

Macintosh users may see a proxy image icon in the title bar. This is dimmed when the document is in an unsaved state and is reliant on there being a preview icon; many JPEGs will not have these until saved as something else. Control-drag the proxy icon to copy and relocate the saved file to another location. Command-click to view the file's folder heirarchy and jump to a specific folder location.

Preview box options

Hold down the Option/Alt key to display the file size and resolution information. Hold down the Command/Ctrl key to display the tiling.

Mouse down to display a scaled preview of the size the image will print with the current page setup. Title bar proxy icon

Figure 6.9 The window layout of a Photoshop document as it appears on the Macintosh. If you mouse down on the arrow icon next to the status information box, you can select the type of the information you wish to see displayed there.

Managing document windows

You can create a second window view of the image you are working on by choosing View > New View. The image is duplicated in a second window. For example, you can have one window with the image at a Fit to Screen view and the other zoomed in close-up on a detailed area. Any changes you make can then be viewed simultaneously in both windows. If you refer back to the chapter on color management you will remember you can use multiple window views to soft proof the image in different color spaces. You can arrange the way all the document windows are displayed on the screen. Choose Window > Documents > Cascade to have all cascading down from the upper left corner of the screen. Choose Window > Documents > Tile to have all the currently opened image windows tiled edge to edge.

Figure 6.10 To open a second window view of a Photoshop document, choose View > New View. Changes applied to the close-up view are automatically updated in the full frame view. New view document windows can usefully be used to display the same image with different color proof setups applied, so you can preview an RGB image in a different CMYK color space in each new view window.

Photo: Eric Richmond.

Rulers, Guides & Grid

The Grid provides you with a means for aligning image elements to the horizontal and vertical axis (go to the View menu and choose Show Grid). To alter the grid spacing, go to the General preferences and select Guides & Grid. To see a practical example of using Guides in a project that involves a PageMaker layout created partly in Photoshop, see the tutorial at the end of Chapter Eleven about preparing a flyer design for Ocean Images, swapping between PageMaker and Photoshop. Guides can flexibly be positioned anywhere in the image area and be used for the precise positioning and alignment of image elements. Guides can be added at any time, providing the Rulers are displayed (View > Show Rulers). To add a new guide, mouse down and drag out a new guide from the ruler bar. Release the mouse to drop the guideline in place. If you are not happy with the positioning, select the move tool and drag the guide into the exact required position. But once positioned, it is a good idea to lock the guides to avoid accidentally moving them again.

Figure 6.11 These windows show the Grid (back) & Guides. To display the Grid, chose View > Show > Grid. To position a Guide, choose View > Show Rulers and drag from either the horizontal or vertical ruler. Hold down the Shift key as you drag to make the guide snap to a ruler tick mark (providing View > Snap is checked). Command/Ctrl-H will toggle hiding/showing Extras like the Grid & Guides. Hold down the Option/Alt key to switch dragging a horizontal guide to dragging it as a vertical (and vice versa).

'Snap to' behavior

The Snap option in the View menu allows you to toggle the snap to behavior for the Guides, Grid, Slices, Document bounds and Layer bounds. The shortcut for toggling snap to behavior is Command-semicolon (;). When the Snap to is active and you reposition an image, type or shape layer, or use a crop or marquee selection tool, these will snap to one or more of the above. It is also the case that when snap is active, and new guides are added with the Shift key held down, the guide will snap to the nearest indentation on the ruler. Objects on layers will snap to position when placed within close proximity of a guide edge. The reverse is also true: when dragging a guide, it will snap to the edge of an object on a layer at the point where the opacity is greater than 50%. Furthermore you can Lock Guides and Clear Guides. If the ruler units need changing, double-click anywhere on a ruler to call up the Ruler Units preferences dialog box. If the rulers are visible but the guides are hidden, dragging out a new guide will make the others reappear. You can even position a guide using New Guide... Enter the exact measurement coordinate for the horizontal or vertical axis in the dialog box.

The Photoshop palettes

The Photoshop palettes can be positioned anywhere you like on the screen by mousing down on the palette title bar and dragging to a new location. You can change the depth of a palette by dragging the size box at the bottom. To return a palette to its default size, click the zoom box at the top (Macintosh) or click the minimize/maximize box (Windows). One click will resize, a second click collapses the palette. Double-clicking the palette tab will collapse the palette. If an uncollapsed palette is positioned on the bottom of the screen display, the palette collapses downwards when you double-click on the palette tab and open upwards again when you double-click.

Palettes can be grouped together. To do this mouse down on the palette tab and drag it across to another palette. When palettes are grouped this way they are like folders in a filing cabinet. Click on a tab to bring a palette to the front of the group. To separate a palette from a group, mouse down on the tab and drag it outside of the palette group.

Palette docking

The Photoshop palettes can be arranged in individual groups (as in the default work space layout setting) or they can be docked together as shown right. If you have a limited sized screen this is a convenient way of arranging the palettes and it also makes it easier to expand and shrink the height of individual palettes so as to allow more room to expand to one or more of the other palettes.

To set up palette docking, first separate all your palettes and position one palette (like Color) immediately below another (the Navigator/Info/Character & Paragraph set) and slowly drag the tab of the lower palette up to meet the bottom edge of the one above. As the palettes dock, you will see the bottom edge of the upper palette change to a double bar. Release and the two palettes are joined. Drag the Swatches and Style palette across to rejoin the Color palette. Repeat by separating the History and Actions palette and doing the same with the History palette, dragging the tab up to the base of the Color palette set.

When the cursor is positioned over the palette divider, you will see the icon change to a double arrow, indicating that you can adjust the relative height between two sets of palettes (where allowable). If you drag on the lower height adjustment/grow tab in any palette, you can adjust the overall height of the docked palette grouping.

0.0.0

Figure 6.12 The Photoshop 7.0 palettes shown with vertical docking.

Workspace settings

If you are searching for a particular palette and can't find it, the palette may just be hidden. Go to the Window menu and select the palette name from the menu. The Tab key shortcut will toggle hiding and showing all the palettes. Tab + Shift will toggle hiding/showing all the currently visible palettes except the Tools palette and Options bar. This is useful to remember if all your palettes seem to have disappeared. Try pressing the Tab key to get to view them again.

If at any time you wish to restore the palette positions, go to the Window > Workspace menu and select Reset Palette Locations. You can save the current palette arrangement as a custom Workspace. Go to the Window menu and choose Workspace > Save Workspace... A dialog box will pop up that will ask you to name the workspace and save it. The next time you visit the Window > Workspace menu you will see the saved workspace appear in the menu listing. This is a real handy feature that enables you to switch quickly between different custom palette arrangements. If you want to be extra clever, you can record the loading of a saved Workspace setting as an action and assign a hot key to play the action. This will allow you to switch workspace settings using a single keystroke. If you want to remove a workspace setting, use the Delete Workspace... command. If you have a second monitor display, you can arrange for all the palettes to be displayed nestled on the second screen, leaving the main monitor clear to display the whole image.

File Browser

The File Browser is one of the star attractions of Photoshop 7.0. More detailed information about the File Browser can be found in the preceding Chapter Five on file management and output. The Browser palette behavior is a cross between a Photoshop palette and a document window. It makes sense to use the File Browser big on the screen and you will probably want to open it up first as a separate window and scale it up as big as you can make it and then either close or dock it to the palette well in the Options bar. The next time you open the File Browser up, the size setting will be remembered. Personally, I prefer to dock the File Browser to the palette well. This allows me to select an image from the thumbnail pane area, and when I double-click to open the image, the File browser will close as the selected image(s) opens (Option/Alt + double-clicking will keep the File Browser open on screen). If you have a two monitor setup then of course you can always have the File Browser permanently left open as an undocked palette window. Using this setup, the File Browser will always remain open after you use it to open an image. It is useful to know that you can use the F5 keyboard shortcut if you want to refresh the list tree view of folder information and update it to recognize a recently created folder.

Figure 6.14 The File Browser palette.

Navigator

The Navigator is usually grouped with the Info, Character and Paragraph palettes. The Navigator offers an easy and direct method of scrolling and zooming in and out of the image window. The palette window contains a small preview of the whole image and enables you to scroll very fast, with a minimum of mouse movement by dragging the colored rectangle. This colored rectangle indicates the current view as seen in relation to the whole image (other rectangle colors can be selected via the palette fly-out menu options). To operate the zoom, hold down the Command/Ctrl key and drag the mouse to define an area to zoom to.

Alternatively, with the slider control at the bottom, you can quickly zoom in and out or click on the 'little mountain' or 'big mountain' icons to adjust the magnification in increments. You can also type in a specific zoom percentage in the bottom left corner up to two decimal places and hit Return or Enter to set the new zoom percentage. It is also possible to resize the palette as shown in the illustration here, by dragging the bottom of the palette window out – this will provide you with a bigger preview.

Info

This palette reports information relating to the position of the cursor in the image window, namely: pixel color values and coordinate positions. When you drag with a tool, the coordinates update and in the case of crop, marquee, line and zoom tools, report back the size of a dragging movement. The submenu leads to Palette Options... Here you can change the preferences for the ruler units and color readouts. The

hfo	1				
	R :	161		C :	35%
	G ;	129		M :	48%
Λ.	B :	114	1.	Y :	49%
				К:	6%
	X :	5.144		W :	
t,	Y :	6.042	1.1	Н:	

default color display shows pixel values for the current selected color mode plus the CMYK equivalents. When working in RGB, illegal colors which fall outside the current CMYK workspace gamut are expressed with an exclamation mark against the CMYK value.

΄ ά	Photoshop	File Ec	lit Image	Layer	Select	Filter	View V	Nindow	Help ≋	HS	v •	Sun 7:31 PM
		Feather: 0	px 🗌 🗇 AntHa	liased S	ityle : Norma	******	* * 16 U	h:	Height		Brushes Tool Pres	iets (File Browser)

Tool Options bar

When you first install Photoshop, the Options bar will appear at the top of the screen, snapped to the main menu. This is a very convenient location for the tool options, and you will soon appreciate the ease with which you can make changes to the options with minimal mouse navigation movement. The Options bar can be unhooked, by dragging the gripper bar (on the left edge) away from the top of the screen. The Options bar contains a 'palette well' docking area to the right, which will be visible whenever the Options bar is docked at the top or bottom of the screen and your monitor pixel display is at least 1024×768 pixels (although ideally you will want a larger pixel display to see this properly). Palettes can be docked here by dragging a palette tab into the Options bar palette well. Palettes docked this way are made visible by clicking on the palette tab. One advantage of this arrangement is that you can use the Shift+Tab key shortcut to toggle hiding the palette stack only, keeping just the Tools palette and Options bar visible. The individual Options bar settings for each tool are shown throughout the rest of this chapter. To reset a tool or all tools, mouse down on the tool icon on the left. The 'tick' and 'cross' icons are there to make it simpler for users to know how to exit a tool which is in a modal state.

In Photoshop 7.0 you can change the palette tab order by Control/Right mouse-clicking on a palette tab that is in the well. A contextual menu will enable you to select to move the palette tab left or right or to the beginning or end of the palette well.

Tool Presets

The Tool Presets palette can be used to store custom tool presets. All of the Photoshop tools have a range of tool options and the Tool Presets palette allows you to configure a specific tool setting and save it. This will allow you to quickly access a number of tool options very quickly and saves you the bother of having to reconfigure the Options bar settings each time you use a particular tool. For example, you might find it useful to save crop tool settings for different image dimensions and pixel resolutions. The example opposite shows a display of presets for all available tools. If you click on the Current Tool Only button at the bottom of the palette, you can restrict the preset options to the current tool.

The Tool Presets palette is particularly useful for storing pre-configured brush preset settings. In fact one of the first things you should do is go to the Tool Presets palette submenu and choose Load Presets... Choose: Presets > Tools > Brushes.tpl. Another thing that may not be immediately apparent is the fact that you can also use the Tool Presets to save Type tool settings. This again is very useful, as you can save the font, font size, type attributes

and font color settings all within the single tool preset. This feature will be very useful, for example, if you are working on a web page design project.

Character

In the Character palette you can exercise full control over the font character attributes such as: point size, leading, tracking, baseline shift and text color. The Character palette provides a level of character control that is comparable to InDesign's text handling (when the type tool is selected, click on the 'palettes' button to open this and the Paragraph palette). Multilingual spell checking is available and the small type buttons at the bottom enable you to quickly modify the capitalization of text, plus select anti-aliasing options.

Helv	etica (TT)		Regular	F
T	12 pt		(Auto)	1
AIV	Metrics	₹ AY	0	1
T	100%	T	100%	٦
	Opt	Co lor:		

Paragraph

Photoshop will let you place multiple lines of text. The Paragraph palette is where you can exercise control over the paragraph text alignment and justification. The indentation controls enable you to indent the whole paragraph left and right, or just indent the first line of text.

Para	graph 🔪	
	 = =	
→■	0 pt	≣l+ 0 pt
' ≢'	0 pt]
•	0 pt	
	lyphenate	

Brushes

The standard brush presets in Photoshop range from a single pixel, hard-edged brush, to a 300 pixel-wide soft-edged brush, plus various elliptical and other creative textured brush shapes in the default list. To find and select a new brush preset, mouse down on the downward pointing arrow, next to the brush shape icon in the Options bar (you can do this when any other painting type tool is selected in the Tools palette). Control/right mouse-clicking in the document window area will open the contextual menu and open the Brush Preset list on screen next to the cursor. Click on the brush you wish to select. Once you start painting, the menu will then close. If you double-click a selected brush the menu will close automatically. Control/right mouseclick+Shift-clicking will allow you to select a new paint blending mode or choose Edit Brush... which will open the Brush Preset list again. You can use the square bracket keys on the keyboard, to make the brush larger or smaller (the upper brush size limit is now 2500 pixels). Use the square bracket+Shift keys to adjust the edge hardness of the brush on-the-fly. You can add a new brush by choosing the New Brush... option in either the Options bar brush submenu, or by clicking on the New brush icon in the Options bar brush menu, or the Brushes palette submenu. The New Brush dialog will appear and allow you to name the new brush shape, then click OK to append it to the current list. You will notice that Photoshop 7.0 no longer has a separate Airbrush tool. Instead, the Brush tool features an Airbrush mode button in the Options bar.

Brushes palette

The brush presets determine the brush shape only. You can make the brush relatively larger or smaller either by adjusting the slider control, selecting a different brush preset or using the square bracket keys (between the 'P' and the Return key) to modify the brush preset size on-the-fly. The Brush Tool Presets (to the left of the brush presets in the Options bar) are a combination of two things: the brush preset and brush attributes, which are now defined in the separate Brushes palette – this includes settings for things like the 'brush dynamics'. If you are using a pressure sensitive pen stylus and you click on the Other Dynamics checkbox (see Figure 6.17), you can

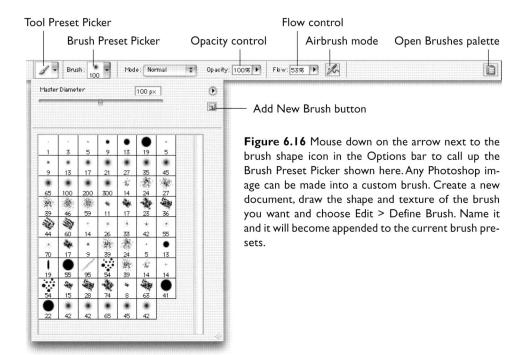

determine how the paint opacity and flow will be controlled by the pen pressure or the angle of tilt of the pen. The Wacom Intuos range includes some pens that have a thumbwheel control and in Photoshop 7.0 you can exploit all of these responsive built-in Wacom features to the full via the brush dynamics settings. You will notice that as you alter the brush dynamics settings, the brush stroke preview below will change to reflect what the expected outcome would be if you had drawn a squiggly line that faded from zero to full pen pressure (likewise with the tilt and thumbwheel). This visual feedback is extremely useful as it allows you to experiment with the brush dynamics settings in the Brushes palette and learn how these will affect the brush dynamic behavior. The following paragraph explains these settings in a little more detail.

The 'jitter' settings introduce randomness into the brush dynamic behavior. Increasing the opacity jitter means that the opacity will still respond according to how much pen pressure is applied, but there will be a built-in random fluctuation to the opacity that will fluctuate even more as the jitter value is increased. The flow setting governs the speed at which the paint is applied. To understand how the brush flow dynamics work, try selecting a brush and quickly paint a series of brush strokes at a low and then a high flow rate. When the flow rate is low, less paint will be applied, but more if you increase the flow setting or apply more pressure (or you paint slower). Other tools like the dodge and burn toning tools, use the terms Exposure and Strength. Essentially these have the same meaning as the opacity controls.

rushes		۲	Brushes	
rush Presets	Opacity Jitter	0%	Brush Presets	Size Jitter 0%
Aush Treats Shape Dynam iss Scattering Texture Dual Brush Color Dynamics Other Dynamics Other Dynamics Wet Edges Arbrush Smoothing Protect Texture	Flow Jitter		Brush Tip Shape Shape Dynamics Scattering Texture Dual Brush Color Dynamics Other Dynamics Other Dynamics Noise Wet Edges Arbrush Smoothing Protect Texture	Con tro I: Pen Tilt Cox Minimum Dismeter 7% Till Scale 200% Angle Jitter 00% Con tro I: Pen Tilt Cox Con tro I: Off Cox Phimum Roundhe as
Protect Texture	-			

Figure 6.17 Highlight a brush dynamic option in the Brushes palette to display the dynamics settings on the right. Click in the checkbox if you want to activate the settings and modify them.

The Shape dynamics can be adjusted as well to introduce jitter into the size angle and roundness of the brush. The scattering controls can enable you to produce broad, sweeping brush strokes with a random scatter. The Color dynamics let you introduce random color variation to the paint color. The foreground/background color control can be useful as this will let you vary the paint color between the foreground and background color, according to how much pressure is applied. The Dual brush and Texture dynamics introduce texture and more interactive complexity to the brush texture. It is worth experimenting with the Scale control in the Dual Brush options. The Texture dynamics utilize a choice of blending modes for different effects and of course you can add a custom texture of your own design, direct from the Pattern presets. When you have finished tweaking with the Brushes palette dynamics and other settings, go to the Tool Presets palette and click on the New preset button at the bottom, to add your new settings as a preset.

Figure 6.18 If you select the Aurora preset (see Figure 6.17 top right), you can experiment with the pen tilt settings for things such as size and angle in the Shape Dynamics settings. I then set Turquoise as the foreground color and purple for the background. I used a pen pressure setting to vary the paint color from foreground to background and created the doodle opposite by twisting the pen angles as I applied the brush strokes.

Styles

Styles are layer effect presets. New custom layer effect combinations can be saved as Styles, where they are represented in the palette by a square button icon, which will visually indicate the outcome of applying the style. Styles can incorporate the new Pattern and Gradient fill layer effects.

Swatches

You can choose a foreground color by Clicking on a swatch in the Swatches palette. To add a new color, click in the empty area at the bottom (and name the new color being added). Option/Alt-click to erase an existing swatch. New sets of color swatches can be appended or replaced via the palette submenu. You can edit the position of swatches (and other presets) simply by dragging with the cursor.

Svatches

Color

Use this palette to set the foreground and background colors by dragging the color sliders, clicking inside the color slider or in the color field below. Several color modes for the sliders are available from the submenu including HTML and hexadecimal web colors. Out-of-gamut CMYK colors are flagged by a warning symbol in the palette box. Black and white swatches appear at the far right of the color field.

Preset Manager

The Preset Manager manages all your presets from within the one dialog. It keeps track of: brushes, swatches, gradients, styles, patterns, layer effect contours and custom Shapes. Figure 6.19 shows how you can use the Preset Manager to replace a current set of brushes. You can append or replace an existing set (if the current set is saved, then you can easily reload it again). The Preset Manager will directly locate the relevant preset files from the Presets folder. The Preset Manager can be customized, which is particularly helpful if you wish to display the thumbnails of the gradients (see Figure 6.20). If you double-click any Photoshop setting that is outside the Photoshop folder, it will automatically load the program and append the relevant preset group.

Figure 6.19 Use the Photoshop Preset Manager to load custom settings or replace them with one of the pre-supplied defaults. Presets include: Brushes, Swatches, Gradients, Styles, Patterns, Contours and Custom Shapes.

Figure 6.20 Apart from being able to load and replace presets, you are able to choose how the presets are displayed. In the case of Gradients, it is immensely useful to be able to see a thumbnail preview alongside the name of the gradient.

Actions

Actions are recordable Photoshop scripts. The palette shown opposite has the default actions set loaded. As you can see from the descriptions, these will perform automated tasks such as adding a vignette or creating a wood frame edge effect. If you go to the palette fly-out menu and select Load Actions... you will be taken to the Photoshop 7.0/Presets/ Photoshop Actions folder. Here you will find many more sets of actions to add to your Actions palette. To run an Action, you will mostly need to have a document already open in Photoshop and then you simply press the Play button to commence replay. You can record your own custom actions as well. Chapter Twelve explains these in more detail and lists many other useful Photoshop shortcuts.

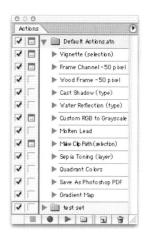

History

Photoshop can temporarily store multiple undo states and snapshots during a Photoshop session. These history states are recorded in the History palette. The number of recorded states can be anywhere between 1 and 1000, although the more histories you record the more memory Photoshop will need to save all of these. You can click on an earlier history state to revert to that particular stage of the edit, or you can paint in from history, using the history brush. For more information, see the later section on History, page 167.

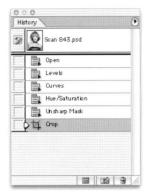

Layers

Photoshop layers are akin to layers of acetate overlaying the background layer. Each layer can contain an image element, be that a duplicate of the background image, a copied selection from another layer, another Photoshop document which has been dragged across using the move tool or Photoshop text. Adjustment layers are image adjustment instructions in a layer form. Layers can be grouped together in sets (note you can now go beyond the 99 layers limit in a single document). You can apply masking to layer contents with either a pixel layer mask or a vector mask. Layers can blend with those underneath in twenty two different blending modes. Layer effects/ styles can be used to add effects such as drop shadows, gradient/pattern fills or glows to a text or image layer. Custom styles can be loaded from and saved to the Styles palette. You will find some of the submenu options for layers are duplicated in the Layer main menu. See Chapter Eleven for more information about layers and montage techniques.

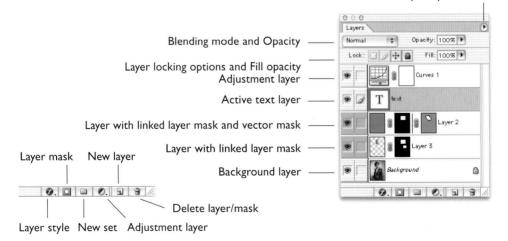

Channels

A Photoshop grayscale mode image is comprised of a single 8-bit channel of image information, with 256 levels (except when in 16-bit per channel mode). RGB images are comprised of three channels: Channel 1-Red, Channel 2-Green and Channel 3-Blue (RGB); CMYK images, four channels: Channel 1-Cyan, Channel 2-Magenta, Channel 3-Yellow and Channel 4-blacK. The Photoshop channels palette displays the color channels in this order, with a composite channel (Channel ~) listed at the top. Use the Command/Ctrl key+the channel number (or tilde key in the case of the composite channel) as a keyboard shortcut for viewing channels individually. When saving a selection (Select > Save Selection), this action either generates a new alpha channel or overwrites an existing one. New channels can also be added by clicking the Add channel button at the bottom of the Channels palette (up to 24 channels including the color channels are allowed). For specialist types of printing, alpha channels can be used to store print color information like varnish overlays or fifth/ sixth color printing of special inks. Photoshop has a spot channel feature enabling spot color channels to have a color specified and be previewed on screen in color (see Chapter Fifteen). You can use the Channels palette submenu or the buttons at the bottom of the Channels palette to delete, duplicate or create a new channel.

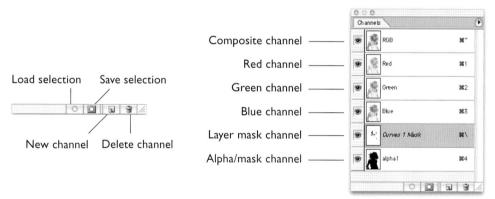

Paths

A vector path is a mathematically described outline which, unlike a pixel-based mask channel, is resolution-independent and infinitely editable. Paths can be imported from a vector drawing program such as Adobe IllustratorTM, or they can be created within Photoshop using the pen path or shape tools. A freshly drawn path is displayed as a Work Path in the palette window. Work Paths should be saved (drag down to the New Path button) if you don't wish the current work path to be overwritten. A path can be used in the following ways: to convert to a selection; apply as a layer clipping path or save as a clipping path in an Encapsulated PostScript (EPS) or TIFF file. To rename a path double-click it.

Tools palette

The Tools palette contains fifty-five separate tools and their icons give a clue as to each tool's function. The individual tool options are located in the Options bar (Window > Show Options) and double-clicking any tool will automatically display the Options bar if this happens to be hidden for some reason. Figure 6.21 shows the Tools palette layout. Within the basic Tools palette are extra tools (designated by the small triangle at the bottom of the icon). These become visible when you mouse

Figure 6.21 The Tools palette with keyboard shortcuts shown in brackets.

down on the Tools palette icon. You will notice that each tool or set of tools has a keyboard shortcut associated with it (this is displayed when you mouse down to reveal the nested tools or hover with the cursor to reveal the tool tip info). For example, pressing 'C' on the keyboard will activate the crop tool. Where more than one tool shares the same keyboard shortcut, you can cycle through these other tools by holding down the Shift key as you press the letter key. If you prefer to restore the old behavior whereby repeated pressing of the key would cycle the tool selection, go to the Photoshop menu, select Preferences > General and deselect the Use Shift Key for Tool Switch option. Personally, I prefer to use the shift modifier. You can also Option/Alt-click the tool icon in the Tools palette to cycle through the grouped tools.

If you select a particular tool and a 'prohibit' warning sign appears, you are probably working on a deep-bit image. For example, if you try to paint on an image in 48-bit color using the brush tool, a prohibit sign will appear instead of the brush tool icon. Clicking in the image document window will call up a dialog explaining the exact reason why you cannot access or use a particular feature. If you click at the very top of the Tools palette, this will now open the Adobe On-line... dialog (also available in the File menu). Any late-breaking information plus access to on-line help and professional tips are all easily accessible within Photoshop.

E Feather: 0 px Anti-alased Style: Normal Width: Height:

Selection tools

The usual editing conventions apply in Photoshop: pixels can be cut, copied and pasted just as you would do with text in a word processing document. Mistakes can be undone with the Edit > Undo command or by selecting a previous history state in the History palette. Selection tools are used to define a specific area of the image that you wish to modify separately, float as a layer or copy and paste. The use of the selection tools in Photoshop is therefore like highlighting text in a word processor program.

The marquee options include rectangular, elliptical or single row/single column selection tools. The lasso tool is used to draw freehand selection outlines and has two other modes – the polygon lasso tool, which can draw both straight line *and* freehand selections and the magnetic lasso tool. The magic wand tool selects pixels on the basis of their luminosity values within the individual channels. If you have a picture of a red London bus (there are still a few left in London) click on the bus with the magic wand tool and 'hey presto' the red color is selected! That's what most people expect the magic wand tool to do; in reality it does not perform that reliable a job. I

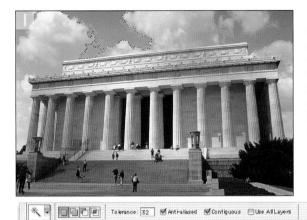

I The magic wand tool can be used to create a selection of pixels which are similar in color to the point where you clicked. So, clicking in the blue sky area will select all the blue pixels surrounding the click point. Because the Contiguous option is switched on, the selection is limited to neighboring pixels only.

2 If you were to deselect the Contiguous option in the Options bar, the magic wand tool will then select blue pixels of similar tonal value from everywhere in the image. This has now selected the blue sky areas on the other side of the cloud.

3 If you have most of the desired pixels selected, the Select > Grow command will expand the wand selection according to the tolerance value configured in the magic wand Options bar.

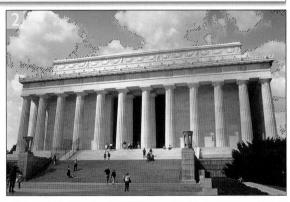

Figure 6.22 The Options bar has four modes of operation for each of the selection tools: Normal; Add to Selection; Subtract from Selection; and Intersect Selection.You can also achieve these same operating modes by using the modifier keys.

find it works all right on low resolution images (such as those prepared for screensized viewing). You can adjust the magic wand tolerance setting so that it will select fewer or more pixels, based on how similar they are in color to the pixels you are clicking on. The tolerance setting governs the sensitivity of the magic wand selection. When you click on an area in the image, Photoshop selects all the adjacent pixels whose numeric color values are within the specified tolerance either side of the pixel value. If the pixels clicked on have a mean value of 120 and the tolerance setting is set at the default of 32, Photoshop will select pixels with a color value between 88 and 152. You can use the smoothing options in the Select menu to tidy up a magic wand selection. If you are going to create complex selections this way then really you are often better off choosing the Select > Color Range option, that does base the selection on color values. This selection command provides all the power of the magic wand tool, but has much more control. I rarely ever use the magic wand when defining critical outlines, but do find it quite useful when I want to make a rough selection area based on color. In short, don't dismiss the wand completely but don't place too much faith either in its capabilities for professional mask making. There are better ways of going about doing this, as shall be explained later in the book.

Modifier keys

Macintosh and Windows keyboards have slightly different key arrangements, hence the double sets of instructions throughout the book reminding you that the Command key on the Macintosh is equivalent to the Control (Ctrl) key on a Windows keyboard (because Windows PC computers don't have a Command key) and the Macintosh Option key is equivalent to the Alt key in Windows. In fact, on the Macintosh compatible keyboards I use, the Option key is labeled as Alt. Macintoshes do have a Control key too. On the Mac its function is to access contextual menus (more of which later). Windows users will find their equivalent is to click with the right mouse button. Finally, the Shift key operates the same on both Mac and PC.

These keys are 'modifier' keys, because they modify tool behavior. Modifier keys do other things too – hold down the Option/Alt key and click on the marquee tool in the Tools palette. Notice that the tool displayed cycles through the options available. Drag down from the system or Apple menu to select About Photoshop... The splash screen reopens and after about 5 seconds the text starts to scroll telling you lots of stuff about the Adobe team who wrote the program etc. Hold down the Option/Alt key and the text scrolls faster. If you hold down the Command/Ctrl key and choose About Photoshop... you will see the *Liquid Sky* beta test version of the splash screen. *Liquid Sky* is an early eighties science fiction movie, which I did try to watch once (in the interests of research). If nothing else it serves as a reminder of how terrible the music scene was around then! If you want to see another Easter egg, go to the

Layers palette, hold down the Option/Alt key and choose Palette Options from the palette submenu. For the most part, modifier keys are used in conjunction with the selection tools and as you get more proficient you should be able to reach to the appropriate key instinctively without your eyes having to leave the screen.

Figure 6.23 The modifier keys on a Macintosh keyboard and their Windows PC equivalents.

The Shift and Option/Alt keys affect the shape and drawing behavior of the marquee tools: holding down the Shift key when drawing a marquee selection constrains the selection to a square or circle; holding down the Option/Alt key when drawing a marquee selection centers the selection around the point where you clicked on the image.

Holding down the Shift+Option/Alt keys when drawing a marquee selection constrains the selection to a square or circle and centers the selection around the point where you first clicked. Here is another useful tip: after drawing the selection, do not release the mouse button yet – hold down the Spacebar. This allows you to reposition the placement of the selection. Release the Spacebar and you can continue to modify the shape as before.

After the first stage of drawing a selection, whether by marquee, lasso, magic wand or a selection has been loaded from a saved alpha channel with subsequent selection tool adjustments, the modifying keys now behave differently.

Holding down the Shift key as you drag with the marquee or lasso tool adds to the selection. Holding down the Shift key and clicking with the magic wand tool also adds to the existing selection.

Holding down the Option/Alt key as you drag with the marquee or lasso tool subtracts from the selection. Holding down the Option/Alt key and clicking with the magic wand tool also subtracts from the existing selection. A combination of holding down the Shift+Option/Alt keys together whilst dragging with a selection tool (or clicking with the magic wand) creates an intersection of the two selections.

To summarize: The Shift key adds to a selection. The Option/Alt key subtracts from a selection and the Shift+Option/Alt keys intersect a selection. To find out more about practical techniques requiring you to modify selection contents, refer to Chapter Eleven on montage techniques.

♀ ♀ ゅ Lasso: freehand/polygon/magnetic

The lasso tool behavior is more or less identical to that of the marquee selection tools – the same modifier key rules apply. To use the standard lasso tool, just drag around the area to be selected holding down the mouse as you draw. When you release the mouse, the selection joins up from the last point drawn with the starting point.

In polygon mode, you can click to start the selection, release the mouse and position the cursor to draw a straight line, click to draw another line and so on. To revert temporarily to freehand operation, hold down the Option/Alt key and drag with the mouse. Release the Option/Alt key and the tool reverts to polygon mode. To complete the polygon lasso tool selection position the cursor directly above the starting point (a small circle icon appears next to the cursor) and click.

Per Feather: Opx @Antraliased Width: 10 px Edge Contrast: 10% Frequency: 57 Pen Pressure

The magnetic lasso and the magnetic pen tool both use the same code and they are therefore basically the same in operation, except one draws a selection and the other a pen path. The magnetic lasso has a sensing area (set in the Options bar). When you brush along an image edge, where an outline is detectable, the magnetic lasso intelligently prepares to create a selection edge. You continue to brush along the edges until the outline is complete and then you close the selection.

This innovation is bound to appeal to beginners and anyone who has problems learning to draw paths with the pen tool. I reckon on this being quite a powerful Photoshop feature and should not be dismissed lightly as an 'idiot's pen tool'. Used in conjunction with a graphics tablet, you can broaden or narrow the area of focus by varying the stylus pressure. Without such a tablet, you have basic mouse plus keyboard con-

I Where there is a high contrast edge, the magnetic lasso has little problem following the suggested path roughly drawn by dragging along the shirt collar. Fastening points are automatically added along the path. The center cross-hair hotspot will help guide you when locating the edge.

2 The size of the magic lasso selection area can be enlarged by lessening the pressure if using a graphic tablet input device. This makes drawing an outline much quicker. For precise edge definition, add more pressure to narrow down the tool's field of view.

3 In a situation like this there is quite a lot of room for latitude. As you draw the tool away from the edge, it does not add another point until it senses a continuation of the edge. You can watch the tool laying down a path like a magnet sticking to an edge. To scroll the screen as you work, hold down the Spacebar – this temporarily accesses the hand tool without disturbing the operational flow of the selection tool.

trol, using the square bracket keys ([and]) to determine the size of the tool focus area. The only way to truly evaluate the performance of the magnetic tools is to take them for a spin and learn how to use them in combination with the relevant keyboard keys. In operation, the magnetic lasso and magnetic pen tool operate alike: the magnetic lasso draws a pseudo path, laying down fastening points along the way – the distance apart of the points can be set in the Options bar as a frequency value, whilst the edge contrast specifies the minimum contrast of an edge before the tool is attracted. As you brush along an edge, an outline follows the edge of greatest contrast within the brush width area and sticks to it like a magnet.

4&5 If you veer too far off course, reverse the path of the tool and hit the delete key to erase the previous point (there are no limits to this type of undo). To complete the selection, hit the Enter key or double-click. The end points will join up and if there is a gap, attempt to follow and continue the image outline.

I The magnetic tools in Photoshop operate by analyzing the composite image to determine where the edges of an object lie. The difficulty is that the edges are not always as clear to Photoshop as they seem to be to us.

2 One answer is to sometimes add a temporary, contrast increasing adjustment layer to the image. So, add a new curves adjustment layer and make the curve an 'S' shape. Now the outline appears much clearer and the magnetic tools have no trouble seeing the edges. When the magnetic selection or path is complete, discard the adjustment layer.

Layers	1	ł
Normal	Oplacity: 100	178
Lock:	🖸 🌶 🖨 🛛 Fill: 100	178
•	Dunes 1	
	Background	۵

Photograph: Peter Hince.

To reverse a magnetic outline, drag back over the outline so far drawn. Where you meet a fastening point, you can either proceed from that position or hit the delete key to reverse your tracks even further to the fastening point before that and so on... You can manually add fastening points by clicking with the mouse.

When defining an outline, a combination of mousing down with the Option/Alt key changes the tool back to the regular lasso to manually draw round an edge. Holding down the Option/Alt with the mouse up changes the tool to the polygon lasso (or freeform pen tool if using the magnetic pen). Other selection modifier key behavior comes into play before you start to drag with the tool – hold down the Shift key then drag to add to an existing selection. You don't have to keep the mouse pressed down as is necessary with the lasso. When using the magnetic lasso, you can just click, drag and only click again when you wish to lay down a fastening point.

To complete a selection, click on the start point. Double-click or hit Enter to close with a line determined by the magnetic tool. Photoshop will intelligently follow the line you are currently on and close the loop wherever there is good edge contrast for the tool to follow. Option/Alt+double-click closes the path with a straight line segment.

▶_⊕ Move tool

The move tool can now be more accurately described as a move/transform/alignment tool. The transform mode is apparent whenever the Show Bounding Box is checked (initially a dotted bounding box appears around the object). When you mouse down on the bounding box handles, the Options bar display will change to reveal the numeric transform controls (no longer a menu item). This transform feature is only active when the move tool itself is selected and not when you use the Command/Ctrl key shortcut.

When several layers are linked together, you can click on the align and distribute buttons in the Options bar as an alternative to navigating via the Layer > Align Linked and Distribute Linked menus (see Chapter Fifteen for more about the align and distribute commands). The move tool is also activated whenever you hold down the Command/Ctrl key. The exceptions to this are when the slice or slice select tools are selected (the Command/Ctrl key toggles between the two), or when the hand, pen tool or path selection tools are active. The Option/Alt key modifies move tool behavior. Holding down the Option/Alt key plus the Command/Ctrl (move tool shortcut) as you drag a selection makes a copy of the selection.

You can use the move tool to:

- Drag and drop layers and selections from one image window to another.
- Move selections or whole images from Photoshop to another application.
- Move selection contents or layer contents within a layer.
- Copy and move a selection (hold down Option/Alt key).
- Apply a Transform to a layer.
- Align and/or distribute layers.

When the move tool is selected, dragging will move the layer or selection contents (the cursor does not have to be centered on the object or selection, it can be anywhere in the image window). When the Auto Select Layer is switched on, the move tool will auto-select the uppermost layer containing the most opaque image data below the cursor. This is a useful mode for the move tool with certain layered images. If you have the move tool selected in the Tools palette and the Auto Select Layer option is unchecked, holding down the Command/Ctrl key temporarily inverts the state of the move tool to Auto Select Layer mode. Where many layers overlap, you can use the move tool plus Ctrl/right mouse-click to access the contextual layer menu. This is a more precise method of selecting any layer with greater than 50% opacity from within the document window.

1		3				1111.01334.2.0.000.0000	1		1			
11 1	71	¥.	Width:		Height:		Resolution:	pixels/inch 💲	16	Front Image	Clear	
1 *	+	19		L	Lundaur.			Preserver +	1 8	The stand of the s	C on a	

Crop tool

The crop tool uses color shading to mask the outer crop area. This provides a useful visual clue when making a crop. Figure 6.24 shows the Options bar in 'crop active' mode, where the default shade color is black at 75% opacity. This color can easily be changed by clicking on the color swatch in the Options bar and choosing a new color from the picker. The standard color and opacity will enable you to preview the crop with most images quite adequately. Only if the images you are working on have very dark background will you benefit from changing the color to something like a 'ruby lith' red or another lighter color. You can also hide/show the crop outline using the View menu > Hide Extras command. The Delete button in the Options bar will delete layered image data outside of the crop boundary. The Hide button will crop the image, but only hide the layer data that is outside the crop boundary (also referred to as big data). The hidden layer data will be preserved, but only on non-background layers. When one or more layer's contents extend beyond the canvas boundary, the Image > Reveal All command can be used to enlarge the canvas size to show the hidden 'big data'.

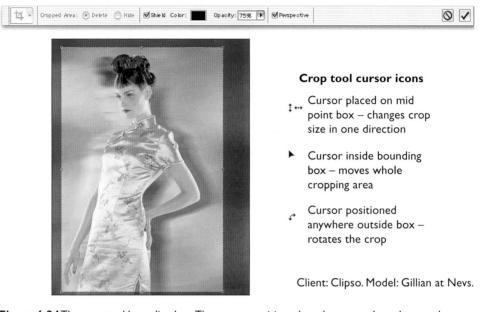

Figure 6.24 The crop tool bounding box. The cursor positioned on the corner box changes the crop dimensions both horizontally and diagonally. The center point can be repositioned to set the central axis of rotation.

Figure 6.25 In this example the Image > Trim... command is used to crop the image based on transparency. Photoshop crops all four edges, removing transparent contents only.

You can use the Enter key to OK the crop and the Escape (esc) key to cancel and exit from a crop. On Macintosh and PC keyboards, these keys should be diagonally positioned, with the 'esc' key at the top left and Enter key at bottom right. Drag the crop tool across the image to marquee the area to be cropped. Refine the position of the crop by directly dragging any of the eight crop handles. If View > Snap to > Document bounds is checked, the crop tool will snap to the edge of the document. To avoid this, go to the View menu and uncheck the Document Bounds or general Snap

To behavior. If the Perspective box is checked in the crop tool options bar, this will take you into the perspective cropping mode. For more about perspective cropping, see Chapter Eight.

To constrain the proportions of the crop, hold down the Shift key as you drag. You can reposition the crop without altering the crop size by dragging within the crop area. To rotate the angle of the crop, move the cursor anywhere just slightly outside the crop window. The crop bounding box has a movable center point. When you place the cursor and drag above the center point the central axis of rotation can be repositioned. The Image > Trim... command can be used to crop an image based on pixel color values. Figure 6.25 shows an example of how trimming can crop an image based on transparency.

Figure 6.26 Images can be sliced up in Photoshop 6.0 using the slice tool.You can optimize individual slices inside the Photoshop Save for Web dialog (ImageReady slices will also be recognized in Photoshop). Choose Layer > 'New Layer Based Slice' to create slices based on Photoshop layers.This will update the slices when layer effects like Drop Shadows are added or adjusted.

	* •	Style : Normal 📫	Width:	Height :	Slices From Guides	
--	-----	------------------	--------	----------	--------------------	--

Slices are a web designer's tool that is used to divide an image into rectangular sections. These are then used in Photoshop or ImageReady, for example, to specify how each individual slice will be optimized, what file format a slice area will be saved in and what compression shall be utilized. You use the slice tool to manually define a user-slice. As you create user-slices, Photoshop automatically generates auto-slices to divide up the other areas (as can be see in Figure 6.26). You can use the slice afterwards. If you are looking for the Show Slice Numbers checkbox, this is now contained in the Guides, Grid and Slices preferences. In Photoshop 7.0 you can now auto-create slices from the Photoshop guides, by clicking on the Slices From Guides button in the Options bar.

The paint tools

The painting tools are all grouped below the selection and move tools. There are some common options available for these tools – they all make use of blending modes and have variable opacity settings. If you have a graphic tablet as your input device (which I highly recommend) the stylus pressure sensitivity options will become active in Photoshop. These offer fine control over tool behavior (see the earlier section on the Brushes palette). The Fade options found in the Brushes palette brush dynamics are not stylus-dependent. The number of fade steps entered will allow you to 'fade out' a brush stroke. Here is a rundown of the main Photoshop paint tools.

Healing brush/Patch tool

These two tools are the main star attraction of Photoshop 7.0. The healing tools will enable you to perform complex retouching tasks with an incredible level of finesse and in a fraction of the time that it took previously. For examples of the healing brush and the patch tool I action, check out some of the repairing and retouching tutorials shown in Chapter Ten.

Brush: •••	Mode : Normal 📫	Opacity: 100% 🕨	Fbw: 53% 🕨 📈	٦
------------	-----------------	-----------------	--------------	---

🖌 🛛 Brush

The brush tool can be used with a range of brush sizes from a single hard edged pixel up to the largest soft edged brush (2500 pixels). The airbrush mode makes the brush tool mimic the effect of an airbrush, producing a spray of paint. As you click with the mouse or press down with the stylus, just as in real life, if you stop moving the cursor, the airbrush paint will continue to spread out until the opacity level you set is reached. The Flow control determines how 'fast' the brush tool applies paint to the image. You can open the Brushes palette by clicking on the palette icon at the far right. The Wet Edge painting mode (now in the Brushes palette options) builds extra density around the edges of the brush stroke. This imitates a natural water color effect.

Brush: • •	Mode: Normal 🗳	Opacity: 100% 🕨	🖻 Auto Erase	
------------	----------------	-----------------	--------------	--

Pencil

The pencil produces hard edged, anti-aliased, pencil-like drawing lines. The pencil tool is a fast response sketching tool. The 'Auto Erase' option converts the tool from painting with the foreground to the background color. The Auto Erase feature can also be accessed by holding down the Option/Alt key when painting with the pencil.

🛃 🐮 🔹 Clone stamp/Pattern stamp

An essential tool for retouching work such as spotting (discussed later in Chapter Ten) and general image repairing. The clone stamp tool is used to sample pixels from one part of the image to paint in another. Keep the Aligned box checked, hold down the Option/Alt key and click where you want to sample from. Release the key and click in the area you want to clone to. This action defines a relationship between sample and painting positions. Once set, any subsequent clicking or dragging will allow you to apply the clone stamp, always using the same coordinates relationship

until a new source and destination are defined. The sample point can also be from a separate image. This is useful for combining elements or textures from other pictures. The clone stamp normally samples from a single layer only. The Use All Layers option permits the clone sample to be taken from merged layer pixel information. The pattern stamp tool allows you to select a pattern in the Options bar and paint using the chosen pattern as your image source. The Impressionist mode option adds some jitter to the pattern source and can be used to produce a more diffuse pattern texture.

3.	Brush:	Mode: Normal	1	Opacity: 100% 🕨	Fbw: 100% 🕨 🗍	to		

3 History brush

Before History made its first appearance in Photoshop 5.0, there were few ways you could restore a previous image state. The History amalgamates some of the old work-arounds into a single Photoshop feature. It augments the use of the Snapshot and very cleverly makes use of the image tiling to limit any unnecessary drain on memory usage. One can look at the History as a multiple undo feature in which you can reverse through up to 1000 image states, but in actual fact History is a far more sophisticated and powerful tool than just that. Painting from History saves you from tedious work-arounds like having to duplicate a portion of the image to another layer, retouching this layer and merging back down to the underlying layer again.

The History palette displays the sequence of Photoshop states as you progress through a Photoshop session (as shown in Figure 6.28). To reverse to a previous state, you can either click on it or drag the arrow slider back up the list. The number of histories allowed can be set in the Photoshop preferences. When the maximum number of history states has been reached, the earliest history state at the top of the list is discarded. If you reduce the number of history states allowed, any subsequent action will also cause the earlier history states to be discarded.

History brush and Snapshot

To create a snapshot, click on the Snapshot button at the bottom of the palette. Snapshots are stored above the divider – this records the image in its current state and prevents this version of the image from being overwritten for as long as the document is open and being edited. The default operating mode stores a snapshot of the opening image state. You can choose not to store an opening image this way if you prefer or take more snapshots at any time to add to the list. This feature is useful if you have an image state that you wish to temporarily store and not lose as you make further image changes. There is no constraint on only having a single snapshot stored at a time. In the History palette options you can check to automatically generate a new snapshot each time you save (which will also be time-stamped). This can be useful, but be aware that it may cause Photoshop's memory usage to increase significantly. Alternatively, you can click the duplicate image button to create a duplicate image state and then save this as a file.

Figure 6.27 Click on the New Snapshot button at the bottom of the History palette – this will record a snapshot of the history at this stage. If you Option/Alt-click the button, there are now three options: Full Document, which stores all layers intact; Merged Layers, which stores a composite; and Current Layer, which stores just the currently active layer. The adjacent New Document button will duplicate the active image in its current history state.

	Scan 820.psd
N	Shap shot 1
	Open
	Hue/Saturation 1 Layer
ļ	Load Selection

To use the history brush, go to the History palette and click on the space just to the left of the history state you wish to paint from - you will see a history brush icon appear against it. You can then paint information in from a previous history state (or from one of the snapshots) to the active state. The history brush lets you selectively restore the previously held image information as desired. That is a simple way of looking at the history brush, but it is actually more versatile than that. The alternative spotting technique in Chapter Ten shows how the history feature can be used to avoid the need for duplicating layers. The history feature does not really take on the role of a repeat Edit > Undo command and nor should it. There are several actions which will remain only undoable with the undo command, like intermediate changes when setting shadow and highlights in the levels dialog. Furthermore there are things which can be undone with Edit > Undo that have nothing to do with the history. If you delete an action or delete a history, these are only recoverable using Edit > Undo. So although the history feature is described as a multiple undo, it is important not to confuse history with the role of the undo command. The undo command is toggled and this is because the majority of Photoshop users like to switch quickly back and forth to see a before and after version of the image. The current combination of undo commands and history has been carefully planned to provide the most flexible and logical approach - history is not just as an 'oh I messed up. Let's go back a few stages' feature, the way some other programs work, it is a tool designed to ease the workflow and allow you more creative options in Photoshop.

History stages	Scratch disk
Open file	61.2
Levels adjustment layer	138.9
Curves adjustment layer	139.9
Rubber stamp	158.3
Rubber stamp	159.1
Rubber stamp	160.1
Rectangular marquee	139.7
Feather 100 pixels	149.9
Inverse selection	162.6
Levels adjustment layer	175.3
Flatten image	233.5
Unsharp mask filter	291.7
Close	

Figure 6.28 The accompanying table shows how the scratch disk memory will fluctuate during a typical Photoshop session. The opened image was 38.7 MB in size and 250 MB of memory was allocated to Photoshop. Notice how minor local changes to the image do not increase the amount of memory used compared with the global changes. The history states are recorded in the History palette. The active history state is indicated by the pointer icon (circled in blue above).

History and memory usage

Conventional wisdom suggested that any multiple undo feature would require vast amounts of memory to be tied up storing all the previous image states. Testing Photoshop history will tell you this is not necessarily so. It is true that a combination of global Photoshop actions will cause the memory usage to soar, but localized changes will not. You can observe this for yourself – set the image window bottom left corner status display to show Scratch Disk usage and monitor the readout over a number of stages. The right hand value is the total amount of scratch disk memory currently available – this will remain constant, watch the left hand figure only. Every Photoshop image is made up of tiled sections. When a large image is in the process of redrawing you see these tiles rendering across the screen. With history, Photoshop memorizes changes to the image at the tile level. If a brush stroke takes place across two image tiles, only the changes taking place in those tiles are updated and therefore the larger the image the more economical the memory usage will be. When a global change takes place such as a filter effect, the whole of the image area is updated and memory usage will rise accordingly. A savvy Photoshop user will want to customize the his**Figure 6.29** This picture shows the underlying tiled structure of a Photoshop image when it is being edited. In this example we have a width of four tiles and a height of three tiles. This is the clue to how history works as economically as possible. The history only stores in Photoshop memory the minimum amount of data necessary at each step. So if only one or two tile areas are altered by a Photoshop action, only the data change for those tiles is recorded.

tory feature to record a reasonable number of histories, while at the same time being aware of the need to change this setting if the history usage is likely to place too heavy a burden on the scratch disk memory. The example in Figure 6.28 demonstrates that successive histories need not consume an escalating amount of memory. After the first adjustment layer, successive adjustment layers have little impact on the memory usage (only the screen preview is being changed). Clone stamp tool cloning and brush work affect changes in small tiled sections. Only the flatten image and unsharp mask filter which are applied at the end add a noticeable amount to the scratch disk usage. The Purge History command in the Edit > Purge menu provides a useful method of keeping the amount of scratch disk memory used under control. If the picture you are working with is exceptionally large, then having more than one undo can be both wasteful and unnecessary, so you should perhaps consider restricting the number of recordable history states. On the other hand, if multiple history undos are well within your physical system limits, then make the most of it. Clearly it is a matter of judging each case on its merits. After all, History is not just there as a mistake correcting tool, it has great potential for mixing composites from previous image states.

Non-linear history

Non-linear history enables you to branch off in different directions and recombine effects without the need for duplicating separate layers. Non-linear history is not an easy concept to grasp. The best way to think about non-linear history is to imagine each history state having more than one 'linear' progression, allowing the user to branch off in different directions instead of as a single chain of events in Photoshop. You can take an image down several different routes, whilst working on the same file in a single Photoshop session. Snapshots of history branches can be taken and painted in with other history branches without the need to save duplicate files. Non-linear history requires a little more thinking on your part in order to monitor and recall image states, but ultimately makes for more efficient use of the available memory. To see some practical examples of how to use this and other history features in a Photoshop retouching session, refer to Chapter Eleven on montage techniques.

Key combination	Action
Command/Ctrl-Z (Toggles Undo	/Redo)
Command/Ctrl-Z	Undo/Redo command
Command/Ctrl+Option-Z	Step back through history states
Command/Ctrl+Shift-Z	Step forward through history states
Command/Ctrl+Shift-Z	
Command/Ctrl-Z	Step back through history states
Command/Ctrl+Shift-Z	Step forward through history states
Command/Ctrl-Y	
Command/Ctrl-Z	Step back through history states
Command/Ctrl-Y	Step forward through history states

Figure 6.30 This is a summary of the outcome of the permutations of the three types of undo/redo settings available in the Photoshop menu > Preferences > General options. The toggle undo/redo setting is the default. The Command+Shift-Z and Command-Y behaviors are identical: they allow you to disable the toggle undo function. However, selecting the Command/Ctrl-Y option will lose you the ability to use the Command/Ctrl-Y shortcut to toggle soft proofing.

3 Art history brush

The art history brush was introduced in version 5.5. I have to confess that this is not the most essential Photoshop tool that was ever invented and am at a loss to know how a photographer like myself might wish to use it. Nevertheless, with art history you use the art history brush to sample from a history state, but the brush strokes have some unusual and abstract characteristics which smudge the pixels with sampling from the selected history state. The brush characteristics are defined in the Art History Options bar. Fidelity determines how close in color the paint strokes are to the original color. The larger the Area setting, the larger the area covered by and more numerous the paint strokes. I To explore the potential of the art history brush, I took the backlit flower image and applied a Brush Stroke > Ink Outlines filter. I then clicked to the left of the unfiltered history state, to set this as the history source. The art history brush is located next to the history brush in the Tools palette. With it you can paint from history with impressionistic type brush strokes.

2 The most significant factor will be the brush stroke type – in this particular example I mostly used 'Dab' and set the blending mode to Lighten only. The brush shape will have an impact too, so I varied the choice of brushes, using several of the bristle type brushes (see Photoshop brushes, earlier in this chapter).

🖉 🔹 Brush : 🍨 🗣

000

Mode: Brush

Eraser/background eraser/magic eraser

Opacity: 100% 🕨

10

The eraser removes pixels from an image, replacing them with the current background color. There are three brush modes: brush, pencil and block. If you check the Erase to History box, the eraser behaves like the history brush. Holding down Option/Alt as you paint also erases to the currently selected History. The brush flow option is ony available when erasing in brush mode. Note that some graphic tablet devices like the WacomTM series operate in eraser mode when you flip the stylus upside down. This is recognized in Photoshop without having to select the eraser tool.

Erase to History

I The magic eraser tool operates like a combination of the magic wand followed by a delete command. For this reason it is sometimes best to duplicate a layer first before you do any erasing. Remember, you can always use the history feature as a means to restore any mistakenly erased pixels. 2 In this first example, I clicked with the magic eraser on the sky area about half way up to the left of the spire. The magic eraser options were set to Contiguous. This meant that only neighboring pixels which fell within the specified tolerance (32) would be selected by the magic eraser and deleted.

3 When the Contiguous option is deselected, all pixels with a color value within the specified tolerance will be deleted. In this example, I clicked with the magic eraser in the same position as example 2. Nearly all of the blue pixels are erased at a stroke, like all the sky pixels on the right of the spire, but also some of the blue pixels contained in the shadow of the roof. This does not matter too much because I can always use the history brush later to restore any detail which becomes lost this way.

4 The background eraser tool provides more precise control. Here the tool is set to erase sampling 'Once' and in Find Edges mode. This means that when I click and drag, all pixels within a specified tolerance (or pressure applied by the stylus) of the pixel value where I first clicked will be erased by the tool. The background eraser will also erase the background sample color from the edge pixels – this will help remove the color contamination as you erase. The Find Edges mode preserves the edge sharpness better.

To summarize the other erasing tools: the background eraser erases pixels on a layer to transparent based on the pixel color sampled, while the magic eraser works like the paint bucket tool in reverse – erasing neighboring or 'similar' pixels, based on the pixel color value where you click. The magic wand and paint bucket tools also have the 'Contiguous' mode of selection, available as a switchable option in the Options bar. Switching this on or off allows you to make a selection based either on neighboring pixels only falling within the specified tolerance or all pixels in the image of a similar value.

The Extract command

I The Photoshop Extract command is a sophisticated, automated masking tool and can be compared directly to competing plug-in products. The Extract command is an integral part of the program and works well in combination with the background eraser which can remove any portions of the image that the Extract command fails to erase. You first define the edge of an object, roughly painting along the edge with the highlighter tool (Smart Highlighting makes this task easier now) and mistakes can be undone using Command/Ctrl-Z. Where the object to be extracted has a solid, well-defined interior, you can fill the inside areas using the fill tool.

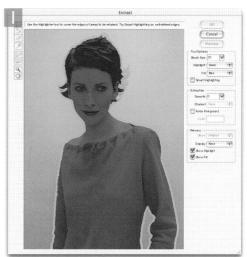

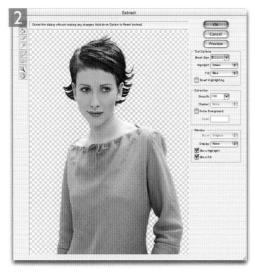

2 When you click on the Preview button, Photoshop calculates and previews the resulting mask in the dialog window. Inside the dialog window interface, you can edit the mask edges with the highlighter, eraser and fill tools or adjust the smoothness to remove any pixel artifacts. You can also tidy up the extraction in the preview using the new clean-up tools. Test with the Preview as many times as you wish before proceeding to apply the chosen settings and erase the areas outside the object to transparency.

For more on how to use the new eraser tools and the Extract command, see Chapter Eleven on montage techniques.

Client: YU salon. Model: Kate Broe at M&P.

The gradient tool can be used to draw linear, radial, angular reflected or diamond gradients. Go to the Options bar and click on the gradient ramp (top left) to select a gradient option such as Foreground to Background color, or click on the small arrow to the right to open the gradient list. When you drag with the gradient tool inside the image window, a gradient fill is created between those two points. Hold down the Shift key to constrain the gradient angle to a horizontal/vertical or 45 degree angle. Check the Reverse box to reverse the gradient fill colors before you drag. The Dither checkbox should be kept on – this will add a subtle noise, ensuring there is less risk of any banding appearing in the gradient fill. When the Transparency box is checked, the transparency masks in gradients are recognized. A number of preset gradients are readily available when you first open the gradient list from the Options bar. You can also easily edit and create your own gradient pattern and any alterations you make to an existing preset gradient will not overwrite that preset. See the accompanying tutorial showing how to create and customize a gradient.

Gradients can also be applied as a fill layer in Photoshop. Go to the Layers palette, click on the adjustment layer button and select Gradient Layer. This action will add a gradient that fills the whole layer and add a layer mask. This feature is like any other type of adjustment layer in that it allows you to edit the gradient fill. You can alter the precise angle or gradient type etc. at any time.

Foreground to Background	Gradient Editor
Foreground to Transparent	Presets
Black, White	
Red, Green	Load
Violet, Orange	
Blue, Red, Yellow	Name: Custom New
Blue, Yellow, Blue	Gradient Type: Solid
Orange, Yellow, Orange	Smoothness: 100 🍽 %
Violet, Green, Orange	
Yellow, Violet, Orange, Blue	Stops →
Copper	Opacity: 🔊 % Location: 👘 % Delete
Chrome	Color: Location: 0 % Delete

I To create a custom gradient, click on the gradient ramp in the Gradient Options bar and choose Edit... This will open the accompanying Edit dialog box. (Clicking on the side arrow will call up the gradient list – shown here in Small Text view mode.)

 ${f 2}$ Click on the lower left-most stop to select it and then double-click it or click once on the color box – this will open the Color Picker. Choose a new color for the start of the gradient. In this example, I picked a bright blue.

3 If I click above the bar, I can add a new transparency stop. Notice how the lower part of the dialog changes. I can alter the opacity of the gradient at this 'stop' point to, say, 50%. I can position this transparency stop anywhere along the gradient scale and adjust the diamond-shaped midpoints accordingly.

4 I can then add another transparency stop, but this time restore the opacity to 100% and prevent the transparency fading to the right of this point. I added another color stop below and made the color purple. When the gradient editing is complete all I have to do is rename the gradient in the space above and click on the New button. The new gradient will be saved and added to the current gradient set.

2 mothness: 100 V %

oothness: 100	▶%		
. ↓		\$	
Stops			
Opacity: 50	▶%	Location: 26	% Delete

noothness: 10					
J	Q	La Los Contractores and the]
1	\$	Â			
Opacity:	» %	Location:		Delete	
Color:	Þ	Location: 0	% (Delete	

Noise gradients

I It is important to note that the Noise Gradient Editor is separate to the Solid Gradient Editor and any settings made in the Solid Gradient Editor will have no bearing on the appearance of the noise gradient. When you select Gradient Type: Noise, the smooth gradient ramp will be replaced by a random noise ramp. Clicking on the Randomize button will present you with many interesting new random gradient options to choose from.

Presets	ОК
Magenta, Green, Yellow	Cance
Purple, Green, Gold	Load.
Red, Purple, Blue	Save.
e: Custom	New
radient Type: Noise 😫	
toughness: 50 🕨 %	
	Options:
Color Model: RGB +	Options:
Color Model: RGB +	

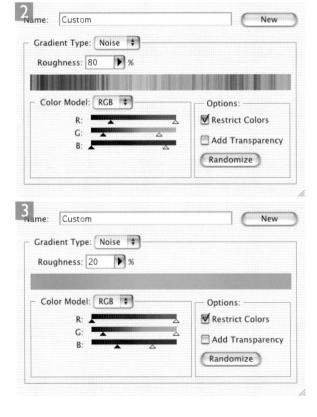

2 Increase the amount Roughness to make the noise gradient more spiky. The color sliders below edit the color content. In RGB mode, the red right-hand slider controls the amount of red content, while the left-hand slider controls the complimentary, cyan content and so on... Check the Saturate Colors box to boost color richness.

3 The Noise Gradient Editor is a very versatile tool, and it is well worth experimenting with the roughness slider – lower percentage settings can produce some very subtle effects.

More about gradients is covered in the Preset Manager section of this chapter, page 128 and Chapter Fourteen on coloring effects and the use of gradient fill and gradient map fill layers.

	8.	Fill: Fore ground	Pattern :	Mode: Normal	Opacity: 100% 🕨 Tolerance: 32 🖉 Anti-aliased @Contiguous 📄 All Layers
- 10.0				A State of the second second	

Paint bucket

In some ways this tool is in effect nothing more than 'make a magic wand selection based on the sampled color and Tolerance setting in the Options bar and fill the selection with the current foreground color or predefined pattern'. In this mode of operation, there is none of the flexibility associated with making a magic wand or Color Range selection and modifying it before filling. You can use the paint bucket to quickly fill the inside areas of a mask or quickmask outline. The Contiguous option is also available for the paint bucket (see the magic wand description) and the All Layers option neatly allows you to fill using a pixel color sample based on all layers. The paint bucket can also be used for filling with a pattern as well as with a solid color. Choose the Pattern mode from the Options bar and select the pattern type.

	0.	Brush:	Mode: Normal 📫	Strength: 50%	🗐 Use All Layers		
--	----	--------	----------------	---------------	------------------	--	--

👌 🛕 剜 🛛 Focus: blur/sharpen/smudge

Using the blur tool is just like painting with the gaussian blur filter. I often use the blur tool to soften portions of an image or to locally modify an alpha channel mask. The Use All Layers option is new to Photoshop 7.0. When you use the blur, sharpen or smudge tool, it will read all the visible image data when adding blurred, sharpened or smudged pixels to the currently active layer. Use the sharpen tool sparingly, as excessive sharpening can create nasty image artifacts. It is much better to make a feather edged selection of the area to be sharpened and apply the unsharp mask filter instead. When the blur or sharpen tool is selected, you can temporarily switch between one tool and the other, by holding down the Option/Alt modifier key.

50 .	Brush:	Mode : Normal 🗘	Streng th: 50%	🗎 Use All Layers	📄 Finger Pain ting		
------	--------	-----------------	----------------	------------------	--------------------	--	--

The smudge tool selects the color of the pixels where you first click and smears the pixels in whichever direction you drag the brush. For best results I recommend using a pressure sensitive graphics tablet. The Finger Painting option uses the current foreground color for the start of the smudge. It is best to think of this as an artist's tool like a palette knife used in oil painting.

Toning tool options	
Dodge tool	Function
Option+Shift+S	Set Dodge to Shadows
Option+Shift+M	Set Dodge to Midtones
Option+Shift+H	Set Dodge to Highlights
Option/Alt key	Toggle to Burn tool
Burn tool	Function
Option+Shift+S	Set Burn to Shadows
Option+Shift+M	Set Burn to Midtones
Option+Shift+H	Set Burn to Highlights
Option/Alt key	Toggle to Dodge tool
Sponge tool	Function
Option+Shift+D	Set Sponge to Desaturate
Option+Shift+S	Set Sponge to Saturate

Figure 6.3 I The toning tool shortcut options.

Brush: 65 Range: Midtones 1 Exposure: 50% 1

Toning: dodge/burn/sponge

Dodging and burning should be familiar photographic concepts. Photoshop provides a nice element of control over the tool effect: you can choose to apply the toning effect selectively to either the Highlights, Midtones or Shadows. Thus if you want to darken or burn the shadow portion of an image without affecting the adjacent highlights, choosing the burn tool in Shadows mode will enable you to do this. As an alternative to the clone stamp tool, the dodge tool is excellent for removing wrinkles and facial lines without altering the underlying texture if applied in very low percentages. The third option is the sponge tool, which has two modes: Saturate increases the color saturation, Desaturate lowers the color saturation. The handy shortcuts listed in Figure 6.27 permit quick access to the tonal range application settings. As with the blur and sharpen tool, holding down the Option/Alt modifier key will temporarily switch between the dodge and burn tools.

Show Bounding Box	Combine Dans Combine	
	Auto Add/Delete	٩
	Pen Options	
	Magnetic	9

🖎 🍦 🏠 🏠 🏠 🏠 ト 🛛 Pen and path drawing

Photoshop provides a suite of vector path drawing tools that work in the same way as the pen path tools found in drawing programs like Illustrator and Freehand. For detailed instructions on drawing paths and working with the pen tool, refer to Chapter Eleven on montage techniques. The magnetic pen tool behavior is more or less identical to the magnetic lasso tool described earlier.

T Helvetica (TT)	Regular T 12 pt		
T Helvetica (TT)	Regular 💽 🕂 12 pt	aa Drisp	

TIT TIT Type tool

The type tool allows direct on-canvas text editing. There are two ways you can use the type tool: either click in the image window and begin typing – this will add a single line of text – or you can click and drag to define a type box to which you can add lines of wraparound text. Click on the Palettes button (on the far right in the Options bar) to bring the Character and Paragraph palettes to the front of the palette set. These provide full typographic control of the text.

Because the type is in vector art form, it remains fully editable. To edit, highlight the type using the type tool. (Tip: choose View > Hide Extras to hide highlighting.) You can change the fonts, apply different colors to all the text or just single characters, or enter new text. Layer effects/styles can be applied to both type layers and image layers. Layer effects automate the process of adding grouped layers to provide effects such as drop shadows. Although you can create advanced text effects with plug-ins like Vector Effects from Metacreations, there are so many more text effects which can only be achieved in Photoshop. Layer effects now offer a phenomenal variety of text effects and you can also distort text using the warp controls that are available from the Options bar Warp Text menu.

If you are using a PC, you will want to take advantage of the free update to version 7.0.1. Among other things, this will fix a known problem where type layer data can become corrupted. This is a book about Photoshop and photography. A rich variety of text effects can be achieved in Photoshop and designers who work in print and multimedia often mainly use the program for this purpose. Since there are plenty of other Photoshop books devoted mainly to the needs of graphic designers, I am going to concentrate on the needs of image makers. But you will find more information on using the type tools contained in Chapter Fifteen.

Shape tools

Photoshop can let you create shapes that can be in the form of a filled layer with a vector mask (formerly referred to as a layer clipping path), a solid fill, or a path outline. You can define polygon shapes and also import custom shapes from EPS graphics, such as a regularly used company logo, and store these as Shape presets using the Preset Manager. The shape tools are a recently added crossover feature from ImageReady. Single pixel or wider lines can be drawn with the line shape tool. To constrain the drawing angle by 45 degree increments, hold down the Shift key (this applies to all the painting tools as well). Arrowheads can be added to the line either at the start or finish of the line. Click the Shape... button in line tool Options to customize the appearance of the arrowhead proportions.

Annotation tools

You can add text or sound notes to a file in Photoshop. Documents that are annotated in this way can be saved in the Photoshop, PDF or TIFF formats. To annotate an open document, select the text note tool and click inside the image window. A note icon is placed together with an open text window. Enter text inside the window – for example, this can be a short description of the retouching which needs to be carried out on this part of the picture. After completing the text entry, close the text window. The text note will remain as a small icon floating above the actual image. Although viewable in Photoshop, these notes will not be visible when you actually come to print the image. If you save a copy of an image as a PDF and send this to a client, they will be able to open it in Acrobat, add notes in Acrobat and export a Notes file for you to import back into the original Photoshop image. To delete a note or delete all notes, Control/right mouse-click on a note icon. The contextual menu will offer you the choice of deleting that note or all notes in the current document. If you want to append a sound note to a file, check in your System Control Panels that the computer's built-in microphone is selected as the incoming sound source. When you click in the window with the sound note tool a small sound recording dialog appears. Press the record button and record your spoken instructions. When finished, press Stop. The sound message will be stored in the document when saved in the above file formats.

Samp le Size : 3 by 3 Average

Street St

The eyedropper samples pixel color values from any open image window and makes that the foreground color. The sample area can be set to Point, 3×3 Average, 5×5 Average. The Point option will sample a single pixel color value only and this may not be truly representative of the color you are trying to sample. You might quite easily be clicking on a 'noisy' pixel or some other pixel artifact. A 3×3 average, $5 \times$ 5 average sample area will usually provide a better indication of the color value of the pixels in the area you are clicking. If you hold down the Option/Alt key, the sample becomes the background color (but when working with any of the following tools - brush, pencil, type, line, gradient or bucket - holding down the Option/Alt key will create a new foreground color). The sampler tool provides persistent pixel value readouts in the Info palette from up to four points in the image. The sample point readouts will remain visible all the time in the Info palette. The sample points themselves are only visible whenever the color sampler tool is selected. The great value of the color sampler tool is having the ability to monitor pixel color values at fixed points in an image. To see what I mean, take a look at the tutorial in Chapter Eight, which demonstrates how the combination of placing color samplers and precise curves point positioning means that you now have even more fine color control with valuable numeric feedback in Photoshop. Sample points can be deleted by dragging them outside the image window or Option/Alt-clicking on them (whenever the color sampler tool is selected).

Measure

The measure tool provides an easy means of measuring distances and angles. To draw a measuring line, open the Info palette and click and drag with the measure tool in the image window. The measure tool also has a protractor mode – after drawing a measuring line, Option/Alt-click on one of the end points and drag out a second measuring line. As you drag this out, the angle measurements are updated in the Info palette. The measure tool line will only remain visible when the tool is selected, or you can hide it with the View > Hide Extras command. The measure tool line can be updated at any time by clicking and dragging any of the end points. As with other tools the measure tool can be made to snap to the grid or guides.

🙄 🔍 🔹 Navigation tools – hand and zoom

To navigate around an image, select the hand tool and drag to scroll. To zoom in on an image, either click with the zoom tool to magnify, or drag with the zoom tool, marqueeing the area to magnify. This combines a zoom and scrolling function. In normal mode, a plus icon appears inside the magnifying glass icon. To zoom out, hold down the Option/Alt key and click (the plus sign is replaced with a minus sign). A useful shortcut well worth memorizing is that at any time, holding down the Spacebar accesses the hand tool. Holding down the Spacebar+Command/Ctrl key calls up the zoom tool (except when editing text). Holding down the Spacebar+Option/ Alt calls up the zoom tool in zoom out mode. An image can be viewed anywhere between 0.2% and 1600%. Another zoom shortcut is Command/Ctrl-plus (Commandclick the '=' key) to zoom in and Command/Ctrl-minus (next to '=') to zoom out. The hand and zoom tools also have another navigational function. Double-click the hand tool to make the image fit to screen. Double-click the zoom tool to magnify the image to 100%. There are buttons on the Options bar which perform similar zoom commands: Fit On Screen; Actual Pixels; Print Size. Navigation can also be controlled from the Navigator palette, the View menu and the lower left box of the image window. Checking the Resize Windows to Fit box will cause the Photoshop document windows to always resize to accommodate resizing, but within the constraints of the free screen area space. The Ignore Palettes checkbox will tell Photoshop to ignore this constraint and resize the windows behind the palettes.

Foreground/background colors

As mentioned earlier when discussing use of the eyedropper tool, the default setting has black as the foreground color and white as the background color. To reset the default colors, either click on the black/white foreground/background mini icon or simply click 'D'. Next to the main icon is a switch symbol. Clicking on this exchanges the colors, so the foreground becomes the background. The keyboard shortcut for this is 'X'.

OO

Selection mode/Quick mask

The left icon is the standard for Selection mode display. The right icon converts a selection to display as a semitransparent colored 'Quick mask'. Double-click either icon to change the default overlay mask color. Hit 'Q' to toggle between the two modes.

Screen display

The standard mode displays images in the familiar separate windows. More than one document can be opened at a time and it is easy to select individual images by clicking on their windows. The middle display option changes the background display to an even medium gray color and centers the image in the window with none of the distracting system window border. All remaining open documents are hidden from view (but can be accessed via the Window menu). Full Screen mode displays the image against a black background and hides the menu bar. The Tools palette and other palettes can be hidden too by pressing the Tab key. To show all the palettes, press the Tab key again. To toggle between these three viewing modes, press the 'F' key. You can also use Tab+Control/right mouse-click to cycle through each open image window, however the associated screen display is set. Here is another tip: if you are fond of working in Full Screen mode with a totally black border, but miss not having access to the menu bar, in the two full screen modes you can toggle the display of the menu bar with the Shift-F keyboard command. When you are in the middle fullscreen viewing mode you can replace the gray colored pasteboard by selecting a new color in the Color Picker and Shift-clicking with the paint bucket tool in the pasteboard area. Warning: this action cannot be undone with Command/Ctrl-Z!

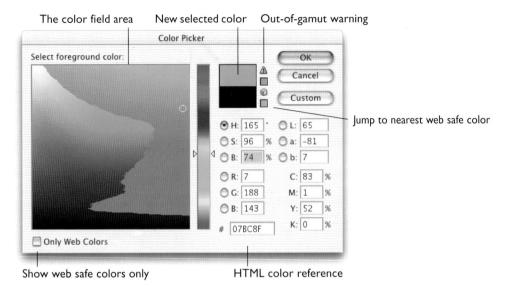

Figure 6.32 The Photoshop Color Picker, which is shown with a 'grayed out' color field because Gamut Warning is currently checked in the View menu. The alert icon beside the newly selected foreground color tells you it is out of gamut. If you check on the cube icon below, this will make the selected color jump to the nearest HTML web safe color. If you check the Only Web Colors box the Color Picker will display the restricted web safe color palette.

The second

Jump to button

ImageReadyTM 7.0 is a stand-alone application, that is installed with Photoshop 7.0. Clicking on the 'Jump to' icon will switch you from Photoshop to ImageReadyTM and vice versa, without having to exit from the current program. The file will always continue to remain open in the previous program and you can select different programs to jump to from the File > Jump to menu. Upon installation, applicable application aliases are installed in the Photoshop 7.0 > Helpers > Jump to Graphics Editor folder, i.e. Adobe IllustratorTM from Photoshop or HTML editing programs like Adobe GoLiveTM from ImageReadyTM. If the other program is not currently open, the Jump to button will launch it.

Summary

The tools and palettes mentioned here will be cropping up again over the following chapters. Hopefully the later tutorials will help reinforce the message. In order to help familiarize yourself with the Photoshop tools and Palette functions, help dialog boxes will pop up after a few seconds whenever you leave a cursor hovering over any one of the Photoshop buttons or tool icons (see: Show Tool Tips in the General Preferences). A brief description is included in the box and tools have their keyboard shortcuts written in brackets.

File Formats

Chapter Seven

hotoshop supports just about any image file format you care to mention. Choosing which format to output your images to should be determined by what you want to do with that file and the list can then be further narrowed down to a handful of recognized formats, appropriate to your needs. You may want to choose a format that is intended for prepress output, or screen-based publishing, or maybe you wish to use a format that is suitable for image archiving only. Screenbased publishing is a rapidly growing sector of the publishing industry and it is predicted that the percentage of designers operating in cross-media publishing, i.e. screen and print, will soon overtake those working in print design only. The Save for Web dialog contains a lot of useful web format tools and Photoshop 7.0 ships with ImageReadyTM 7.0, which is a stand-alone web image editing program, and you can switch back and forth between Photoshop 7.0 and ImageReadyTM 7.0 to produce optimized, sliced images, animated GIFs and even rollover buttons complete with JavaScript code. Adobe InDesignTM and Adobe GoLiveTM enable you to share Photoshop files between these separate applications and see changes made to a Photoshop file be automatically updated in the other program. This modular approach means that many Adobe graphics programs are able to integrate with each other.

While an image is open in Photoshop, it can be manipulated without being limited by the range of features supported in the original source format. If you open an EPS format image in Photoshop and simply adjust the levels and save it, Photoshop will overwrite the original. But you can also edit the same EPS image in Photoshop, adding features such as layers or adjustment layers. When you come to save, you will be shown the Save dialog shown in Figure 7.1. This reminds you that the file contains features that are not supported by the EPS file format and alerts you to the fact that if you click Save now, not all the components in the image (i.e. layers) will be fully saved. This is because while you can save the file as an EPS, the EPS format does not support layers and the document will therefore be saved in a flattened state. If I were to select the native Photoshop file format and check the Layers box, then it will become possible for me to now save this version of the image in the native Photoshop format *and* preserve the layer features. Only the Photoshop, PDF and TIFF formats are capable of supporting all the Photoshop features such as vector masks and image adjustment layers. Saving in the native Photoshop format should result in a more compact file size, except when you save a layered Photoshop file with the Maximize Backward Compatibility checked in the preferences. Figure 7.18 at the end of this chapter contains a summary of file format compatibility with the various Photoshop features.

Contractor and Alasta	ave As: artifacts.eps		
	ormat: Photoshop EPS	\$	
	Where: 🗇 art 07	. 🗩 (*	
💭 art 07	Þ	fundamentals.tif	Ă
art 08	•	aop.eps	Q
art 09	₽.	artifacts.eps	
art 10	4	🙀 clipso.eps	
art 12			
Chant			Ŧ
	New Folder	Add to Favorites	
Save:	🖻 As a Copy	Annotations	
	Alpha Channels		
	Layers		
		Working CMYK	
Color:	Use Proof Setup: \		
Color:	Use Proof Setup: 1	ile: Adobe RGB (1998)	
Color:			

Figure 7.1 The Photoshop Save dialog box.

TIFF (Tagged Image File Format)

This is the most universally recognized, industry-standard image format. Labs and output bureaux generally request that you save your output image as a TIFF, as this can be read by most other imaging computer systems. If you are distributing a file for output as a print or transparency, or for someone else to continue editing your

master file, you will usually be safest supplying it as a TIFF. Photoshop TIFFs now support alpha channels and paths, although bureaux receiving TIFF files for direct output will normally request that a TIFF file is flattened and saved with all alpha channels removed. An uncompressed TIFF is about the same size as shown in the Image Size dialog box. The TIFF format in Photoshop offers several compression options. LZW (which appears in the Save dialog box) is a lossless compression option. Data is compacted and the file size reduced without any image detail being lost. Saving and opening will take longer when LZW is utilized, so some bureaux will request that you do not use it. ZIP is another lossless compression encoding that like LZW is most effective where you have images that contain large areas of a single color. JPEG compression is a lossy compression method and is described more fully later. TIFF has the benefit of being able to support transparency and all of the Photoshop 7.0 features (should you wish to). The byte order is chosen to match the computer system platform the file is being read on. However, most software programs these days are aware of the difference, so the byte order is far less relevant now. The main formats used for publishing work are TIFF and EPS (and also the native Photoshop file format in an Adobe InDesignTM or IllustratorTM workflow, where Maximize Backwards Compatibility must be switched on). Of these, TIFF is the more flexible format, but this does not necessarily imply that it is better. The PDF file format is also gaining popularity for DTP (desktop publishing) work. TIFF files can readily be placed in QuarkXPressTM, PageMakerTM, InDesignTM and any other DTP or word processing document. The TIFF format is more open though and unlike the EPS format, you can make adjustments within the DTP program as to the way a TIFF image will appear in print.

Figure 7.2 The TIFF save options allow you to apply LZW, ZIP or JPEG compression to a file. The Save Image Pyramid option will save a pyramid structure of scaled-down versions of the full-resolution image.TIFF pyramid-savvy DTP applications (there are none I know of yet) will then be able to display a good quality TIFF preview, but without having to load the whole file. If an open image contains alpha channels or layers, the Save dialog in Figure 7.1 will indicate this and you can keep these options checked to preserve these in a TIFF save. If the File Saving preferences have Ask Before Saving Layered TIFF Files switched on a further alert dialog will warn you after clicking OK to the TIFF options the first time you save a layered TIFF.

EPS

EPS (Encapsulated PostScript) files are the preferred format for placing large color separated files within a page layout document. The EPS file format uses a low resolution preview to display the image on screen while the image data is written in the PostScript language used to build the output on a PostScript device. The image data is 'encapsulated' which means it cannot be altered outside of the program that created it (i.e. Photoshop). The downside of using EPS is that all the PostScript image data must be processed by the RIP every time you make an output, even if only a smaller amount of data is required to produce a proof and EPS files can take longer to process than a TIFF. However, you get an almost instantaneous rendering of the image preview when editing a DTP document on the screen. The saving options include:

Preview display: This is a low resolution preview for viewing in the page layout. The choice is between None, a 1-bit/8-bit TIFF preview which is supported on both platforms, or a 1-bit /8-bit/JPEG Macintosh preview. I recommend the 8-bit preview mode or JPEG Macintosh preview if working on the Mac.

Encoding: The choice is between ASCII or Binary encoding. ASCII encoding is more generic but generates large files and is suited to PC platforms only. Binary encoded files are half the size of ASCII encoded files and can therefore be processed more quickly. JPEG coding produces the smallest sized, compressed files. Use JPEG only if you are sending the job to a Level 3 PostScript printer. Bear in mind that image quality will become significantly degraded whenever you select a lower quality JPEG compression setting.

Include Halftone Screen and Include Transfer Functions: For certain subjects, images will print better if you are able to override the default screen used on a print job. Transfer functions are similar to making Curves image adjustments. Check these boxes if you want information entered to override the default printer settings. They do not alter the screen appearance of the image and are adjusted to accommodate dot gain output. The screen and transfer functions are defined in Photoshop. If printing the same file to two different printers, you may wish to save one file for the final print job as it is and save another version for the proof printer specifying the use of preset transfer functions to compensate for the different printing characteristics.

PostScript Color Management: This will enable PostScript Level 2 devices or higher to read the Grayscale, RGB or Lab profiles embedded in Photoshop and convert as necessary. But I believe it is better to let Photoshop handle the color management and conversions.

If any vector data is present in the document this can be interpreted such that the vector information will be rasterized in the EPS file. As usual, clipping paths can be saved in an EPS file – a clipping path will act as an outline mask when the EPS file is placed into a page layout program. If you have a work path saved in the Paths palette it can be specified to be used as the clipping path from within Photoshop.

DCS

	DCS 2.0 Format	unerranente	
Preview:	Macintosh (JPEG)		ОК
DCS:	Single File with Color Composite (72 pixel/inch)	*	Cancel
Encoding:	Binary	*	
🗌 Include H	alftone Screen		
🗐 Include 1	ransfer Function		
🗐 Include \	/ector Data		
🗐 Image In	terpolation		

Figure 7.3 The DCS 2.0 Format options dialog box.

QuarkXPress also uses a version of the EPS format known as DCS (Desktop Color Separations). The DCS 1.0 format generates five separate files: one preview composite and four-color separation files. It can be difficult to manage all these individual color plate files, especially when there are a lot of images in a folder. The DCS 2.0 format is a self-contained file containing the preview and separations. Crucially, DCS 2.0 supports more than four color channels, i.e. spot colors and HiFi color.

Photoshop PDF

The PDF (Portable Document Format) is an electronic publishing format used primarily for the distribution of document layouts, although it is fast gaining acceptance for prepress work and is the principal format for Adobe Acrobat[™] and Adobe Illustrator[™]. Adobe Acrobat Reader is a freeware program and widely available to install from consumer magazine CDs or can be downloaded from the Adobe website. CD Presentations, like that found on the Adobe Photoshop Tutorial CD, use the Acrobat PDF format to display electronically published documents. Adobe Acrobat can reproduce pages designed in InDesign or Illustrator to be viewed as self-contained documents. Best of all, Acrobat documents are small in size and can be printed at high resolution. The main selling point of PDF is its independence of computer

ZIP JPEG Quality: 10 Maximum * small file large file Save Transparency Image Interpolation Downgrade Color Profile PDF Security Security Settings Include Vector Data Embed Fonts	 ZIP JPEG Quality: 10 Maximum + small file Save Transparency Image Interpolation Downgrade Color Profile ♥ PDF Security Security Settings ♥ Include Vector Data 	- Encoding	ОК
Quality: 10 Maximum malifie large file Save Transparency Image Interpolation Downgrade Color Profile PDF Security Security Settings Include Vector Data Embed Fonts	Quality: 10 Maximum * malifik large fik Save Transparency Image Interpolation Downgrade Color Profile PDF Security Security Settings Include Vector Data Embed Fonts	🔘 ZIP	
Save Transparency Image Interpolation Downgrade Color Profile PDF Security Security Settings Include Vector Data Embed Fonts	small file large file Save Transparency Image Interpolation Downgrade Color Profile PDF Security Security Settings Include Vector Data Embed Fonts	● IPEG	Cancel
Save Transparency Image Interpolation Downgrade Color Profile PDF Security Settings Include Vector Data Embed Fonts	Save Transparency Image Interpolation Downgrade Color Profile PDF Security Security Settings Include Vector Data Embed Fonts	Quality: 10 Maximum 🗘	
 Image Interpolation Downgrade Color Profile PDF Security Security Settings Include Vector Data Embed Fonts 	Image Interpolation Downgrade Color Profile PDF Security Security Settings Include Vector Data Embed Fonts	small file large file	
 Image Interpolation Downgrade Color Profile PDF Security Security Settings Include Vector Data Embed Fonts 	Image Interpolation Downgrade Color Profile PDF Security Security Settings Include Vector Data Embed Fonts	è	
 Image Interpolation Downgrade Color Profile PDF Security Security Settings Include Vector Data Embed Fonts 	Image Interpolation Downgrade Color Profile PDF Security Security Settings Include Vector Data Embed Fonts	🖱 Save Transparency	
♥ PDF Security Settings ♥ Include Vector Data ■ Embed Fonts	♥ PDF Security Security Settings ♥ Include Vector Data ■ Embed Fonts		
Include Vector Data	Include Vector Data	Downgrade Color Profile	
Embed Fonts	Embed Fonts	PDF Security Security Settings)
		🗹 Include Vector Data	
Ilea Outlines for Text	Use Outlines for Text	Embed Fonts	
_ Use Outlines for Text		🔄 Use Outlines for Text	

operating system and the fonts installed on the client's computer. I can create a document in PageMakerTM and export as an Acrobat PDF using the Acrobat Distiller program (Distiller is part of the Acrobat program and also included as a separate, stand-alone application with PageMaker). Anyone who has installed the Acrobat Reader program can open the PDF document I supply and see the layout just as I intended it to be seen, with the pictures in full color plus text displayed using the correct fonts. The Photoshop PDF format (see Figure 7.4) can save *all* Photoshop 7.0 features, with either JPEG or lossless ZIP compression and is backwards compatible in as much as it will save a flattened composite for viewing within programs that are unable to fully interpret the Photoshop 7.0 layer information.

The PDF format in Photoshop is particularly useful for sending Photoshop images to people who don't have Photoshop, but do have Acrobat Reader on their computer. If they have a full version of Acrobat they will even be able to conduct a limited amount of editing, such as changing a text layer slightly. Photoshop is also able to import or append annotations from Adobe Acrobat. The Include Vector Data options allow you to embed text layer fonts and vector layer information. Use the Use Outlines for Text option only if you are dealing with an application that will have trouble interpreting the embedded font information.

PDF Security	
Password Required to Open Document	ОК
User Password: *****	Cancel
Password Required to Change Permission and Passwords]
Master Password: ******	
Encryption Level: 40-bit RC4 (Acrobat 3.x, 4.x)	1
🗹 No Printing	
🗹 No Changing the Document	
No Content Copying or Extraction, Disable Accessibility	
No Adding or Changing Comments and Form Fields	
▲ If set, the Master Password is required each time the file is opened in Photoshop. Other security restrictions (such as printing) are applied to the file only when it is opened in Adobe® Acrobat®.	
nie only when it is opened in Adobe® Acrobat®.	

Figure 7.5 The Photoshop PDF Security options.

Figure 7.6 If you try to open a generic Acrobat PDF from within Photoshop by choosing File > Open, you will see the PDF Page selector dialog, shown bottom left. Select individual or multiple pages to rasterize as images in Photoshop. If you choose File > Import > PDF Image, you can extract the individual images (or Import All) from a self-contained PDF document.

PDF security

The PDF security options allow you to restrict file access to authorized users only – you can introduce password protection to open a file in either Acrobat or Photoshop. And you can also have a secondary password for permission to print or modify the PDF file in Acrobat. Note that this level of security only applies to reading the file in Acrobat. You can only password protect the opening of a PDF file in Photoshop. Once opened in Photoshop, it will be fully editable. There are two security options: 40-bit RC4 for lower-level security and compatibility with versions 3 and 4 of Acrobat and 128-bit RC4, for higher security and Acrobat 5 only.

Importing multi-page PDF files

The Photoshop Parser plug-ins enable Photoshop to import any Adobe Illustrator, EPS or generic single/multi-page PDF file. Complete PDF document pages can be rasterized and batch processed to be saved as Photoshop image document files. Use File > Import > PDF Image to extract all or individual image/vector graphic files contained in a PDF document as separate image files (see Figure 7.6).

Figure 7.7 Two JPEG images: both have the same pixel resolution and both have been saved using the same JPEG quality setting. Yet the cloud image will compress to just 21 kilobytes, while the windows image is almost three times bigger at 59 kilobytes. This is because of all the extra detail contained in the street picture. The more contrasting sharp lines there are, the larger the file size will be after compression. For this reason it is best not to apply too much unsharp masking to an image before you save it as a JPEG. If necessary, you can deliberately apply blur to a background in Photoshop to remove distracting detail and thereby reduce the JPEG size.

PICT

PICT is primarily a Macintosh file format which while it can be read by PC versions of Photoshop, it is not a format for DTP work, although it has some uses in certain multimedia authoring applications. The PICT format utilizes lossless Run Length Encoding compression – areas of contiguous colors (i.e. subjects against plain color backgrounds) compress more efficiently without any image degradation, although files can be compressed using various levels of JPEG compression. I would add though that there is nothing about PICT which the native Photoshop file format cannot do better and there are also some pixel size limitations with the PICT format.

JPEG

The JPEG (Joint Photographic Experts Group) format provides the most dramatic way to compress continuous tone image files. The JPEG format uses what is known as a 'lossy' compression method. The heavier the compression, the more the image becomes irreversibly degraded. For example, an 18 MB, $10" \times 8"$ file at 300 ppi resolution can be reduced in size to around 1 MB with hardly any degradation to the quality of image. If you open a moderately compressed JPEG file and examine the structure of the image at 200%, you will probably see that the picture contains a discernible checkered pattern of 8×8 pixel squares. This mosaic pattern will easily be visible at actual pixels viewing when using the heaviest JPEG setting. Compression is more effective if the image contains soft tonal gradations as detailed images do not compress quite so efficiently and the JPEG artifacts will be more apparent.

Once an image has been compressed using the JPEG format, it is not a good idea to resave it as a JPEG a second time, because this will only compound the damage already done to the image structure. Having said that, providing the image pixel size remains identical, the destruction caused by successive overwriting is slight (except in those areas of the picture which have been altered). The JPEG format should mainly be used to save a copy of an image whenever you want to reduce the file size so as to occupy a much smaller space than the original. You normally want to compact a file in this way for inclusion on a web page, faster electronic distribution, or saving a large file to a restricted amount of disk space. Some purists will argue that JPEG compression should never be used under any circumstances to save a photographic image. If an EPS or TIFF file is saved with JPEG file compression this can cause problems when sending a file to some older PostScript devices, so that is one good reason for not using JPEG. But otherwise, the image degradation is barely noticeable at the higher quality compression settings, even when the image is viewed on the screen in close-up at actual pixels viewing, never mind when it is seen as a printed output. Wildlife photographer Steve Bloom once presented two Pictrograph Figure 7.8 The JPEG Options save dialog box. Baseline Standard is the most universally understood JPEG format option and one that most web browsers will be able to recognize. Baseline Optimized will often yield a slightly more compressed sized file than the standard JPEG format and most (but not all) web browsers are able to correctly read this. The Progressive option creates a JPEG file that will download in an interlaced fashion, the same way as GIF files can be encoded to do so.

tte: None	\$	ОК
Image Options		Cancel
Quality: 6 Medi	um 🛊	Preview
nall file	large file	
ê		
Format Options		
Baseline ("Standard	")	
Baseline Optimized		
Progressive		
Scans: 3		
Size		
~212.83K	^{37.6s} @ 56.6Kbp	

000)l	Comparison		0	
		ms, 2.16 GB avail			
Na	ame	Size 🔻	Kind		
Ň	clipso.tif-uncompressed	616 KB	Adobe Photoshop TIFF file		
2	clipso.psd-Native	292 KB	Adobe Photoshop file		
N	clipso.pct 32bit	288 KB	Adobe Photoshop PICT file		
	clipso.tif-LZW	212 KB	Adobe Photoshop TIFF file		
	clipso.tif-ZIP	196 KB	Adobe Photoshop TIFF file		14 5
N.	clipso.tif-HiJpg+Pyramid	196 KB	Adobe Photoshop TIFF file		=
Ŵ	clipso.png	192 KB	Adobe Photoshop PNG file		
N	clipso.tif-HiJpg	144 KB	Adobe Photoshop TIFF file		
N.	clipso.jpg-12	116 KB	Adobe Photoshop JPEG file		
GF	clipso.gif-S4W	56 KB	Adobe Photoshop GIF file		
	clipso.jpg-6	52 KB	Adobe Photoshop JPEG file		Client: Clips
	clipso.jpg-0	44 KB	Adobe Photoshop JPEG file		Model: Bianca at Nev
N.	clipso.tif-LoJpg	40 KB	Adobe Photoshop TIFF file		

Figure 7.9 Here we have one image, but saved thirteen different ways and each method producing a different file size. The opened image measures 500×400 pixels and the true file size is exactly 586 kilobytes. The native Photoshop format is usually the most efficient format to save in. Large areas of contiguous color such as the white background are recorded using a method of compression that does not degrade the image quality. The PICT format utilizes the same 'run length encoding' compression method, while the uncompressed TIFF format doggedly records every pixel value and is therefore larger in size.

prints at a Digital Imaging Group meeting. One of these was output from a 24 MB uncompressed original and the other a 2 MB JPEG version. Neither I or any of the other imaging experts could tell which was which.

File formats for the Web

The JPEG format is mostly used for web design work. A medium to heavy amount of JPEG compression can make most photographs small enough to download quickly over the Internet. Image quality is less of an issue here when the main object is to reduce the download times. Photoshop compresses images on a scale of 0–12. A setting of 12 will apply the least amount of compression and give the highest image quality. A setting of 0 will apply the greatest amount of compression and be the most lossy. When you choose to save as a JPEG, the document window preview will change to reflect how the compressed JPEG will look after it is reopened again as a JPEG. The JPEG Options dialog box will also indicate the compressed file size in kilobytes and provide an estimated modem download time. This feedback information is tremendously helpful. If you save a master file as a JPEG and later decide the file needs further compression, you can safely overwrite the last saved JPEG using a lower JPEG setting. It is possible to repeat saving in the JPEG format this way. For as long as the image is open in Photoshop, all data is held in Photoshop memory and only the version saved on the disk is successively degraded.

As you can see in Figure 7.8, JPEG compression is a most effective way to reduce file size, but this is achieved at the expense of throwing away some of the image data. JPEG is therefore known as a 'lossy' format. At the highest quality setting, the image is barely degraded and the JPEG file size is just 70 kilobytes, or 12% of its original size. If we use a medium quality setting the size is reduced further to just 18 kilobytes. This is probably about the right amount of compression to use for a photograph that features in a typical web page design. The lowest compression setting will squeeze the original 586 kilobytes down to under 7K, but at this level the picture will appear extremely 'mushy' and it is best avoided.

Other file formats for the Internet

Only one thing matters when you publish images on the Web and that is to keep the total file size of your pages as small as possible. The JPEG format is the most effective way to achieve file compression for continuous tone images, whereas graphics that contain fewer, distinct blocks of color should be saved using the GIF format. Occasionally one comes across a photograph to be prepared for a web page that would save more efficiently as a GIF (see Figure 7.10) and vice versa – there are some graphics

that will benefit from being saved as a JPEG (see Figure 7.11). Photoshop includes saving options that allow you to save a copy from any type of image state, choosing whether to include an ICC profile or not in your JPEG file. Some web servers are case sensitive and will not recognize capitalized file names. Go to Edit menu and select Preferences > Saving Files and make sure the Use Lower Case Extensions box is checked.

Figure 7.10 Exception to the rule 1: This high contrast landscape image contains very few tones. As a 350 pixel tall JPEG the smallest I could make it was around 33 kilobytes. Not bad, but as a six color GIF it only occupied 18 kilobytes and with little comparative loss in quality.

Figure 7.11 Exception to the rule 2:The Index page graphic for the Association of Photographers website would normally have been saved as a GIF (at around 20 kilobytes). The problem here was that the subtle gray tones looked terrible when dithered to the 216 color Web Palette. I therefore saved as a JPEG retaining the subtlety, making the size now 30 kilobytes, still keeping the total page size within a tolerable limit.

GIF

The GIF (Graphics Interchange Format) format is normally used for publishing graphic type images such as logos. To prepare an image as a GIF, the color mode must be set to Indexed Color. This is an 8-bit color display mode where specific colors are 'indexed' to each of the 256 (or fewer) numeric values. You can select a palette of indexed colors that are saved with the file and choose to save as a CompuServe GIF. The file is then ready to be placed in a web page and viewed by web browsers on all computer platforms. That is the basic concept of how GIFs are produced. Photoshop contains special features to help web designers improve the quality of their GIF outputs, such as the ability to preview Indexed mode colors whilst in the Index Color

ve for Web tools			ize settings Optimize men
Pr	eview display options	Preview men	u Output settings
	Save	For Web	
Original Optimized	2-Up (4-Up		
37 100			Save
9			Cancel
× ~			Done
	7.0	77.	Settings:
			JPEG C Optimized
🛛 Afte	r Dark Afte	r Jark	Maximum 😫 Quality: 85 🕨 🖸
			Progressive Blur: 0
2.4	122.	. 40 M 20 -	CC Profile Matte:
PERSONAL PROPERTY AND INC.			Color Table Image Size
The second second		No.	Original Size Width:1067 pixels
			Height 300 pixels
			New Size
			Width: 373 pixels
			Height: 280 pixels J
			Percent: 34.96
			Quality: Smooth (Bicubic)
Original: "SF street n 306K	nenge.psd" JPEG 32,39K 12 sec @ 28.8Kbp	85 quality	Apply
	12 sec @ 26.6Kbp	12	
100% R: 91	G: 89 B: 68 Apha: 255 Hex: 585944	hdex: -)
Zoom level	Color information	5	elect browser menu
	Br	owser preview but	ton Modify JPEG qualit
	N-45.0	in Canina	
		uality Setting	
	Use		ОК
	All Text Layers		Cancel
	Channel: None	(ite)	Preview
	Quality		

Figure 7.12 The Save for Web interface. Click on the button next to the Quality setting to open the Modify Quality Setting dialog. This will allow you to use an alpha channel to zone optimize the JPEG compression range or as shown above you can check the All Text Layers box to apply a higher quality compression setting to the text areas and a lower compression to the remaining image.

Minimum: \$60%

-

Maximum: \$89%

mode change dialog box and an option to keep matching colors non-dithered. This feature will help you improve the appearance of GIF images and reduce the risks of banding or posterization. Be aware that when the Preview is switched on and you are editing a large image, it may take a while for the document window preview to take effect, so make sure that you resize the image to the final pixel size first. You will find that when designing graphic images to be converted to a GIF, those with horizontal detail compress better than those with vertical detail. This again is using a form of Run Length Encoding (RLE) compression.

Save for Web

The Save for Web option is found in the File menu. This comprehensive dialog interface gives you absolute control over how any image can be optimized for web use when choosing either JPEG, GIF, PNG-8 or PNG-24 formats. The preview display options include: Original, Optimized, 2-up and 4-up views. Figure 7.12 shows the dialog window in 2-up mode display. With Save for Web you can preview the original version of the image plus up to three variations using different web format settings. In the annotation area below each preview, you are able to make comparative judgements as to which format and compression setting will give the best payoff between image quality and file size, and also determine how long it will take to download at a specific modem speed. Use the Preview menu to select from a list of modem and Internet connections on which these download times are based. You can also use the Preview menu list to select a preview setting and simulate how the web output will display on either a Macintosh display, a PC Windows display or with Photoshop compensation. The Select Browser menu allows you to select which web browser to use when you want to preview a document that has been optimized, in the actual browser program (see Figure 7.15).

Photoshop provides an option for Progressive JPEG formatting. Most Netscape and Internet Explorer browsers support this enhancement, whereby JPEGs can be made to download progressively the way interlaced GIFs do. The optimized format (see checkbox below the Optimize menu) can apply more efficient compression, but again is not generally compatible with any but the more recent web browsers. The quality setting can be set as Low, Medium, High, Maximum or it can be set more precisely as a value between 1 and 100%. Custom Save for Web output settings can be saved via the Optimize menu. The Blur control will allow you to soften an oversharpened original and obtain further file compression when using the JPEG format.

Next to the Quality setting is a small selection mask icon. Click on this icon to open the Modify Quality Settings. In the JPEG mode Save for Web dialog you can set zone optimized levels of compression based on the text layer/vector layer content or an alpha

Desired File Size:	32	K	Ок
— Start With —	+++++++++++++++++++++++++++++++++++++++	AND THE REPORT OF THE	
Current Setti	Cancel		
O Auto Select (GIF/JPE	G	
— Use ———			
Current Slice			
C Each Slice			
Total of All S	lices		

Figure 7.13 Under the Optimize menu you can choose Optimize To File Size and specify the optimum number of kilobytes you want the file to compress to.

channel stored in the master document (see Figure 7.12) so that areas of important detail can have less JPEG compression applied to them. Adjust the sliders to establish the range of JPEG compression from the total mask to no mask areas, and vary the softness of this transition. In Figure 7.12, the Use All text Layers option is checked and you can see a preview of the mask based on the text layer in the Modify Quality settings dialog. A higher quality of JPEG compression will be applied to the text in the final JPEG output. In the Save for Web GIF format mode (discussed next), an alpha channel can also be used to zone optimize the color reduction and modify the dither settings. The Save for Web Save dialog lets you save as: HTML and Images, Images only, or HTML only. The output settings allow you to determine the various characteristics of the Save for Web output files such as: the default naming structure of the image files and slices; the HTML coding layout; and whether you wish to save a background file to an HTML page output (see Figure 7.14). Figure 7.15 shows an example of a temporary document window generated with the HTML code generated by Save for Web along with the HTML code in the format specified in the output settings.

Figure 7.14 The HTML section of the Optimize Settings found in the Save for Web dialog. Other menu options include Background, Saving, and Slices. Click on the Generate CSS button to create cascading style sheets based on the current image slicing.

Settings: Defa	ult Settings		ОК
HTML	•		Cancel
- Formatting -			0
Tags Case:	BODY	*	Prev
Attribute Case:	ROWSPAN	•	Next
Indent:	Tabs	•	Load
Line Endings:	Mac	10)	Save
Coding	ments		
Always Quot			
Always Add			
Close All Tag			
Include Zero	Margins on Body Tag		

The Image Size options are fairly similar to those found in the Image > Image Size dialog box. You can simply enter a new percentage to scale the image to and check what impact this will have on the file size (this will change the file size in all the optimized windows). An alternative approach is to select Optimize To File Size from the Optimize menu (see Figure 7.13). Use this to target the optimized file to match a specific kilobyte file size output and if you wish, have Photoshop automatically determine whether it is better to save as a GIF or JPEG.

The GIF Save for Web options are also very extensive. You have the same control over the image size scale and can preview how the resulting GIF will appear on other operating systems and browsers – the remaining options all deal with the compression, transparency and color table settings that are specific to the GIF format. The

Figure 7.15 When a browser window preview is selected (see Figure 7.11), the default browser program is launched and a temporary page will be created, like the one illustrated opposite. This will allow you to preview the Save for Web processed image as it will appear on the final web page. This is especially useful for checking if the RGB editing space used will be recognized differently by the browser. If you are relying on embedded ICC profiles to regulate the color appearance on screen, you can check to see if the profile is indeed being recognized by the selected web browser program.

Figure 7.16 This close-up view of the JPEG saved at the 10% quality setting clearly reveals the underlying 8×8 pixel mosaic structure, which is how the JPEG compression method breaks down the continuous tone pixel image into large compressed blocks. At the higher quality settings you will have to look very hard to even notice any change to the image. Successively overwriting a JPEG will degrade the image even further. However, if no cropping or image size change takes place, the degradation will only be slight. As a general rule always re-JPEG an image from the uncompressed master file.

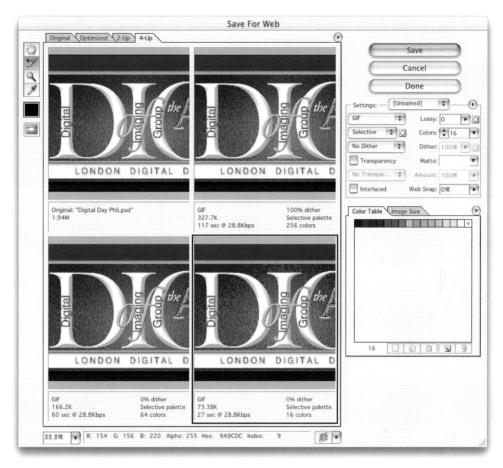

Figure 7.17 The Save for Web interface showing GIF settings. Design: Rod Wynne-Powell.

choice of color reduction algorithms allows you to select the most suitable 256 maximum color palette to save the GIF in. This includes the 8-bit palettes for the Macintosh and Windows systems. These are fine for platform specific work, but such GIF files may display differently on the other system's palette. The Web palette contains the 216 colors common to both platforms and is therefore a good choice for web publishing if viewers are limited to looking at the image on an 8-bit color monitor display. The Perceptual setting produces a customized table with colors to which the eye is more sensitive. The default Selective setting is similar to the Perceptual table, but more orientated to the selection of web safe colors – this is perhaps the best compromise solution to opt for now as even the most basic PC setup sold these days is well able to display 24-bit color. The Adaptive table palette samples the colors which most commonly recur in the image. In an image with a limited color range, this type of palette can produce the smoothest representation with a limited number of colors, but is less ideal for web publishing.

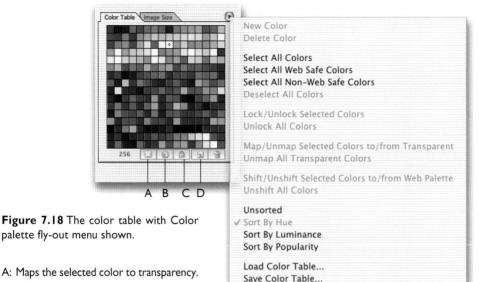

- B: Shifts/unshifts selected colors to the Web palette.
- C: Adds eyedropper color to the palette.
- D: Deletes selected colors.

The Lossy option allows you to reduce the GIF file size by introducing file compression. This can be helpful if you have an overlarge GIF file, but too much compression will noticeably degrade the image until it looks like a badly tuned TV screen. The diffusion dithering algorithm is effective at creating the impression of greater color depth and reducing image banding. The Dither slider allows you to control the amount of diffusion dithering. The Pattern and Noise options have no dither control. If the image to be saved has a transparent background, the Transparency option can be kept checked in order to preserve the image transparency in the saved GIF. To introduce transparency in an image you can select the color to make transparent using the eyedropper tool and clicking inside the image preview area. The color chosen will appear selected in the color table. Select one or more colors and click on the Map Selected Colors to Transparent button in the Color table. You can apply a diffusion, pattern or noise dither to the transparent areas, which will help create a smoother transparent blend in your GIF.

The Web Snap slider will let you modify the Color table by selecting those colors that are close to being 'browser safe' and making them snap to these precise color values. The slider determines the amount of tolerance and you can see the composition of the Color table being transformed as you make an adjustment. The Interlace option will add slightly to the file size, but is worth selecting – the image will appear to download progressively in slices.

File format	RGB	СМҮК	Indexed Color	Grayscale	Layers	Alpha Channels	Paths	ICC	Annotations
Adobe Photoshop	•	•	•	•	•	•	•	•	•
Adobe Photoshop 2.0	•	•	•	•		•	•	•	
FlashPix	•			•			•		
CompuServe GIF			•						
JPEG	•	•		•			•	•	
Photoshop EPS	•	•	•	•			•	•	
Photoshop DCS 1.0		•					•	•	
Photoshop DCS 2.0	•	•		٠		•	•	•	
Photoshop PDF	•	•	•	•	•	•	•	•	•
PICT	•		•	•			•	•	
PNG-8			•	•		•	•		
PNG-24	•			•		•	•		
Scitex CT	•	•		•			•		
TIFF	•	•	•	•	•	•	•	•	•

Figure 7.19 File format saving options showing which Photoshop features can be saved in the listed formats. Those indicated with a red dot are savable on the Mac OS only.

PNG (Portable Network Graphics)

This is a newish file format used for the display and distribution of RGB color files online. PNG (pronounced 'ping') features improved image compression and enables alpha mask channels (for creating transparency) to be saved with the image. Other advantages over JPEG and GIF are higher color bit depths, supporting up to 32-bit images and limited built-in gamma correction recognition, so you can view an image at the gamma setting intended for your monitor. Newer versions of Netscape Navigator and Microsoft Internet Explorer web browsers will support the PNG format.

IVUE

The IVUE format was used by the Live Picture program for display and image processing in Live Picture. Although Live Picture is currently discontinued, there are a lot of die hard fans of the program who will want to continue to use it. Files can be converted from Photo CD or a TIFF file to the IVUE pyramid structure format using the Live Picture software before they can be opened in the Live Picture program. Photoshop and Live Picture complement each other and for that reason you can import IVUE files into Photoshop, for further modification. The IVUE Import plug-in (which came with Live Picture) must first be installed in the Photoshop plug-ins folder.

FlashPix

The FlashPix format was jointly developed and backed by Eastman Kodak, Live Picture, Microsoft and Hewlett-Packard and is based on the Live Picture IVUE pyramid structure format. High resolution images in the FlashPix format can be viewed at incremental resolutions via a web browser. To view the full sized image on the screen, a screen resolution preview only is downloaded. If you zoom in to a small section, just the detail information in that area of the picture is downloaded to the browser. The viewer can inspect an image at full view and select any area in close-up quickly without at any time having to download the entire image. Note that the FlashPix format plug-in must be installed using the Custom rather than the Easy Install option. Microsoft[®] OLE is required to run FlashPix – check the Microsoft[®] OLE 2.08 checkbox.

When saving in the FlashPix format there are options for compression (with a choice of strengths) or no compression. As a FlashPix image is opened in Photoshop, a choice of image resolutions is offered – this is similar to the choice of Image PAC resolutions you get with Photo CD.

Future of electronic publishing

It is important for professional image makers to be able to meet the requirements of different workflows. In the early days of digital imaging we were mostly concerned about meeting the needs of repro and the ability to edit large files in Photoshop and choose the right output file format for print. These days we have to take into account the constraints of screen publishing as well and also the growing importance of Acrobat PDF as a file format for distribution, soft proofing and final art delivery.

Basic ImageAdjustime

The aim of this chapter is to introduce everything you need to know about opening up a picture and carrying out basic image corrections. That is all most people ever want to know, but one can soon become distracted and confused by the many image controls available in Photoshop. The procedures outlined here show some of the methods I use to prepare my own images. Of course, all the image adjustment commands are useful in one way or another – not even the simple Brightness/Contrast command should be regarded as totally redundant. What I have done here is provide a guide to the image corrections which professionals would use. I suggest these techniques provide the greatest scope for correcting and fine tuning your images and are a good solid base on which to build your retouching skills.

Cropping

hapte

You can open an image file in Photoshop the same way as you would any other type of document, by choosing File > Open... If you are scanning the image, make sure the scanner software and Import plug-in filters are installed correctly, then choose File > Import > (select scanner module). Select the crop tool from the Tools palette and drag to define the area to be cropped. To zoom in on the image as you make the crop, you will find it useful to use the zoom tool shortcut: Command/Ctrl+Spacebar and marquee drag area to magnify. To zoom out, here is a handy tip: use Command/Ctrl+O, which is the shortcut for View > Fit To Window. Then zoom back in again to magnify another corner of the image to adjust the crop handles.

poed Areas (*) Delete (*) Hide (*) Shield Color:

ta.

2 You can also make a crop using the rectangular marquee tool. Define a selection and choose Image > Crop. The constraining options available in the marquee options include Constrain Aspect Ratio and Fixed Size. Note that irregular-shaped selections are also recognized, but the crop will be the bounding box and the selection will be retained.

I First crop the picture – this is normally done with the crop tool. Drag across the image to roughly define the cropping area. As was explained in Chapter Six, the cursor can be placed above any of the eight handles in the bounding rectangle to reposition the crop. Placing the cursor inside the crop area allows you to move the crop.

0 1

2	34	•	Width: 6 cm	Height: 8 cm	Resolution:	300	pixels/inch	Front Image	C	Clear	
10000		10000		A DEALER AND			CONTRACTOR OF THE OWNER OF THE	 Contraction of the second second second	*********		

Opacity: 75% 🕨 🗇 Perspective

3 You can enter the target image dimensions and resolution in the above crop options boxes. Type in the numeric values and measurement units. To match the dimensions and resolution of an existing picture, make the target image active and click Front Image (this automatically sets the fixed target size to match the image size). Activate the other image and apply the crop tool. The image will be cropped to match the resolution and size of the former image.

4 Mouse down and drag to rotate the crop around the center point (which can be positioned outside the crop area). You normally do this to realign an image that has been scanned slightly at an angle. Should there not be enough canvas size available, Photoshop will add the current Background color as extra canvas (or transparency if not a Background layer) after cropping. The crop bounding box center point (see image 1) can be repositioned to change the central axis of rotation.

Orientation and canvas

Use the Image > Rotate controls to orientate your image the correct way up. For example, you can rotate the image 90 degrees clockwise or anticlockwise, or by an arbitrary amount, for precise image rotation.

The Image > Canvas size lets you enlarge the image canvas area, extending in any direction, as set in the Canvas size dialog box. This is useful if you want to extend the image dimensions in order to place new elements. In Photoshop 7.0, if you check the Relative box you can simply enter the unit dimensions you want added to the current image size. The pixels that are added will be filled using the current back-ground color. It is also possible to add to the canvas area without having to use the Canvas Size command. After the initial crop placing, just resize the crop boundaries beyond the document bounds and into the pasteboard area.

Figure 8.1 To add extra pixels beyond the current document bounds, use the Canvas Size from the Image menu. In the example shown here, the image is anchored so that pixels will be added equally left and right and to the bottom of the image only. The relative box is checked and this allows you to enter the number of units of measurement you wish to add 'relative' to the current image size.

		Canvas Si	ze	
Curren	t Size: 17.2	м ———		ОК
Width:	16.93 cm			Cancel
Height:	25.4 cm			Curreer
New Si	ze: 20.3M -			
Width:	2	Cm	•	
Height:	1.5	Cm	•	
	🗹 Relative			
Anchor:	~			
	1+1			

Figure 8.2 The crop tool as canvas size tool – drag any one of the bounding box handles outside of the image and into the pasteboard area. Double-click inside the bounding box area or hit Enter to add to the canvas size, filling with the background color.

Precise image rotation

Figure 8.3 When an image is opened up in Photoshop, you may discover that a scanned original is not perfectly aligned. Although the crop tool will allow you to both crop and rotate at the same time, there is another, more accurate way of correcting the alignment. Select the measure tool from the Tools palette and drag along what should be a straight edge in the photo. After doing this, go to the Image menu and select Rotate Canvas > Arbitrary...You will find that the angle you have just measured is already entered in the Angle box. Choose to rotate either clockwise or counterclockwise and the picture will then be accurately rotated so that it appears to be perfectly level.

Big data

The Photoshop, PDF and TIFF formats all support 'big data'. This means that if any of the layered image data extends beyond the confines of the canvas boundary, it will still be saved as part of the image when you save it, even though it is no longer visibly part of the image. If you have layers in your image that extend outside the bounds of the canvas, you can expand the canvas to reveal

all of the 'big data' by choosing Image > Reveal All. But remember, you will only be able to reveal the big data again providing you have saved the image using the PSD, PDF or TIFF format.

When you crop a picture using the crop tool, you can either Delete or Hide the layered big data by selecting one of the radio buttons shown below. If your image contains a background layer, you must first double-click the background layer to promote it to a normal layer if you want the information on this layer to be hidden as well. If you don't Photoshop will always delete the background layer data that you crop.

Perspective cropping

With Photoshop's crop tool you can crop and correct any converging verticals or horizontal lines in a picture, with a single crop action. Let's say you have an image like the example shown in Figure 8.4 where you wish to remove the converging verticals or 'keystone' effect in the photograph of the buildings. If you check the Perspective box, you can accurately reposition the corner handles on the image to match the perspective of the buildings and then apply the crop to straighten the lines that should be vertical. This tweaking adjustment can be made even more precisely if you hold down the Shift key as you drag a corner handle. This will restrict the movement to one plane only. I find the perspective crop tool is very useful when preparing photographs of flat copy artwork as it enables me to always get the copied artwork perfectly square. Edge snapping can be very distracting when you are working with the crop tool. But this can easily be disabled in the View > Snap To submenu (or by using the keyboard shortcut: Command/Ctrl+Shift-;).

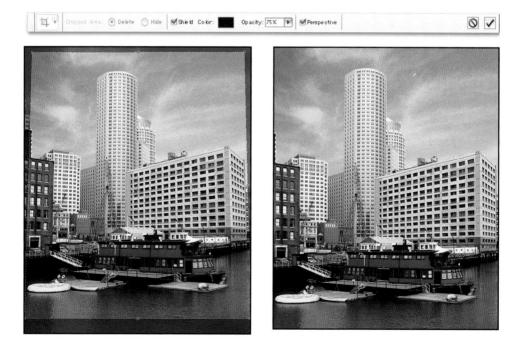

Figure 8.4 You can easily correct the perspective in a photograph. Check the Perspective box in the Options bar and move the corner handles independently. In the example shown here, I altered the crop opacity color to red – this makes it easier to see the crop. The bounding box handles can be hidden if you choose View > Hide Extras. Using this method, you will find it much easier to zoom in and gauge the alignment of the crop edges against the converging verticals in the photograph.

Image analysis

Once you have opened an image and cropped it, the next stage will be to apply a tonal correction. First you will want to take a look at the Levels histogram, which is a graphical representation of the distribution of tonal levels within an image. The histogram in the Image > Adjustments > Levels dialog can inform you of any problems relating to the quality of the scan that you will want to address now by perhaps doing a rescan before you proceed any further.

We are going to start by looking at how to make a basic Levels adjustment. Open an image and choose Image > Adjustments > Levels. The Levels dialog contains its own histogram and typical examples of these are shown below in Figure 8.5. The upper two examples would suggest that an unacceptable amount of detail is being lost in either the highlights or the shadows. The comblike structure of the lower left example is not ideal, but an inevitable consequence of heavy tonal manipulation. It is generally more acceptable to lose tonal separation in the shadow areas than it is in

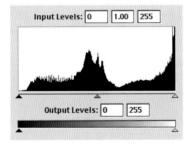

If the levels are bunched up towards the right, this is a sign of highlight clipping.

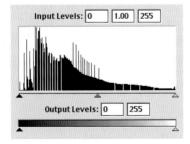

A histogram with a comblike appearance indicates that either the image has already been heavily manipulated or an insufficient number of levels were captured in the original scan.

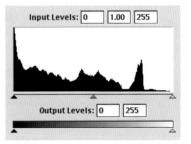

If the levels are bunched up towards the left, this is a sign of shadow clipping.

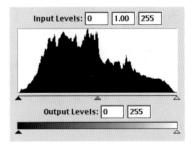

This histogram shows that the image contains a full range of tones, without any shadow or highlight clipping evident and no gaps between the levels.

Figure 8.5 Examples of histogram displays you might come across in the Photoshop Levels dialog.

the highlights. After a Photoshop digital file has been converted to a halftone separation and printed, you would be lucky to be able to detect more than 50 levels of tonal separation from any single ink plate. So the loss of a few levels at the completed edit stage does not necessarily imply that you have too little digital tonal information from which to reproduce a full-tonal range image in print. If you were starting out with a scan which had a histogram that looked like a broken hair comb and intended to carry out further tonal corrections, then clearly you do run the risk of posterization appearing when the picture is printed.

Levels adjustments

The object of tonal correction is to maximize the tonal range of the digital file for its intended output. Your output could be a web page or a transparency, but most likely it will be the printed page and this will eventually involve a halftone separation being made from the digital file. Halftone printing has its limitations but a basic Levels tonal correction made in Photoshop will enhance the image's printed appearance. Figure 8.6 shows an evenly spread histogram in the Levels dialog and no clipping of the shadows or highlights. However, the printing process does not translate a full range of tones in a digital image going from level 0 to 255 as a perfectly

Figure 8.6 The Levels dialog. This shows the histogram for a grayscale image, with the shadows on the left and the highlights on the right. The shadow point Output level is set to 12. This is equivalent to a 95% dot on the press and typically any higher value percentage will clog up to solid black (see Figure 8.7). So setting the shadow point below 12 may cause the shadows to be clipped. The highlight point is set to level 243. This is equivalent to a 5% dot at which point the halftone dot produced by the imagesetter will on the press just be capable of applying ink to the page. Any higher level value will produce a smaller dot but the smaller dot will not register any ink on the page – it will appear as pure white.

reproducible range of tones in print. Figures 8.6 and 8.7 explain some of the reasons for this. If the destination is print, you want the shadow point to begin not at zero, but a little above that, otherwise the shadow tones will clog up on the press. And if keeping the highlight detail is important then you want the brightest highlights to fall slightly short of the brightest levels value of 255.

You should start learning to apply tonal corrections using Levels adjustments. Forget Brightness and Contrast and Color Balance for now – these are not professional tools. Anything you can do in Levels you can also do in Curves, and then some. But to begin with let's look at Levels in more depth.

Figure 8.7 Dot gain is a phenomenon that occurs at the printing stage after the halftone plates have been made. A Photoshop level of 24 is equivalent to a 9% ink dot. An imagesetter would plot this on the film that goes to make the plate as shown left. When the printing press reproduces a halftone ink dot on the page from the plate, the dot will swell in size and hence appears slightly darker. Dot gain will therefore make the 95% shadow halftone dot plotted in Figure 8.6 appear as a solid black.

Figure 8.8 In the case of a high key image such as this, it is important to retain highlight detail. Some highlights we can afford to have burn out to white, and indeed this helps to create the impression of a full tonal range of contrast. In crucial areas where the detail matters such as the white jacket and the blonde hair, it is necessary to make sure that the highlight levels are not set too high and are within the limits of what the press can reproduce. In the Figure 8.6 example, any level that is higher than 243 will reproduce as a dot that is going to be too small for any ink to adhere to the page. Use the Info palette as a tool for checking these crucial numeric values.

N	wigator	Info		
я.	R : 233 G : 233 B : 233		С: М. Ү.	7% 5% 5% 0%
+,	X : 3.76 Y · 2.03	90 LT	W : H :	

Client: West Row. Model: Bianca at Nevs.

Specular highlights

I The guidelines for setting the shadow and highlight points will help you choose the optimum settings for retaining the shadow and highlight detail and work within the constraints of the printing press. At the same time it can also lead to a dull print output if you do not make full use of the tonal range. There are times when you will want to make use of rich blacks and bright paper whites to reproduce a full contrast image. The subject shown here contains highlights which have no detail. If we assign these 'specular' highlights a white point of 243, and the shadow point 12, the printed result will look needlessly dull.

2 The brightest portions of the image are the shiny skin reflections and we can safely let these areas burn out to white, because they do contain image detail. Assign the brightest area in the highlights (where there is detail) as the white point and let the specular highlights print to paper white. The adjusted version benefits from a wider tonal scale making full use of the press and at the same time retains important highlight detail where it matters.

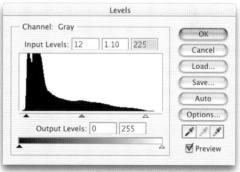

Use the Levels dialog to set the input shadow and highlight points, plus the overall brightness of the picture by adjusting the middle, input 'gamma' slider. Either adjust the shadow and highlight sliders in the Levels dialog box so that they just clip the ends of the histogram bars or you can pick specific target shadow and highlight image pixels and assign a new pixel value.

The first adjustment method is quick and easy to perform. If you want to reset the settings in any of the Image adjustment dialog boxes, hold down the Option/Alt key – the Cancel button changes to Reset. The Auto button can help set the end points automatically – the Auto settings will be covered in the following chapter. It is important to get the adjustments right from the start and this need not take too long to accomplish. The second, more precise method involves assigning specific parts of the image to represent the shadow and the highlight points. The process takes a little longer, but is a more precise way of setting the tonal range, producing neutral shadows, highlights and midtone values. Repro and color experts rely mainly on the numerical pixel values as a guide to judging color balance. Before making the tonal adjustment, go to the Eyedropper options and set the Sample Size to 3×3 Average.

I The Levels dialog box displays the tonal range as a histogram. The tonal range of a scanned image usually needs to be expanded. This is done by dragging the highlight and the shadow Input sliders to just inside the histogram limits. When the Preview box is checked these tonal changes can be seen taking place in the image window area only.

2 A better method of deciding where to set the Input sliders is to hold down the Option/Alt key as you drag the slider. While the Option/Alt key is held down the whole screen is displayed in 'threshold' mode. The shadow and highlight limits are easily discernible. Note that this method differs slightly from earlier versions of Photoshop, in that you do not need to turn the Preview box off and that the threshold mode method works with both Mac and PC systems.

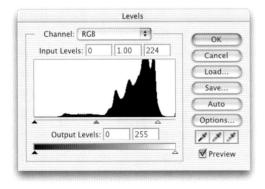

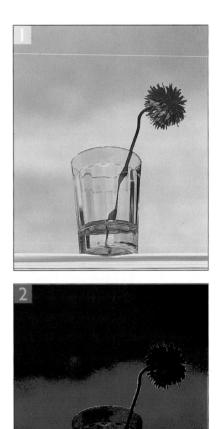

3 Now adjust the gamma slider – this affects the overall brightness of the image. If you prefer, you can enter numeric values for the Input Levels in the boxes above the histogram display. To apply the adjustment to the image, click OK.

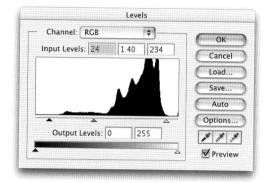

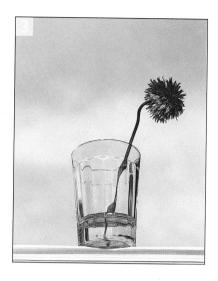

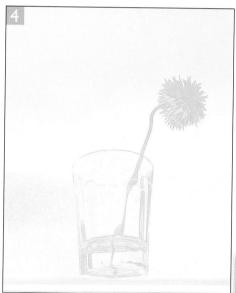

4 The Output sliders determine the output tonal range limits. For example, you can set the shadow and highlight inputs to clip the endpoints and then depending on the need of the press, as described in Figure 8.5, bring in the output sliders to match. You can also use these sliders to soften the contrast of a picture. To create a faded background image, slide the shadow output slider across to the right.

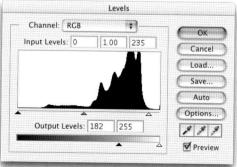

Assigning shadow and highlight points

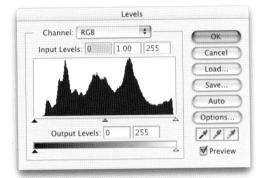

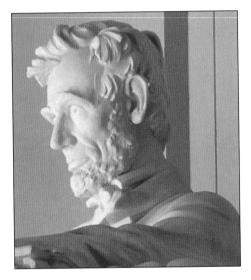

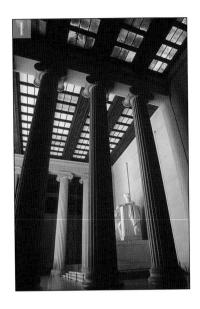

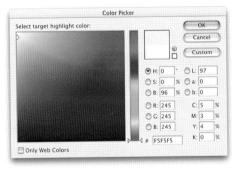

2 Now set the shadow point. Double-click the shadow eyedropper icon and set a brightness setting of 4% in the text box as the target brightness. After that, with the shadow eyedropper still selected, zoom in on the image to identify and click on the darkest shadow point (use the Threshold mode again to help identify). The gamma slider can be adjusted the same way as in the last example to adjust the relative image brightness.

Inf	0				
	R :		1	с:	23%
	G :	204		M :	17%
a.	B :	204	10.	Y :	17%
				К :	0%
	X :	3.39		W :	
ъ	Y :	1.96	11	H :	

Figure 8.9 The Info palette can be used to read color information which helps determine whether the colors are neutral or not regardless of any monitor inaccuracies. Equal values of R, G, and B give a neutral gray tone.

Unsharp masking

The only sharpening filter you really need is the Unsharp Mask (Filter > Sharpen > Unsharp Mask). This sounds like a contradiction in terms, because how can unsharpening make a picture sharper? The term in fact relates to the reprographic film process whereby a light, soft unsharp negative version of the image was sandwiched next to the original positive during exposure. This technique was used to increase the edge sharpness on the resulting plate. The Photoshop Unsharp Mask (USM) filter reproduces the effect digitally and you have a lot of control over the amount of sharpening and the manner in which it is to be applied. Sharpen and Sharpen More are preset filters which sharpen edges but feature none of the flexibility associated with USM.

Do all pictures need to be sharpened and could they not have been scanned sharper in the first place? Wherever possible, use an unsharpened original as your master and apply any sharpening as necessary in Photoshop at the end of the editing session. Much depends on the capture device, scanner or scanner settings, because a lot of manufacturers like to sneak in some unsharp masking in the default settings. If you find this is happening, turn off the sharpening in the scanner software. Most scans will still benefit from a little USM and Photo CD images in particular will always require sharpening. The Kodak Photo CD system relies on the softness of the scanned image to enable the Image PAC files to compress more easily on to the CD disc and produce equally good quality results at any of the chosen resolutions. So although it may not *always* be required, it can sometimes be necessary to apply some level of unsharp masking to get an image looking sharp on the monitor and do this in Photoshop. While unsharp masking may make a picture look sharper, this apparent sharpening is achieved at the expense of introducing artifacts into the image that will permanently degrade the picture and possibly emphasize any noise present. Furthermore, if you sharpen the image before carrying out color adjustments and any retouching, the sharpening artifacts can become even more noticeable afterwards.

Sharpening for repro

The printed result will not exactly match what you see on the screen. The process of converting a digital image to a halftone plate and from there to ink on the page inevitably incurs a loss of sharpness along the way. For this reason it is always necessary to 'sharpen for repro'. This means that if you are preparing a picture to appear in print, you have to apply an extra amount of unsharp masking, beyond what would make the image look sharp enough on screen. Such unsharp masking must be done at the end of a Photoshop session and after conversion to CMYK. It therefore makes sense to keep a master version which you can reseparate from as requested and always apply the final unsharp masking on a copy version. Unsharp masking artifacts will create darker and lighter pixels. This can affect the tonal range, so it is best not to set the final levels till after applying USM. Figure 8.10 reproduces three versions of an image: raw Photo CD scan; sharpened for display on the screen; and sharpened for repro output. You may find when you make your sharpening for repro, that it helps to view the image on screen at 50% magnification. At this viewing scale, you can probably get a better idea of how sharp the picture will appear in print after applying the USM sharpening.

Amount

The amount setting controls the intensity of the sharpening applied. The higher the percentage (up to 500%) the greater the sharpening effect will be. The correct amount to apply will vary depending on the state of the image and the type of press output. Generally speaking, I would typically apply an amount between 120% and 200%. Experience will help you make the right judgment on screen as to what the correct amount to use should be. Try setting the amount value really high to begin with. Try to find out which Radius and Threshold settings work best at this high Amount setting and then reduce the percentage to an appropriate level.

Figure 8.10 The left-most version shows a raw Photo CD scan converted to CMYK and reproduced without using any USM. The middle version has been partially sharpened only to appear sharp on the monitor. The version on the right has been converted to CMYK and additional USM applied to appear correct when printed in this book. Photograph: Peter Hince.

Figure 8.11 When presented with an image or portion of an image that needs 'bringing into focus', a higher Radius setting will help create the illusion of better definition. The above pictures are all sharpened with an amount of 150% and Threshold setting of 1. From left to right: No sharpening, Radius 1, Radius 2.

Figure 8.12 The high amount of sharpening in the Figure 8.13 example (page 221) will produce chromatic artifacts around the backlit bubbles. If this happens, apply an Edit > Fade command and change the blending mode to Luminosity. This has the same effect as converting an image to Lab mode and sharpening the luminosity channel only (but quicker).

Opacity:	85	%	ОК
	ſ		Cancel
Mode: Norm	nal	;	Preview

Radius

The Amount setting controls the level or intensity of unsharp masking, but the Radius and Threshold settings affect the distribution of the sharpening effect. The Radius setting controls the width of the sharpening effect and the setting you should choose will depend very much on the subject matter and the size of your output. The recommended setting is usually between 1 and 2. As the Radius setting is increased you will notice how the edges are emphasized more when using a wider radius. Figure 8.11 demonstrates the impact increasing the Radius can have on the edge sharpness, while all the other settings remain constant.

Threshold

The Threshold setting controls which pixels will be sharpened based on how much the pixels to be sharpened deviate in brightness from their neighbors. Higher Threshold settings apply the filter only to neighboring pixels which are markedly different in tonal brightness, i.e. edge outlines. At lower settings more or all pixels are sharpened including areas of smooth continuous tone. If the Threshold setting is 4, and two neighboring pixels have values of 100 and 115, then they will be sharpened, because their tonal difference is greater than 4. If one pixel has a value of 100 and the other 103, they will be left unsharpened because the pixel difference is less than 4. Raising the Threshold setting will enable you to sharpen edge contrast, but without sharpening any scanner noise or film grain which is visible. Scans made from 35 mm film originals may benefit from being sharpened with a higher Threshold setting than would need to be applied to a 120 film scan.

Selective sharpening

Anti-aliased text and other graphic artwork is fine left as it is and will not benefit from being sharpened. Photoshop vector objects are on separate layers anyway and will be processed separately by a PostScript RIP when rendered in print. If you do render any of the shape or type layers, try to keep them on their separate layers. Only sharpen the bitmapped image data.

The unsharp masking controls will enable you to globally correct most pictures and prepare them ready for print output. But you may find it preferable to selectively apply the sharpening in a way that will reduce the problems of unwanted artifacts becoming too noticeable. For example, the blue channel is often the one which contains the most noise. Go to the Channels palette and Shift select the red and green channels only, while selecting the composite channel eye icon. You may not want to apply sharpening globally to every image. You should refer to the history section in Chapter Six for advice on how to use the History palette and history brush. Basically, you can create a sharpened image state in Photoshop, undo the sharpening in the History palette, but select the sharpened image state as the history source. You can then use the history brush to selectively paint in any unsharp masking.

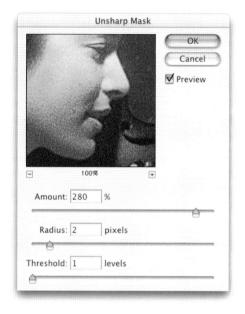

Figure 8.13 This photograph taken of musicians underwater was shot through a very scratched plastic porthole.As a result of these environmental conditions, the picture was already quite soft in appearance and therefore needed a lot of extra sharpening. But the problem with doing that is that at a low threshold setting, the high Amount and Radius also emphasized the film grain. Increasing the Threshold to 10 solved the problem.The photograph was made to appear sharper but without sharpening too much of the film grain.

Photograph by Eric Richmond.

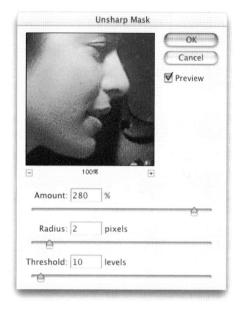

ustme

The image adjustment controls discussed in the preceding chapter take care of the regular image enhancements. So now we shall get to grips with the fine tuning aspects of the Photoshop image adjustment controls, not to mention some of the fun things which can be done while playing around with color. The Curves, Color Balance and Variations image adjustments allow you to exercise control over what happens to the color in either the shadows, highlights or midtones. Yet there are times when you want to narrow down the adjustments further and just work on a particular range of colors only, without affecting the overall color balance. It is also important to stress here that the color data in an image can easily become lost through repeated image adjustments. It is a bit like trying to carry a round of drinks from the bar – the less steady your hand, the more drink that gets spilt. The glasses will never get fuller, only emptier. Pixel color information will progressively become lost through successive adjustments as the pixel values are rounded off.

Hue/Saturation

19 DU

First we will start with the Hue/Saturation command. The dialog controls are based around the HSB (Hue, Saturation, Brightness) color model, which is basically an intuitive form of the Lab color model. When you select the Hue/Saturation image adjustment you can alter these components of the image globally or selectively apply an adjustment to a narrow range of colors. The two color spectrum ramps at the bottom of the Hue/Saturation dialog box provide a visual clue as to how the colors are being mapped from one color to another. The hue values are based on a 360 degree spectrum. Red is positioned in the middle at 0 degrees. All other colors are assigned numeric values in relation to this, so cyan (the complementary color of red) can be found at either -180 or +180 degrees. Adjusting the hue slider only will alter the way color in the image will be mapped to a new color value. Figure 9.1 shows extreme examples of how the colors in a normal color image will be mapped by a Hue adjustment only. As the hue slider is moved you will notice the color mapping outcome is represented by the position of the color spectrum on the lower color ramp. Saturation adjustments are easy enough to understand. A plus value will boost saturation, a negative value will reduce the saturation. Outside the Master edit mode,

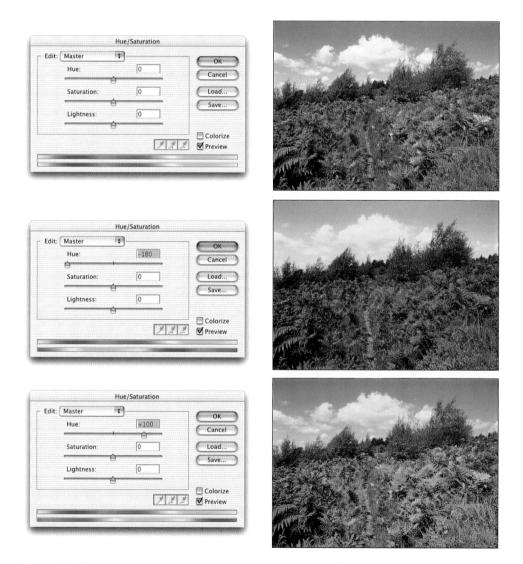

Figure 9.1 Examples of extreme 'hue only' adjustments using the Hue/Saturation image adjustment.

I In the following example, we have a composite image where gold body paint makeup was applied to the skin, but the film recorded the gold as a much redder color than was desired.

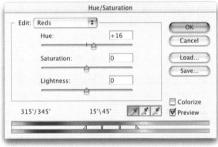

Michael Smiley - Edinburgh Fringe poster.

2 In the Hue/Saturation dialog box, you will notice a pull-down menu defaulted to Master that contains a list of the subtractive and additive primary colors. These narrow the color control to these color ranges only. So, by selecting Reds from this menu, you can enhance or subdue the saturation of the red color component of the image and shift the red colors so that they become more yellow and less magenta.

3 After that, select Yellows and similarly tweak the settings – this time to adjust the yellow component only and in this case enhance the color saturation.

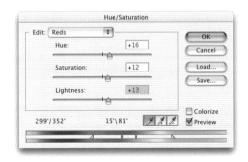

Edit: Master		ОК
Hue:	0	Cancel
Saturation:	0	Load
Lightness:	0	Save
	1 A	Coloriza

Master 🕴 -		ОК
Hue:	0	Cancel
Saturation:	25	Load
Lightness:	0	Save
	1 2 2	☑ Coloriz ☑ Preview

I in the default mode, changes made will affect the image globally. As you adjust the Hue slider, the upper color ramp always remains as it is and you will see the lower color ramp shift accordingly.

Edit:	Magentas	•		ОК
	Hue:	0		Cancel
	Saturation:	0		Load
	Lightness:	0		Save
255	/299*	₩ 302°\345°	1 A	Coloriz
	4	III N		

2 If you click on the Colorize button, the default setting is a primary red color (180 degrees) at 25% Saturation and 0% Lightness. Notice that the pop-up menu is dimmed and that the lower color ramp reflects the color value as defined above.

3 The pull-down menu is used to specify a narrow range of colors. You can be very specific as to which colors are to be altered. Here you see the magenta range of colors have been selected from the menu. The two vertical markers creating the gap in the middle of the sliders represent the chosen color range to modify and the spaces defined by the outer triangular markers represent the threshold drop-off either side of the color selection.

4 Now watch what happens when the Hue, Saturation and Lightness sliders are adjusted and extra colors moving towards the red end of the spectrum are shift added with the eyedropper. See how the lower color ramp colors reflect the cast introduced to the shot.

you can choose from one of six preset color ranges with which to narrow the focus of the Hue/Saturation adjustment. Once in any of these specific color ranges, a new color value can be sampled from the image window, around which to center a Hue/Saturation adjustment. Shift-click in the image area to add to the color selection and Option/Alt-click to subtract colors (see page 225).

When the Colorize option is switched on, the hue component of the image is replaced with red (hue value 0 degrees), lightness remains the same at 0% and saturation is 25%. Some people recommend this as a method of obtaining a colored monochrome image. Yes it works, but frankly I would suggest you follow some of the steps outlined later in Chapter Thirteen on black and white effects.

Color balancing with Levels

While the Levels dialog box is open, you can at the same time correct color casts by adjusting the gamma in the individual color channels. Where you see the pop-up menu next to the channel at the top, mouse down and choose an individual color channel to edit. Increasing the gamma in the Green channel will make an image appear more green (RGB mode). In CMYK mode, increasing the gamma setting in the *Magenta* channel will make the image go more green. To neutralize midtones, in the Levels or Curves dialog box, select the gray eyedropper and click on an area in the image that should be a neutral gray. The levels will automatically adjust the gamma setting in each color channel to remove the cast. Levels may be adequate enough to carry out basic image corrections, but does not provide you with much control beyond reassigning the highlights, shadows and midpoint color values. The best tool to use for color correction is Curves. This is because you can change the color balance and contrast with a degree of precision that is not available with the Levels, Color Balance and Variations image adjustments.

Figure 9.2 Individual color channel Levels adjustments can be applied to adjust the color balance.

Vellow

Magenta

Cyan

Blue

Red

Variations

Figure 9.3 The Variations dialog displays color balance variations based on the color wheel model (shown right). Here you see the additive primaries, red, green, and blue, and the subtractive primaries, cyan, magenta, and yellow, placed in their complementary positions on the color wheel. Red is the opposite of cyan; green is the opposite of magenta, and blue, the opposite of yellow. Use these basic rules to gain an understanding of how to correct color.

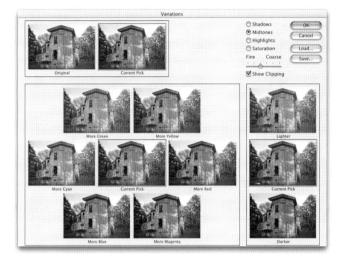

Figure 9.4 The Variations interface will enable you to modify the color of the shadows, highlights or midtones separately. For example, clicking on the red preview will cause the red variant to shift to the centra and readjust the surround previews accordingly. Clicking on the cyan preview will restore the central preview to its original color balance. In this respect, Variations is just like the Color Balance adjustment, but you also have built in the saturation adjustment and a lighter or darker option. And you can save or load a previous Variations adjustment setting. Variations may be a crude color correcting tool, but it is nonetheless a useful means by which to learn color theory.

Auto adjustments

The Image > Adjustments menu contains three auto adjustment commands: Auto Levels, Auto Contrast and Auto Color. The difference between each is explained in Figure 9.5. Of these, Auto Color (which is new to Photoshop 7.0) is the most effective auto adjustment. But if you choose Levels or Curves, you will notice an Options button. This will open an Auto dialog in which you can specify an auto correction method, plus neutralize the midtones and set the clipping values for the highlights and shadows.

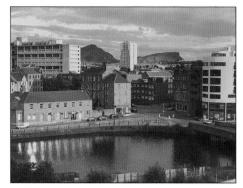

Before

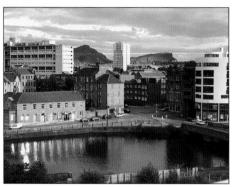

Auto Contrast (Enhance Monochromatic Contrast)

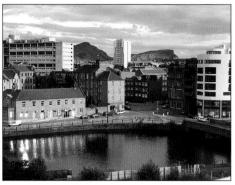

Auto Levels (Enhance Per Channel Contrast)

Auto Color (Find Dark & Light Colors)

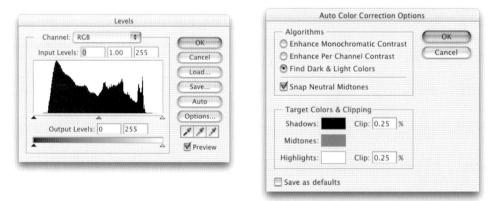

Figure 9.5 These photographs show the three auto adjustment methods (with equivalent descriptions as displayed in the Levels and Curves dialogs). Auto Levels expands the shadow and highlight points in all three color channels – this will generally improve the image contrast and color balance. Auto Contrast will apply an identical adjustment across all three channels. This will increase the contrast, but without correcting any color cast. The Auto Color option will map the darkest and lightest colors to the colors shown in the Options dialog. If Snap Neutral Midtones is selected, Auto Color will also neutralize these (as in the Auto Color example shown here). You can customize the Clipping values to set how much the highlights and shadow tones are clipped by the image adjustment.

Color Balance

The Color Balance is a sort of blind curves adjustment command. The interface controls may look intuitive enough, but it is not really the most useful tool for balancing and correcting color. If you are able to follow the later tutorials which show how to use curves adjustments to correct color accurately, then you might as well disregard Color Balance. Although I do sometimes use Color Balance to tone black and white photographs.

Variations

The Variations adjustment offers a more impressive and easy to use dialog box. It is identical to Color Balance in that you can choose to make an image more green or more cyan in the shadows, midtones or highlights plus you can select from the darker, lighter and more/less saturated options. The increments of adjustment can be fine or coarse and warnings of channel clipping can be displayed in the previews if Show Clipping is checked. Variations is not bad as a starting tool for beginners, because it combines a wide range of basic image adjustment tools in a single interface and an out-of-gamut warning is given when the safe limits of an adjustment have been reached.

Curves adjustments

Any adjustment that can be done in Levels can also be done using Curves. The Curves interface may be less intuitive, but it is much more powerful because you can not only set the shadows and highlights, but also have accurate control of the overall contrast as well as in the individual color channels. Figure 9.6 shows the Curves dialog. You can toggle enlarging the dialog view by clicking the zoom button in the bottom right corner. You can also toggle the grid by Option/Alt-clicking in the graph area; the finer grid allows for more accurate tweaking. The linear curve line represents the tonal range from 0 in the bottom left corner to 255 levels top right. The vertical axis represents the input values and the horizontal axis, the output values. So, if you move the shadow or highlight points only, this is equivalent to adjusting the input and output sliders in Levels. In Figure 9.6, the highlight input point has been moved in several levels. The following example shows how simple it is to use Curves to correct an RGB image where we wish to make the shadows lighter but without lightening the overall photograph. With Curves, you can target a specific range of tones and remap the pixel values to make them lighter or darker or increase the contrast in that tonal area only. To use a musical analogy, you could say that choosing curves over levels is like playing with a fretless guitar as opposed to a fretted instrument. Various examples of curves use are featured throughout this book.

Figure 9.6 Curves corrections can be exactly the same as making a Levels adjustment. In this example, the two ends of the curve have been dragged in as you would in Levels, in order to set the optimum shadow and highlight points. You can control both the lightness and the contrast of the image by adjusting the shape of the curve. Click on the bottom right box to enlarge the curves dialog, as shown below.

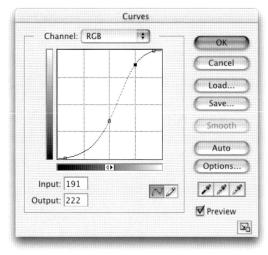

Figure 9.7 If you click on the horizontal output ramp, the curve point readouts will be displayed using density percentages when in RGB and ink percentages when in CMYK. The curve is also reversed in CMYK, with the shadow point in the top right corner and the highlight point in the bottom left. If you Option/Alt-click anywhere inside the grid area the grid units will switch from 25% to 10% increments.

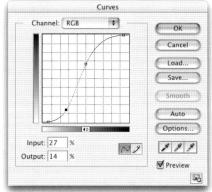

For example, Chapter Fourteen shows how coloring effects can be achieved through individual channel curves adjustments. The default RGB units are measured in brightness levels from 0 to 255. CMYK curves are by default displayed differently (click on the horizontal output ramp to toggle between displaying with levels or ink percentage readouts). This alternate mode (see Figure 9.7) is designed for repro users who primarily prefer to see the output values expressed as ink percentages.

The next example shows how you adjust the curve to both improve image contrast and correct the color balance at the same time. Providing the monitor has been correctly calibrated, this can all be judged by eye on the screen. I The photograph shown here lacks detail in the shadows. The information is there but in its current state the hair will print too dark. We don't want to lighten all of the photograph, otherwise the mood in the original picture will become lost. Choose Image > Adjustments > Curves. The dialog box contains a line on a graph on which you can remap the image tones. Identify which portion of the curve needs adjustment by mousing down in the image area (such as on the darker areas of the hair) and watch where the circle appears on the curve.

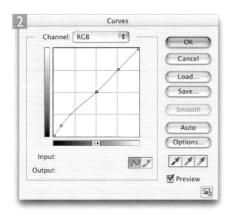

2 Click on the curve line to anchor both the midpoint and the highlights. Now refer back to stage one which helped you determine where to add a point on the shadow end of the curve, click on the curve and drag upwards to lighten. The line bends to form a smooth curve and the shadows are made lighter. Precise positioning of the curve anchor points is achieved by using either the keyboard arrow keys or entering numeric values in the Input and Output boxes below.

Client: Schwarzkopf Ltd. Model: Maria at M&P.

3 In this corrected version the midtone and highlight tone values remain unaltered, while the shadow detail has been lifted. You can always use Curves in this way to exert fine control over the lightening or darkening at precise points on the tonal scale.

There is also a more precise way of correcting the color balance. If you exploit the fine tuning capabilities built into the Curves dialog and combine this with the use of the color sampler tool, you can correct with absolute precision. Repro professionals will often rely more on the numeric readouts to judge the color in a digital image.

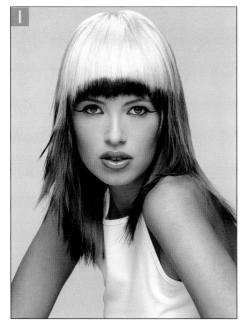

I The above photograph has a cold color cast. This is particularly noticeable in the backdrop, which should be a neutral gray. If I want to correct the color in this picture, the best method is to apply a curves image adjustment. Go to the Image > Adjustments menu and choose Curves...

2 This shows you the curves corrected version. The main Curves dialog allows you to make tonal corrections to the composite color channel (in this case, the RGB composite channel). I dragged down from the RGB channel to select first the red color channel and added a couple of control points to the curve to adjust the color balance for the midtones and highlights. If you are not happy about the position of a curve point, it is very easy to move it around and change the shape. When a control point is selected, to select the next point, use Control/Right mouse-click+Tab. To select the previous control point, use Control/ Right mouse-click+Shift+Tab.To get rid of a point altogether, drag it to the outer edge of the graph or Command/Ctrl-click on the point in the grid. I then went to the Blue channel and added a couple of points. This time to correct the color for the shadows and highlights in the Blue channel.

Client: Anita Cox Salon.

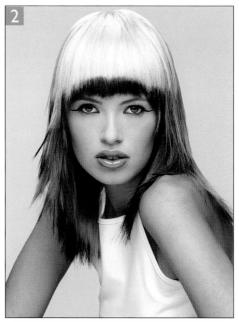

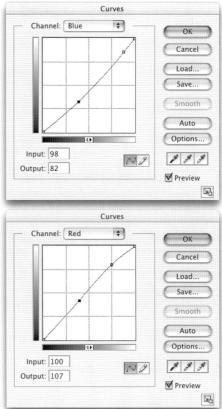

The follow-on tutorial, featuring the white boot, is a good example of where the Info palette readout can be used to determine the neutrality of the image tones and is the ultimate guarantee of perfect color correction. If you match up the RGB values so that red = green = blue, the resulting color is always a neutral gray. Remember, this is not the case with CMYK color (see Chapter Four on color management).

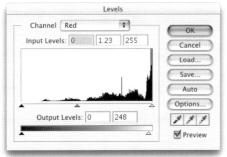

Inf	0						
A.	R G B	•		8	СМҮК		
+,	X Y	:		t	W H	:	
#1 A	RGB			#2 *	R G B		224 238 240
#3 K	RGB		165 179 184				

I When you have a white object photographed against a white background, any color cast will always be very noticeable. First of all select the color sampler tool and click on the image in up to four places to locate the persistent color readouts at different places on the boot.

Inf	0				
A.	R : G : B :	255 255 255	я.	С: М: Ү:	0% 0% 0%
+,	X : Y :	4.11 3.87	ti	₩ : H :	
#1 *	R : G : B :	165 182 184	#2 *	R : G : B :	220 236 237
#3 K	R : G : B :	168 184 185	1		

2 Follow the Levels adjustment procedure as outlined in the previous chapter (Assigning shadow and highlight points, page 216). Expand the tonal range and neutralize the shadows and highlights as much as possible. This improves the picture already and removes most of the cyan cast.

To add a new color value as a control point on the curve, Command/Ctrl-click inside the document window and you will see a control point appear on the corresponding portion of the curve. If you use Shift+Command/Ctrl to click in the document window, Control points will be automatically added to all three color channels at once. So when adding control points to color correct the white boot, I would Shift+Command/Ctrl click on top of each of the color sampler points to add these as control points in all three color channels in the Curves dialog. When you are editing the points in the Curves dialog, use Shift-click to select multiple points. As you adjust one control point the others will move in unison. To deselect all the points, use Command/Ctrl-D. When a single point is selected you can select the next point using Control/Right mouse-click+Tab and the previous point by using Control/Right mouseclick+Shift+Tab.

3 The color sample points can be repositioned as necessary by dragging on them with the color sampler (you can access the tool while in an image adjustment dialog, by holding down the Shift key). Apply a Curves adjustment and adjust each color channel curve as necessary. The first RGB readout figure in the Info palette tells you exactly where to position the point on the curve (see the Input numeric box). Either manually drag the point or use the keyboard arrows (Shift+arrow key moves the control points in multiples of 10) to balance the output value to match those of the other two channels. What you adjust at one point on the curve will affect the shape and consequently the color in another part. This is why it is advisable to monitor the color values across the range of tones from light to dark. Remember that you can shift select image sampled colors to add points to the curve.

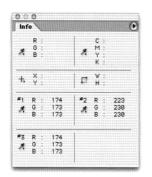

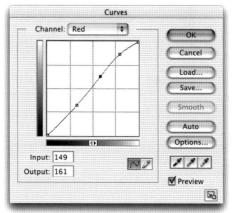

Arbitrary Map mode

If you click on the Arbitrary Map mode button in the Curves dialog, you can sketch in the grid area with the pencil cursor to create a freehand curve map shape. The results are likely to be quite repulsive, but if you click on the smooth button a few times you will see the curve become less jagged and the tonal transitions will then become more gentle. Another example of an Arbitrary Map mode curves adjustment can be found in Chapter Thirteen on black and white effects.

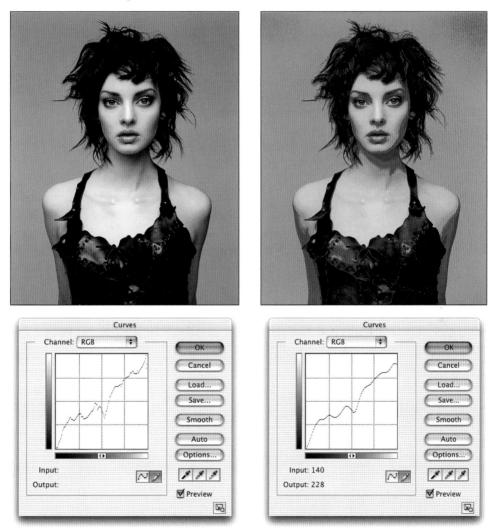

Figure 9.8 If you click on the Arbitrary Map button in the Curves dialog, you can draw a freehand curve shape like the one shown here. Click on the Smooth button to produce a gentler effect.

Client: Anita Cox Salon. Model: Sorcha, Bookings.

Replace Color

Hue/Saturation crops up again in the Replace Color command, which is really like a combination of the Select > Color Range and Hue/Saturation command combined in one. With Replace Color, you can select a color or range of colors, adjust the fuzziness of your selection and apply the Hue/Saturation adjustments to those selected pixels only. Alas, the selection made this way is not savable. For critical situations you will want to make a Color Range type selection first and while the selection is active, choose New Adjustment Layer... > Hue/Saturation from the Layers palette. This two-step process is probably the more flexible approach.

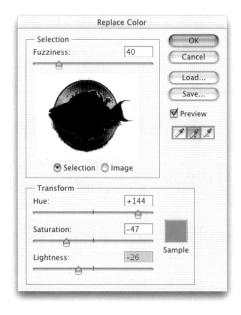

I This is the before image. Using the Replace Color adjustment command we can quickly take the image information in the purple backdrop and alter the Hue, Saturation and Lightness values. This image adjustment command is not available as an adjustment layer, because the single command is a combined two-stage process which involves making a pixel selection.

2 Choose Image > Adjustments > Replace Color. To make the selection, first click with the eyedropper either on the image or in the dialog box mask preview window. Click again with the 'add eyedropper' icon to add to the selection. Click with the 'minus eyedropper' to remove colors. Use the Fuzziness control slider to determine how much tolerance you want to apply to the selection area (see magic wand tool). Now change the Hue/ Saturation values. As you can see here, the biggest change took place with the Hue, making the background go green instead of purple. Small saturation and lightness adjustments were also necessary.

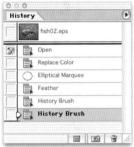

Figure 9.9 To use Color Range, click in the document window or dialog preview to sample a color on which to base your selection. The Fuzziness control is like the Tolerance control in the magic wand options. Click on the plus or minus eyedroppers to add or remove colors from the selection. The dialog preview can either display the original image or preview the selection as a mask. The Selection Preview can allow you to view the selection represented as a quickmask.

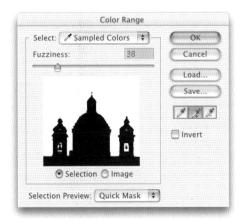

3 After performing the Replace Color operation, there was a little spill-over on to the blue plate. All you have to do is erase the offending areas you can use the history brush to do this, then make a circular selection with the elliptical marquee tool. The marquee actions can be modified when you hold down the Option/Alt key to draw out from the center and constrained to a circle when you hold down the Shift key at the same time. If at any time you also hold down the Spacebar, you can drag to reposition the selection. If you release the Spacebar (but have still held down the Option/Alt+Shift keys), you can carry on expanding or contracting the selection. Now feather the selection and select the Open image state as the History source and restore the original unaltered image.

Photograph: Rod Wynne-Powell.

Color Range

Where the magic wand creates selections solely based on luminosity, the Select > Color Range option creates selections that are based on color values which are similar to the sample pixel color. Among other things, you can use the Color Range command to make a selection based on out-of-gamut colors. This means you can use Color Range to make a selection of all those 'illegal' RGB colors outside the CMYK gamut and apply corrections to these pixels only. This task is made easier if you feather the selection slightly and hide the selection edges (View > Hide Extras). Then choose View > Gamut Warning. Adjustments can be made using the Selective Color or Hue/Saturation commands as before. Local areas may also be corrected with the sponge tool set to Desaturate.

Adjustment layers

Adjustment layers and the Image > Adjustments commands are identical in purpose. Adjustment layers offer the facility to apply multiple image adjustments and/or fills to an image and have these changes remain 'dynamic'. In other words, an adjustment layer is an image adjustment that can be revised at any time – adjustment layers enable the image adjustment processing to be deferred until the time when the image is flattened. Adjustment layers are automatically 'layer masked' layers, which when selected, can be painted upon in black to remove areas from the adjustment effect. Used in conjunction with History, they give Photoshop a three-dimensional work space of not just multiple, but limitless, undos. One potential drawback is that having a lot of adjustment layers in an image may slow down the monitor preview. This slowness is not a RAM memory issue, but to do with the extra calculations that are required to redraw the pixels on the screen. Adjustment layers are savable in the Photoshop native, TIFF and PDF formats. Also note that the threshold preview mode is now enabled in the Levels adjustment layer dialog.

Multiple adjustment layers

You can have more than one adjustment layer saved in a document, with each producing a separate image adjustment. In this respect, they are very useful because combinations of adjustments can be previewed to see how they will affect a single layer or the whole image before you apply them. You can have several adjustment layers in a file and choose to readjust the settings as many times as you want. It is possible to keep changing your mind and make multiple changes to an adjustment layer without compromising the image quality. The ability to edit adjustment layers and mask them to selectively apply an adjustment provides the most obvious benefit over making a series of normal image adjustments. I used to wrongly assume that when you flattened all the adjustment layers, the effect of doing so was as if you had made a single image adjustment. But this is not so. When you flatten an image, Photoshop will apply all the adjustment layers sequentially as if you had made a series of normal image adjustments.

Blending mode adjustments

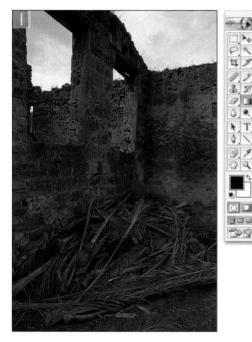

I You can use the layer blending modes as an alternative method to lighten or darken an image. In this example we have a dark image that needs to be made brighter. Go to the Layers palette and add a new adjustment layer. It does not particularly matter which – in this example I chose Levels.

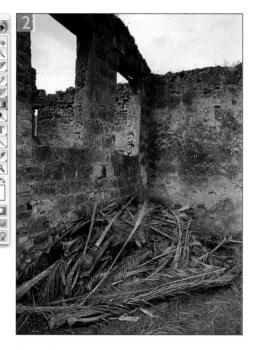

2 Highlight the adjustment layer and change the blending mode to Screen. The result of this will be the same as if you had made a copied Background layer and set it to Screen blend mode. Screening will make the image lighter and Multiply will make the image darker. I then added a gradient to the adjustment layer using the default foreground/background colors. This partially hid the adjustment layer and retained some of the original darker tones at the top of the picture. Not many people are aware of the fact that you can make use of the layer blending modes in conjunction with adjustment layers to lighten or darken an image. The example on page 239 demonstrates how the screen blending mode can be used to lighten a dark photograph. There is an argument suggesting that the calculations used in a screen or multiply blending mode will actually add levels to an image. So this technique may well help in situations where you wish to preserve the fragile image data instead of pulling the levels apart through the use of aggressive Levels or Curves image adjustments.

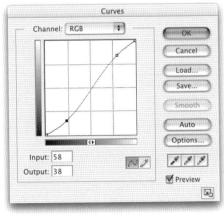

I When you increase the contrast in an image, you will also increase the color saturation.

2 If you apply a Curves adjustment as an adjustment layer, try changing the blending mode to Luminosity. This will increase the contrast in the original scene, but without increasing saturation.

16 bits per channel support

Most of the techniques described in this book have been carried out in Photoshop on files that were in 24-bit RGB color. And a 24-bit image is made up of three 8-bit color channels. But most scanners and professional digital cameras are able to capture more than 8 bits per channel – they can capture what is known as high-bit data. If an imported file has more than 8 bits per channel data, it will be opened in Photoshop in 16 bits per channel mode (an RGB file will be treated as 48-bit color). The main advantage of this is that instead of having only 256 data points per color channel and 8 bits per channel image, you can have up to 65 000 in a 16-bit file. That is quite a lot more levels of tone to play around with, especially when using levels or curves. Figure 9.10 shows two histogram displays that compare the result of editing an image in 8 bits per channel and 16 bits per channel modes.

Photoshop will support color adjustments, cropping, rotating and use of the clone tool and healing brush in 16 bits per channel mode. And since Photoshop 6.0 this has been extended to include Lab color, Canvas Size adjustments and the following filters: Gaussian Blur; Add Noise; Dust & Scratches; Median; Unsharp Mask; Solarize; and High Pass. Wherever possible, I always aim to begin my editing with a file that has been scanned or captured using high-bit data and brought into Photoshop in 16 bits per channel mode. I will crop the picture and apply a Levels and Curves adjustment to get the picture looking good on the screen and then and only then, will I convert the image to 8 bits per channel mode as this will enable me to use all the features in Photoshop. You may not feel the need to use 16 bits per channel all the time for every job, but I would say that for critical jobs where you don't want to lose an ounce of detail, it is essential to make all your preliminary edits in this mode.

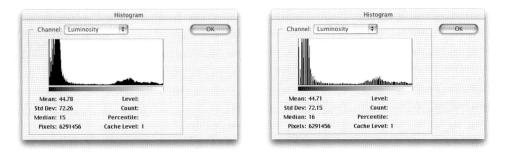

Figure 9.10 The histogram on the left is from an image in 8 bits per channel mode that started out in 16 bits per channel mode but where the levels were expanded using a couple of Levels and Curves adjustments. The histogram on the right is of the same image after the same adjustments had been applied as before, but the image was in 8 bits per channel mode throughout. As you can see, if you keep a picture in 16 bits per channel mode while you apply levels and curves adjustments, much more of the levels data will be preserved as a result.

Selective Color

The Selective Color command is the ultimate, precision color control tool. It allows you to selectively fine tune the color balance in the additive and subtractive primaries, blacks, neutrals and whites. In that respect the controls are fairly similar to the Hue/Saturation command, except here you can adjust the cyan, magenta, yellow and black component of the chosen color range. The Selective Color command is therefore a tool for correcting CMYK color, but you can also use it to prepare an RGB file before converting it to CMYK. The color control available with Selective Color is a bit like adjusting the sound on a music system with a sophisticated graphics equalizer. Subtle or quite strong changes can be made with ease to the desired band of color tones. The Selective Color command is therefore another alternative to the Hue/Saturation adjustment for getting RGB colors to fit the CMYK color space. In the accompanying example, I show how the gamut warning can help you pinpoint the illegal out-of-gamut colors in RGB. You may want to consider carrying out such adjustments using two window views: one with the normal RGB version and the other with gamut warning and the Working CMYK proofing switched on in the View menu.

As a final note on the above technique – there is bound to be a noticeable color shift and more than just the blue colors will benefit from adjustment. Since the initial blue did not exist in CMYK it had to be converted to something else. What that something else is, well, that is the art of preparing images for four-color printing. The trick is to convert the existing colors in a way that the color values obviously change but the final perception looks right to the eye. Blue skies are a good example – bright deep blues do not convert well to CMYK, as deep blue will fall outside the CMYK gamut, and the default conversion that does work convincingly to the eye. But you can use Selective Color to adjust the values of the magenta, cyan and black color plates so that these will produce another type of blue using a different combination of inks. Where the color matching is critical, Selective Color may help to correct an imbalance and improve the output color, provided the output color to be targeted is within the CMYK gamut. When this is not so, special printing techniques must be adopted, like adding an extra printing plate to substitute a custom color.

You may like to explore other refinements to the technique shown here. For example, the CMYK Preview window could also have the Gamut Warning switched on as well. As corrections are made using Selective Color, you can see whether the colors are changing to your satisfaction and still falling inside the CMYK gamut. I This is not an easy one to show because we are starting with an 'RGB' image that is printed in CMYK. But imagine you have an RGB scan that looks fine on screen, but not all the colors fall within the CMYK gamut. A relative colorimetric CMYK conversion will automatically translate the out-of-gamut RGB colors to their nearest CMYK equivalent. If there are only a few out-of-gamut RGB colors to start with, there will be little change to the image appearance after converting.

2 To check if this is the case, you can select View > Proof Setup > Working CMYK and then choose View > Gamut Warning. The latter will display outof-gamut RGB colors with a predefined solid color (refer to the Preferences section in Chapter Six). If the gamut warning shows any out-of-gamut pixels you can bring them within the CMYK gamut using the Image > Adjustments > Selective Color command to selectively shift the magenta and yellow percentages that affect the blue component color.

Colors: Blues	-		<
Cyan:	0	% _ Can	cel
Magenta:	-6	% Load	
Yellow:	+12	% ØPrevi	ew
Black:	0	%	

3 In the previous picture the 'illegal' RGB colors have been adjusted so that when the conversion takes place all the RGB colors now have a direct CMYK equivalent. You can also just as easily use the Hue/Saturation command to do this job. I used Selective Color because it is a fine-tuning color adjustment tool and one based around the destination CMYK color model. A Relative percentage change will proportionally add or subtract from the current value. So if the cyan value is currently 40% adding a Relative 10% will equal 44%. Adding an Absolute 10% will make the new value 50%.

Repairing an Image

Most photographers are interested in the potential of using Photoshop as a tool for retouching pictures. So we shall start with simple techniques like cloning and then go on to explore some other advanced methods that can be used to clean up and repair damaged photographs. The clone stamp is a popular retouching tool even if it is a little difficult to master. But everyone has been very excited by the healing brush and patch tool, both of which are new to Photoshop 7.0, which can make Photoshop retouching so much easier to accomplish. The healing brush in particular can always be guaranteed to impress!

Basic cloning methods

hapte

The clone stamp tool is used to repeat parts of an image elsewhere and requires some basic keyboard/mouse coordination. Select the clone stamp from the Tools palette. To establish the area where you wish to sample from, hold down the Option/Alt key and click. Then release the Option/Alt key and click or mouse down to paint over the area you want to clone to. When the Aligned box is checked, the sample area retains the same angle and distance in relation to where you paint with the clone stamp tool. When the Aligned option is unchecked, the sample point remains fixed for all brush strokes. This latter mode is ideally used when the sample area is very small, as you can keep a tight control over the area you are sampling from. But the Aligned mode is the most appropriate option to select for everyday spotting. Select the Use All Layers option to sample from all merged layers. As with all the other painting tools, you can change brush size, shape and opacity to suit your needs. While you may find it useful working with different combinations of these settings with the painting tools, the same does not apply to the clone stamp tool. Typically you want to stick to using the fine to medium-sized brushes (just as you would always choose a fine paintbrush for spotting bromide prints). I mostly always leave the opacity set to 100%. Cloning at less than full opacity usually leads to telltale evidence of cloning. Where the film grain in the photograph is visible, this can lead to a faint overlapping grain structure, making the retouched area look slightly blurred or misregistered. When smoothing out skin tone shadows or blemishes, I will occasionally switch to an opacity of 50% or less. Retouching light soft detailed areas means I can get away

I Normally snapped to the top or bottom of the screen, the Options bar displays the clone stamp options. The 'Aligned' box is normally checked by default. The Nonaligned mode allows you to set the source sample point so that repeat cloning always commences from the same source point for each new stroke you paint. The tool opacity should be left at 100%. Sometimes painting at a lower opacity will work, but the best way to disguise your cloning is to use the clone stamp at 100%.

2 This example shows the source image area identified by a surrounding yellow rectangle. All the other clones (which are marked with cyan rectangles) were repeated from the same source starting point using the clone stamp in Nonaligned mode.

3 In Aligned mode, Photoshop will always maintain the relationship (the alignment) between the sample and painting points. The clone stamp tool can only act on the active layer, but when the Use All Layers box is checked, Photoshop will sample data from all the layers that are currently visible, as if they were a single flattened layer.

Brush: 21 Mode: Normal Opacity: 100% Flow: 100% Aligned & Use Al Layers

with this. Otherwise stick to 100%. And for similar reasons, you don't want the clone stamp to have too soft an edge; ideally make the clone stamp brush shape have a slightly harder edge. Lines and wrinkles can be removed effectively with the dodge tool or with the brush tool set to Lighten mode. If you are cloning over an area where there is a gentle change in tonal gradation, unless the point you sample from matched the destination point exactly in hue and lightness, it will be almost impossible to disguise your retouching work. In these situations you will be better off using the healing brush, which is described later in this chapter.

Figure 10.1 You can sample the sky from one image window and copy it using the clone stamp to another separate image. Option/Alt-click with the clone stamp in the source image, select the other image window and click to establish a cloning relationship between the source and destination images.

Spotting used to be such a laborious and tricky process. I am reminded of an old story about a commercial photographer who rather than use a scalpel knife to remove a black speck in the sky, would paint in a couple of wings and turn it into a seagull. Thankfully with Photoshop anyone can learn to quickly spot a picture now.

Add Noise			
	OK Cancel		
	Ð		
Amount: 5 % Distribution Uniform Gaussian			
Monochromatic			

Figure 10.2 Gradient banding is a common problem in Photoshop. Banding can occur whenever you apply a heavy blur filtration. It can also sometimes appear on gradient fills. The gradient options include a dither mode and this will help somewhat. However, the best way to hide banding is to apply a small amount of noise, using the Noise > Add Noise filter. The Gaussian option will produce a more irregular distribution of noise. The example here shows a noticeably banded gradient with and without the noise being added. The noise filter is well worth remembering any time you wish to hide banding or make Photoshop paintwork appear to merge better with the grain of the scanned original.

Retouching a color negative

It is possible to retouch a masked color negative and output again to film as a negative. In the accompanying example, the client wanted the color negative original to be scanned as a positive, so that it could be output again to film as a color negative. The color negative scan can be displayed on the screen as a positive image by the introduction of an extra layer and three adjustment layers, one to neutralize the mask, one to invert the image and the others to expand the levels and increase the color saturation. You can then spot and retouch the active background layer without actually altering the color or masking the color negative original. The following example uses a color negative photograph that was scanned as if it were a positive original to include the orange color mask and was then output to film as a color negative again. This is a refined version of a technique which was devised by Rod Wynne-Powell of Solutions Photographic.

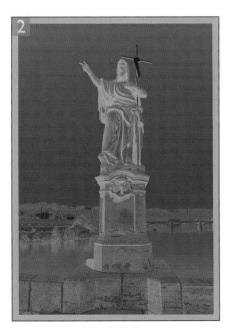

I The scanned negative requires some retouching prior to being output as a negative again. It would be hard to retouch the negative as it is because the colors are inverted with an orange colored mask and the tonal range is too narrow for us to see properly what is going on. The following steps are intended for viewing a positive version of the image. The added layers can be discarded later.

2 The first stage is to counterbalance the orange mask – sample from the rebate using the eyedropper tool set to a 3×3 pixel sample radius (go to the eyedropper tool options). Then go to the Layers palette, click on the adjustment layer button and add a Color Fill adjustment layer. And then add an Invert adjustment layer above this. Option/ Alt-click on the dividing line between the two adjustment layers – this will create a clipping group with the color fill layer. Now change the color fill layer opacity to 50% and the blending mode to Color. As you can see, this neutralizes the orange mask.

3 Next add an Invert adjustment layer to the top of the layer stack. This step inverts the tonal values exactly which converts the negative into a pale positive image.

4To boost the contrast, make a second adjustment layer. Select Levels and in the Levels dialog box, click on the Auto Levels button. Finally add a Hue/ Saturation adjustment layer and increase the overall saturation. We now have an approximated positive image preview. If I want to do any retouching, this must be carried out on the background layer. When the retouching is completed, discard the adjustment layers and output to transparency.

Layers	/		Ð
Normal	÷.	Oplacity: 100% 🕨	
ock:	1+0	Filk 100% 🕨	
•	8	Hue/Saturation 1	Constanting of the local division of the loc
•	<u>اخف</u> ه 	Levels 1	
•		hvert 1	
	•	Invert 2	
	8	Co.lor Fill 1.	
• 3	Backgrou	nd	۵

Alternative spotting technique using the history brush

This method of spotting a photograph has evolved from a technique that was first described by Russell Brown, Senior Creative Director of the Adobe Photoshop team. It revolves around using the Remove Dust & Scratches filter, which is found in the Filter > Noise submenu and can be used to remove image defects. If this filter is applied globally to the whole image, you will always end up with a soft-looking result. You are actually only meant to apply this filter selectively to the damaged portions of a picture in Photoshop. The technique shown here has the advantage of applying the filtered information precisely to fill in the dirty areas without the risk of destroying the tonal values in the rest of the picture.

I This photograph serves as a good example with which to demonstrate the history brush spotting technique, as there are a lot of hair and scratch marks that are clearly visible in this picture.

2 Go to the Filter menu and choose Noise > Remove Dust & Scratches to the image. Check the filter dialog preview and adjust the Amount and Threshold settings so that most of the marks appear to have become dissolved away by the filter and click OK to apply this filtration to the image.

to g

 Image: Second second

3 Now go to the History palette and click on the previous unfiltered image history state, but set the history brush source to paint from the filtered version. Select the history brush and change the history brush blending mode in the tool options bar to Lighten. As you paint over the dark spots, the history brush will lighten only those pixels that are lighter than the sampled history state. All other pixels will remain unchanged.

4 Continue using the history brush in this way. To remove light spots, change the tool blending mode to Darken.

As you can see, this method works well when you have a picture that is very badly damaged and where using the clone stamp would be a very tedious process. What is really clever is the way that the history brush is used in Lighten or Darken mode so that Photoshop can be made to target replacing specific pixels. However, you may encounter a problem if the photographic original contains noticeable film grain. It may help to apply a small amount of noise after applying the Dust & Scratches filter. Add enough noise to match the grain of the original. This will enable you to better disguise the history brush retouching. To add noise on a separate layer, Option/Alt click the Add New Layer button in the Layers palette. This will pop a New Layer dialog. Select Overlay as the blending mode and you will notice that you can now check the Fill with Overlay-neutral color (50% Gray) box below. In this blending mode the layer will have no visible impact on the underlying layers. But if you filter the layer and add noise, you can create a film grain layer. Try adding a layer mask to this layer to selectively add or remove the noise.

Working with the healing brush

The healing brush is a dream tool to use for all types of retouching work. The healing brush and patch tool utilize some extremely clever math to perform complex blends to produce smooth seamless retouching results. I did once try asking Marc Pawliger, who is the principal engineer on the Photoshop team, to explain how the healing brush worked, but all I can remember is that it has something to do with complex algebra which went completely over my head. But it will help you to understand a little about how the Healing brush and patch tool work, so here is my simplified interpretation of what these tools do.

The healing brush is used in the same way as the Clone Stamp tool, although it is important to stress that the healing brush is more than just a magic clone stamp and has its own unique characteristics and methods of working with it. You can establish a pixel sample point by Option/Alt-clicking an area of an image to sample from. You then release the Option/Alt key and mouse and click in a new part of the image and paint with the healing brush to carry out your retouching.

After you set the sample point and paint with the healing brush, it will analyze the texture from the sample area and apply a blend to the painting area that merges the texture sampled from the sample point and smoothly blend this with the color and luminosity of the painting area. Around the outer edge of where you paint with the healing brush, a soft edge with a feathered radius of up to 10 pixels is used to calculate a smooth transition of color and luminosity with the pixels outside the painting area. For this reason there is no need to use a soft edged brush and in fact you will find that you get more controlled results using a hard edged brush.

In practice, the healing brush is able to perfectly blend sampled pixels with the destination point. When you paint with the healing brush it can seem a little strange that you don't need to match the sample area with the color and lightness of the destination point. To get the best results you have only to look at matching the textures. The default mode for the healing brush has the Aligned box unchecked. This makes sense, because when you are using the healing brush to specifically retouch just the skin tones (as shown in the accompanying example) you ideally want the sample point to always be made from the same area of skin tone texture. If you want to switch to retouching the backdrop (as in the second example) you can then set a fresh sample point that matches the texture of the background pixels. The healing brush can only work on a layer that contains actual pixels. Unlike the Clone Stamp tool, you cannot create an empty layer and check an All Layers box in the Options bar to have all the retouching take place on that layer only. You can either retouch with the healing brush directly on to the Background layer or make a selection of the area of interest, copy this as a new layer: Layer > New > Layer via Copy (Command/Ctrl+J) and retouch the pixels on this layer and thereby have the ability to always be able to undo all the retouching. The problem with adding pixel layers is that this will increase the file size and potentially slow down the healing brush. On a fast machine there should only be a very slight time-lag after applying each click or small stroke with the healing brush.

You can also use a pattern preset as the source for the healing brush. You can either choose a pre-loaded preset or create your own. The Pattern Maker in the Filter menu in Photoshop 7.0 is ideal for this purpose as you can sample from just a small area of useful texture in an image and use the Pattern Maker to create a randomly generated pattern source that can be used to apply a smoothly blended texture over a larger area of the picture using the healing brush. The healing brush has a choice of blending modes. The Replace mode is identical to the clone stamp tool, except it allows you to merge film grain more reliably and smoothly around the edges of your brush strokes. Or choose from a cutdown list of brush blending modes. The healing brush is already utilizing a special form of image blending to perform its work. The other healing brush blending modes can produce different results, but in my opinion they won't actually improve upon the ability of the healing brush in Normal mode.

Although the healing brush can appear to be a miracle retouching tool once you get the hang of how it works, you still have to be careful about retouching any blemishes that are close to a sharp change in tonal contrast. The second example using the healing brush illustrates the problem quite clearly. Even though a hard edged brush is being used, the healing brush stroke will tend to pick up the darker colored pixels adjoining the edge of the brush painting area.

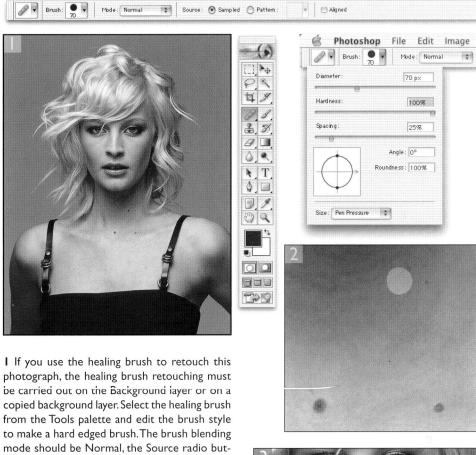

2 To use the healing brush, Option/Alt-click to define the source point. This should be a clean area of skin texture. You are now ready to retouch with the healing brush. Click on the areas of skin tone with the healing brush where you wish to remove a blemish. If you are using a pressure-sensitive tablet as an input device, then the default brush dynamics will be size-sensitive. Apply light pressure to paint with a small brush, apply heavy pressure for a full-sized brush.

ton checked and the Aligned box left unchecked.

3 Continue using the healing brush to complete the skin tone retouching. In this example I sampled one pixel source point for the chest and neck areas and another to retouch the face.

Client: Thomas Macmillan. Model: Sophie Boeson – Models One.

I The healing brush is the perfect retouching tool to use when you are faced with the challenge of having to retouch blemishes against a backdrop such as the one shown here. This is because the backdrop contains gentle transitions of tone. It used to be extremely difficult to retouch backdrops in shots like this when all you had was the clone stamp.

 ${\bf 2}$ A potential problem arises when you wish to retouch a blemish that is adjacent to a sudden shift in lightness or color.

3 In this picture you can see that even if you use the healing brush with a small hard edged brush, the brush may pick up the darker tones of the model's dress and you will get to see the ugly looking shading shown here.

4 The answer to the problem is to make a preselection first of the area you wish to heal (with maybe some minimal feathering) and thereby restrict the extent to which the healing brush tool analyzes the surrounding pixels.

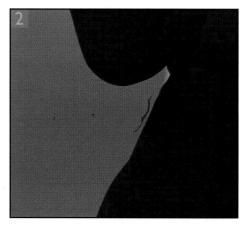

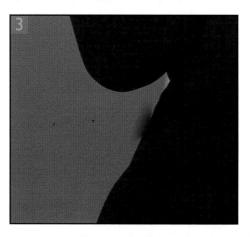

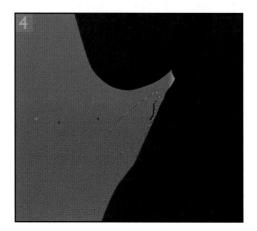

Client: Anita Cox. Model: Steph at IMG.

Patch tool

The patch tool uses the same complex algebra as the healing brush to carry out its blend calculations, but the patch tool uses selection-defined areas instead of a brush. When the patch tool is selected, it initially operates in a lasso selection mode that can be used to define the area to patch from or patch to. For example, you can hold down the Option/Alt key to temporarily convert the tool to become a polygonal lasso tool with which to draw straight line selection edges. You don't actually need the patch tool to define the selection, any selection tool or selection method can be used to prepare a patch selection. Once you have a selection made, select the patch tool to proceed to the next stage. As before, the patch tool has to work with either the Background layer or a copied pixel layer.

In Destination mode you can drag the selection area with the patch tool to a new destination point and Photoshop will perform a healing blend calculation to merge the sampled patch area with the underlying pixels in the new area of the image. In Source mode the you can drag the selection area with the patch tool to a new destination point to select the pixels that will replace those in the original source selection area. The Use Pattern button in the Options bar for the patch tool will let you fill a selected area with a preset pattern using a healing type blend.

I The patch tool works in a way that is similar to the healing brush. Using the picture opposite, I can show you how the patch tool can be used in Source mode to cover up the metal staples that are holding the large pot together. When you select the patch tool you can use it just like the lasso tool to loosely define a selection area. For example, you can use the Option/Alt modifier key to temporarily switch from free form lasso to polygonal lasso selection drawing mode. Or you can use any other preferred selection method (it really doesn't matter at this stage) as you prepare the image for patching. Note that as with the healing brush, the patch tool must be used on the Background layer or a layer that contains pixels for you to modify.

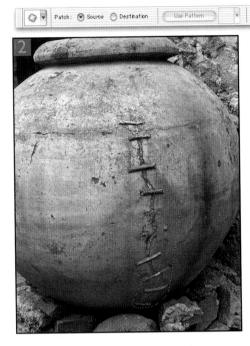

2 When you have finished defining the selection for the area you want to patch, make sure that the patch tool is selected in the Tools palette and drag inside the selection to relocate it on an area of texture that you wish to sample from.

4 If the patch/healing process was successful, you should see an almost completely smooth join. The pixels that you selected to be sampled from in the patch process will adjust their luminosity and color to blend with the pixels in the original defined area, to match the lighting and shade etc. However, you won't always get a 100% perfectly convincing result. In the example used here, I made a couple of attempts at patching the staples before finding a patch selection that would work well. Furthermore, as when using the Clone Stamp tool, you have to beware of any repeating patterns giving away the fact that the image has been cloned. I finished retouching this photograph by applying a few healing brush strokes to remove some of the telltale signs.

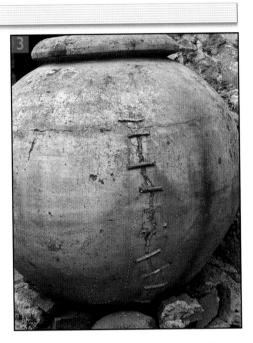

3 As you release the mouse, Photoshop will commence calculating a healing blend, analyzing the pixels from the source area you just defined and using these to merge seamlessly with the pixels in the original selection area.

I The patch tool uses the same blending calculations as the healing brush to perform its blend calculations. In this image I want to demonstrate how you can use the patch tool in Destination mode to make a duplicate of this fishing boat.

2 Use the patch tool to define a rough selection outline of the boat. In use, the patch tool is just like the lasso tool, you can use the Option/Alt modifier key to draw straight line points. If you prefer you can use any other selection tool such as the magic wand or convert a selection from a pen path.

3 Make sure that Destination is selected in the Options bar. When the selection is complete, use Command/Ctrl+Option/ Alt+T to copy the pixel selection and add the free transform bounding box to the selected pixels. Drag the transform to a new location. In this example I dragged the transform across to the right, aligned the center point to the horizon and held down the Shift and Option/Alt keys, to scale the transform down in size to make the second boat smaller and appear to be further away in the distance.

4 I then hit Enter just to OK the transformation. After that I moused down with the patch tool inside the selection area and moved the selection very slightly. If you follow these steps precisely and release the copied selection. the patch tool will calculate how to merge the dropped selection with the underlying pixels. This will produce a smooth looking blend with the surrounding sky and sea area. The patch tool works well with a subject such as this, because the sea and sky provide a fairly smooth backdrop for blending the pixels smoothly.

Photograph: Thomas Fahey.

Healing brush strategies

The following example illustrates how you can use the healing brush and patch tool to solve a rather more complex retouching problem. Although the healing brush and patch tool are natural candidates to use here, I need to plan carefully how they will be used, as I will also need to rely on the clone stamp tool to do some of the preparation work, in particular where the edges of the selection to be healed extend to the edge of the document bounds.

I Let us consider how we would go about covering up all the exposed bricks in the picture opposite, so as to match the remaining plaster work. Some of these areas are too large to use the patch tool in one operation. Notice how I prepared three paths to define some of the areas to be repaired, which closely follow the outline of the cactus leaves. These will be used in the following steps. To begin with, I converted Path 2 into a selection by dragging the Path 2 palette icon down to the Make Selection button in the Paths palette.

Pa	aths						\mathbf{e}
3	Pati	n 1					
	Pati	h 2					
7	Pati	h 3					
	0	0	0	1 Arra	5	3	12

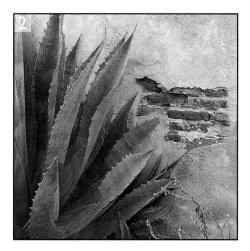

2 I then used this selection to copy the pixels to make a new layer. Choose: Layer > New > Layer via Copy (Command/Ctrl+J).I clicked on the Lock Transparency box in the Layers palette and selected the clone stamp, and was then able to clone some of the pixels in the image to provide a wall textured border edge on the left and the right. I did this in order to provide the healing brush or patch tool some edge pixels to work with. If I don't do this, Photoshop will try to create a patch blend that merges with the cactus leaf colors.

3 I could try selecting the healing brush and attempt to sample some of the plaster texture to fill in the remaining gap. In this and the other sections to be repaired, the area to be covered up was so large that I decided to create a new pattern based on a small selection of the image. I made the Background layer active and chose Pattern Maker from the Filter menu. I then marquee selected a small area as shown here.

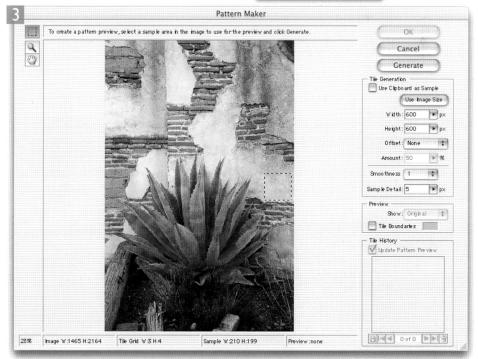

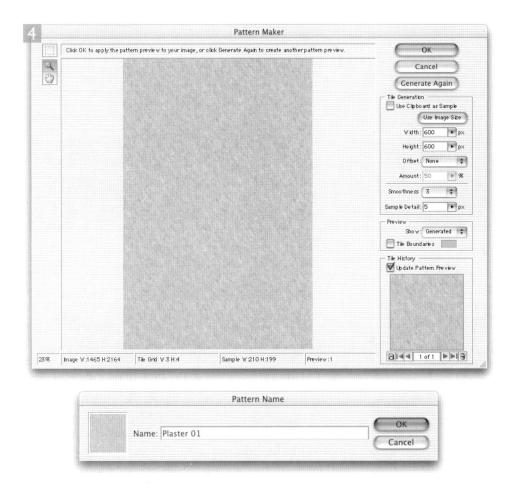

4 I made the tile area fairly large – 600 pixels square in this example, and I set the Smoothness setting to 3. If I click on the Generate button at the top of the dialog, the Pattern Maker will generate a randomized pattern that is a wraparound texture. The result of which is previewed in the dialog. I didn't need to click OK as this will apply the texture as a fill to the current image. Instead I clicked on the Save Preset Pattern button at the bottom of the dialog. Once I had named the new pattern, it was appended to the other Pattern presets.

5 I then activated Layer I again, selected the patch tool and drew a rough selection of the plaster wall area I had just prepared as shown in this close-up image.

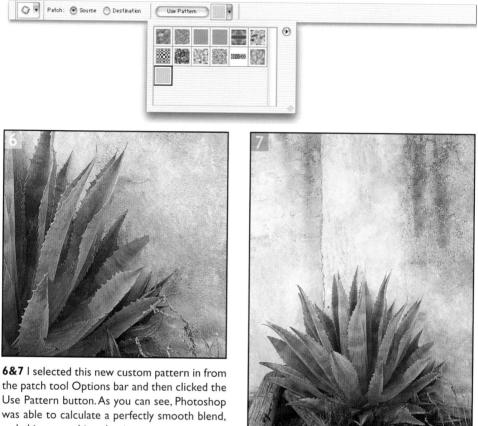

was able to calculate a perfectly smooth blend, and this was achieved using a texture pattern that had been synthesized in Photoshop. I repeated using this method on the other parts of the photograph and ended up with the finished result seen here.

Cloning selections

Cloning with the clone stamp tool is an acquired skill and to hide your cloning effectively, you need to keep changing the source point you are sampling from. If you don't, you may find parallel herringbone patterns betray signs of your retouching. The clone stamp tool always clones from the previous image state and does not resample the 'clone added' pixels. The previous techniques are suitable for many repair jobs, but it is not always practical to reconstruct everything using the clone stamp, healing brush or patch tool. This can matter where it is important to match the geometry of the photograph. The next example shows how to replace an area to be repaired with a cloned selection from another part of the same image. I In the following steps I shall demonstrate how to clone the windows in the building on the right. If I were to use the clone stamp tool to sample and copy the windows, then the perspective of the cloned windows would not match correctly. So instead, I will make a selection of some of the windows in order to copy them as a new layer and then position this copied layer to match the correct perspective.

2 First make a rough selection of the area we are going to copy from. Select the polygonal lasso tool and set the Feather to 3 pixels. Click with the polygonal lasso tool around the outside of the upper windows to make a selection as shown.

3 Now that we have a feathered selection of the windows, go to the Layer menu and choose New > Via Copy. Or you can use the keyboard shortcut Command/Ctrl-J. The copied selection will appear as a separate layer in the Layers palette. Select the move tool and drag the new layer down to where we wish to add the new windows.

4 As was predicted, the cloned windows do not match the perspective of the rest of the building after they have been copied and repositioned. Select the Edit > Free Transform command. A bounding box will appear around the layer I contents. Hold down the Command/Ctrl+Shift keys and drag the middle left handle upwards. Repeat with the middle right handle. This modifier key combination will constrain the transform to a shear type transformation. Then drag either the top or bottom middle handle to compensate for any vertical stretching. The photograph on the right shows how the layer I preview looked after the perspective correcting transformation had been applied. Hit Enter to apply the transform.

Restoring a faded image

If you need to restore a photograph that suffers from uneven fading, the solution is to make an image adjustment to darken the photograph and then selectively remove this image adjustment to restore the areas which were not faded. The technique shown here uses adjustment layers, which provides a quick and easy way of allowing you to selectively apply an image adjustment.

menu.

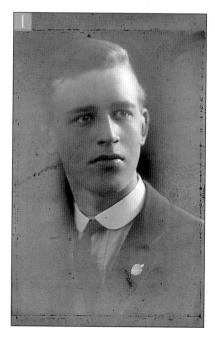

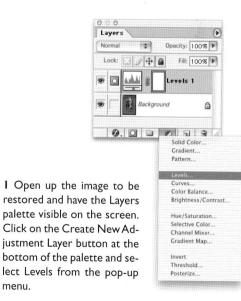

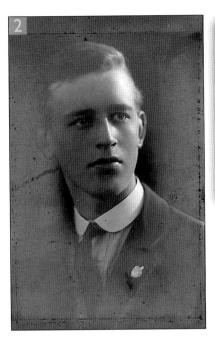

3 When the adjustment layer is selected, painting anywhere in the image area is just like painting on a layer mask linked to an image layer. To restore the lightness at the center of the photograph, drag with the gradient tool in radial gradient mode from the center outwards, using the default foreground/background colors, and the gradient options set to the foreground to background gradient option.

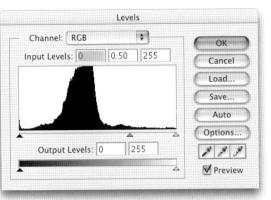

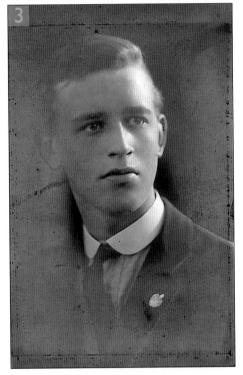

1

4 8

3 3

T.

30

00

600

tog

BA

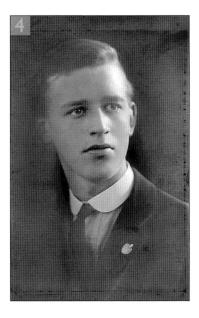

4 Readjust the Levels adjustment layer again in order to balance the fade (double-clicking the adjustment layer will reopen the Levels dialog box). You can also add to the radial gradient fill by selectively painting on the adjustment layer mask with a low opacity brush. For this final version, I changed the layer blending mode from Normal to Multiply and reduced the blend opacity slightly. This action darkened the outer edges while keeping the same lightness in the center of the photograph.

Keyboard shortcuts

You will notice in this chapter that I introduced a few keyboard shortcuts for the menu and Tools palette commands. Newcomers to Photoshop will no doubt prefer sticking to the longer routine of selecting tools by clicking on them in the Tools palette and navigating through the menus and submenus. After a month or so, try to absorb the keyboard shortcuts, learning a few at a time.

Here are a few examples of the essential keyboard shortcuts: rather than keep switching between the current tool and the move tool, it is much easier to temporarily access it by holding down the Command/Ctrl key (except when the pen or hand tool is selected), then instead of using the mouse, you can also control movement via the keyboard arrow keys, nudging the layer or selection in 1 pixel (10 pixels with the Shift key also held down) increments. A series of nudges count as a single Photoshop step in History and can easily be undone with a single undo or step back in History.

Hold down the Spacebar to temporarily access the hand tool and hold down Command/Ctrl+Spacebar to zoom (magnify). To zoom out, hold down the Option/ Alt+Spacebar keys. If the hand tool is already selected, then holding down either the Command/Ctrl or Option/Alt keys will have the same effect. Double-clicking the zoom tool will set the view to actual pixel size (100%) as does the keyboard combination of Command/Ctrl+Option/Alt-0. Double-clicking the hand tool will set the view to the fullest screen size within the constraints of the visible palettes. The alternative keyboard shortcut is Command/Ctrl-0. These are both useful time saving features and it is also worth mentioning that these actions are governed by whether the palette and Tools palette windows are currently displayed or not. Pressing the Tab key will toggle hiding and displaying the Tools palette and all palettes (except when a palette settings box is selected). The Shift+Tab keys will keep the Tools palette in view and toggle hiding/displaying the palettes only. When the palettes are not displayed the image window will resize to fill more of the screen area. These and other shortcuts are all listed in menu and palette order in Chapter Twelve.

Time now to explore more ways of digitally retouching your pictures and making repairs to an image. Some of these techniques will demand a reasonable level of drawing skill and ideally you should be using a pressure-sensitive graphic drawing tablet as your input device rather than a mouse. Mistakes can easily be made – in other words, before proceeding, always remind yourself: 'now would be a good time to save a backup version to revert to.'

I have included in this chapter a mixture of Photoshop retouching techniques that would be useful for photographers and have selected a few specific Photoshop retouching tasks that demand a special approach, like how to retouch areas where there is not enough information to clone from. In one of the following examples, I show how to retouch using the paint brush and where it is important to carefully disguise your retouching. Unless you are careful, your brush strokes may not look as if they are part of the original photograph (excessive cloning, especially at low opacities, creates the same type of mushy result). The reason such brushwork tends to stand out is because the underlying film grain texture is missing. This can easily be remedied by introducing the Add Noise filter selectively to the 'painted' pixels.

Removing moiré patterns

Moiré pattern problems can occur when you shoot digitally. A typical example of this can be seen in the accompanying example. In a still-life setup, one solution would be to change the digital capture resolution (this applies to scanning backs mainly) or adjust the shooting distance slightly. Otherwise, you can remove moiré by duplicating a layer, apply a hefty amount of Gaussian blur to the copied layer and then set the blurred layer blending mode to Color. This clever technique was shown to me by Thomas Holm of Pixl in Denmark. When you use a color blending mode, the color information only is blurred and the luminosity (the detail information) remains unblurred. But I would advise applying a layer mask to the blurred layer and selectively painting in the blurred layer.

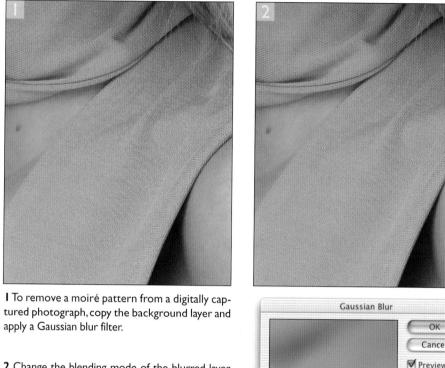

2 Change the blending mode of the blurred layer to Color and adjust the layer opacity as necessary.

Scanning halftone images

When a halftone printed image is scanned, you will quite often notice that a moiré pattern is introduced as a result of the scanning process. The severity of the moiré depends on a number of factors such as the coarseness of the printed screen, the scanning resolution and the angle at which the original page was scanned. Rotating the page by 15 degrees can make a big difference and it is easy enough to rotate the page back into alignment once captured in Photoshop by using the crop tool. Try also scanning at the higher resolutions and work downwards in gradual increments to find the optimal resolution. The viewing scale on the monitor can also appear to compound the problem of moiré, so inspect at either 100%, 50% or 25% viewing.

The bigger question though is the legality of copying pictures from a publication. Fine if it is your own work, but do make sure that permission of the copyright holder is always sought. Be warned that steps are being taken to inhibit infringement of copyright. First of all, images can be invisibly encrypted using either the SureSign or Digimarc systems which are available as third-party plug-ins for Photoshop (the Digimarc plug-in is included with Photoshop 7.0). Photoshop always displays the copyright symbol © in the title bar whenever it discovers that a Digimarc or other watermark has been invisibly embedded in the file, or if the photograph is otherwise marked in the File Info as being copyright protected. You won't always be aware that a published picture has this tagging embedded. The process of removing the moiré plus smoothing away the halftone dots may actually enhance the encrypted signature instead of destroying it. It has to be said that at the smaller file sizes used to publish on the Internet, the robustness of any fingerprint is much weaker. See also Chapter Five for more information about image protection.

Moiré patterns can be eliminated by softening the image detail in the worst affected channels followed by a resharpening. You can soften an image using the Gaussian blur, Median Noise filter or a combination of the two. Some scanner software programs have their own descreening filters. These may or may not do a good job. The advantage of the method outlined here is that with a manual correction, you only soften as much detail as is absolutely necessary.

I Start with as large a scan as possible with the intention of reducing the image size later. The moiré pattern is mostly found in the green and blue channels, there is a slight amount in the red channel. To minimize image degradation, apply just a small amount of Gaussian blur or Noise > Median to the red channel.

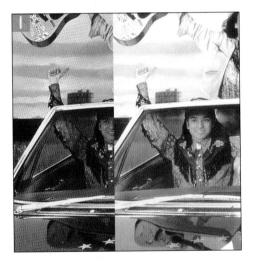

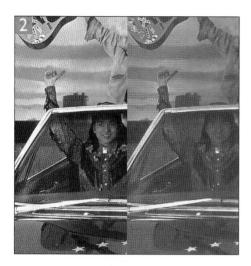

2 The green and blue channels require more softening.Work on each channel individually and apply the Median filter (Filter > Noise > Median). Use a small Median Radius value. If you cannot remove all traces of the moiré, try applying a Gaussian blur first followed by the Median filter.

3 Any remaining traces of moiré should disappear after reducing the file size. Finally apply unsharp masking to restore some of the lost sharpness.

Tool applications and characteristics

Some Photoshop tools are more suitable for retouching work than others. The blur tool is very useful for localized blurring – use it to soften edges that appear unnaturally sharp. Exercise caution when using its neighbor, the sharpen tool. In my experience the sharpen tool has a tendency to produce unpleasant artifacts. If you wish to apply localized sharpening, try selecting an area with the lasso tool, feather the edge by 5 pixels or so and apply an unsharp mask to this selected area. If you have a selection saved, this can be converted to a path (load the selection, go to the Paths palette and choose Make Work Path). You can use paths as a guideline for stroking with Photoshop tools. For example, the blur tool can be used to selectively soften an edge. So, if you want to soften the outline of an image element and have a matching selection saved, convert this to a path, select the blur tool and choose Stroke (Sub) Path from the Paths palette. And, of course, in the History palette you can always selectively paint back in the non-blurred image state data using the history brush.

The smudge tool is a paint smearing tool. It is important to recognize the difference between this and the blur tool which is best suited for merging pixels. The smudge tool is more of a painting tool, either used for blending in a foreground color or 'finger painting', smearing pixels across an image. Smudge strokes look odd on a photographic image unless you are trying to recreate the effect of Instant PolaroidTM smearing. A better smudge tool is the super putty plug-in which is part of the Pen Tools suite freely distributed by WacomTM. Some retouchers like to use the smudge tool set to Finger Painting to drag out mask pixels to follow the outline of hair strands, for example. I tend to stick with the brush tool nearly all the time, making use of the options in the Brushes palette (the full options are available only if you have a pressure-sensitive graphic tablet device installed). Under the Other Dynamics options you can set to use a low stylus pressure to produce faint brush strokes. And under the Size Dynamics you can set the Size control to also be linked to the stylus pressure.

Brush blending modes

The painting and editing tools can be applied using a variety of blending modes which are identical to those you come across in layers and channel operations. You could try experimenting with all the different tool blending mode combinations but I wouldn't advise you do so, as it is unlikely you will ever want to use them all. I reckon that the following modes are probably the most useful: Screen, Multiply, Lighten, Darken and Color when combined with the paint brush, blur and gradient tools. I photograph and clean up a lot of hair and beauty type photographs and sometimes get requested to tidy up the hair color where perhaps the roots are showing. I will first marquee the area and float it to a new layer so that if I don't like the result I can ditch the new layer. I sample a color from the area with the right hair color, then set the brush to Color mode and paint over the roots. When painting in Color mode, the lightness values which define the hair texture and shape are unaffected - only the color values are replaced. The saturation values remain unaffected, so it may be necessary to run over the area to be colored beforehand, desaturating the area and then coloring it in. Painting in Color mode has many uses. Artists who use Photoshop to colorize scanned line art drawings will regularly use the Color and other blending modes as they work. Painting using the Color blending mode is also ideal for hand coloring a black and white photograph.

Beauty retouching

I The first thing to retouch here are the eyes, which I nearly always want to lighten to some extent. I used the lasso tool to draw around the outline of the whites of the eyes. This selection does not have to be perfect – a reasonably steady hand is all you need! After that go to the Select menu and choose Feather... and enter a feather radius of 1 or 2 pixels. After making the selection and feathering it, mouse down on the Adjustment Layer button at the bottom of the Layers palette and select Levels. This will automatically add a Levels adjustment layer with a layer mask based on the selection just made. I normally adjust the Levels gamma to between 1.25 and 1.4.1 also added a Hue/Saturation adjustment layer to gently reduce the saturation of the red veins in the eyes. I then Option/Alt-clicked between this and the Levels adjustment layer in the Layers palette to create a clipping group with the eye lightening adjustment layer.

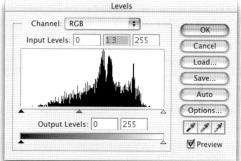

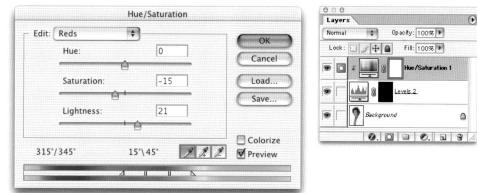

2 When you create a clipping group in the Layers palette, the clipped layer will be displayed indented with a downward pointing arrow, as shown in the Layers palette screen shot below. I next wanted to concentrate on retouching the face. This is done by marqueeing the head and making a new layer via copy (Command/Control-J). This will enable me to modify the pixels on a separate layer, without permanently altering the background layer. Mistakes are easily made and this way I can always revert to the before version and compare the retouched layer with the original version of the image.

Layers		
Normal	Op acity: 100% F	J
Lock:	🖸 🌶 🖨 🛛 Fill: 100% 🕨)
	F	n 1
9	Levels 2	
•	Layer 1	
	Background	۵

3 I do all my beauty retouching using the brush tool on this copied layer. I always prefer to use a pressure sensitive stylus and pad such as the Wacom Intuos[™], because this allows me a much finer degree of control than I can get with a normal mouse. Whenever you select a painting type tool you can select from a number of options from the Brushes palette that will enable you to determine what aspects of the brush behavior (brush dynamics) will be governed by the way you use the pressure sensitive stylus. Photoshop will not just be aware of the amount of pressure you apply with the stylus. If you are using the Wacom Intuos[™], Photoshop is now able to respond to input information such as the angle of tilt or the movement of the thumbwheel (if you have one). In the example shown here I have checked the Other Dynamics checkbox and selected Pen Pressure from the Control menu.

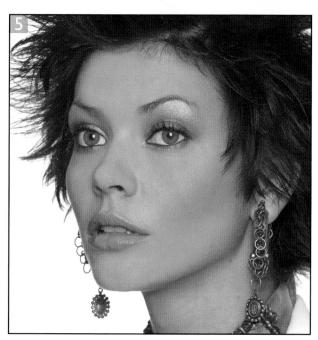

4 In the example on page 273, I began by painting with the brush tool in Lighten mode. When the brush tool is selected, you can sample a flesh tone color by Option/Alt-clicking in the image window. I then brushed lightly over the darker areas of the face such as underneath the eyes, to lighten the darker areas. When using Lighten mode only the pixels that are darker than the sampled color will be replaced. It is also a good idea to always keep resampling new colors as you paint.

5 (See page 273). I continued painting like this in Lighten mode to smooth other areas of the face. Where there were some shiny highlights, I switched to using the brush tool in Darken mode. I sampled a new color that was a touch darker than the highlights and painted over these areas to remove the shine. When using Darken mode only the pixels that are lighter than the sampled color will be replaced. I like to retouch at 'full volume' so to speak. Some fashion photographers quite like the super-retouched effect. Others will argue that too much retouching will make the model's skin look more like a plastic doll rather than that of a real woman. It is up to you, but I usually prefer to fade the opacity of the retouched layer. Try reducing the layer opacity down to somewhere between 55 to 85%. Doing so will restore more of the original skin texture. The final result will be retouched but look more convincing.

6 Finally, I introduced a curves adjustment to increase the contrast in the red and green color channels and decreased the contrast in the blue color channel, to produce a subtle cross processing type of look to the photograph.

Client: Andrew Price Salon. Model: Lisa Moulson at MOT models.

Softening the focus

If you wish to soften the focus, the best way to go about this is to apply a Gaussian blur filtration and follow this with a Fade command (the Fade command will also fade an image adjustment or a paint stroke) in order to restore some of the sharpness contained in the unfiltered image state. As shown below, you can change the fade blend mode to achieve interesting variations with which you can simulate favorite camera and darkroom printing techniques. If you prefer, duplicate the background layer, apply a Gaussian blur and selectively remove the blurred layer using a layer mask.

Figure 10.3 With the javelin thrower example, I applied a Gaussian blur filter and followed this with Edit > Fade Gaussian Blur and changed the mode to Darken. This action will simulate diffusion dark-room printing. With the forest scene I applied a similar amount of blur and faded using Lighten mode. This produced a soft focus lens effect.

Rescuing shadow detail

Sometimes no amount of Curves contortion can successfully lift up the shadow tones without causing the rest of the image to become degraded. Curves adjustments must be done carefully. The curve shape should be smooth, otherwise gentle tonal transitions will become lost and may appear posterized. There are similarities here with the problems faced when trying to get the best full tone print from a contrasty negative. The invention of multigrade black and white paper was a godsend to photographic printers who were then able to print using a combination of paper grades with one or more enlarger exposures. If you have ever printed in the darkroom yourself, you'll know what I mean. If not, don't worry – all you need to know is that the Photoshop method I am about to describe can achieve the same end results in black and white or color. The following example describes a Photoshop technique that exploits the adjustment layers feature.

Although I used a Curves adjustment layer to lighten the shadows in this example, you can simply add a curves adjustment layer (or in fact any adjustment layer, it really does not matter) and set the layer blending mode to Screen. This will make the underlying layers interact with themselves in a screen blend mode. It is the same as if you were to merge all the visible layers and duplicate the resulting layer and set the duplicate layer to screen. If you select Multiply, you can darken the image, as the visible layers will then multiply with themselves.

Shadow tones can appear compressed or lost for a variety of reasons. It may not be the image but the monitor display which is at fault, so check the monitor has been properly calibrated and that the viewing conditions are not so bright as to flare the screen. You should also realize that computer monitors are not able to represent a full range of tones displayed in evenly balanced steps. All monitors compensate for their limited dynamic range by applying a small amount of tonal compression in the highlights and more tonal compression in the shadow areas. If there really is a problem with the shadow detail, the true way to find out is to check the histogram in Levels and rely on that for guidance. If you see a bunched-up group of bars at the left of the histogram - then you know that you have compressed shadow tones. Knowing a little about the picture's history helps. I once had to correct some transparency scans where the film had been underexposed and push processed by at least two stops. The image was contrasty, yet there was information in the shadows which could be dug out. Or maybe you can see from the original photograph that the lighting was not quite good enough to capture all the shadow detail. You will be amazed how much information is contained in a high quality scan and therefore retrievable.

2 Choose Image > Adjustments > Invert to invert the alpha I channel. Apply some Gaussian blur to soften the alpha I 'luminance mask' (you may want to add a little Gaussian noise if you see any banding) and then apply a curves adjustment to lighten the shadow areas and darken the midtone/highlights.

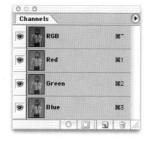

I Create a luminance mask based on the composite channel. Command/Ctrl-click the RGB (~) channel in the Channels palette. Then click on the Save selection as channel button to convert the selection into an alpha channel.

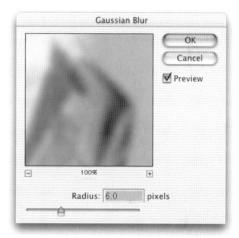

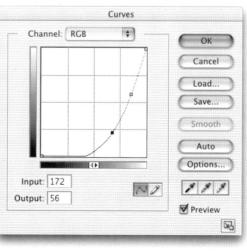

Client: Anita Cox. Model: Sze Kei at Rage.

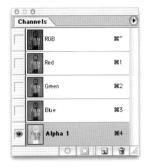

3 Load the modified Alpha I channel as a selection and click on the Add adjustment layer button in the Layers palette and choose Curves. This action will open the Curves dialog and add a layer mask to the new adjustment layer based on the selection. Now apply a curves adjustment to mainly lighten the shadows. The layer mask will selectively apply any adjustment you make to the darker areas of the photograph only.

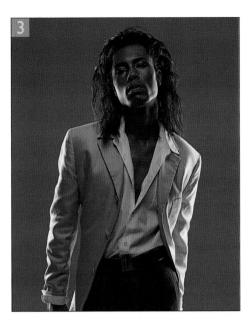

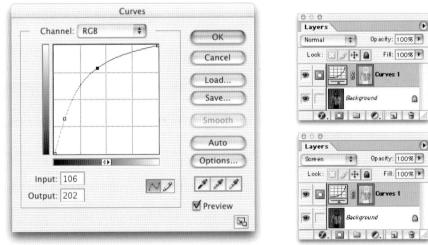

Dodge and burn

The dodge and burn tools are certainly very handy, but they are not really suitable for use as the Photoshop equivalent of the darkroom printing methods. The tutorial featured earlier in this chapter showed you how to restore a faded photograph by using a combination of adjustment layers and a soft radial mask. So, to dodge or burn a large area of a picture, you are better off making a heavily feathered selection and applying a Levels or Curves image adjustment – the results will be a lot smoother. The dodge and burn tools are better suited for modifying small areas of a picture only and mostly using light opacity brush strokes. The great thing about these two tools is that they can be targeted to act on just the Highlights, Midtones or Shadows alone. My only criticism or warning is that these tools cannot always modify the hue, saturation and brightness values together in a convincing manner. This is not a huge problem, just something to watch out for. If you try to dodge an area of a picture too much, you might discover it removes too much of the saturation as well, so use them carefully. The other difficulty Photoshop users face is the slowness of the large brushes, although this is not a fault of the program, rather a limitation of the desktop computers used to run Photoshop. The associated sponge tool is great for tweaking color saturation. Again be careful when applying the sponge tool in Saturate mode, not to allow clipping or artifacts to appear. Use the sponge in Desaturate mode to correct for oversaturated areas, to smooth color transitions or to reduce the saturation of out-of-gamut colors. And as with many other tools, always use it at a low opacity setting.

When you first discover the clone stamp tool, it is natural to think that it should be used for all blemish removals. Not so, cloning out facial wrinkles and such like can also be done with the dodge tool set to Midtones and applied with a smallish soft edged brush at low opacity (1-2%). After gently brushing with the dodge tool, you will notice how the lines start to disappear. As was demonstrated earlier, I also like to paint color in using the brush tool set to Lighten mode. Keep in mind the ability to restrict the application of the dodge and burn tools and its usefulness will become apparent in all sorts of situations. To improve the definition of hair silhouetted against a light background, you can use a small low opacity brush burn tool set to Shadows to build up the fine hair detail without darkening the background.

Andre Berein Montage Bechniques

onfusion often arises when trying to understand the relationship between alpha channels, masks, Quick mask mode and selections. Let me help ease the learning curve by saying they are interrelated and essentially all part of the same thing. That is to say, a selection can be viewed as a Quick mask or saved as an alpha channel (also referred to as a mask channel). An alpha channel can be converted to make a selection, which in turn can be viewed back in Quick mask mode. Also discussed later in this chapter is the use of image layer masks and vector masks and how to draw paths with the pen tool and convert these to selections.

Selections and channels

So when you read somewhere about masks, mask channels, image layer mask channels, alpha channels, Quick masks and saved selections, the writer is basically describing the same thing: either an active, semipermanent or permanently saved selection. We will begin with defining a selection. There are several tools you can use to do this – the marquee, lasso, magic wand and Select > Color Range. The marquee comes in four flavors: rectangular, oval, single pixel horizontal row and vertical column. The lasso has three modes – one for freehand, another for polygon (point by point) drawing and a magnetic lasso tool. When you use a selection tool to define an area within an image (see Figure 11.1), you will notice that a selection is defined by a border of marching ants. Selections are only temporary. If you make a selection and accidentally click outside the selected area with the selection tool, it will disappear – although you can restore the selection with Edit > Undo (Command/ Ctrl-Z).

During a typical Photoshop session, I will draw basic selections to define areas of the image where I want to carry out image adjustments and afterwards deselect them. If you end up spending any length of time preparing a selection then you will usually want to save the selection as an alpha channel (also referred to as a mask channel). To do this, choose Save Selection from the Select menu. The dialog box will ask if you want to save as a new selection. Doing so creates a brand new alpha channel. If you check the Channels palette, you will notice the selection appears there labeled as an alpha channel (#4 in RGB mode, #5 if in CMYK mode). To reactivate this saved selection, choose 'Load Selection' from the Select menu and select the appropriate channel number from the submenu, or Command/Ctrl-click the alpha channel in the Channels palette.

You don't have to use the selection tools at all. You can also create a new alpha channel by clicking on the Make New Channel button at the bottom of the Channels palette and fill the empty new channel with a gradient or paint in the alpha channel with a painting tool using the default white or black colors. This new channel can then be converted into a selection. In between masks and selections we have what is known as a Quick mask. To see how a selection looks as a mask, switch to Quick mask mode (click on the right-hand icon third up from the bottom in the Tools palette). Now you see the selection areas as a transparent colored overlay mask. If the mask color is too similar to the subject image, double-click the Quick mask icon, click on the Color box in the opened dialog and choose a different color with the Color Picker. In Quick mask

mode (or when working directly on the alpha channel) you can use any combination of Photoshop paint tools, Image adjust commands or filters to modify the alpha channel content.

To revert from a Quick mask to a selection, click the selection icon in the Tools palette (a quick tip is to press 'Q' to toggle between the two modes). To reload a selection from the saved mask channel, go Select > Load Selection. Command/Ctrl-clicking a channel is the other shortcut for loading selection and by extension, combining Option/Alt+Command/Ctrl-channel # (where # equals the channel number) does the same thing. Alternatively you can also drag the channel icon down to the Make Selection button in the Channels palette.

Figure 11.1 The right half of the image shows a feathered selection (feathering is discussed later in this chapter) and the left half the Quick mask mode equivalent display.

Summary of channels and selections

Selections

In marching ants mode, a selection is active and available for use. All image modifications made will be effective within the selected area only. Selections are temporary and can be deselected by clicking outside the selection area with a selection tool or choose Select > Deselect (Command/Ctrl-D).

Quick mask mode

A semipermanent selection, whereby you can view a selection as a transparent colored mask overlay. To switch to Quick mask mode from a selection, click on the Quick mask icon in the Tools palette or use the keyboard shortcut 'Q' to toggle between selection and Quick mask mode. Quick mask modifications can be carried out using any of the fill or paint tools.

Alpha channels

A selection can be stored as a saved selection, converting it to become a new alpha channel (Select > Save Selection). A selection can be reactivated by loading a selection from the saved channel (Select > Load Selection). Alpha channels, like color channels, contain 256 shades of gray, 8-bit information. An anti-aliased selection, or one that has been modified in Quick mask mode with the fill and paint tools, will contain graduated tonal information. An active alpha channel (click on the channel in the Channels palette to make it active) can be manipulated any way you want in Photoshop. A saved channel can be viewed as a colored transparent mask, overlaying the composite channel image, identical in appearance to a Quick mask. To view this way, highlight the chosen mask channel to select it and click on the eye icon next to the composite channel.

Work paths

A work path can be created in Photoshop using the pen tool in work path mode. A path is (among other things) an alternative method for defining an image outline. A work path (closed or not) can be converted to a foreground fill, stroke or a selection. For example, in the Paths palette, drag the path icon down to one of the buttons such as the Make Selection button. An active selection can be saved as a path – choose Make Path from the Paths palette submenu. Saving a selection as a path occupies just a few

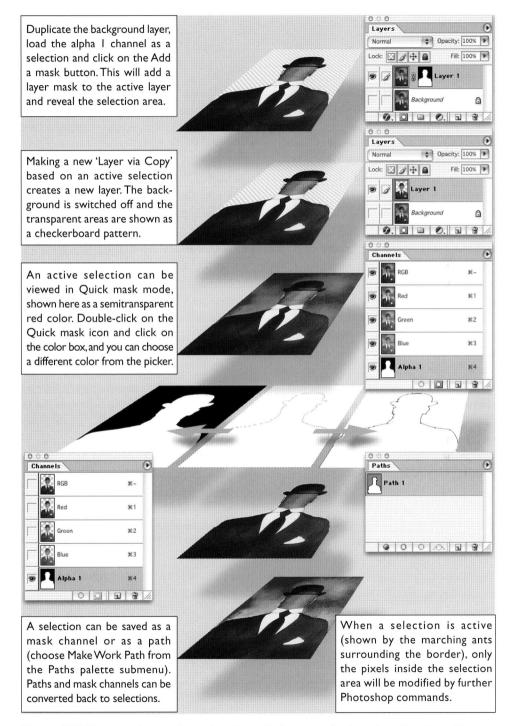

Figure 11.2 The above diagram shows the relationship between selections, channels, paths and layers.

kilobytes of file space. This is only more economical than saving as an alpha channel if you are saving in the TIFF format. Paths cannot save graduated tone selections though. A saved path can only generate a non-anti-aliased, anti-aliased or feathered selection, but we'll come to that later on in the chapter. A path can be used to define a vector mask (which will mask a layer's contents) or it can be used in Create Shape Layer mode to add a filled layer which is auto masked as you define a path outline.

Modifying selections

As was mentioned in Chapter Six, to modify the content of a selection you need to learn how to coordinate the use of the modifier keys with the dragging of the mouse as you define a selection. To add to a selection with a selection tool, hold down the Shift key as you drag. To subtract from a selection with a selection tool, hold down the Option/Alt key as you drag. To intersect a selection with a selection tool, hold down the Shift+Option/Alt keys as you drag. Placing the cursor inside the selection and dragging moves the selection boundary position, but not the selection contents. The magic wand is a selection tool too – click with the wand, holding down the appropriate key(s) to add or subtract from a selection.

To expand or shrink a selection, choose Select > Modify > Expand/Contract. Selections can be modified up to a maximum of 100 pixels (but produces angled corners when expanding a rectangular marquee selection). Other options include Border and Smooth. To see how these work, make a selection and choose Select > Modify options. Enter various pixel amounts and inspect the results by switching from selection to Quick mask mode. The border modification feature is rather crude and can be improved by applying feathering or saving the selection as a channel and filtering with Gaussian blur. An example of a border modification is featured in the Extract tutorial on page 323.

Smoothing and enlarging a selection

Selections that are made using the magic wand or Color Range method, under close inspection are rarely complete. The Smooth option in the Select > Modify submenu addresses this by enabling you to smooth out the pixels selected or not selected to the level of tolerance you set in the dialog box.

The Grow and Similar options enlarge the selection using the same criteria as with the magic wand tool, regardless of whether the original selection was created with the wand or not. To determine the range of color levels to expand the selection by, enter a tolerance value in the Options palette. A higher tolerance value means that a wider range of color levels will be included in the enlarged selection. The Select > Grow option expands the selection, adding contiguous pixels, i.e. those immediately surrounding the original selection of the same color values within the specified tolerance. The Select > Similar option selects more pixels from anywhere in the image of the same color values within the specified tolerance.

Anti-aliasing and feathering

All selections and converted selections are by default anti-aliased. A bitmapped image consists of a grid of square pixels. Without anti-aliasing, a diagonal line would be represented by a sawtooth of jagged pixels. Photoshop gets round this problem by anti-aliasing the edges – filling the gaps with in-between tonal values. All non-vertical/

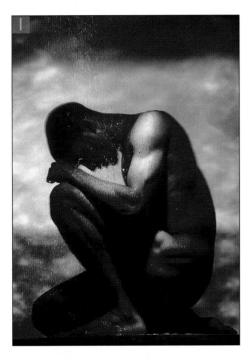

I The objective here is to make a simple soft edged selection based on tonal values and change the color of the background slightly. Use the magic wand tool to make a selection of the backdrop. A tolerance setting of 25 was used. Enlarge the selection locally by choosing Select > Grow. Note that the amount of growth is governed by the tolerance values linked to the magic wand tool options. 2 The magic wand tool may not select all the desired backdrop pixels. Choose Select > Modify > Smooth, entering a Radius value of between I and 16. The selection is now a lot smoother. Smooth works like this: if the Radius chosen was 5, Photoshop will examine all pixels with an $II \times II$ pixel block around each pixel. If more than half are selected, any stray pixels will be selected as well. If less than half are selected, any stray pixels will be deselected.

3 With the selection satisfactorily complete, hide the selection edges (View > Hide Extras) and open the Hue/Saturation dialog box.Adjust the Hue and Saturation sliders to color the selected area.

Edit: Master	÷	ОК
Hue:	+14	Cancel
Saturation:	-7	Load
Lightness:	-10	Save
θ.	1 2	Colorize

Photograph by Eric Richmond.

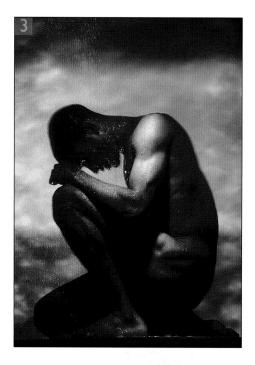

horizontal sharp edges are rendered smoother by this process. Therefore anti-aliasing is chosen by default. There are only a few occasions when you may wish to turn it off. Sometimes you have an 8-bit image which resembles a 1-bit data file (say an alpha channel after you have applied the Threshold command) which needs to be anti-aliased. If it is just a small portion that requires correction, use the blur tool to lightly soften the edge, otherwise follow the technique on the following page.

Anti-aliasing sorts out the problem of jagged edges. Selections usually need to be softened more than this. It is obvious when a photograph has been retouched or montaged, when the edges of a picture element are too sharply defined – the result looks unnatural. The secret of good compositing lies in keeping the edges of your picture elements soft. Study a scanned image in close-up and even the sharpest of images display smooth tonal gradation across the image edges.

To soften a selection edge, go to the Select menu, choose Feather and enter the pixel radius value to feather by. A value between 1.0 or 2.0 is enough to dampen the sharpness of a selection outline, but you can select a much higher radius. For example, if you want to create a custom vignette effect, use the lasso tool to define the outline, feather the selection heavily (50–100 pixels or more depending on file size), invert the selection and apply a Levels or Curves adjustment. This will enable you to lighten or darken the outside edges with a smooth vignette. See Figure 11.1 for an example of a feathered selection seen in marching ant and Quick mask mode.

Layers

Layers are like image layers on acetate overlaying the base background image. Figure 11.2 shows an example of a layered image. You can now add as many new layers as you like to a document up to a new limit of 8000. Every time you drag and drop the contents from one document window into another using the move tool, it becomes a new layer in the destination document. New empty layers can be created by clicking the New Layer button in the Layers palette. A new layer can also be made based on a selection. Choose Layer > New via copy (Command/Ctrl-J). This will 'float' the selection contents, duplicating them to become a new layer in register with the image below. Layers are individually controllable image elements. In any

multilayered document, you can selectively choose which layers are to be viewed (by selecting and deselecting the eye icons), link layers together in groups, arrange groups of layers into layer sets, merge linked layers or merge just those that are visible. To rename a layer in Photoshop 7.0, simply double-click the layer name. The same is also now true for the Paths and Channels palettes. Layers are easily discarded – just drag the layer icon to the Layers palette delete button. In Photoshop 7.0 there is now a Delete Hidden Layers command in both the Layers palette submenu and the Layer > Delete submenu. To duplicate a layer, drag the layer icon to the New Layer button.

Figure 11.3 This is an overview of the Photoshop 7.0 Layers palette. Note how the layers that belong to a set are colored a light gray in the layer stack and also indented. Photoshop allows you to label layers with different colors. The type and layer effect/style features are discussed in greater detail in Chapter Fifteen.

Blending modes

Photoshop layers can be blended with those layers underneath by using any of the twenty two different blending modes available. It helps if you understand and can anticipate the effect an alteration in the blending mode will have upon the final image. The next few pages provide visual examples and a brief description of each of the blending modes in Photoshop. These blending modes are also available as mode options for the painting and fill tools.

Normal

This is the default mode. Changing opacity simply fades the intensity of overlaying pixels by averaging the color pixels of the blend layer with the values of the composite pixels below (Opacity set to 80%).

000

Dissolve

Layers			
Dissolve	Opacity:	80%	F

Combines the blend layer with the base using a randomized pattern of pixels. No change occurs when using Dissolve at 100% opacity. As the opacity is reduced, the diffusion becomes more apparent (Opacity set to 80%).

Darken

0 0 0		
Layers		0
Darken	\$ Opacity: 100%	F

Looks at the base and blending colors and color is only applied if the blend color is darker than the base color.

Multiply

Multiplies the base by the blend pixel values, always producing a darker color, except where the blend color is white. The effect is similar to viewing two transparency slides sandwiched together on a lightbox.

Color Burn

000				
Layers				(
Color Burn	÷	Opacity:	100%	F

Darkens the image using the blend color. The darker the color, the more pronounced the effect. Blending with white has no effect.

Linear Burn

Layers				
Linear Burn		Opacity:	100%	-

The Linear Burn mode produces an even more pronounced darkening effect than Multiply or Color Burn. Note that the Linear Burn blending mode will clip the darker pixel values. Blending with white has no effect.

Lighten

Looks at the base and blending colors and color is only applied if the blend color is lighter than the base color.

Multiplies the inverse of the blend and base pixel values together, always making a lighter color, except where the blend color is black. The effect is similar to printing with two negatives sandwiched together in the enlarger.

Color Dodge

Layers				
Color Dodge	Opacity:	80%	-	

Brightens the image using the blend color. The brighter the color, the more pronounced the effect. Blending with black has no effect (Opacity set to 80%).

Linear Dodge

This blending mode does the opposite of the Linear Burn tool. It produces a stronger lightening effect than Screen or Lighten, but will clip the lighter pixel values. Blending with black has no effect.

Overlay

This plus the following five blend modes, should be grouped together as variations on the theme of projecting one image on top of another. The Overlay blending mode is usually the most effective, superimposing the blend image on the base (multiplying or screening the colors depending on the base color) whilst preserving the highlights and shadows of the base color. Blending with 50% gray has no effect.

Soft Light

Darkens or lightens the colors depending on the base color. Soft Light produces a more gentle effect than the Overlay mode. Blending with 50% gray has no effect.

Hard Light

Multiplies or screens the colors depending on the base color. Hard Light produces a more pronounced effect than the Overlay mode. Blending with 50% gray has no effect.

Vivid Light

Layers			
Vivid Light	Opacity:	100%	F

Applies a Color Dodge or Color Burn blending mode, depending on the base color. Vivid Light produces a stronger effect than Hard Light mode. Blending with 50% gray has no effect.

Linear Light

000			
Layers			0
Linear Light	\$ Opacity:	100%	F

Applies a Linear Dodge or Linear Burn blending mode, depending on the base color. Linear Light produces a slightly stronger effect than the Vivid Light mode. Blending with 50% gray has no effect.

Pin Light

Applies a Lighten blend mode to the lighter colors and a Darken blend mode to the darker colors. Pin Light produces a stronger effect than Soft Light mode. Blending with 50% gray has no effect.

Difference

Layers				
Difference	÷	Opacity:	100%	*

Subtracts either the base color from the blending color or the blending color from the base, depending on whichever has the highest brightness value. In visual terms, a 100% white blend value will invert (i.e. turn negative) the base layer completely, a black value will have no effect and values in between will partially invert the base layer. Duplicating a background layer and applying Difference at 100% will produce a black image. Dramatic changes can be gained by experimenting with different opacities. An analytical application of Difference is to do a pin register sandwich of two near identical images to detect any image changes - such as a comparison of two images in different RGB color spaces, for example.

Exclusion

Layers				
xclusion	•	Opacity:	100%	-

A slightly muted variant of the Difference blending mode. Blending with pure white will invert the base image.

Hue

Layers				
Hue	10	Opacity:	100%	*

Preserves the luminance and saturation of the base image, replacing with the hue of the blending pixels.

Saturation

Preserves the luminance and hue of the base image, replacing with the saturation of the blend-ing pixels.

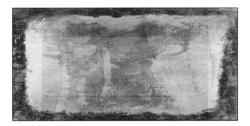

Color

Layers Opacity: 100% F

•

Preserves the luminance values of the base image, replacing the hue and saturation values of the blending pixels. Color mode is particularly suited for hand coloring photographs.

000

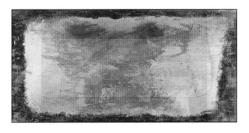

	0.0.0					
Luminosity	Layers					
	Luminosity	+	Opacity:	100%		
		-				

Preserves the hue and saturation of the base image while applying the luminance of the blending pixels.

Masking layers

There are two ways to mask a layer in Photoshop. Portions of the layer image can be removed by adding either a layer mask or a vector mask to the individual layer, which will hide the layer contents. Layer masks are defined using a pixel-based mask while vector masks are defined using path outlines. Either method (or both) can be used to mask unwanted areas in a layer, and do so without permanently erasing the layer contents. By using a layer mask to hide rather than erase unwanted image areas, you can go back and change the mask at a later date. Or if you make a mistake when editing the layer mask, it is easy to correct mistakes – you are not limited to a single level of undo.

Adding an empty image layer mask

If you create an empty layer mask (one that is filled with white) on a layer, you can hide pixels in a layer using the fill and paint tools. To add a layer mask to a layer with all the layer remaining visible, click the Layer Mask button in the Layers palette. Alternatively, choose Layer > Add Layer Mask > Reveal All. To add a layer mask to a layer that hides all the pixels, Option /Alt-click the Add Layer Mask button in the Layers palette. Alternatively, choose Layer > Add Layer > Add Layer Mask > Hide All. This will add a layer mask filled with black.

Adding an image layer mask based on a selection

To add a layer mask based on a selection, highlight a layer, make the selection active and click on the Add Layer Mask button at the bottom of the Layer menu. Or, choose Layer > Add Layer Mask > Reveal Selection. To add a layer mask to a layer with the area within the selection hidden, choose Layer > Add Layer Mask > Hide Selection. Or Option/Alt-click the Layer Mask button in the Layers palette. Choosing 'Add Layer Mask > Reveal Selection' was how I created the top layer in Figure 11.2. A layer mask is active when a thin black border appears around the layer mask icon and the Brush icon in the Layers palette changes to a circle surrounded by gray ([]).

Viewing an image layer mask in Mask or Rubylith mode

The small Layer Mask icon shows you roughly how the mask looks. You can if you wish view the mask on its own as a full screen image: Option/Alt-click the Layer Mask icon to view the layer mask as a full mask. Option/Alt+Shift-click to display the layer mask as a transparent overlay (rubylith). Both these actions can be toggled.

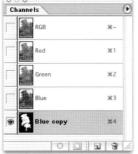

3 Duplicate the Background layer and keep this layer active. Switch off the eye icon for the original Background layer and load the alpha mask channel as a selection. Click on the Add layer mask button in the Layers palette. This will use the active selection to form a layer mask with the selected areas hiding the layer contents.

I To separate an object like this tree from the background, you need to create an alpha channel mask of the tree outline and use this as a layer mask to hide the unwanted areas.

 ${\bf 2}$ This shows the completed alpha channel mask. A pixel-based mask is more suitable for this type of masking as the subject contains soft detailed edges (the following masking technique makes use of a vector mask in which the subject to be masked contains smooth geometric edges).

Applying and removing image layer masks

When work is complete there are several ways to remove a layer mask. From the Layer menu, choose Layer > Remove Layer Mask. A dialog box asks do you want to Discard, Cancel the operation or Apply the layer mask? Select either option and

	Auto Add/Delete
	I To make an outlin tograph, I drew a p path active and click button in the Layer ration. This added a vector mask. You Content to switch justment/fill layers. 2 I can make a H apply this to the t use the direct pat path edges.
Layers	2

Fill: 100% F

۵

0

Cancel

Load.

Save

Colorize

Preview

Auto Add/Delete

p/Sa

4

Backaround

6. C C Saturation

+33

-68

-3

9 9 9

Lock:

Edit: Master

Hue

Saturation

1

Lightness:

Paths Path 1	000				
1					
	Path 1				

I To make an outline of the leather top in this photograph, I drew a pen path first. I made the work path active and clicked on the New adjustment layer button in the Layers palette and selected Hue/Saturation. This added an adjustment layer with a linked vector mask. You can use Layer > Change Layer Content to switch between different types of adjustment/fill layers.

2 I can make a Hue/Saturation adjustment and apply this to the top only. To edit a vector mask, use the direct path selection tool to revise the path edges.

click OK. With the mask icon for the layer selected in the Layers palette, click on the palette delete button or drag the active layer mask icon to the delete button. The same dialog box appears asking do you want to Discard, Cancel the operation, or Apply the layer mask? To temporarily disable a layer mask, choose Layer > Disable Layer Mask. To reverse this, choose Layer > Enable Layer Mask. Another shortcut is to Shift-click the Layer Mask icon to disable, click again to enable. When a layer mask is disabled the icon is overlaid with a red cross. Control/right mouse-click the mask icon to open the full list of contextual menu options to apply, discard or disable a layer mask.

Vector masks

A vector mask is just like an image layer mask, except the masking is described using a vector path. A vector mask can be edited using the pen path tools or the shape geometry tools. Because a vector mask is vector based, it is resolution-independent and can be transformed or scaled to any size without a loss in image quality. To add a vector mask from an existing work path, go to the Paths palette, make a work path there active and choose Layer > Add Vector Mask > Current Path.

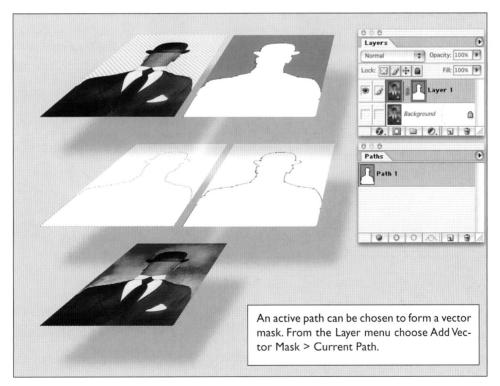

Figure 11.4 The above diagram shows the relationship between paths and vector masks.

You will notice that a vector mask icon is represented by a path outline. The gray fill represents the hidden areas. This visual clue will become important when you wish to make a hole in the layer and need to draw an additional path in subtract mode, which is placed inside the first and subtracts from it. An example of this scenario is shown later in the Spirit of St Louis tutorial.

Working with multiple layers

Layers have become such an essential Photoshop feature for doing complex montage work. It was not always so – in the early days of digital imaging, even high-end workstations were limited to working with just one layer at a time. When working with more than one layer you can choose to link layers together by creating links in the Layers palette. To do this, click in the column space between the eye icon and the layer name – you will see a link icon appear. When two or more layers are linked, movement or transform operations will be applied to the linked layers as if they were one, but they still remain as separate layers, retaining their individual opacity and blending modes. To unlink a layer, click on the link icon to switch it off.

Layer masks and vector masks are by default linked to the layer content. If you move a masked layer, the mask moves with it, as long as no selection is active – then any movement or transformation of the layer content will be carried out independently of the associated mask. Switch off the link between layer mask/vector mask and the layer, then the two become unlinked. Any further movements or transformations can now be applied to the layer or the layer/vector mask separately. You can tell if the layer or the layer/vector mask are selected – a thin black border surrounds the layer or layer mask icon and the icon the right of the eye icon changes from a paint brush to a selection icon. Photoshop's adjustment layers act just like real layers. If you want an image to interact with itself (i.e. apply a Multiply blend), rather than make a copy layer as before, create an adjustment layer (any one will do) and apply the required blending mode, this will save you consuming extra RAM memory.

Layer set management

Layers can now be organized more efficiently in sets. This brings several advantages: because multilayered documents can be grouped together inside the Layers palette in nested folders or 'sets', the Layers palette stack can be made less cluttered and groups of layers in a complex document can therefore be organized more logically. Layers grouped in a set can be made visible/invisible by clicking on the Layer set eye icon. It is possible to adjust the opacity and blending mode of a set as if it were a single layer, while the layers inside the set itself can contain subsets of layers

Layer sets

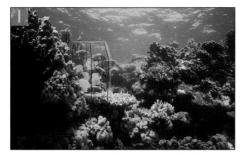

I A total of forty-six layers were used in the construction of this image. When a Photoshop document ends up with this many layers, the layer stack can become extremely unwieldy. It is possible to organize layers within layer sets. All the layers which relate to the yellow butterfly fish are grouped together in a single layer set folder. I was able to group them by shift-clicking on the fish in the document window using the move tool in Auto Select mode. This linked each layer I clicked on. Then I chose New Set From Linked... from the Layers palette menu.

2 The visibility of all layers in a set can be switched on or off and the opacity of the layer set group can be adjusted as if all the layers were a merged layer. Double-clicking a layer set will call up the Layer Set Properties dialog. Here you can select a label color and rename the set.

Photograph: Peter Hince. Client: Araldite. Agency: Warman & Bannister.

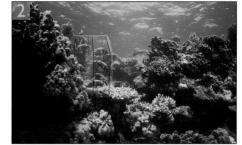

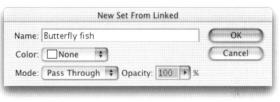

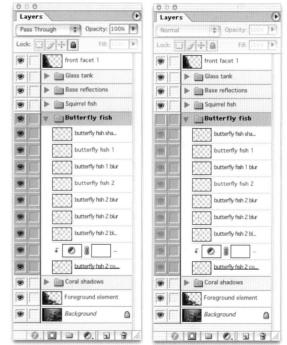

with individually set opacities and blend modes or adjustment layers. You can also add a layer mask or vector mask to a layer set and use this to edit the layer set visibility as you would with an individual layer. To reposition a layer, click on the layer and drag it up or down the layer stack. To move a layer into a set, drag it to the set icon or into the open set list. Dragging a layer down and to the left of the icon of I The four letter layers here are grouped together in a set. Layer A is using the Multiply blending mode; B is using Overlay; C is using Difference; and D is using the Screen blending mode. The blending mode of the set these layers are contained in is 'Pass Through'. This means that the layers in the set blend with the layers below the same as they would if they were in a normal layer stack.

2 If I select Layer D and Option/Alt+double-click the layer to open the Layer Style dialog, I can alter the advanced blending options. The Knockout option allows you to 'punch through' the layers. A 'Deep' knockout will make Layer D punch through the three layers below it, straight down to the background layer. Layer D now appears as it would if resting directly above the background layer. A 'Shallow' Knockout will punch through to just above the layer or layer set immediately below.

3 The default layer set blend mode is Pass Through. If you change the layer set blending mode to anything else, then the layers within the set will continue to blend with each other as before, but will not interact with the layers underneath as they did in Pass Through mode. When the layer set blend mode is Normal, the set's layers appear as they would if you switched off the visibility of the background layer. the last layer in a set and releasing will move the layer out of the set. To drag the last layer in a set out of that set, drag it across to the left and release. Clicking on the Create a new set button will add a layer set above the current target layer. Command/ Ctrl-clicking on the Create a new set button will add a layer set below the target layer. Option/Alt-clicking opens the New Layer Set dialog. In Photoshop 7.0, you can also lock all layers inside a set via the Layers palette submenu.

Advanced blending options

Layer sets allow you to group a number of layers together such that the layers contained within a set are in effect like a single layer. In Pass Through blending mode the layer blending passes through the set and the interaction is no different than if the individual layers were in a normal layer stack. However, when you select any other blending mode, this is equivalent to what would happen if you chose to merge all the layers in the current set and made them become a single layer.

Color coding

Figure 11.5 Layers can now be color coded. Choose Layer Properties from the Layers palette fly-out menu and pick a color to identify a layer with.

Among the Advance Blending modes, the Knockout blending options enable you to force a layer to punch through some or all of the layers underneath it. A Shallow knockout will punch through to the bottom of the layer set. A Deep knockout will punch through to just above the Background layer. Layer styles are normally applied independent of the layer blending mode. When you check the Blend Interior Effects as Group box, such effects will take on the blending characteristics of the selected layer. Try opening the image opposite from the CD-ROM and observe the Blend Interior Effects options using Layer C which is using the Difference blending mode. The result is the same as if you had 'fixed' the interior layer effect in normal mode and then changed the blend mode to Difference. Other aspects of the Layer Style blending options dialog box are covered in Chapter Fifteen.

Layer locking

Layers and their contents can be locked in a number of ways. The Lock Transparency option is identical to the old Preserve Transparency checkbox. When Lock Transparency is switched on, any painting you do to that layer will only affect the opaque portion of the layer and where the image is semitransparent, will retain that level of transparency. The Lock Image Pixels option will lock both pixels and the transparent areas. If you attempt to paint on a layer locked this way, you will see a prohibit warning sign.

Lock Image will lock the Layer position only. This means that while you can continue to edit a layer's pixel contents, you are not able to accidentally 'knock' the layer position with the move tool or apply a transform command. You can select combinations of Lock Transparency; Lock Image Pixels; and Lock Image, but you can also check the Lock All box for those situations where you wish to lock everything absolutely.

I This shows the Layers palette with a new image layer (Layer I) above the Background layer. Lock Transparent Pixels will prevent you from accidentally painting in transparent areas of a layer.

3 Lock Layer Position will prevent the layer from being moved, while you can continue to edit the layer pixels.

2 Lock Image Pixels will preserve transparency and prevent you from accidentally painting on any part of the image layer, yet allow movement of the layer.

4 Checking the Locking All box will lock the layer absolutely. The layer will be locked in position, the contents cannot be edited, nor can the opacity or blend modes be altered, but the layer can be moved up or down the layer stack.

Transform commands

You have a choice of options in the Image menu to rotate or flip an image. You use these commands to reorientate a document where, for example, the photograph was perhaps scanned upside down. The Edit > Transform commands are applied to a layer or grouped

I You can rotate, skew or distort an image in one go using the Edit > Free Transform command.The following steps show you some of the modifier key commands to use to constrain a free transform adjustment.

2 Place the cursor outside the bounding border and drag in any direction to rotate the image. Holding down the Shift key as you drag constrains the rotation in 15 degree increments.

3 Hold down the Command/Ctrl key as you click any of the handles of the bounding border to perform a free distortion.

4 If you want to constrain the distortion symmetrically around the center of the image, hold down the Option/Alt key as you drag a handle.

6 To carry out a perspective distortion, hold down the Command/Ctrl+Option/Alt+Shift keys together and drag a corner handle. When you are happy with the new shape, press Enter to carry out the transform. Press ESC to cancel. The transform uses the default interpolation method selected in Preferences to calculate the new image shape.

5 To skew an image, hold down the Command/ Ctrl+Shift key and drag one of the side handles.

Photograph by Davis Cairns. Client: Red or Dead.

layers only, whereas the Image menu commands rotate or flip the whole canvas. Select a layer or make a selection and choose either Edit > Transform or Edit > Free Transform (or check Show Bounding Box in the move tool Options bar). Rotating, flipping, scaling, skew and perspective controls can be applied either singly or combined in one process. All these commands are to be found under the Edit > Transform menu and also under the contextual menus (Ctrl/right mouse-click). The Free Transform options permit you to apply any number of tweaking adjustments before applying the actual transform. A low resolution preview quickly shows you the changed image shape. At any time you can use the Undo command (Command/Ctrl-Z) to revert to the last defined transform preview setting.

Numeric Transforms

When you select any of the transform commands from the Edit menu or check Show Bounding Box in the move tool options, the Options bar will display the numeric transform commands shown over the page. The numeric transform options enable you to accurately define any transformation as well as choose where to position the centering reference point position. For example, a common use of the Numeric Transform is to change the percentage scale of a selection or layer. Enter the scale percentages in the Width and Height boxes. If the Constrain Proportions link icon is switched off, you can set the width and height independently.

	NE V	000 X: 767.5 px △ Y: 33.5 px	P: W: 100.0%	≤ 0.0 ° ≠ H: 0.0 ° V: 0.0 °
--	------	------------------------------	--------------	-----------------------------

Repeat Transform

After applying a transform to the image data, you can instruct Photoshop to repeat that transform again. The shortcut is Shift+Command/Ctrl-T. The image transform will take place again on whatever layer is selected and regardless of other steps occurring in between. Therefore you can apply the transform to the same layer again or transform another existing layer.

Figure 11.6 Our eyes have no trouble seeing the edge of this blouse. But a selection tool such as the magic wand will only see closely related pixel luminosity values, and any attempt to define the edge using the magic wand will always prove disappointing. This is a classic example of where the pen tool in Photoshop wins over masking the use of tools that require the presence of a high contrast edge in order to make a reasonably accurate selection.

Transforming selections and paths

You can also apply transforms to Photoshop selections and paths. Make a selection and choose Transform Selection from the Select menu (if you choose Edit > Transform, you will transform the selection contents). Transform Selection is just like the Edit > Free Transform command – you can use the same modifier key combinations to scale, rotate and distort the selection outline. Or you can use Ctrl/right mouseclick to call up the contextual menu of transform options. With Transform Selection, you can modify a selection shape effortlessly. Selections are memorized in Photoshop beyond a single undo. Choose Select > Reselect to bring back the last used selection. Whenever the pen tool is selected the Edit menu will always be in path/point transform mode. This means that whenever the pen tool is selected, you can only transform a completed path or a group of selected path points (the path does not have to be closed). You will not be able to execute a transform on an image layer until another tool is selected.

Drawing paths with the pen tool

Unless you have had previous experience working with a vector-based drawing program like Freehand or Adobe Illustrator, the concept of drawing with paths will be unfamiliar. It is difficult at first to get the hang of it, but I promise you it is well worth mastering the art of drawing with the pen tool. Hard as it may seem at first, it is like riding a bike, and once learned, never forgotten. Paths are useful in several ways: either applying a stroke with one of the paint tools, for saving as a clipping path, or defining a complex selection shape, which can be converted to a selection or applied as a vector mask to mask a layer.

Because it is difficult to master the art of drawing with the pen tool, many people are inclined to give up on paths and persevere with other mask methods. Figure 11.6 shows an example of a photograph where it would be hard to define a smooth edge boundary other than by drawing a path outline. Historically, Photoshop began as a program that was used by its customers to edit relatively small sized image files. The Apple computers in those days could only be expanded in a limited fashion and always at great cost. Consequently, Photoshop was in practice a veritable tortoise compared with the high-end systems then used to retouch large digital files. The Photoshop selection tools like the lasso and magic wand were suited to operating efficiently with small sized files, which was all the program was likely to deal with back then. In a typical design studio, most of the images handled were less than 10 MB in size. Today Photoshop is able to handle files ten times that size with ease on a top of the range desktop computer. The pen tool is the professional's selection tool, so if you are planning to work on large sized files, you will mostly find it quicker to draw a path and convert this to a selection rather than relying on the selection and paint tools alone. The magic wand may do a grand job on tutorial sized images, but is not a method that translates well to working on bigger files. The magnetic tools fall half way between. They are cleverly designed to automate the selection process, but there is usually no alternative available but to manually define the outline with a path.

Guidelines for drawing pen paths

We shall start with the task of following the simple contours illustrated in Figure 11.7. You will find a copy of this image in a layered Photoshop format on the CD-ROM. This Photoshop file contains saved path outlines of each of the shapes. The background layer contains the basic image and above it there is another layer of the same image but with the pen path outlines and all the points and handles showing. Make this layer visible and fade the opacity if necessary so that you can follow the handle positions when trying to match drawing the path yourself. Start at kindergarten level with the letter 'd'. If you mastered drawing with the polygon lasso tool, you

Figure 11.7 The path tutorial file which can be found on the CD-ROM.

will have no problem doing this. Click on the corner points one after another until you reach the point where you started to draw the path. As you approach this point with the cursor you will notice a small circle appear next to the cursor which indicates you are now able to click (or drag) to close the path. Actually this is better than drawing with the polygon lasso, because you can now zoom in if required and precisely reposition each and every point. As before, hold down the Command/Ctrl key to switch to the pointer and drag any point to realign it precisely. After closing the path, hit Command/Ctrl-Enter (not Enter on its own any more) to convert the path to a selection.

If you now try to follow the 'h', this will allow you to concentrate on the art of drawing curved segments. Observe that the beginning of any curved segment starts by dragging the handle outward in the direction of the intended curve. To understand the reasoning behind this, imagine you are trying to define a circle by drawing a square perimeter. To continue a curved segment, click and hold the mouse down while you drag to complete the shape of the end of the last curve segment and predict the initial curve angle of the next segment. This assumes the next curve will be a smooth continuation of the last. Whenever there is a sharp change in direction you need to make a corner point. Convert the curved segment by holding down the Option/Alt key and clicking. Click to place another point. This will create another straight segment as before in the 'd' example.

Hold down the Command/Ctrl key to temporarily access the direct selection tool which can be used to reposition points. When you click a point or segment with this tool, the handles are displayed. Adjust these to refine the curve shape. The 'v' shape will help you further practice making curved segments and corner points. A corner point should be placed whenever you intend the next segment to break with the angle of the previous segment. In the niches of the 'v' symbol, hold down the Option/Alt key and drag to define the predictor handle for the next curve shape.

Pen tool in action

I will now show you how to use the pen tool to draw a closed path outline around a portion of the shoe pictured here. To show the results clearly, the images here are printed as viewed on the monitor, working at a 200% scale view. Because path outlines can be hard to reproduce in print, I have added a thin blue stroke to make them a little more visible.

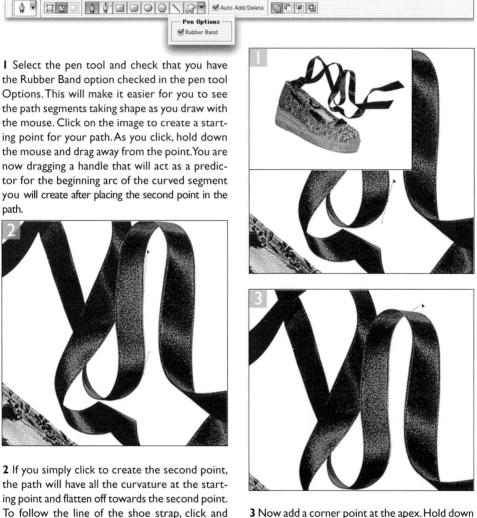

3 Now add a corner point at the apex. Hold down the Option/Alt key and click with the mouse whilst continuing to drag the handle upward and outward to the right. The Option/Alt key action defines it as a corner point and the dragging concludes the curvature of the segment just drawn.

308

drag the mouse following the flow of the image

curve shape. You will now notice that there are

two equidistant handles in line with each other

leading off from the second path point. You have

just completed drawing a curved segment.

4 After making a corner point, hold down the Option/Alt key again and drag the handle out downwards to the right, to begin drawing a series of curved segments.

5 Drawing a straight segment is the easy part. End the curved segment by Option/Alt-clicking the last point and simply click to draw a straight or series of straight lines.

6 Continue to draw the shape of the path as before. When you reach the end of the path and place the cursor on top of the original starting point a tiny circle appears to the bottom right of the pen tool icon. Clicking now will complete the path and create a closed path. Drag the mouse as you complete this operation to adjust the final curve shape.

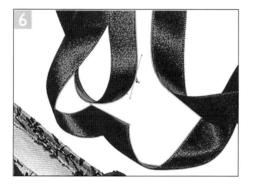

These are the basic techniques for drawing straight line and curved segment paths. Try practising with the supplied tutorial image to get the hang of using the pen tool. Your first attempts probably won't be spot on. Don't worry too much, the following tutorial shows you how to refine the path outline.

I Activate the work path in the Paths palette. A work path is only temporary. If you activate the path icon and draw a new path, it is added to the work path. If you don't activate the work path, the original is lost and a new work path created. Double-click the work path or drag the icon down to the Make New Path icon. Photoshop renames it Path I. It will now be savable as part of the image just like an alpha channel.

3 Reposition the points and redraw the curved segment by Option/Alt dragging the handles until the curves more neatly follow the contours of the ribbon. Points can be added or deleted using the add point or delete point tools, but also when the pen tool is selected clicking on a segment or clicking on an existing point will do the same thing and is a very convenient and easy to remember shortcut.

2 Select the direct selection tool from the Tools palette (or hold down the Command/Ctrl key with the pen tool selected) to select one or more points on a path. Marquee-drag to select multiple points. You can click on any of the selected points or segments and drag to reposition them. The selected path points will all move in unison.

Montages

No matter how much one attempts to fake reality in Photoshop, there are always going to be limitations as to how natural an image can look when assembled as a composite in Photoshop. It certainly helps if the elements to be combined all meet the right criteria. Providing that the perspective of the individual elements is the same and the lighting conditions are near enough right, half the battle will already be won. If you don't have these attributes there to begin with in the elements to be assembled, it will be virtually impossible to produce a convincing composite. Another thing to remember is that pixel sharp edges rarely exist in a photographic image. Smooth, soft edges always look more convincing.

Now to put the previous discussion on drawing a path with the pen tool in context. The first montage technique demonstrated here shows you how to prepare a silhouette based on a cutout made entirely with the pen tool. A pen path is the most sensible solution to use here because the object to be cut out has a smooth 'geometric' outline and the background behind the aircraft is very 'busy' and it would be almost impossible to separate the aircraft from the scenery behind using any other method. This technique also shows a use of vector masks in Photoshop. The Spirit of St Louis, flown by Charles Lindbergh, made the world's first solo transatlantic flight from the US to Paris in 1927 and I photographed this historic aircraft inside the Washington DC National Air and Space Museum, Smithsonian Institution. The daylight coming in from the skylight above enabled me to composite the aircraft against a separately shot sky background which produced a realistic looking photographic comp.

I Here are the two images: the sky background and the museum interior shot of the Spirit of St Louis. Roughly resize the St Louis image before positioning it as a layer above the sky. From the Tools palette, select the move tool and drag the whole image across to the sky image window. The aircraft can also be scaled as a layer using the Transform > Scale or Free Transform commands.

2 We need to isolate the aircraft from its surroundings. Because the subject has such a detailed background, there are no automatic ways of doing this in Photoshop, so in this instance, drawing a path is the only solution. Magnify the image to view on screen at 200% and draw a path with the pen tool around the aircraft's edges.

When the pen tool is selected, you can access all the other family of pen path modifying tools using just the Command/Ctrl and Option/Alt keys. Holding down the Command/Ctrl key temporarily changes the pen tool to the direct selection tool. Holding down the Option/Alt key temporarily changes it to the convert point tool. Clicking on a path adds a new point and clicking on an existing point deletes it. To make a hole in a work path, inside the outer edge, click on the Exclude overlapping areas mode button in the pen tool Options bar.

Spirit of St Louis: Pioneers of Flight Gallery. Reproduced courtesy of: National Air and Space Museum, Smithsonian Institution.

	🗹 Auto Add/Delete	
--	-------------------	--

Shape

Layer

SC.

第E 公第E

0%6

Vector Mask

All Layers

3 When the path is complete, make sure that the airplane layer and path are both active. Go to the Layer menu and choose:AddVector Mask > Current Path. This will add a vector mask to the airplane layer based on the active work path. The vector mask will appear linked alongside the aircraft layer.

4 At this stage it is possible to reposition the aircraft again if you wish, because the vector mask is linked to the layer image contents. Under close inspection, the aircraft appears to have been reasonably well isolated by the path. However, where this is not the case, you can edit the vector mask outline using the usual pen path editing tools. If I group select several of the path points around the wheel and move them, you can see how the background is still visible and will now show through.

5 Once you are happy with the way the vector mask is hugging the outline, choose Layer > Rasterize > Vector Mask. This will convert the vector mask into an image layer mask.

Layers				0
Normal		Opaci	ity: 100	%
Lock:	14	a	Fill: 100	% •
	2	La	yer 0	
• 1	Lay			
0			519	3

New Layer Based Slice

Delete Vector Mask

Disable Vector Mask Group with Previous

Add Layer Mask Enable Layer Mask

Ungroup

Arrange Align Linked Distribute Linked Lock All Layers in Set. Merge Down

Merge Visible

6 Activate the image layer mask. Go to the Filter menu and select Other > Minimum and choose a I pixel radius. This step will effectively 'choke' the mask, making it shrink to fit around the edge of your masked object. If you like, fade the last filter slightly using the Edit > Fade... command. Next try applying a I pixel radius Gaussian blur and follow this with an Edit > Fade... of 50% or higher. Now apply a levels adjustment to the mask. Choose Image > Adjustments > Levels, but keep the shadow point set where it is and adjust the gamma and highlight sliders only. The gamma adjustment will need to be quite extreme. In effect what has been done over these past few steps is to shrink the mask slightly, soften the edge and now use the Levels adjustment to fine tune the choke on the mask.

7 If the mask is mostly OK and only a couple of areas need adjustment, then you will still do well to follow all the above steps, but in the History palette, revert back to the history state before you began adjusting the mask (you might want to ensure Allow Non-Linear History is switched on in the History palette options). Then click on the history brush icon for the very last state and select the history brush from the Tools palette. The image has now fully reverted to the unmodified layer mask state, but wherever you paint with the history brush, you can paint in the modified mask and vary the opacity of the history painting as you do so.

8 By this stage, the Spirit of St Louis should appear successfully cut out from its original museum surroundings. Because an image layer mask has been used to isolate the aircraft, no pixels have actually been erased and the mask can be edited at any time.

9 Select the aircraft layer again and Option/ Alt+mouse down on the adjustment layer button in the Layers palette. Choose Curves and in the New Layer dialog box, check Group With Previous Layer. This will ensure that the following color adjustment will affect this layer only. The curves adjustment made the aircraft slightly more blue and therefore blend more realistically with the color balance of the sky.

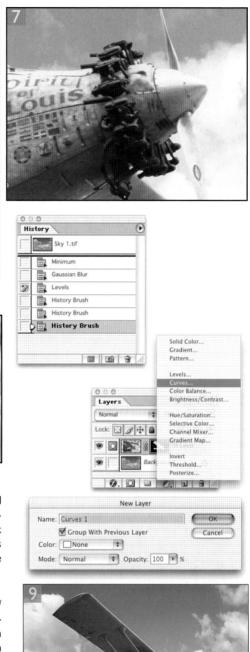

10 I duplicated the aircraft layer and applied a motion blur to this copied layer. This was placed as shown in the Layers palette and the opacity reduced to 80%. I then prepared a spinning propeller illustration. I dragged this in as a separate layer and transformed it to match the scale of the aircraft. This final tweaking helped create the illusion of the Spirit of St Louis flying through the air. Except, did they have high speed color film to record the transatlantic flight in 1927?

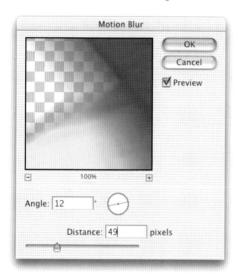

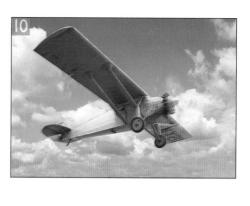

Layers	
Normal Cpacity:	40%
Lock: 🖸 🌶 🖨 🛛 Fill:	100%
Prop blur	
💌 두 🔊 🖁 🗆 c	Curves 1 copy
🔊 🖉 💽 🖁 📐 St.L	ouis copy
🔊 🗌 F 🔕 🖁 🔤 c	Curves 1
💌 🥅 💽 St. La	ouis.
Background	۵

Masking hair

Once you get the hang of using the pen tool and combining its use with vector masks, you will soon discover that this is an effective way of isolating a subject such as in the previous composite where the object you wish to cut out contains smooth, geometric contours.

When you are presented with a subject that contains a complex outline, such as the model's hair in the next photograph, the main question is: how do you go about separating the hair from the background? More to the point, how can you do this convincingly without it looking like an obvious retouch job? The trick here is to make use of the existing color channel contents and to copy the information which is already there in the image and modify it to produce a new mask channel. So instead of attempting to trace every single strand of hair with the pen or paintbrush tool, you can save yourself a lot of time by recycling the information already contained in the color channels and use this to define the finely detailed edges. You will find that the pen tool can then be used to finish off tracing the curves of the model's body.

Whenever I shoot a subject where I intend later to make a cutout, I always ensure that I am shooting against a plain colored background. I find white backgrounds usually provide the best channel contrast. It depends as well on the color of the destination background I am using. If you want later to combine a studio shot against a blue sky, it might well help if you plan to shoot against a sky blue backdrop in the studio.

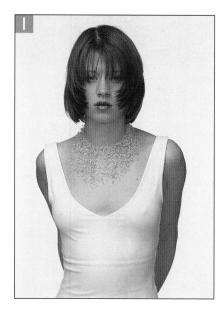

2 Let's start by examining the individual color channels. I am only really interested in finding a shortcut for masking the hair at this moment. I activated the Channels palette. Of the red, green and blue channels, it is the blue channel that contains the most depth and contrast in the hair. I dragged the blue channel down to the new channel button at the bottom of the palette. This action duplicated the channel.

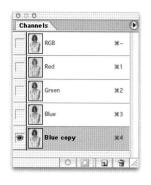

I In the previous Spirit of St Louis example, the most appropriate method for creating an outline was to draw a path with the pen tool. This was because the subject was a mechanical object with lots of smooth curves and straight lines. Masking the outline of a person is another story though. You can use the pen path tools to draw around the body and shoulders, but what about the individual strands of hair? We can get round this by making use of information already contained in the image and use this as the basis for a new alpha channel mask.

Client: Nigel Alexandre. Model: Cressy at Nevs.

3 I wanted to increase the definition of the hair outline in the new 'blue copy' alpha channel. I went to the Image menu and chose Apply Image... Let me explain the settings that were chosen here: the listed target channel is the one we are looking at - 'Blue Copy'. The source image was the same image document (no other document was open) and the source channel to 'apply' with was going to be Blue Copy as well and the Blending mode was set to Multiply. This meant that the Blue Copy channel was blending with itself using the Multiply mode. In addition, I checked the Mask box and selected Blue Copy again to use this channel as the mask and checked the Invert box. This meant that an inverted Blue Copy channel was used as a mask. The shadow areas were multiplied to become darker, while the highlights were masked.

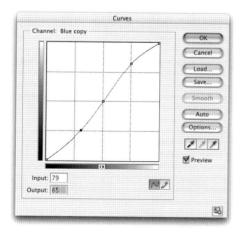

4 After doing this, I applied a Curves adjustment as shown here, to add more contrast to the hair outline.

5 The rest of the body outline was defined using the pen tool, referring to the color composite image.

7 I finished off the mask by filling in any gaps using the brush tool to produce a completed mask channel. This mask channel could be used for various purposes. For instance, I could make a selection of the background and lighten it to pure white.

6 When the work path was complete, I hit Command/Ctrl+Return and chose Select > Feather. I Entered a pixel amount of I or 2. I selected the Blue Copy alpha channel again and filled the feathered selection area with Black. I used the rectangular marquee tool to draw inside the head and fill the interior of this selection also with black.

One cannot stress enough just how important it is making a good mask when compositing with any image editing program. Once you have prepared a decent mask, the remaining composite work will all fall into place. Retouched photographs will not look right if they feature 'pixel-sharp' edges. Softer masks usually make for a more natural-looking finish. Experiment by softening your masks – a mask derived from a path conversion will be too crisp, even if it is anti-aliased. So, either feather your selections and if you have a layer mask, try applying a little Gaussian blur. You might find it helpful to use the blur tool to locally soften mask edges. Or you could apply a global Gaussian blur filtration to the whole mask and use the history brush to restore the unblurred version.

8 I opened a new backdrop image and selected the move tool and dragged this new image across to become a new layer on top of the image we have been working on. The new backdrop layer appeared in the Layers palette as Layer I. Next, I changed the layer blending mode to Multiply and chose Edit > Free Transform and scaled the overlaying layer to fit the canvas boundaries.

9 I loaded the Blue Copy alpha channel as a selection and clicked on the Add layer mask button. This had the effect of adding a layer mask to reveal the selected areas. The end result should be a masked background. I changed the blending mode to Multiply. Where there are stray hairs, the backdrop layer 'multiplied' with these pixel values and preserved the visibility of every single hair strand. Where the background layer was white, the pixels blended the same as when in Normal mode.

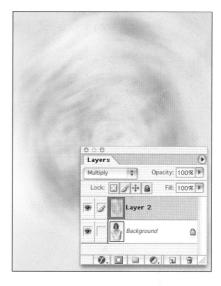

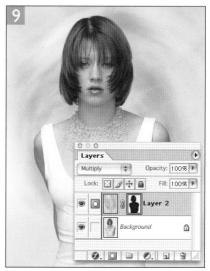

10 I selected the Background layer and reloaded the Blue Copy channel as a selection and made a new layer via copy (Command/Ctrl-J) and switched off Lock Transparency. I applied a horizontal Motion blur and set the blending mode to Screen and reduced the layer opacity.

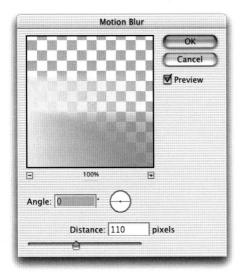

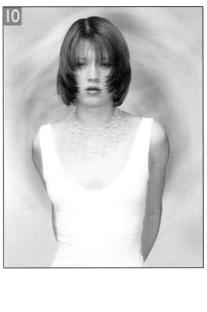

Clipping groups

You can create clipping groups within layers. The lowest layer in a clipping group acts as a layer mask for all the grouped layers above it. To create a clipping group, you can either link layers together and choose Layer > Group Linked, Option/Altclick the border line between the two layers, or use Command/Ctrl-G to make the selected layer group with the one below. When a layer is grouped, the upper layer(s) becomes indented. All layers in a clipping group assume the opacity and blending mode of the bottom layer. To ungroup the layers, Option/Alt-click between the layers, the layers ungroup and the dotted line becomes solid again. To demonstrate clipping groups in action, I am going to continue the tutorial, showing how to add an adjustment layer to the backdrop layer and make the adjustment apply to the backdrop layer only.

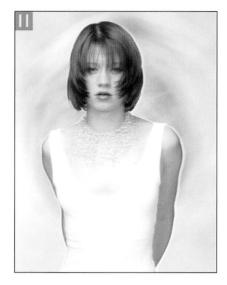

II I wanted to lighten the backdrop layer in such a way that I could revise any adjustment made. Obviously, an adjustment layer was called for, but I wanted it to affect this specific layer only. By holding down the Option/Alt key as I clicked the Add adjustment layer button from the Layers palette, this opened the New Layer dialog and allowed me to check the Group With Previous Layer box. The new adjustment layer was grouped with the layer immediately below. If you forget to do this, you can also Option/Alt-click the dividing line between the two layers. Either action will create a layer clipping group where the upper layer is masked by the one underneath. To emphasize the Layer 2 blurred glowing edge effect, I added a new empty layer to the top of the layer stack and filled this with white. I then Command/Ctrl-clicked Layer 2 to load this as a selection and clicked on the Add layer mask button in the Layers palette.

12 And finally, I added a Curves adjustment layer to colorize all the combined layers. I applied a cross-processing type curve. To see the curve settings used, check out the cross-process curves in Chapter Fourteen.

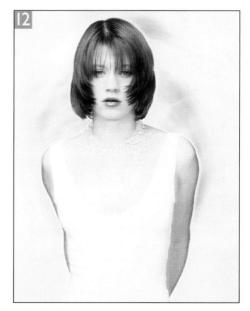

Extract command

The Image > Extract command is able to intelligently isolate an object from its background. While automatic masking can sometimes make light of tedious manual masking, it can rarely ever be 100% successful. However, the enhancements added since version 6.0 certainly do make the Extract command a more workable tool now. Before using the command, you may find it helpful first to duplicate the layer which is to be extracted. The active layer will be displayed in the Extract dialog window. You then define the outline of the object using the highlighter brush. This task is made easier using the Smart Highlighting option, which is like a magnetic lasso tool for the Extract command. Smart highlighting will work well on clearly defined edges and can be temporarily disabled by holding down the Command/Ctrl key as you drag. You have to highlight the complete edge of the object first (excluding where the object may meet the edge boundaries) and then fill the interior with the Extract fill tool (clicking again with the fill tool will undo the fill). The Extract command eraser tool can be used to erase highlight edges and when using the highlighter tool, you can toggle between highlighter and eraser by holding down the Option/Alt key. When the edges and interior fill are completed, click on the Preview button to see a preview of the extraction, or click OK to make an immediate extraction. The edge touchup tool can be used inside the preview window to add definition to weak edges – adding opacity where it sees transparency inside the edge and removing opacity outside of this edge. The cleanup tool will merely erase transparency from the extraction or restore erased transparency when you Option/Alt-drag.

Tool Options The slider control will set the highlight or eraser brush size, or you can enter a numeric value in the box. Choose a color for the Highlight and Fill displays.

Extraction The smoothness can be set anywhere between 0 and 100. If the preview shows an incomplete pixel selection, increasing the smoothness value will help reign in the remaining pixels. Force Foreground is useful where the object interior edge is particularly hard to define and the interior pixels are of a similar color value. Select the eyedropper tool to sample the interior color and check Force Foreground.

Preview The view choices can be switched between the original image and the current extracted versions. The Show option allows you to choose the type of matte background to preview the extraction against. This can be the standard, transparent, Photoshop background pattern, gray, white, black or any other custom color.

Load Highlight - the usage for this is explained in the following text.

Figure 11.8 The Extract command dialog box options.

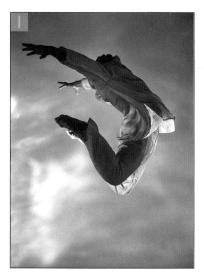

Ħ

#1

#2

¥3

224

0008/

0.0.0

.

Channels

RGB

Bhu

utline border

 0
 0

 Layers
 •

 Normal
 •

 Opacity:
 100%

 Lock:
 •

 •
 •

 •
 •

 •
 •

 •
 •

 •
 •

 •
 •

 •
 •

 •
 •

 •
 •

 •
 •

 •
 •

 •
 •

 •
 •

 •
 •

 •
 •

I In this example, I used the Extract command to try to isolate the dancer from the background. This was not going to be easy as there was not a great deal of color difference between the subject and the background. I first duplicated the Background layer. This ensured that the original image information is still preserved as pixels are erased with the Extract command. Another strategy would be to take a Snapshot of the original image state.

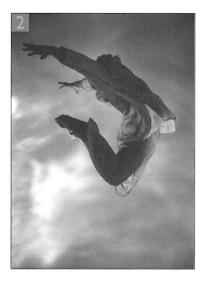

2 I began by making a rough selection of the outer area using the magic wand and tidied this selection using the Quick mask mode. The selection was not critical – this was just a shortcut that saved me drawing an edge highlight later. Back in selection mode, I went to the Select menu and chose Modify > Border and entered a value of 6 pixels. I saved the border selection as a new alpha channel in the Channels palette and inverted this new alpha channel.

3 I chose Image > Extract. The pre-saved Alpha I channel could now be loaded as a highlight edge under the Extraction Options. If you think the highlight edge needs adjustment, do so using the highlight and eraser tools – you want the highlight edge to overlap the foreground and background areas. But the highlight edge must form a complete enclosure (you can ignore where the object meets the image boundaries).

4 To automatically fill the interior, I selected the fill tool and clicked inside the object area. The interior of the object is now filled and you can click on the Preview button to test the success of the extraction before proceeding to click OK.

5 At this stage I was now able to tell if the extraction was going to work well or not. I used the zoom tool to magnify the preview to inspect the edges more closely. To zoom out, hold down the Option/Alt key and click with the zoom tool in the preview. I selected the cleanup tool and dragged to erase stray pixels from the background and Option/Alt-dragged to restore opacity where too many pixels have been extracted. You can use the edge cleanup tool to follow edges, adding opacity where the tool sees transparency inside the edge and removing opacity outside of the edge. I changed the brush size to make the brush bigger or smaller as necessary. The preview here shows the object isolated against the transparent grid pattern. However, the preview can be altered to display the object against a white, black, gray or custom color matte background. This will help you to visually determine the success of the extraction.

6 If the outline required further refining, I could go to the dialog View menu and switch between the extracted preview and the original image. I selected the Show Fill and Show Highlight options and edited the highlight edge using the highlighter and eraser tool as before. When all of this had been completed, I clicked OK to process the image.

Photograph by Eric Richmond.

Complex image blending

I A photo composite will only look convincing if the elements to be combined together are shot with a matching perspective. The camera position and lens used should be the same in each shot. This is especially true where a wide-angle lens perspective has been used. Julian Calder took these two pictures for a book titled 'Keepers of the Kingdom'. The flag bearer could not make it to the Robert the Bruce statue location, so he had to be shot separately and the two pictures blended together later using Photoshop. They were photographed with a longer than normal focal length lens, so in

this instance, any slight perspective difference would be less noticeable. If you are combining library shots with a shallow perspective, you can always blur the background detail as necessary, to make it appear slightly out of focus. This will help add an illusion of photographic depth.

2 To get the shadows and lighting to match, the flag bearer was flipped (Image > Rotate Canvas > Flip Horizontal). Then the flag bearer image was dragged using the move tool across to the Robert the Bruce window, which made the flag bearer become a new separate layer. The positioning does not have to be too precise just yet. The most difficult part of this job is making a convincing silhouette of the flag bearer. When working with highresolution files, the pen tool provides the most accurate method to define an outline edge. This is especially true here, around the lower part of the tunic where the edges are quite dark and the magnetic lasso or any other type of masking tool would have a tough time trying to differentiate where the edge lies.

3 Sometimes it is better to cheat, or rather make use of information that is already contained in the image. For example, I could see there was enough contrast in the red channel between the flag and the background and was therefore able to use this as the basis for making a mask channel. The red channel was duplicated and the contrast increased using the Curves command. I then carefully filled the flag interior using the paintbrush tool. This screen shot shows two stages of progress - the finished alpha channel mask and the duplicated red channel (shown inverted to stand out more).

4 The alpha channel so far masks the flag only and very importantly, the soft edges are preserved where the flag was fluttering in the wind. As was mentioned earlier, the lower half of the body is less easy to distinguish and this is where the pen path drawn at stage two can now finish the job off. The path is selected and converted to a selection by hitting Command/Ctrl-Enter. | applied a feather of a 2 pixel radius and filled the selection interior with white. The selection can also be inverted in order to tidy up the outside areas by filling with black brush strokes.

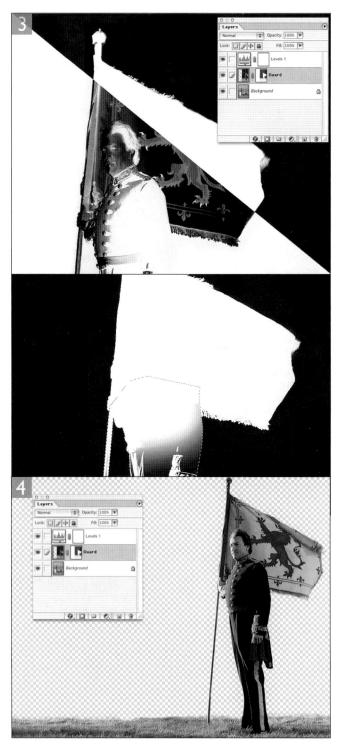

5 When all the mask preparation had been completed, the modified alpha channel was loaded as a selection and converted to a layer mask which would be used to cut out the flag bearer layer from the dark surround.

6 Once the client was happy with the finished composition, I found it helped if I merged all the layers, flattened the file and tidied up the image (but I remembered to keep a layered version archived). Where the grass blends from the foreground to the background, I smoothed out some of the rough areas. The client also later wanted the picture to extend as a landscape format, so it was necessary to stretch the lefthand portion of the photograph and carefully clone portions of the sky to hide any distortion.

Removing a matte color

2 Use the Layer > Matting > Remove Black Matte command to remove all the stray black pixels. Likewise, the Remove White Matte command will remove the white pixels from a cutout which was once against a white background. Where you have colored fringing, the Layer > Matting > Defringe command will replace edge pixels with color from neighboring pixels from just inside the edge. I If you add a layered image with an anti-aliased edge, some of the edge pixels will still contain some of the original background color. If the original picture has a black background, when the cutout appears pasted as a layer against the new backdrop, some of the black matte pixels will appear as a dark gray around the outline edge.

Client: Pierre Balmain. Model: Louise at Nevs.

Ribblehead Viaduct by Ian McKinnell

The following steps highlight the work of London-based photographer Ian McKinnell. Ian was commissioned by the UK design agency Stocks Austin Sice to illustrate the annual report of a software company called Logica. This was one of a series of five pictures illustrating various aspects of Logica's aspirations and goals, in this case 'teamwork'. Ian worked closely with the art director, Nick Austin, in conceiving the images to illustrate these often abstract ideas. Landscape was one of the themes which ran through the report and after much research the backgrounds were narrowed down to three locations across Britain. It was a very hard week's work – this photograph was taken at Ribblehead Viaduct in the Yorkshire Dales. 'I still remember the look of surprise on the face of the man behind the hire car check-in when I returned what was a brand new Mercedes I had for only six days and that now had over 3500 miles on the clock!'

The main photograph was taken just after dawn, which involved my assistant and I lugging some very heavy 5×4 equipment over the moors in the dark, accompanied by some very colorful language as one or other of us stepped in things we would rather have not. It was one of a few different shots of the viaduct taken that morning. Had I known when I was there that this was the shot then I would have taken a number of other sheets of film to capture the parts of the landscape obscured by the original columns, but it's always easier to work these things out later when it's too late! Fortunately I did remember to take shots of my assistant, Lorenzo, in a similar position to the model's as a guide to matching the dawn's early light in the studio. In order to control the perspective of the image and to keep the verticals vertical, it was essential to use a 5×4 camera.

I The most difficult part of this job (apart from wandering the moors in the dark) was to match the perspective and lighting of the models to the original image. Using paths, I extended the key perspective lines to establish their vanishing points, creating a box for each of the three columns to be filled by the people and establishing the eye line (i.e. where the center of the camera lens should be).

2 I then had each of these boxes output on to film to use as a template in the back of my 5×4 camera. Getting the perspective right for the models at the shooting stage was critical, as few changes could be made later without the image appearing false and unnatural. The template boxes ensured that the people were the right shape to fit into the image. Manipulating 3D images convincingly in a 2D software package is very difficult. Careful study of the original viaduct image and the guide shots of my assistant helped form the basis for the lighting setup, the choice of lens

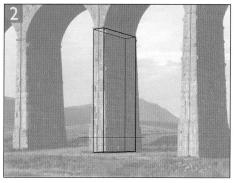

and camera position. The models had to stand on boxes to establish the correct eyeline and then push hard on the ceiling so that their arms were tensed and looked as if they could be holding up a weight. It was very uncomfortable for them and they could not hold the position for very long! I didn't try to match the color of the original sunlight as it would be easier to make these color changes later in Photoshop.

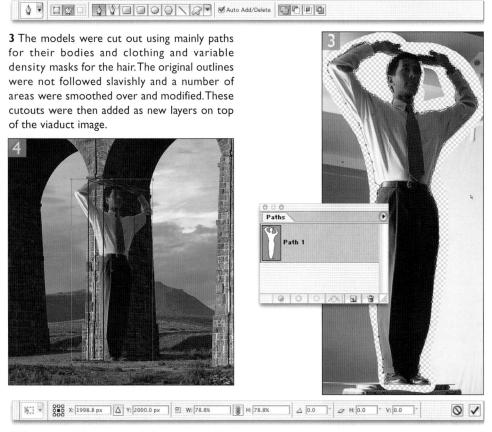

4 The exact sizing was carried out by reducing the opacity of the models (so that the original column could be seen through them) and carefully tweaking the exact shapes using the Free Transform. In some instances, a little perspective control had to be introduced, but this was minimal and was done by eye until it looked right. This took many attempts, so I kept the original cutouts handy in case I needed to start over again. To ensure the highest quality in an image, it is best to avoid using the Transform more than once. If I cannot get it right the first time, I will not transform it again, but start from scratch.

5 When the models were placed in their final positions, work could begin on extending the background to remove the viaduct columns and create the impression they were supporting the bridge. The clone stamp retouching was carried out on separate layers so that any mistakes could

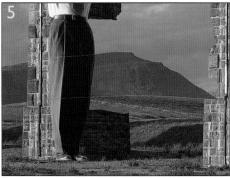

easily be corrected. To control the shape of the mountains in the background, the outline was defined with a path, converted to a selection and feathered by one or two pixels. Using Command/ Ctrl+Shift-I, I could swap between the mountains and the sky to build up a convincing edge.

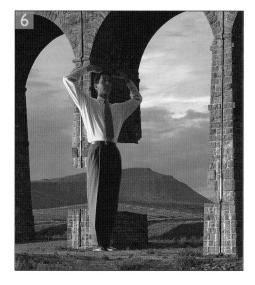

7 One of the touches that (hopefully) makes this image seem more convincing, are the little bits of grass and vegetation which go over the people's shoes. It is little touches like this which help create a sense of scale. This was achieved by copying part of the background image behind the shoes, pasting it into a new layer on top of the shoes and using the eraser tool to remove the areas I didn't want. There is usually more than one way of approaching a problem in Photoshop. For example, I could have achieved the same result by using a layer mask.

8 A lot of work had to be done on the faces and hands of the models to try to get them to look as if they had really had been there and that the viaduct was casting shadows on them. Much of this was done using the brush tool on a separate layer that is set to the Darken blending mode. Some areas were lightened using curves, with a lot of attention paid to keeping the colors consistent.

Lock: 🖸 🖉 🕂	Fill: 100%
🔊 🔽 🕨 🎒 Bits	and pieces
9 🗍 🔻 🛄 Mid	dle Man
	Middle Man darkening

6 The most difficult and time-consuming area to fix was the grass around the legs and feet. I try not to keep cloning the same areas of the original images repeatedly. Instead, I try to find areas from elsewhere in the image, then copy and paste it over the area I need to cover and then use a curves adjustment to try to match the color and density of the area underneath. I then erase the areas I don't need. In many cases, adding a little noise over a cloned area can help it look more convincingly part of the photograph. A great advantage of using 5×4 originals is that there is very little grain in the scanned images. With smaller format films it can be very difficult to match the more pronounced grain.

Photograph: Ian McKinnell. Client: Logica. Agency: Stocks Austin Sice.

9 Each person had their own curves adjustment layer for small tweaks to their density and color, using a mask so as not to affect the rest of the image, and another curves adjustment layer over the whole image. I use these adjustment layers so that I can keep changing my mind and try lots of variations with-

out changing the original image until the last minute. The most vital part of building an image such as this is the planning, visualizing the final image in your mind and then working backwards from there.

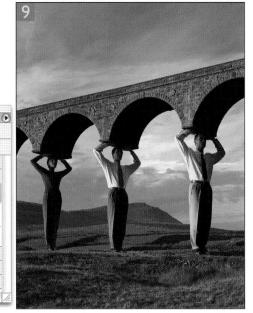

Exporting clipping paths

Clipping paths are vector paths that can be used to mask the outline of an image when it is exported to be used in a DTP layout program such as Adobe PageMakerTM, Adobe InDesignTM or QuarkXPressTM. You will remember me saying earlier that a selection can be converted to and from a path? If an image document contains a closed path, when you save it as an EPS format file, there is an option for selecting that path as a clipping path. In Adobe IllustratorTM, for example, you can use the saved clipping path as a masking object.

Imagine a catalog brochure shoot with lots of products shot against white ready for cutting out. Still-life photographers normally mask off the areas surrounding the object with black card to prevent unnecessary light flare from softening the image contrast. Whoever is preparing the digital files for export to DTP will produce an outline mask and convert this to a path in Photoshop or simply draw a path from scratch. This is saved with the EPS file and used by the DTP designer to mask the object.

Clipping paths are an effective tool for lots of projects, but not in every case. I had a design job to do for photographer Peter Hince, who asked me to design a brochure showing a collection of his underwater photographs, Ocean Images. I assembled the twelve black and white pictures in Adobe PageMakerTM. They all had rough edged

rebates that Peter wanted preserved. I could have made a path outline of each image and placed these on top of the background image. What I did instead was to prepare the design in PageMakerTM, scaling the individual images and working out their position. After that I reproduced a similar guideline layout in Photoshop and created a multilayered image, positioning the individual images and merging them all into one to make a single CMYK, EPS file. The steps below demonstrate how I retained the subtlety of the borders, which may otherwise have become lost.

Another good reason for doing things this way is that it saves on the RIP time for proofing and imposition and reduces the chances of file errors. On the other hand, clients might ask you to alter one of the images after seeing the proof, so save that multilayered Photoshop original for backup!

I The background layer consisted of a water reflection pattern. All the individual photographs were aligned to Guides, as they would appear in the final design and grouped on the one layer. Before proceeding to the next stage, I copied this layer by dragging it down to the New Layer button.

2 To demonstrate the following steps, I worked on a cropped view of the above layout, which shows just a single picture against the water background layer. I switched off the Eye icon for the copy layer and made the original Turtle layer active. I now wanted to remove the white pixels from the outer edges of the turtle image frame.

Photographs: Peter Hince/Ocean Images.

3 I Option/Alt+double-clicked the layer to open the Layer Options dialog box and held down the Option/Alt key to split and drag the highlight sliders for This Layer, as shown here. What this does is to remove the pure white tones from blending with the underlying layers. It also made some of the inner highlight areas transparent. These can be covered up with the copy layer.

4 I activated the copy layer again and marqueed inside the image border. When finished, I inverted the selection (Select > Invert Selection) and deleted or cut the selected area (Edit > Cut). I then flattened the image before saving to export to the DTP program, but also saved a layered copy of the image in case any further adjustments were required.

G etting to know the basics of Photoshop takes a few months, learning how to become fluent takes a little longer. There are a great many keyboard shortcuts and not all of them are listed in the manual. In this chapter I have grouped together a list of tips and keyboard shortcuts to help expand your knowledge of Photoshop. These are a reminder of some of the suggestions covered elsewhere in the book – use it as a reference for productive and efficient Photoshopping. Learn the keyboard shortcuts a few at a time, and don't try to absorb everything at once.

The key to efficient working is to plan your projects in advance. Rather than dive straight in, think through first about what you want to achieve – either write down or make a mental note of what it is you want to do and work out the best order in which to do everything. An obvious example would be to avoid preparing your work at high resolution when the final and only use was just a few megabytes. You would want to reduce the file size at the beginning of the Photoshop session rather than at the end in order to save on the computer processing time. Another reason is that there is often more than one way of doing something and a little time spent thinking through things at the beginning will save much in the long run. This is particularly true if working on an underpowered computer or you are pushing your machine to its limits.

Where a project requires experimentation to see which effects work best, it may be wise to start with a low resolution version first. This will enable you to edit quickly without waiting for the dreaded wristwatch or egg timer. Make a note of the settings that looked best and repeat these at higher resolution. This is a particularly handy way of exploring the different blending modes and filters but remember that the filter effects may work slightly differently at higher resolutions and the settings will need to be scaled up. Instead of making notes you could try recording the steps used as an action. This can then be replayed on subsequent images. Process an image once, recording each step used, stop the recording and play the action on single images or batches of images. You will find several Actions already available when you install Photoshop and discover many more which are freely available on the Internet. One such site is Actions X Change maintained by Joe Cheng and can be found at: <www.actionxchange.com>. Another is the Elated site <www.elated.com/toolbox/actionkits/>. Both these sites have ready prepared actions or sets of actions with examples of the types of effects achieved with them for you to freely download for use in Photoshop. To find out more about actions, see the section Working with actions on page 346. Macintosh/ Windows key equivalents are used everywhere else in this book, but due to lack of space, only the Macintosh keys are listed in the tables. Remember, the PC equivalent for the Command key is Ctrl and the Option key is Alt. Here are the single key shortcuts for accessing tools and commands in the Tools palette:

Toolbox	
A	Direct selection path/path component selection tools
В	Brush/pencil tools
С	Crop tool
D	Reset to default Foreground/Background colors
E	Eraser/background eraser/magic eraser
F	Toggle the three screen display modes
Shift+F (after first F)	Toggle menu bar on/off in two secondary display modes
G	Gradient/paint bucket tools
Н	Hand tool
Spacebar	Access hand tool whilst any other tool is active
I	Eyedropper/color sampler/measure tools
J	Healing brush/patch tools
К	Slice/slice select tools

To cycle through the hidden tools, hold down the Option/Alt key and click again on the tool icon in the Tools palette or hold down Shift and press the key shortcut again. For example, if the eraser tool is currently selected, Option/Alt-click the eraser tool icon or press Shift-E to cycle through the other eraser tools. There is also an option in the first dialog of the General Preferences that allows you to cycle through the tools without using the Shift key modifier.

Toolbox continued	
L	Lasso/polygonal lasso/magnetic lasso tools
М	Rectangular/elliptical marquee tools
N	Notes/audio annotation tools
0	Dodge/burn/sponge tools
Ρ	Pen/freeform pen path drawing tools
Q	Quick mask mode/selection mode
R	Blur/sharpen/smudge tools
S	Clone stamp/pattern stamp tools
Т	Type tool
U	Shape drawing tools: rectangle/rounded rectangle/ellipse/polygon/line/custom
V	Move tool
Command key	Access move tool whilst any tool is active, bar pen tool
Arrow keys	Nudge selection border only, by I pixel
Arrow keys	Whilst move tool selected: nudge selection by I pixel
Shift+Arrow keys	Nudge using 10 pixel increments
W	Magic wand tool
x	Exchange foreground/background colors
Y	History brush/art history brush
Z	Zoom tool
Hold down Option key	Zoom out when the zoom tool is selected
Command+Spacebar-click	Zoom in
Option+Spacebar-click	Zoom out

Toolbox continued	
Shift+A	Toggle between direct select/path component selection tools
Shift+B	Toggle between brush and pencil tools
Shift+E	Cycle through eraser tools
Shift+G	Toggle between gradient and paint bucket tools
Shift+l	Cycle through eyedropper tools and measure tool
Shift+J	Toggle between healing brush and patch tool
Shift+K	Toggle between slice and slice select tools
Shift+L	Cycle through lasso tools
Shift+M	Toggle between rectangular and elliptical marquee tools
Shift+N	Toggle between notes and audio annotation tools
Shift+O	Cycle through toning tools
Shift+P	Toggle between pen and freeform pen tools
Shift+R	Cycle through focus and smudge tools
Shift+S	Toggle between clone stamp and pattern stamp tools
Shift+T	Cycle between the different type tools
Shift+U	Cycle between the different shape tools
Shift+Y	Toggle between history and art history tools

Efficient running

Allocate as much RAM memory as possible (see Chapter Six) and run Photoshop on its own. Keep the minimum number of image files open at any one time. Check the scratch disk size by having the status box at the bottom of the image/application window set to show Scratch Disk memory usage. Once the left-hand value starts to exceed the right, you know that Photoshop is running short of RAM memory and employing the scratch disk as virtual memory. To copy selections and layers between documents, use drag and drop actions with the move tool. This will save on memory usage and preserve any clipboard image at the same time. Save either in the native Photoshop format or as a TIFF to the hard disk and not to removable media devices (nor should a removable drive be used as a scratch disk).

File menu	
Keyboard shortcut	Function
Command-N	File > New File
Command+Option-N	File > New File using previously selected settings
Command-O	File > Open File
Command+Shift-O	File > Open File Browser
Command-W	File > Close Window/Close File
Command+Shift-W	File > Close All
Command-S	File > Save
Command+Shift-S	File > Save As
Command+Shift+Option-S	File > Save for Web
Command+Shift-P	File > Page Setup
Command-P	File > Print with Preview/Print File (see Preferences)
Command-P	File > Print File/Print with Preview (see Preferences)
Command+Shift+Option-P	File > Print One Copy
Command+Shift-M	Jumps to the default Jump to application
Command-Q	File > Quit
F5	Refresh the File Browser list tree view
FI2	File > Revert to last saved version as a new history state
Esc or D	Activate Don't Save after File > Close (System command)
Esc or Command-Period (.)	Cancel or Abort function (System command)

Contextual menus

A good many shortcuts are just a mouse-click away. Contextual menus are available throughout Photoshop. On a Macintosh you use Control-click and on the PC use right mouse-click to open a contextual menu in an image document window or a Photoshop palette such as the Layers, Channels or Paths palette. For example, you can Control-click/right mouse-click in the document window to access a list of all the menu options associated with the currently selected tool.

Edit menu	
Keyboard shortcut	Function
Command-Z	Edit > Undo last operation (see Preferences)
Command+Shift-Z	Edit > Step forward through history
Command+Option-Z	Edit > Step backward through history
Command+Shift-F	Edit > Fade last operation (image adjustment, filter etc.
Command-X	Edit > Cut
Command-C	Edit > Copy
Command+Shift-C	Edit > Copy Merged
Command-V	Edit > Paste
Command+Shift-V	Edit > Paste Into
Option+Delete/Backspace	Edit > Fill with foreground color
Command+Delete/Backspace	Edit > Fill with background color
Option+Shift+Delete/ Backspace	Fill layer with foreground color while preserving transparency
Command+Shift+Delete/ Backspace	Fill layer with background color while preserving transparency
Shift+Delete/Backspace	Open Edit > Fill dialog box
Command+Option+Delete/ Backspace	Fill from history
Command-T	Edit > Free Transform
Command+Shift-T	Repeat the last applied Transform
Command+Option-T	Free Transform with Duplication
Command+Option+Shift-T	Transform again with Duplication
Command+Shift-K	Edit > Color settings
Command-K	Open General Preferences
Command+Option-K	Open General Preferences (last used dialog box)

Selections

Holding down the Shift key when drawing a marquee selection constrains the selection being drawn to a square or circle.

Holding down the Option/Alt key when drawing a marquee selection centers the selection around the point from where you first dragged.

Holding down the Shift+Option/Alt keys when drawing a marquee selection constrains the selection to a square or circle and centers the selection around the point where you first clicked.

If you hold down the Spacebar at any point, you can reposition the center of the selection. Release the Spacebar and continue to drag using any of the above combination of modifier keys to finish defining the selection.

After drawing a selection and releasing the mouse, hold down the Shift key to add to the selection with the lasso, marquee or magic wand tool.

Hold down the Option/Alt key to subtract from the existing selection with the lasso, marquee or magic wand tool.

Hold down the Shift+Option/Alt key to intersect with the existing selection using the lasso, marquee or magic wand tool.

Window display options

Choose Window > Documents > Cascade to display windows stacked one on top of the other going from top left to bottom right of the screen. Choose Window > Documents > Tile to display document windows edge to edge.

Moving and cloning selections

To move the border outline only, place the cursor inside the selection border and drag. To move the selection contents, use the move tool (Command/Ctrl) – just hold down the Command/Ctrl key and drag inside the selection. If a selection is active, and you drag a layer, dragging outside the selection area, the selection will move with the layer. To clone a selection (without making it a layer), hold down the Option/Alt key+Command/Ctrl key and drag.

Image menu			
Keyboard shortcut	Function		
Command-L	Image > Adjustments > Levels		
Command+Shift-L	Image > Adjustments > Auto Levels		
Command+Shift+Option-L	Image > Adjustments > Auto Contrast		
Command+Shift-B	Image > Adjustments > Auto Color		
Command-M	Image > Adjustments > Curves		
Command-B	Image > Adjustments > Color Balance		
Command-U	Image > Adjustments > Hue/Saturation		
Command+Shift-U	Image > Adjustments > Desaturate		
Command-I	Image > Adjustments > Invert Image Color		
Command+Shift-F	Edit > Fade Image Adjustment		
Option+Image > Duplicate	Holding down the Option key whilst choosing Image > Duplicate bypasses the Duplicate dialog box		

The Option/Alt key can be used in combination with any of the above image adjustment commands (just as you can with filters) to open up the relevant dialog box with the last used settings in place. This is a generic Photoshop interface convention. The above fade command will fade filters, image adjustments and all types of brush strokes. It used to be located in the Filter menu, but is now an Edit menu item.

Select menu		
Keyboard shortcut	Function	
Command-A	Select > Select All	
Command-D	Select > Select None	
Command+Shift-D	Select > Reselect	
Command+Option-D	Select > Feather	
Command+Shift-I	Select > Invert Selection	

Layer menu	
Keyboard shortcut	Function
Command+Shift-N	Layer > New Layer
Command+Option+Shift-N	Layer > New Layer (without dialog box)
Command-G	Layer > Group With Previous Layer
Command+Shift-G	Layer > Ungroup
Command-E	Layer > Merge Down
Command+Option-E	Clone layer contents to the layer directly below
Command-J	Layer > New > Layer Via Copy (float to new layer)
Command+Shift-J	Layer > New > Layer Via Cut
Command+Shift-E	Layer > Merge Visible
Command+]	Arrange > Bring a layer forward in the stack
Command+Shift+]	Arrange > Bring a layer to the top of the stack
Command+[Arrange > Send a layer backward in the stack
Command+Shift+[Arrange > Send a layer to the bottom of the stack

Filter menu	
Keyboard shortcut	Function
Command-F	Filter > Apply last filter used (with same settings)
Command+Shift-F	Edit > Fade filter
Command+Option-F	Open dialog with last used filter settings
Command+Option-X	Filter > Extract
Command+Shift-X	Filter > Liquify
Command+Shift+Option-X	Filter > Pattern Maker

View menu			
Keyboard shortcut	Function		
Command-Y	View > Proof Colors (see Preferences)		
Shift+Command-Y	View > Gamut Warning		
Command-plus	View > Zoom in with window resizing		
Command+Option-plus	View > Zoom in without resizing window size		
Command-minus	View > Zoom out with window resizing		
Command+Option-minus	View > Zoom out without resizing window size		
Command-zero	View > Fit To Screen (constrained by open palettes)		
Double-click hand tool	View > Fit To Screen (constrained by open palettes)		
Option+Command-zero	View > Actual Pixels at 100%		
Double-click zoom tool	View > Actual Pixels at 100%		
Command-H	View > Show Extras (selections/target path/grid/ guides/slices/notes)		
Shift+Command-H	View > Show/Hide Path only		
Command-;	View > Show/Hide Guides only		
Command-'	View > Show/Hide Grid only		
Command-R	View > Show/Hide Rulers		
Shift+Command-;	View > Snap (guides/grid/slices/document bounds)		
Command+Option-;	View > Lock Guides		
Double-click guide with move tool	Edit Guides & Grid settings: color and increments		
Control+Tab	Cycle through open document windows (Mac)		

Window menu	
Keyboard shortcut	Function
Tab key	Hide/show all palettes
Shift-Tab key	Hide/show all palettes except Tools palette and Options bar

Info and Navigator

Double-click the ruler margins to open the Units & Rulers preferences. Control/ Right mouse-click on a ruler to change the Units settings. You can use the keyboard numbers to set the tool opacity while any paint or fill tool is selected (1 = 10%, 9 = 90%, 0 = 100%). For more precise settings, enter any double number values in quick succession (i.e. 04, 23, 75 etc.). Use the up arrow to increase values in the box by 1% and use the down arrow to decrease values in the box by 1% (hold down the Shift key to decrease or increase by 10%). The Navigator palette provides a swift way of scrolling across an image. The bottom left box in the Navigator palette indicates the current viewing percentage scale. As with the identical box in the document window display, any value can be entered between 0.19% and 1600.00%. To zoom to a specified percentage and keep this box highlighted, hold down the Shift key whilst press-

Navigation		
Keyboard shortcut	Function	
Page up	Scroll up by one screen	
Page down	Scroll down by one screen	
Shift+Page up	Scroll up in smaller steps	
Shift+Page down	Scroll down in smaller steps	
Shift+Page up/Page down	Scroll up or down a single frame of a Filmstrip file	
Command+Page up	Scroll left one screen	
Command+Page down	Scroll right one screen	
Command+Shift+Page up	Scroll left one screen in smaller steps	
Command+Shift+Page down	Scroll right one screen in smaller steps	
Home key	Display top left corner of image	
End key	Display bottom right corner of image	

ing Enter. Use the Navigator slider control to zoom in and out or mouse down on the left button to zoom out incrementally and the right button to zoom in. The dialog palette preview display indicates by a red rectangle which portion of the image is visible in relation to the whole – the rectangle border color can be altered by going to the palette options. To scroll quickly, drag the rectangle across the Navigator palette screen. Hold down the Command/Ctrl key and marquee within the thumbnail area to specify an area to zoom to. The Navigator palette can also be resized to make the preview window larger.

Working with Actions

Photoshop is able to record a script of the operations performed in a Photoshop session and save them as an Action. These Actions can then be replayed on other images and shared with other Photoshop users so that they can repeat this sequence of Photoshop steps on their computer. Actions can save you the bother of laboriously repeating the same steps over and over again on subsequent images. To make things even easier, there is a Batch command in the File > Automate menu. You can use the Batch interface to automatically process any folder of images and have the files either save and overwrite or save to a new folder location, such as batch opening the images from a Kodak Photo CD disc.

Playing an Action

A folder set of prerecorded Actions was added to the Actions palette when you installed Photoshop 7.0. To test them out, open an image, select an Action from the menu and press the Play button. Photoshop automatically starts running through the recorded sequence of commands, just like a pianola. If the number of steps in a complex Action exceeds the number of available histories, there will be no way of completely undoing all the commands when the action has completed. So as a precaution, either take a snapshot in the History palette or save the document before executing an Action and if you are not happy with the result, fill from the saved snapshot in History or revert to the last saved version. Extra sets of Actions are easily loaded by simply going to the Actions palette menu and highlighting one of the named sets in the list. The Commands.atn set will install a number of useful preset Actions that will assign basic Photoshop actions like Cut and Paste with Function keys. Note that the Adobe Photoshop 7.0 > Presets > Actions folder contains a PDF document illustrating all the preset Action outcomes. If you are sent a Photoshop Action as an Action document (it may be appended with .atn), instead of loading it via the Actions palette, you can just double-click it to open Photoshop and automatically install it in the Actions palette.

Recording Actions

First, record your action using a dummy image. Click the New Action button at the bottom of the Actions palette. Name the new Action you are about to record and then press the Record button. You can also at this stage assign a Function key combination that will in future initiate the Action. Now carry out the Photoshop steps you wish to record and when finished, press the Stop button in the Actions palette. Actions will be able to record most Photoshop operations including use of the Paths, History palette steps, the Lighting Effects filter, Apply Image and most of the tools in Photoshop including the shape tools. Tools such as the marquee and gradient fills are recorded based on the currently set ruler unit coordinates. Where relative positioning will be required, choose the Percent units in Units & Rulers preferences before you begin recording. Avoid using commands which as yet cannot be recorded with an Action. This is less of a problem now, as the scriptability of Photoshop has been vastly improved, but certain operations like brush strokes (or any of the other painting tools) cannot be recorded as this goes beyond the scope of what can be scripted.

Watch out for recording commands that rely on the use of named layers or channels (that may be present in your dummy file, but will not be recognized when the Action is applied to a new image). Also try to make sure that your actions will not always be conditional on starting in one color mode only, or being of a certain size. If you need the Action to work with different sized images, set the ruler units to Percent before recording. If you intend recording a complex Action, the best approach is to carefully plan in advance the sequence of Photoshop steps you intend to record. The example overleaf demonstrates how to record a basic Action. A break can be included in an Action. This will initiate a message dialog to appear on screen. This message dialog can include a memo to yourself (or another user replaying the Action), reminding you of what needs to be done at this stage. Actions can be saved as Sets of Actions. If you want to save a single action, duplicate it by Option/Alt dragging to a new Set. If you hold down the Command/Ctrl+Option/Alt keys as you choose Save Actions... this will save the text descriptions of the Action steps for every Photoshop Action displayed in the Actions palette.

Troubleshooting Actions

Check that the image to be processed is in the correct color mode. Many Actions, such as those that use certain Photoshop filters, are written to operate in RGB color mode only. Color adjustment commands will not work properly if the starting image is in Grayscale or Indexed Color. Some pre-written Actions require that the start image fits certain criteria. For example, the Photoshop text effect Actions require

that you begin with an image that already contains layered text. If you have just recorded an Action and having trouble getting it to replay, you can inspect it command by command. Open a test image and expand the Action to display all the items. Hold down the Command/Ctrl key and click on the Play button. This will play the first command only. If there is a problem, double-click the command item in the list to rerecord it. Hold down the Command/Ctrl key again and click on the Play button to continue. To replace an item completely, press Record and perform a new step, then click Stop. This will delete the old step and replace it with the one you have just recorded.

Batch processing Actions

One of the great advantages of Actions is the ability to record an Action and then apply it to a batch of files. The Batch Actions dialog can be accessed via the File > Automate menu. You will need to select a Source folder and a Destination folder (if you want to save copy files to a new folder). Photoshop will also accept all currently opened files as the source. Figures 12.1 and 12.2 show you how to configure Batch Actions processing.

I The normal procedure when recording an Action is to start with a dummy image, record all your steps and then test the Action to make sure it is running correctly. The Action can easily be edited later where there are gaps or extra steps that need to be included.

Photograph: Davis Cairns. Client: Red or Dead Ltd.

2 This Action is designed to add a color fill layer and apply a custom gradient fill.Action recordings should be as unambiguous as possible. For example, if you record a step in which a named layer is brought forward in the layer stack, on playback the action will look for a layer with that name. Therefore, use the main Layer menu or Layer key command shortcuts listed in this chapter. Doing so will make your Action more universally recognized. **3** In this Action, a new layer is created and filled with a KPT gradient. The Action requires that a mask channel is present in the starting image to be loaded as a layer mask to reveal the object on the background layer.

4 When the recording is complete, hit the Stop button in the Actions palette. Expand the Action items to inspect the recording. Just before the filter step, I inserted a 'Stop' with a message reminding me that the next step requires me to select a KPT gradient. The Stop allows the Action to continue playing after pressing Enter.

Automation plug-ins

This Photoshop feature will allow third-party developers to build plug-ins for Photoshop that will be able to perform complex Photoshop operations. The Photoshop suite of automated plug-ins is described on the following pages. These should be of special interest to everyone, including those who only use Photoshop occasionally and wish to carry out skilled tasks like resizing an image without constantly having to refer to the manual. They can operate like 'wizards'. An on-screen interface will lead you through the various steps or else provide a one-step process which can save you time or be built into a recorded Action. Figure 12.1 An example of the Batch Action dialog set to apply a prerecorded Action. Select the Action you wish to apply from the pop-up menu at the top. Then choose the source folder containing the images to process. You can either instruct Photoshop to save and close, overwriting the original or select a destination folder where the processed files should be saved to. If you included an Open command in the recorded Action, then don't override this command, although you will want to override the save file operation as the recorded command will probably be to a different destination folder. The file naming options enable you to define the precise naming structure of the batch processed files.

Figure 12.2 The Batch interface in Photoshop 6.0 features a section where you can specify the file naming rules of files saved from a Batch process. For example, the file document name itself can be made to be capitalised or made all lower case. Likewise, the file extension can be configured the same way. As you can see from the lists opposite, you can have Photoshop name the batch processed files in a great many ways. The example in the File Naming section (see Figure 12.1) indicates how the resulting file name will appear.

Fit Image

Fit Image... is a very simple automated plug-in that bypasses the Image > Image Size menu item. It is well suited for the preparation of screen-based design work. Enter the pixel dimensions you want the image to fit to, by specifying the maximum pixel height or width. With the Multi-Page PDF to PSD... plug-in, you can open multiple pages of a PDF document as individual Photoshop image files. The opening dialog offers a choice of source file, which pages you want to select, what resolution to open to and the location of the folder to save to.

	Batch		
Play			ОК
Set: Default Acti	ons.atn		Cancel
Action: RGB to CMY	к 🔹		
Source: Folder	19)		
Choose			
Override Action "Oper	" Commands		
Include All Subfolders			
Suppress Color Profile	Warnings		
Destination: Folder			
Choose			
Override Action "Save	As" Commands		
File Naming			
Example: MyFile.gif			
Document Name	+ extension	+	
	+	+	
	+	•	
Compatibility: 🗍 Wind	lows 🗹 Mac OS 9 🗇 Unix		
Errors: Stop For Errors			
Save As			

✓ Document Name document name DOCUMENT NAME 1 Digit Serial Number 2 Digit Serial Number **3 Digit Serial Number** 4 Digit Serial Number Serial Letter (a. b. c...) Serial Letter (A, B, C ...) mmddyy (date) mmdd (date) yyyymmdd (date) vymmdd (date) yyddmm (date) ddmmyy (date) ddmm (date) extension **EXTENSION** None

Picture Package

The Picture Package can automatically produce a picture package page layout based on one or more images and has been enhanced in version 7.0. Figure 12.3 shows how you could have a combination of a single 5×7 , with two postcards plus four smaller sized versions all oriented to fit within a single page design. Many preset templates are available for you to choose from in the dialog layout menu. If you are feeling adventurous, you can go to the Photoshop 7.0/Presets/Layouts folder and open the 'Read Me' file. This describes how to write the basic code to design your own custom layouts. You can base the design on either the frontmost, open document, or browse to select a specific file. You can also click in one of the Picture Package template spaces to load an image file, or replace one of the repeated images. The Label section is useful if you wish to add, say, the file name or have the caption appear within the image area. You can even use this as a way to enter custom text at a low opacity and have it appear in the center of each image (such as a copyright message). If you select the Folder option, Photoshop will use the selected Picture Package template to batch apply to each image in the specified folder. Although this revision of Picture Package is more versatile, it has been done at the expense of being more cumbersome and slower to use.

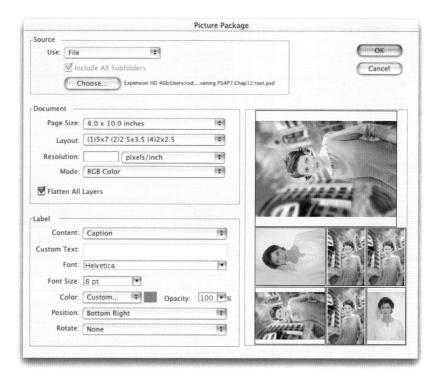

Figure 12.3 The Picture Package dialog box and an example of the resulting print output.

Contact Sheet II

The Contact Sheet II is able to take all the images in a selected folder and construct a contact sheet of these and (if you wish) print the file name as a caption below each picture. Just choose a source folder and all the images will be opened up and assembled to form a contact sheet page. If there are more images in the folder than will fit on a single page grid then these will spill over into a second contact sheet document. The Contact Sheet layout and save destination are specified in the opening dialog box. You can choose to use any font for the caption and also have a choice over the caption point size. Another thing to watch out for is the limit on the caption length, as only the first twelve characters will be displayed, so check how you name the files. A nice refinement with Contact Sheet II is that it remembers the last used settings rather than always opening with the standard default settings. Fans of the Contact Sheet plug-in will be pleased to know that the Photoshop 7.0 version produces contacts with narrower gaps between each image.Mac users should be aware that there is a Contact Sheet and Picture Package plug-in update that you can download from the Adobe website for version 7.0.1. This fixes a flaw caused by certain non-image files in a source folder halting the automated processing in Photoshop.

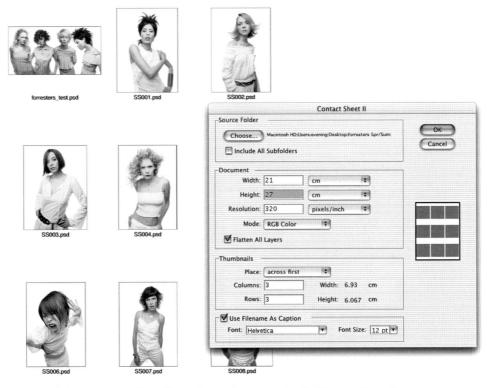

Figure 12.4 The Contact Sheet II interface and an example of a Contact Sheet II output.

Export Transparent Image and Resize Image

These last two Automation plug-ins are located in the Help menu. They are very nicely designed and illustrate just what we might come to expect in the future. The Export Transparent Image interface starts by asking you whether the purpose of the final image is for print or online use. For example, if you want to make a transparent GIF and there is no selection currently active, it will tell you to cancel and make a selection first. From there on it will duplicate the current image and ask clearly put questions about the intended final output and guide you towards that desired goal. The Resize Image Automation plug-in also has a clearly designed interface and takes the user step by step through the process of sizing an image for reprographic or online use (see Figure 12.5).

Width: Height:	362	pixels	
Height:			R
	380	pixels	78
Previe	w		
	Previe	Preview	Preview

A	This assistant will help you to export an image with transparency.
A A	Which option best describes your image?
61	 My image is on a transparent background I have selected the area to be made transparent
	I need to select the area to be made transparent

Figure 12.5 Two dialog boxes from Actions plug-ins found in the Help menu. On the left: the Export Transparent Image, which is asking if the image is already on a transparent background or a selection is currently active. On the right: Resize Image where the user can select the ratio of image resolution to screen resolution selected, plus a warning that the image may need to be rescanned if this size is selected.

Web Photo Gallery

This is one of my favorite automated plug-ins. The Web Photo Gallery (WPG) can process a folder of images and automatically generate all the HTML code needed to build a website complete with thumbnail images, individual gallery pages and navigable link buttons. This Photoshop feature can therefore save you many hours of repetitious work. Imagine you have a set of Photoshop images that need to be forwarded to a client or colleague who has access to the Internet. When you build a selfcontained web photo gallery in Photoshop, the processed images and HTML pages are output to a destination folder. You can then upload this processed folder to your web server and simply pass the URL link on to the person who needs to see the photographs. In the Figure 12.6 example, I decided to call the destination folder 'alcatraz' and I therefore appended '/alcatraz' to my normal website address as the full URL for the recipient to follow.

The source can be any folder of images, regardless of the color mode or color space they are in (subsets of folders can be processed too). But if you want to achieve some level of consistency, you might wish to convert all the source images to sRGB color. It is not essential that you resize them to the exact viewing size, as the Web Photo Gallery options allow you to precisely scale the gallery images and thumbnails down in size while being processed. There is now a choice of eleven template styles to choose from. Some of these are based on a simple HTML table design and others utilize frames and basic JavaScript. Under Options you can enter the banner information, including your contact details and email address. Note that not every custom layout will make use of this information. If you process a folder of images and are not sure about the look of the layout chosen, then try selecting an alternate WPG style. It is worth pointing out that if you have to redo a Web Photo Gallery, Photoshop will usually not need to reprocess all the image data and will instead recode the HTML. You can customize the gallery image, thumbnail sizing, layout appearance and security settings. If you go to the Gallery Thumbnail options, you can choose whether to use the file name, or the File Info information, or both as the caption. You can also choose the number of columns and rows of thumbnail images that should be used with the Simple and Table style layouts. In the Customize Colors options, you can edit the background, text, banner and active link colors. When all the options are set, these will be remembered the next time you use the Web Photo Gallery. Choose your destination folder and click OK. You can also create your own layout templates. Go to the Photoshop 7.0/Presets/Web Contact Sheet folder and use the folders in there as a guide for designing your own customized HTML templates. Remember, when the output folder is complete, you can further enhance the appearance of your gallery pages by importing them into a separate website editing program such as Adobe GoLiveTM.

Figure 12.6 The Photoshop 7.0 Web Photo Gallery is much improved. It will allow you to save extra information such as contact details and an active link to your email address. The new security feature will enable you to apply a visible watermark to the gallery images that are created. This can be based on file data such as the file name, caption information, or alternatively, you can enter custom text.

Site Styles: Vertical Slide Show 1 Email: martin@martinevening.com	ОК
Email: martin@martinevening.com	
	Cancel
Extension: .htm 📪	
Folders	
Choose Macintosh ti OS X:Users:martinev:Pictures:Alcatraz:	3 14
V Include All Subfolders	7
Destination Macintosh HD:alcatraz:	
	CC. Internation
Options: Banner +	Some of the option
Site Name: Alcatraz Island	may not apply to this style.
Photographer: Photography: Martin Evening	
Contact Info: Web site: www.martinevening.com	
Date: 2/5/02	
Font: Helvetica	
Font Size: 2	

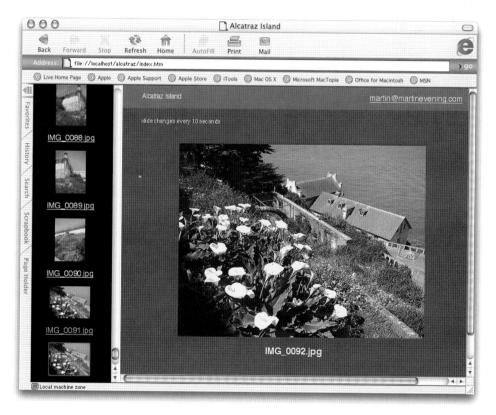

Creating a Droplet

A Photoshop Action can be converted into a self-contained application, known as a Droplet, that can be saved outside of Photoshop to somewhere useful, like the desk-top and which will launch Photoshop and initiate a specific Action sequence, whenever you drag and drop a file on top of the Droplet icon. To create a droplet, go to the File > Automate menu and choose Create Droplet... Figure 12.7 shows the Create Droplet interface. You can name a droplet anything you like, but to be PC compatible you should add an .exe extension, while PC Droplets can be made Mac compatible by dragging them once over to the Photoshop application icon. The options for selecting an action and specifying the file naming structure are identical to those found in the Batch Actions dialog. When finished, click OK to create a new Droplet and choose a location folder to save it to. Droplets are incredibly useful when they are incorporated into a production workflow, as they are effectively self-contained Photoshop batch processing routines. I have got into the habit of keeping a folder located destination folders.

	Create Droplet	na di si	in and the state of the state o
Save Droplet In			ОК
Choose) Macintosh	HD:Users::Desktop:CMYK co	nversion	Cancel
- Play]
Set: JS_PS_Con.a	tn 🗘		
Action: Convert to C	смук 🔹		
Override Action "Open	" Commands		
Include All Subfolders			
Suppress Color Profile	Warnings		
Destination: Folder			
Choose Macintosh	HD:Users::Desktop:PS7:		
Override Action "Save	As" Commands		
- File Naming			
Example: MyFile.gif			
Document Name	+ extension		
	() +	+	
	(*) +	•	
Compatibility: 🗹 Wind	ows 🗹 Mac OS 9 🗹 Unix		
(_
Errors: Stop For Errors	•		
Save As			
JO .	÷.	÷.	Je la
bass sharpening	Resize JPEG CN	YK conversion	Mask

Figure 12.7 The Create Droplet dialog. When you drag and drop an image file on top of a droplet, this will launch Photoshop and perform a single or batch processing operation within the program. You can also include a specific output folder to save the processed image file(s) to as part of the Droplet.

Brushes	Palette shortcuts
Keyboard shortcut	Function
Bracket: [Reduce brush size
Bracket:]	increase brush size
Shift+[Reduce the brush hardness
Shift+]	Increase the brush hardness
Command+Shift-F	Edit > Fade last brush stroke
Caps lock	Display precision crosshair cursor/brush size cursor
Double-click a brush preset	Rename the brush
Click in an empty space	Create a new brush
Option-click on a brush preset	Delete a brush preset
Control+Shift-click with a painting tool	Open the brush presets dialog – hit Enter to dismiss the dialog
Control+Shift-drag with a painting tool	Open the brush presets dialog – the dialog will be dismissed when you release the mouse
Shift key	Having started using the brush, then pressing and holding the Shift key will use this brush in a straight line to the next click

Swatches	Palette shortcuts
Keyboard shortcut	Function
Click on swatch	Choose swatch as foreground color
Drag a swatch	Reposition a swatch in the Swatches palette
Option-click on swatch	Choose swatch as background color
Click in an empty slot	Add the foreground color as a swatch and name it
Shift+Option-click in a slot	Add the foreground color as a swatch without naming it
Shift-click swatch color	Replace a swatch with the foreground color
Command-click on swatch	Remove swatch from palette

Color	Palette shortcuts
Keyboard shortcut	Function
Shift-click Color bar	Cycle between all the color spectrum options
Control-click Color bar	Specify Color bar to use
Click gamut warning swatch	Select nearest in gamut color
History	Palette shortcuts
Keyboard shortcut	Function
Command-Z	Toggle moving back and forward one step (undo/redo)
Command+Option-Z	Move one step back through history
Command+Shift-Z	Move one step forward through history
Click New Snapshot button	Create a new Snapshot
Click New Document button	Create a new document from current image state
Option-click on history state	Duplicate any previous history state

See Figure 6.26 in Chapter Six for more variable history shortcut options.

Layers and channels

Extra layers will add to the overall file size and add to the RAM memory usage. Photoshop will also take longer to calculate the screen redraw every time you scroll the image or change the viewing magnification. If you anticipate editing very large image files (over 50 MB RGB) then you should raise the number of Image Cache levels in the General Preferences from four to five, or even higher. Doing this will speed up the screen redraws at lower viewing magnifications. Adjustment layers may only occupy a few kilobytes of file space, but when a document contains several adjustment layers, this too can slow down the time it takes to refresh the screen image. There are two things that can be done to remedy this – either temporarily switch off the eye icons on these layers or merge them with the layers below and apply the adjustment permanently.

If you want to save lots of channels, the native Photoshop file format will save the channels more compactly. A simple silhouette type mask will not add much to the total file size of a Photoshop document. However, this is not the case when you save using the TIFF file format, unless you use one of the TIFF compression options.

Layers	Palette shortcuts
Keyboard shortcut	Function
Click New Layer button	Create new empty layer
Option-click New Layer button	Create new empty layer, showing New Layer dialog box
Drag layer to New Layer button	Duplicate layer
Click palette Delete button	Delete selected layer (or drag layer to delete button)
Option-click palette Delete button	Delete selected layer (bypassing alert warning)
Option+[Select next layer down
Option+]	Select next layer up
Shift+Option+[Select bottom layer
Shift+Option+]	Select top layer
Double-click layer name	Rename layer
Option+double-click layer name	Open Layer Style dialog box
Double-click adjustment layer icon	Edit adjustment layer settings
Option+double-click adjustment layer	Edit Layer Style blending options
Double-click layer style icon	Edit Layer Style effect options
Keyboard numbers (1=10%, 9=90%, 0=100%)	Set layer opacity whilst a non-painting tool is selected (Enter any double number values in quick succession)
Up arrow	Increase value setting in box by 1%
Down arrow	Decrease value setting in box by 1%
Shift+Up arrow	Increase value setting in box by 10%
Shift+Down arrow	Decrease value setting in box by 10%
Return	Commits edit in pop-up slider in mouse up mode
Escape or Command-period (.)	Exit slider edit in mouse up mode
Click Layer Eye icon	Show or hide layer (toggle)
Option-click Layer Eye icon	View layer on its own/view all layers (toggle)

Layers continued	Palette shortcuts continued
Keyboard shortcut	Function
Command-click layer thumbnail	Load layer transparency as a selection
Command+Shift-click layer thumbnail	Add layer transparency to selection
Command+Option-click layer thumbnail	Subtract layer transparency from selection
Command+Option+Shift-click layer thumbnail	Intersect layer transparency with selection
Click Add a Mask button	Create a layer mask with reveal all/reveal selection
Option-click Add a Mask button	Create a layer mask with hide all/hide selection
Option-click layer mask thumbnail	View layer mask as a mask on its own (toggle)
Command-click layer mask icon	Load a layer mask as a selection
Click in Link icon area	Link/unlink a layer to currently selected layer
Click Link layer between the layer mask/clipping layer thumbnail	Lock/unlock the layer and the layer mask/clipping layer
Shift-click layer mask/clipping layer thumbnail	Disable/enable layer mask/clipping layer
Double-click layer mask thumbnail	Open Layer Mask Display Options
Shift+Option-click layer image mask thumbnail	View layer mask as an alpha channel (rubylith)
Option-click the divide line between two layers	Toggle between creating a layer clipping group and ungrouping
1	Switch on/switch off Lock transparent pixels
Option-click layer eye icon	Hide all layers except that one (toggle)
Command+Option+Shift-E	Merge visible layers to selected layer
Option+Merge Down	Merge down and leave a copy of the selected layer
Option+Merge Linked	Merge a copy of linked layers into layer below

Layer sets can help you manage and organize the layers in a complex document (see Chapter Eleven). When image documents with multiple layers are arranged using sets, you can quickly change the visibility and blending options for all the layers in the set at a stroke. You can also consider saving the different layered versions of the image as you progress, before merging and moving on to the next stage. This way, you will always be able to revert back to any previous layered version of the image.

Layer sets	Palette shortcuts
Keyboard shortcut	Function
Click new layer set button	Create new layer set above target layer
Command-click new layer set button	Create new layer set below target layer
Option-click new layer set button	Create new layer set with layer set options dialog
Command+Shift-J	Create new layer set from all linked layers
Command+Shift-J	Create new layer set from selected layer
Click trash icon	Delete selected layer set (with an alert)
Option-click trash icon	Delete selected layer set (without an alert)
Command-E	Merge selected layer set
Command+Shift-]	Move set to top of the stack
Command-]	Move set up, move layer into set that is right above it or move top layer in a set out of the set
Command-[Move set down, move layer into set that is right below it or move bottom layer in a set out of the set
Command+Shift-[Move set to bottom of the stack
Option+Shift-]	Select topmost layer or set
Option-]	Select next layer or set (cycle up)
Option-[Select next layer or set (cycle down)
Option+Shift-[Select bottom layer or set
Option-click eye icon for the set	Toggle show all layers/show just this set

Blending modes	
Keyboard shortcut	Function
Shift-plus	Set layer to next blend mode in list
Shift-minus	Set layer to previous blend mode in list
Option+Shift-N	Normal mode
Option+Shift-I	Dissolve mode
Option+Shift-K	Darken mode
Option+Shift-M	Multiply mode
Option+Shift-B	Color Burn mode
Option+Shift-A	Linear Burn mode
Option+Shift-G	Lighten mode
Option+Shift-S	Screen mode
Option+Shift-D	Color Dodge mode
Option+Shift-W	Linear Dodge mode
Option+Shift-O	Overlay mode
Option+Shift-F	Soft Light mode
Option+Shift-H	Hard Light mode
Option+Shift-J	Linear Light mode
Option+Shift-V	Vivid Light mode
Option+Shift-Z	Pin Light mode
Option+Shift-E	Difference mode
Option+Shift-X	Exclusion mode
Option+Shift-U	Hue mode
Option+Shift-T	Saturation mode
Option+Shift-C	Color mode
Option+Shift-Y	Luminosity mode

Channels	Palette shortcuts
Keyboard shortcut	Function
Command-click channel	Load channel as a selection
Command+Shift-click channel	Add channel to current selection
Command+Option-click channel	Subtract channel from current selection
Command+Option+Shift- click channel	Intersect channel with current selection
Shift-click channel	Add to or remove from the channels active
Command-I	Activate channel-1, e.g. red or cyan channel and so on
Command-~ (tilde)	Activate composite channel, e.g. RGB, CMYK or Lab (see page 127: Photoshop 7.0.1 patch for Mac OS X 10.2)
Command+Option-I	Load channel I as a selection and so on to channel 9
Click New channel button	Create a new channel
Option-click New channel button	Create a new channel whilst opening the Options dialog box
Command-click New channel button	Create a new Spot color channel
Click on Save Selection button	Create a new channel from current selection
Option-click on Save Selection button	Create a new channel from current selection with channel options dialog box
Click Load Selection button	Load active channel as a selection
Shift-click Load Selection button	Add selected channel to current selection
Option-click Load Selection button	Subtract selected channel from current selection
Option+Shift-click Load Selection button	Intersect selected channel with current selection
Click Delete button	Delete selected channel (or drag channel to wastebasket)
Option-click Delete button	Delete selected channel (without alert warning)

Paths	Palette shortcuts
Keyboard shortcut	Function
Click New path button	Create a new path
Option-click New path button	Create a new path showing the New Path dialog box
Drag path to New path button	Duplicate path
Click Delete path button	Delete path
Option-click Delete path button	Delete path, bypassing the alert warning
Double-click Path name	Edit the path name
Click Make work path button	Convert a selection to make a work path
Option-click Make work path button	Convert a selection to make a work path via Make Work Path dialog (choose pixel tolerance setting)
Double-click work path icon	Save the work path as a new path
Drag a work path to the New path button	Convert a work path into a new path
Command-click a Path in the palette	Load the path as a selection
Click Load path as a selection button	Convert active closed path to a selection
Option-click Load path as a selection button	Convert active closed path to a selection via Make Selection dialog box
Command+Enter key (selection or path tool active)	Convert active path to a selection
Click Stroke Path button	Stroke perimeter of path with Foreground color
Option-click Stroke Path button	Stroke perimeter of path via the Stroke Path dialog box
Click Fill path button	Fill path with Foreground color
Option-click Fill path button	Fill path via the Fill Path dialog box
Click empty area of Paths palette	Deactivate path

Pen tool	
Keyboard shortcut with pen tool selected	Function
Command key	Direct selection tool (whilst key is held down)
Option key	Convert direction tool (whilst key is held down)
Click on anchor point or path	Remove anchor point/add anchor point (toggle)
Shift key	Constrains the path drawing horizontally, vertically and at 45 degrees
Command-click Path	Activate all control points without selecting them
Command+Shift-click	Add to selected path points
Command+Option-click path in image	Select entire path or uppermost sub-path
Command+Option+Shift- drag path	Clone selected path (Shift key constrains movement to 45 degree increments, let go after first dragging)

General	
Keyboard shortcut	Function
Command-Period (.)	Cancel or abort an operation
Esc	Cancel operation (Crop/Transform/Save)
Delete key	Remove selected area to reveal transparency (on layer) or background color (on background layer)
Option key	When a painting tool is active, use the Option key to sample in window area to make foreground color
Tab key	Toggle Show/Hide palettes (see Window menu)
Tab key	Jump to next setting in any active dialog box
Option-click Cancel button	Change Cancel button in dialog boxes to Reset

Chapter Thirteen Black and White Effects

Duplicating black and white darkroom techniques in Photoshop will be of particular interest to photographers. This chapter shows you how to use Photoshop as your digital darkroom. We will also look at the different ways that you can convert a color image to monochrome. For example, when you change a color image from RGB to Grayscale mode in Photoshop, the tonal values of the three RGB channels are averaged out, usually producing a smooth continuous tone grayscale. The formula for this conversion roughly consists of blending 60% of the green channel, 30% of the red and 10% of the blue. The rigidity of this color to mono conversion formula limits the scope for obtaining the best grayscale conversion from a scanned color original. But by using the Channel Mixer you can create a custom RGB to grayscale conversion.

A black and white image can be reproduced a number of ways in print. If you are working from a basic 8-bit grayscale image, this will have a maximum of 256 brightness levels. A practical consequence of using basic 8-bit grayscale files for print is that as many as a third of the tonal shades will get lost during the reproduction process and this is why images reproduced from a grayscale file can look extremely flat when printed, especially when compared alongside a CMYK printed example. Adding two or more printing plates will dramatically increase the range of tones that can be reproduced from a monochrome image. The fine quality black and white printing you see in certain magazines and books is often achieved using a duotone or conventional CMYK printing process.

Duotone mode

A duotone is made using two printing plates, a tritone has three and a quadtone four. You need to start with an image in grayscale mode first before you convert to a duotone by choosing: Image > Mode > Duotone. The Ink Color boxes display a Photoshop preview of the ink color with the name of the color (i.e. process color name) appearing in the box to the right. The graph icon to the left is the transfer function box. In here you specify the proportions of ink used to print at the different brightness levels of the grayscale image. The transfer function box opens when you double-click the graph icon. You can change the shape of the curve to represent the proportion of ink used to print in the highlights/midtones/shadows. Normally the inks are ordered with the darkest at the top and the lightest inks at the bottom of the list. There are a number of duotone Presets (plus tritones and quadtones) to be found in the Photoshop Goodies folder. Experiment with these by clicking the Load... button in the duotone dialog box and locating the different preset settings.

Printing duotones

The only file formats (other than Photoshop) to support duotones are EPS and DCS. So save using these when preparing an image for placing in either an InDesign[™] or QuarkXPress[™] document. Remember though that if any custom ink colors are used to make the duotone, these need to be specified to the printer and this will add to the cost of making the separations if CMYK inks are already being used in the publication. Duotones that are converted to Multichannel mode are converted as spot color channels. Alternatively you can take a duotone image and convert it to CMYK mode in Photoshop. This may well produce a compromise in the color output as you will be limited to using the CMYK gamut of colors.

So, I hear you say, 'in that case why not use the CMYK mode instead of duotone, what difference will an extra plate make between a tritone and CMYK?' Well, a designer's job is to make the best use of his or her skills within an allocated budget. It is common for a color print job to include extra plates beyond the four employed in CMYK. Yes, you can construct many flat colors using a mix of these four inks, but designers have to be wary of misregistration problems. It is all right to specify large headline text in a process color, but not smaller body text. For this reason, designers specify one or more process colors for the accurate printing of colors other than black or a pure cyan, magenta or yellow. A typical custom brochure print job with full color images might require a total of six color plates, whereas a brochure featuring black plus one or two process colors requires fewer printing plates to make sumptuous duotones or tritones. You find designers working within the limitations of black plus two custom inks are still able to pull off some remarkable illusions of full color printing.

Duotone: 159 dk orange 614 (Pantone)

Duotone: 327 aqua (50%) bl1

Duotone: 506 burgundy (75%) bl 3

Tritone: BMC blue 2 (Process)

Normal – Grayscale Mode

Tritone: bl 313 aqua 127 gold (Pantone)

Quadtone: bl 541 513 5773 (Pantone)

Quadtone: Custom (Process)

Quadtone: Extra Warm (Process)

Figure 13.1 Examples of preset duotones (see Goodies folder) applied to a grayscale image. Process color duotones are formed using the standard CMYK process inks. Pantone (or any custom process color ink) duotones can be made from specified color inks other than these process colors.

2 When the Preview is checked in Duotone Options, any changes you make to the duotone settings will immediately be reflected in the appearance of the onscreen image. In the example shown here, a custom color tritone was selected and the component ink colors are displayed with the darkest color at the top. If I double-click the orange graph icon, this will open the transform curve dialog. The transform curve is similar to the image adjustment curves, except a little more

restrictive in setting the points. The color ramp in the duotone dialog reflects the tonal transformation across an evenly stepped grayscale ramp and you can specify the ink percentage variance at set points along the horizontal axis. I The grayscale display in Photoshop is foremostly based on the assumption that you want to see a representation on screen of how the grayscale file will print. Go to the Color Settings and select the anticipated dot gain for the print output. This will be the Photoshop grayscale work space that all new documents will be created in or be converted to. If you are working on a grayscale image intended for screen-based publishing then go to Window > Proof setup and select the Windows RGB preview.

	Color	Settings
Settings	: Custom	P
Advance	d Mode	
Working	Spaces	
RGB:	Adobe RGB (1998)	(e)
CMYK:	Euroscale Coated	
Gray:	Dot Gain 20%	÷) (S
Spot:	Dot Gain 20%	🗘 🕅 Pr

0: 0	% 60:	%	ОК
5:	% 70:	%	Cancel
10:	% 80:	%	Load
20:	% 90:	%	
30:	% 95:	× (Save
40: 20	% 100: 90	%	
50:	%		

	Duotone Options	
Type: Tritone	•	ОК
Ink 1:	Black	Cancel
		Load
Ink 2:	PANTONE 165 C	Save
Ink 3:	PANTONE 457 C	Preview
Ink 4		
Overpr	int Colors)	

369

Full color toning

When you select a duotone preset you get to see a preview of the color on the screen and this opens up many possibilities for the creative use of working in duotone mode to simulate all types of print toning effects. Because of this I now use Duotone mode much more often and will maybe afterwards convert the image to either RGB or CMYK color. The other alternative is to start with the image in RGB or CMYK color mode and desaturate (see the Black and white from color Channel Mixer technique, page 376 for guidance on producing custom grayscale conversions) or convert a grayscale file to RGB color mode and use some of the other techniques demonstrated here which simulate traditional darkroom toning techniques. The simplest way of toning an image is to use the Color Balance adjustment. I am normally inclined to disregard the Color Balance as a serious color correction tool. But in situations such as this, the simple Color Balance controls are perfectly adequate for the job of coloring a black and white image. The Color Balance controls are intuitive: if you want to colorize the shadows, click on the Shadows radio button and adjust the color settings. Then go to the Highlights and make them a different color and so on. If you apply the color adjustment as an adjustment layer, you can afford to make quite a dramatic color adjustment and then fade the adjustment layer opacity afterwards.

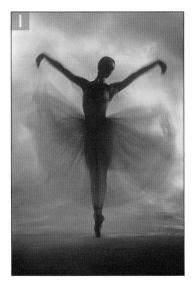

Color	Levels: +4	-23	-23		Cancel
Cyan		0		Red	Preview
Magenta				• Green	
Yellow	÷	- 1		⇒ Blue	
Tone Balar	nce				
O Shadows	Midtones	⊖н	ighlights		

I Start with a grayscale image and convert to RGB color mode or take an RGB image and choose Image > Adjust > Desaturate (or use the 'black and white from color' Channel Mixer in monochrome mode method described later on). Then add a Color Balance adjustment layer to colorize the RGB/monochrome image. Choose New Adjustment Layer... from the Layers palette fly-out menu and select Color Balance. Click on Shadows and move the sliders to change the shadow tone color balance.

Photograph: Eric Richmond.

2 Repeat the same thing with the Midtones and Highlights. Return to the Shadows and readjust if necessary. With an adjustment layer you can return again to alter these Color Balance settings at any time. The Color Balance image adjustment method is ideal for toning monochrome images. To further modify the Color Balance toning, try varying the adjustment layer opacity in the Layers palette.

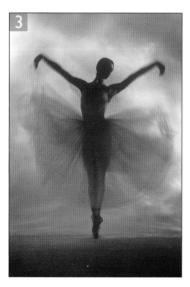

3 Providing the original monochrome image is in RGB or CMYK color mode, the Channel Mixer is another interesting tool that can be used for coloring an image and imitating color toning effects. For more instructions on Channel Mixer use, see the simulating sunset light technique described in Chapter Fourteen.

Output Channel: Blue	*		ОК
Source Channels			Cancel
Red:	-13]%	Load
Green:	+15]%	Save
lê			Preview
Blue:	+92	% •	
Constant:	0]%	
<u></u>	1		

Split toning

For those who are not familiar with this printing method, a split tone is a black and white image that has only been partly toned or where a mix of toning effects has been applied. For example, a silver print is placed in a bleach bath to remove all the silver image, then it is thoroughly washed and placed in a bath of toner solution, that replaces the bleached silver with the sepia or other dye image. If the print is only partially bleached, you get an interesting split tone effect in the transition between the base and toned colors. The following steps demonstrate how to use the Layer blending options in conjunction with adjustment layers.

I The color original is converted to monochrome while remaining in RGB – use Image > Adjust > Desaturate or apply the Channel Mixer in Monochrome mode.

2 Tone the desaturated image using a Color Balance adjustment layer as was described in the previous example. Click on the Midtone and Shadow buttons and move the sliders to adjust the shadow and midtone colors. Keep the Preserve Luminosity option checked, as this will help maintain a consistent lightness in the image.

Color Balance

Cvan

Magenta

Yellow

Tone Balance

Color Levels: 11

Shadows OMidtones

Preserve Luminosity

Color Balance

-9

Highlights

Red

Green

Blue

Channel Mixer.

Gradient Map..

Invert Threshold.. Posterize...

372

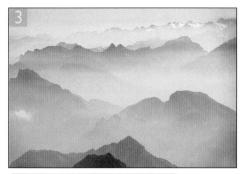

Layers	/		0
Normal	\$	Opacity: 100% 🕨	
Lock:	140	Fill: 100% 🕨	
•	03	Color Balance 2	
•	0	Co lor Balance 1	
	Backg	round 🔒	
•••••••••••••••••••••••••••••••••••••••	0.		1

Styles	Blending Options OK
Blending Options: Custom	Bked Mode: Normal \$
🖰 Drop Shado w	0p ao Ry: 100 % New Style
🖰 Inner Shadow	
🖰 Outer Glow	Advanced Blending
🗎 hner Okv	Fill Opaoity: 100 %
Beve I and Emboss	Channels: VR R O O O B Knockout: None
Contour	
🖂 Texture	Blend Interior Effects as Group Blend Clipped Layers as Group
🔁 Sath	Transparency Shapes Laver
Color Overlay	Layer Mask Hides Effects
C Oradient Overlay	Vector Mask Hides Effects
Pattern Overlay	Blend I': Gray
(Stroke	This Layer: 98 / 214 255
	Underlying Layer: 0 255

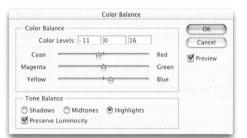

3 Add a second adjustment layer. Choose Color Balance again. Now click on the Midtone and Highlight buttons to set the highlight color tones.

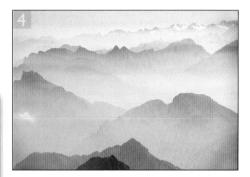

4 Go to the Layers palette submenu and select Blending Options. Hold down the Option/Alt key and drag one half of the shadow triangle slider as shown here to separate the sliders. The wide spacing of the slider halves produces the gentle tonal transition shown here.

Solarization

Some people dismiss the Photoshop Solarize filter as being too basic and of limited use and I'm inclined to agree. It is much better to generate your own custom solarizations using a Curves image adjustment. The original photographic technique is associated with the artist Man Ray and is achieved by briefly fogging the print paper towards the end of its development. Working in the darkroom, you can get nice effects by selectively solarizing the print image: place the partially developed print under a white light source, dodging the print during second exposure. Needless to say, this is a very hit and miss business. The digital method provides more control, because you can precisely select the level of solarization and the areas of the image to be affected.

I Start with an image in Grayscale mode. Go to the Layers palette and add a new Curves adjustment layer (you will want to apply the solarization using this layer and later remove parts of it to reveal the unaffected background layer).

2 Select the arbitrary map tool (circled in red) and draw an inverted V. The easiest way to do this is to draw by Shift-clicking which will create straight lines, or use the point curve tool to draw a series of wavy curves.

3 Add a mask to the adjustment layer: activate the layer and start defining the areas of this layer you wish to erase using the lasso tool. Apply a heavy feathering to the selection: Select > Feather and enter a high value. I used 80 pixels, but you could apply a greater or lesser amount, depending on the file size.

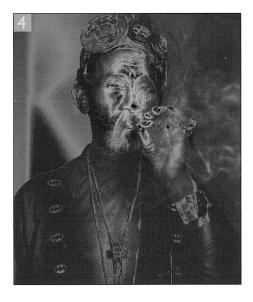

4 Check the success of your feathered selection by switching to Quick mask mode. Don't worry about the mask being absolutely perfect, you can refine the mask in the next stage.

5 Switch back to Selection mode and fill the adjustment layer mask with black. In Layer Mask mode, the default foreground/background colors are black and white: choose Edit > Fill > Foreground Color. Deselect the selection, choose a large brush set to a low opacity and paint in or paint out the unsolarized Background layer.

6 Finally, I merged the layers, converted the image to RGB color mode and colored the picture using the previously described split tone technique.

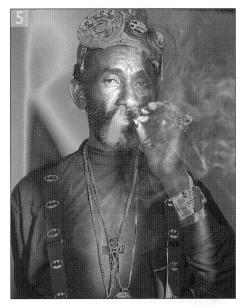

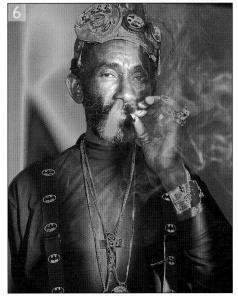

Black and white from color

The distinction between shooting black and white or color is lost on many of the clients I have worked with. How you light and color compose a shot is determined by whether it is intended for color or monochrome. Ideally you would want to shoot with one or the other emulsion type and using the most suitable medium for the capture. Where the medium is a black and white negative, I recommend nothing less than a high quality professional high-bit scan for the job.

A black and white image can be obtained from a CMYK or RGB color original and converted to Grayscale mode easily enough. If, on the other hand, you want to convert from a color file, you do have the latitude in Photoshop of being able to make creative decisions at the prepress stage that will simulate the effect of filtering the lens at the time of shooting on black and white film. A straightforward conversion from RGB to Grayscale mode translates all the color data evenly to monochrome. This is what a panchromatic black and white film does or should be doing rather,

2 Click on the New adjustment layer button in the Layers palette and select Channel Mixer. Check the Monochrome box and adjust the sliders to alter the balance of the color channels used to render the new monochrome version of the original. For the very best results, try to get the percentages in each slider box to add up to 100%. This is not a hard and fast rule – variations other that 100% will just be lighter or darker. Use whichever looks best.

I This is a typical example of how to use the Channel Mixer in Monochrome mode. When photographers shoot with black and white film, the emulsion is more or less evenly sensitive to all colors of the visual spectrum. If you add a strong colored filter over the camera lens at the time of shooting, that color sensitivity is altered as certain wavelengths of color are blocked out by the filter. The following steps mimic the effect of an orange/red lens filter being used to strengthen the cloud contrast in the sky.

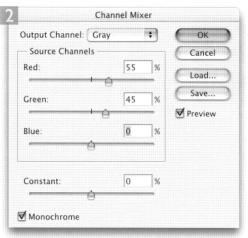

3 The standard conversion to grayscale mixes each color channel using a fixed formula – the resulting monochrome image (on the right) has an acceptable amount of tonal contrast. The Channel Mixer version on the left contains greater contrast between the clouds and the blue sky.

4 Another adjustment layer was added above the final channel mixed version. This time, a Color Balance adjustment layer to create a split tone coloring effect.

because there are slight variations in the evenness of emulsion sensitivity to the visual and non-visual color spectrum. It can be argued that these variations give films their own unique character. You are also probably familiar with the concept of attaching strong colored filters over the lens to bring out improved tonal contrast in a monochrome image. The same principles apply to converting from color to black and white in Photoshop.

 Itayers

 Normal

 Opacity:

 100%

 Iook:

 Iook:

Hue/Saturation Maste Å OK Hue: 78 Cancel Saturation 63 Load. Save. Lightness 0 Colorize 9 9 9 Preview

I I believe that Russell Brown, the Senior Creative Director of the Adobe Photoshop team, was one of the first people to demonstrate the following alternative technique for creating a color to monochrome conversion in Photoshop.

2 Open an RGB image, go to the Layers palette and add a Hue/Saturation adjustment layer. Take the saturation all the way down to zero so that the photograph is desaturated to become a monochrome version of the color original. The result is more or less what you would expect to get if you had simply converted the image to Grayscale.

3 Activate the background layer and add a second Hue/Saturation adjustment layer between the Background layer and the first Hue/Saturation adjustment layer. Set the layer blending mode to Color and check the Colorize box in the Hue/Saturation dialog. You can now adjust the Hue slider and achieve a similar result to adjusting the channel mix in the Channel Mixer as shown in the previous tutorial. You can also adjust the monochrome conversion.

Infrared film simulation

The spectral sensitivity of a photographic film emulsion will extend slightly beyond that of the human visual spectrum. This can sometimes cause problems in color photography when an object radiates light we cannot see, but the film does. This phenomenon, known as metamerism, can affect the way the colors of specific garments can appear the wrong color on the final film. There is also a special infrared sensitive film emulsion you can buy, which is acutely sensitive to infrared radiation. The black and white emulsion is quite grainy. Vegetation reflects a lot of infrared light which we human observers are not aware of. Hence, green foliage will appear very bright and almost iridescent when captured on infrared film.

I This spring woodland scene is a prime candidate with which to demonstrate the following infrared technique. As you can see, there are a lot of fresh green leaves in the picture. What follows is an extension of the color to monochrome technique using the Channel Mixer.

Layers			Ð
Normal		Gpanity: 100%	P
Lock 🖸 🌶	40	ENE 100%	¥
		Channel Mixer	1
• 4 1	Backgro	ound	۵

2 Essentially, what I am attempting to do here is to take this Channel Mixer technique to extremes. Now if we want the green channel to appear the lightest, because that's where all the green foliage information is, then we have got to somehow boost the green channel mix. The maximum setting allowed is 200% which produces a burnt-out 'screened' result. Bearing in mind the 'keep everything adding up close to 100%' rule, I reduced the other two channel percentages, to give them minus values. There was a little cyan coloring in the green, so I reduced the red channel by only 30% and the blue channel was therefore set to minus 70%.

Output Channel: Gray	HHHHHH	\$	ОК
- Source Channels			Cancel
Red:	-30	%	Load
Green:	+200	1%	Save
	1.200	0	Preview
Blue:	-70]%	
- A			
Constant:	+4	7%	
	Louisa		

3 So far so good. Now I want to add some glow to the foliage. It is important that the underlying image has remained in RGB (because it is the adjustment layer which is making the monochrome conversion). I went to the Channels palette and highlighted the green channel and applied a Gaussian blur filtration to that channel only. The result of the full blur is shown opposite. This isn't the desired result, so I followed that with an Edit > Fade Filter command, reducing the blur to a 26% opacity and Screen blend mode.

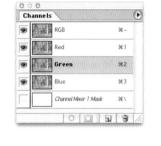

5	%	ОК

		Cancel
\$)	Preview
		•

4 This is the final result after applying the Channel Mixer adjustment and green channel blur on the Background layer. To further simulate the infrared emulsion, try adding a hefty amount of Gaussian noise filtration to either all three color channels or the green channel only.

Adding a photographic rebate

This final example combines several of the black and white techniques discussed in this chapter. If I want to mimic the effect of a photographic type rebate, like that associated with a PolaroidTM negative emulsion, I will go about this by opening a prepared scan of such a rebate, add this as an image layer and set the blend mode to Multiply. The rebate image must have clear 100% white areas. That way, only the dark areas will show through using the Multiply blending mode.

New	1868 >	
Duplicate Layer		
Delete	₽	
Layer Properties		
Layer Style	Þ	
New Cill Leven		
New Fill Layer New Adjustment Layer	•	Levels
Change Layer Content	•	Curves
Layer Content Options.		Color Balance
Type		Brightness/Contrast
Rasterize	•	
		Hue/Saturation
New Layer Based Slice		Selective Color
Add Layer Mask	Þ	Channel Mixer
Enable Layer Mask		Gradient Map
Add Master Mark		Invert
Add Vector Mask Enable Vector Mask	•	Threshold
chable vector wask		Posterize
Group with Previous	ЖG	
Ungroup	☆೫G	
Arrange	•	
Align Linked	•	
Distribute Linked	•	
Lock All Layers In Set		
Merge Layers	ЖE	
Merge Visible	☆%E	
Flatten Image	000	
Matting	Layer	
matting	Norma	Opacity: 100%
	Lock:] / 🕂 🗃 🛛 Fill: 100% 🕨
		Curves 1
and the		
No.		Sel Laure 1
	9	Layer 1
1		
Constanting of the second second	90	Levels 1
min - Vor		
	9	Channel Mixer 1
	•	Background

The Levels adjustment layer above it darkens the image, but I made a rectangular selection feathered of about 150 pixels and filled with black. Only the inside edges of the image are now affected by this adjustment.

The third layer is a specially prepared image layer made from a Polaroid[™] processed shot. This layer is set to Multiply mode which will successfully merge the border rebate to blend with the underlying background image. Lastly, a Curves adjustment layer is added. The red and blue color channel curves were adjusted to alter the color balance.

In this example we can see how the combination of an image layer and three adjustment layers produce a sepia toned print effect. The background image has remained in RGB throughout. The first adjustment layer is a Channel Mixer adjustment – this layer converts the RGB color image to monochrome, using a custom mix of the RGB channel contents.

Client: Tresemme. Model: Stevie at Nevs.

Chapter Fourteen Coloring Effects

t a recent exhibition of digital photography, a visitor was heard to remark: 'It's all cheating isn't it?' A fair comment I suppose, although one should realize that photographers and printers were manipulating their images (or cheating) in darkrooms long before computers came along. The quest for new photographic styles has always inspired image makers to seek out and develop fresh techniques like processing films in the wrong chemistry.

It's all a matter of using any means at your disposal to achieve your ends, which is why computer manipulation should be seen as just another aspect of the image making process. The following techniques begin by emulating the results achieved with chemicals, but as will be seen, there is ample room for exploration to go further and create many types of color shifted results. Use the basic formula as a springboard for new ideas and variations beyond the scope of a wet darkroom.

Photoshop is especially able to handle wild distortions thanks to extended 16-bit channel support with color adjustments This is now available for a limited range of Photoshop functions, including basic filters. Extreme or repeated color changes compound the data loss in each color channel – you may not necessarily notice this unless you later inspect the color channels individually. A Levels histogram readout will certainly show where gaps in the levels occur. Data gets lost when working at 16-bit too, but crucially when you revert or compress to 8-bit color there is more than enough data to fill in the gaps. Close analysis will show the difference between a series of color adjustments made in 16-bit and 8-bit. An 8-bit image may result in some signs of posterization at certain delicate parts of the image. You will see better preserved image detail in the 16-bit color manipulated image.

Cross-processing

There are two types of cross-processing, both of which gained popularity towards the late eighties. There was the E-6 transparency film processed in C-41 color negative chemicals technique and C-41 film processed in E-6. For the latter effect, you used Kodak VHC film, overexposed by 2 stops and overprocessed by 1 stop. The highlights became compressed in the yellow and magenta layers, so pure whites appeared pinky orange and shadow tones contained a strong cyan/blue cast. Most of the mid to highlight detail (like skin tones) got compressed or lost. It was a very popular technique with fashion and portrait photographers who were fond of bleaching out skin tones anyway. In fact, Kodak designed this emulsion specifically for wedding photographers. This was in order to cope with the high contrast subject tones of black morning suits and white bridal gowns. The sales of VHC rocketed. Kodak must have assumed the new demand was coming from their traditional wedding market base, so set about improving the VHC emulsion after which VHC did not cross-process so effectively unfortunately. From a technical standpoint, the manipulation of silver images in this unnatural way is destructive. I have had to scan in cross-processed originals and typically there are large missing chunks of data on the histogram. The digital method of manipulating images to such extremes carries its own risks too. It is all too easy to distort the color in such a way that image data slips off the end of the histogram scale and is irrevocably lost. Having said that, the digital method has the added benefit that you can be working on a copy file and so therefore the original data is never completely thrown away. Secondly, you are in precise control of which data is to be discarded, taking the hit or miss element out of the equation.

I have looked at several methods of imitating the cross-processed look in Photoshop and concluded that Curves adjustments are probably the best method with which to demonstrate these particular techniques. Figure 14.1 replicates the C-41 film processed in E-6 effect. Notice the adjustment of the highlight points in the red and blue channels – this creates the creamy white highlight and the curve shape of the lower portions of the red and blue channels produces the cross-curved color cast in the shadows.

The curves in Figure 14.2 show that the tonal range is uncompressed. A contrast increasing curve is introduced to both the red and green channels, while the blue channel has a complementary shaped contrast-reducing curve – this again creates a cross-curved color cast, as in Figure 14.1. But overall Figure 14.2 produces a more contrasty outcome, similar to the effect of processing E-6 transparency film processed in C-41 color negative chemicals.

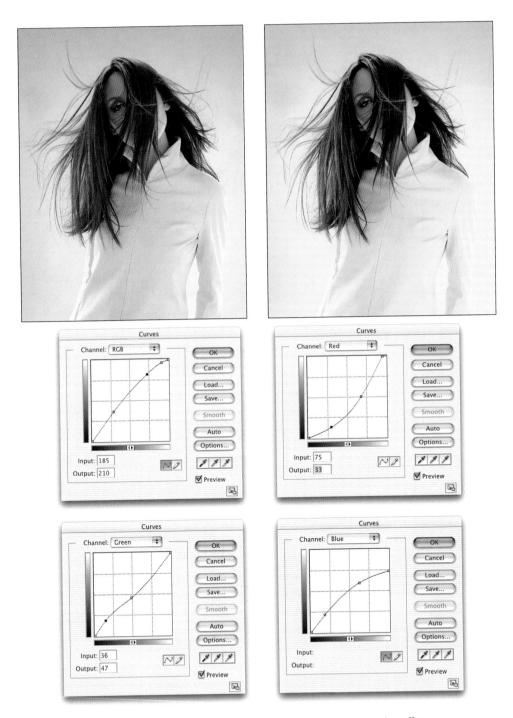

Figure 14.1 The C-41 film processed in E-6 chemicals cross-processing color effect. Client:West Row, Leeds.

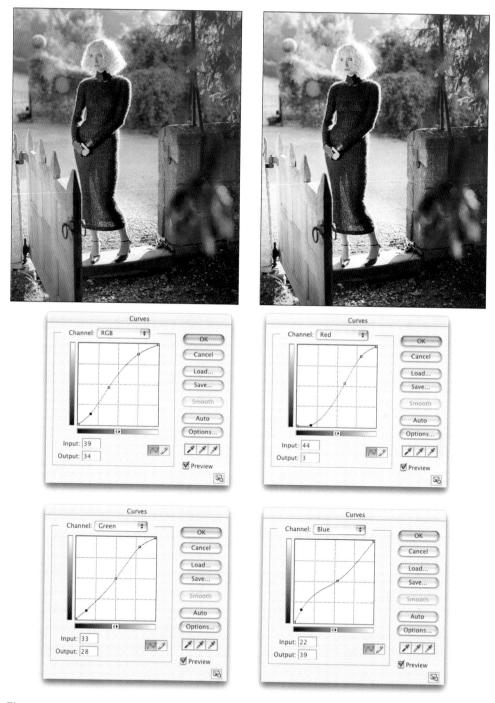

Figure 14.2 The C-41 film processed in E-6 chemicals cross-processing color effect.

Model: Ane Linge. Photograph by Thomas Fahey.

Channel Mixer adjustments

As the Photoshop program develops, so you adapt your way of working. The Channel Mixer can achieve the sort of coloring effects that once could only be done with the Apply Image command. The Channel Mixer is an interesting image adjustment tool, which alters the image by swapping color channel information, sometimes producing quite unique and subtle color adjustments which cannot necessarily be achieved with the other color adjustment tools. Controlling the Channel Mixer is no easy task. The example here shows you how to make a photograph appear to have been taken at sunset and make the scene appear to have richer, golden colors.

I This image is correctly color balanced, but it lacks the drama of a golden warm sunlit image. One answer would be to adjust the overall color balance by applying a curves correction. The Channel Mixer, however, offers a radically different approach, it allows you to mix the color channel contents and does so on-the-fly.

2 Examine the Channel Mixer settings shown below. The main color enhancement occurs in the red channel. I boosted the red channel to 125%, mixed in a little of the green channel and subtracted 34% with the blue channel. Very slight adjustments were made to the green and blue channels, but you will notice how the green and blue channel percentages remained anchored close to 100%.

Channel Mixer	Channel Mixer	Channel Mixer
Output Channel: Red P Source Channels Red: #125 % Green: +13 % Blue: -34 %	Output Channels Green Cancel Source Channels Cancel Red: #2 % Green: +102 % Blue: 0 % Cancel	Output Channel: Blue 🔹 OK Cancel Red: F6 % Load Green: -6 % Ø Preview Blue: +100 %
Constant: +2 %	Constant: 0 ×	Constant: -2 %

Color overlays

There are various ways you can colorize an image in Photoshop and my favorite method is to add a solid color fill layer from the adjustment layer menu in the Layers palette and alter the layer blending mode to either Color or Overlay mode.

The Overlay blend mode generally produces the most satisfying results. Try adding a solid color fill layer, set the blend mode to Overlay (or Color for a slightly more washed-out look) and reduce the opacity to 20–30%. The Color blending mode is grouped with Luminosity, Hue and Saturation. Each of these blending modes operates along a similar principle: an HSB component of the pixel values of the blend layer replaces those of the underlying pixels. HSB refers to Hue, Saturation and Brightness (luminosity). The following technique illustrates how you can combine a color gradient fill in an Overlay blend mode to simulate the effect of filtering the light that is used to light the subject in a photograph.

I This is a fairly simple technique to reproduce, which uses a Gradient Fill layer to simulate the effect of lighting a subject with strong colored gels. To reproduce the technique shown here, the subject has to be shot against a white background. Go to the Layers palette and click on the Adjustment layer button and choose Gradient Fill. It doesn't matter which gradient loads to start with. Close the gradient dialog and change the blend mode for the Gradient Fill layer to Overlay and maybe reduce the Opacity percentage down to 66%. Now double-click the Gradient Fill layer (I also selected the radial gradient option) and choose a suitable color gradient. In this example I chose Blue, Red, Yellow and I checked the Dither checkbox.

	Gradient Editor	product restrict retricted to creater.	
Presets			OK Cancel Load Save
me: Blue, Rec	d, Yellow		New
Gradient Type:			[
			Į
	0 💌 %		(
Smoothness: 10	0 %	% (De	(lete
Smoothness: 10	0 💌 %		lete

2 If the gradient was seen in Normal blend mode it would look like this. But because it is set to Overlay blend mode we get a nice colorized effect as shown in the next diagram.

3 When the Align with layer checkbox is left unchecked and you move the cursor over to the document window, it will change to become a move tool and enable you to position the gradient anywhere you please in the image. To change gradient settings, click on the gradient bar in the Gradient Fill dialog. You can use the Scale setting to scale the proportions of the gradient.

Color mode: The hue and saturation values of the blend layer are combined with the luminosity of the underlying layers. The effect is to colorize the layers below.

Hue mode: Only the hue values of the blend layer are combined with the underlying saturation and luminosity values. The layers beneath are colorized, but the saturation of the base image is retained.

Saturation mode: The saturation values of the blend layer replace those of the underlying layer. A pastel colored overlay layer will cause the underlying layers to become desaturated, but not alter the hue or luminosity values.

Luminosity mode: The brightness values of the blend layer replace those of the underlying, but do not effect the hue and saturation.

Retouching with overlays

Let's look at more ways these and other overlay blending modes can be applied when retouching a photograph. Suppose you have a landscape picture and are looking for a simple method to remove the clouds from the sky. Cloning with the clone stamp tool or cutting and pasting feathered selections could possibly work, but you would have to be very careful to prevent your repairs from showing. For example, how will you manage to clone in the sky around the branches and leaves?

The sky is graduated from dark blue at the top to a lighter blue on the horizon. The easiest way to approach this task is to fill the sky using a gradient set to the Darken blending mode. The foreground and background colors used in the gradient are sampled from the sky image. Darken mode checks the pixel densities in each color channel. If the pixel value is lighter than the blend color it gets replaced with the blend color. In the accompanying example, the clouds (which are lighter than the fill colors) are removed by a linear gradient fill. The trees, which are darker than the fill colors, are left almost completely unaltered. To apply a gradient fill, I clicked the fill layer button at the bottom of the Layers palette and chose Gradient. The Gradient type was Foreground to Background, and I changed the fill layer blending mode to Darken. Before I did this, I loaded the blue channel as a selection. The Blue channel contains the most contrast between the sky and the trees. When a selection is active and you add a new fill or adjustment layer, or you click on the Add layer mask button, a layer mask is automatically added which reveals the selected areas only. As with adjustment layers, fill layers can be adjusted on-the-fly while retaining the layer masking.

Mode: Normal

I The before picture contains a cloudy sky. Sample colors from the top of the sky and from the horizon to set the foreground and background colors.

Opacity: 100% 🕨 📄 Reverse 🕑 Dither 📄 Transparency

2 Load the blue channel as a selection and click on the Create new fill button at the bottom of the Layers palette to add a new gradient fill layer. The Gradient Fill dialog opens. Click OK to add a new layer using the Foreground to Background gradient at the angle shown. Then set the fill layer to Darken blending mode. The pre-loaded selection will have added a layer mask to hide the tree branch outlines.

RGB	ж~
• Red	ℋ 1
Green	¥2
9 Blue	# 3

Layers				
Darken	*	Opacity	: 100%	
Lock:	+ Q	Fil	: 100%	
•		Gra	lient	
•	Backg	round		۵

Gradient Map coloring

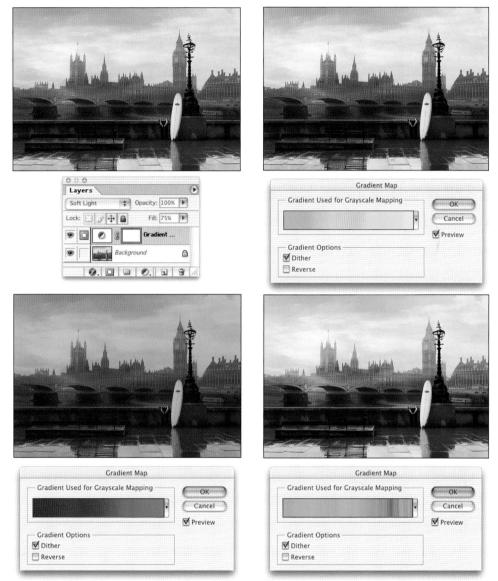

Overlay blending mode at 40%.

Figure 14.3 The above examples show how various types of gradient layers can be applied to a color image as a Gradient Map and how the original photograph can be radically colored in many different ways. The Noise gradients can look very interesting as well. In most cases, I have discovered that it pays to fine tune the smoothness and shape of the gradient using the gradient edit options and also to experiment with the layer blending modes.

Client: Crescendo Ventures. Agency: Moline Willett.

This chapter shows you some of the special things you can now do in Layers and how these features will be of use to image makers as well as designers working in graphics or web design. Layer effects enable multiple (and reversible) Photoshop layering actions. This is a wonderful tool with which to automate the application of various Photoshop effects like embossing or adding a drop shadow. Layer effects can be used in various ways: applying effects to an image element on a layer; text effects with a type layer; and creating special painting effects where an empty layer can have layer effects active and anything painted in that layer will have the effect applied as you add image data to it.

Layer effects and Styles

In Photoshop you can add various layer effects to any of the following: a type layer; an image layer; or a filled layer masked by either a vector mask or a layer mask. The individual layer effects can be accessed via the Layer menu or by clicking on the Add a layer style button at the bottom of the Layers palette. Layer effects can be applied individually or as a combination of effects and these can be saved to become a 'layer Style' and added to the Styles palette presets. Layer effects are fully editable and will follow any edits you make to the type or the contents of a layer. When you add a new effect, the Layer Style dialog will open and allow you to adjust the effect settings. After creating a new layer effects' and an itemized list of all the effects below. Double-clicking the layer/layer effect name or • symbol reopens the Layer Style dialog. Drag and drop the 'Effects' layer to copy the effects to another layer.

Styles	Drop Shado¥ Structure	ОК
Blending Options: Default	Blend Mode: Multiply	Cancel
Drop Shadow	Opacity: 75 %	
Inner Shadow		New Style
Outer Glow Inner Glow Contour	Angle: 120 ° & Use Global Light Distance: 19 px Spread: 9 px Size: 9 px Quality Contour: Anti-aliased Noise: 0 %	Preview
E Stroke	😴 Layer Knocks Out Drop Shadow	

Drop Shadow

As you can see, there are quite a range of options associated with each layer effect. The Drop Shadow uses the Multiply blending mode to make the shadow with the default color set to black. Now obviously you can change these parameters, so the effect can become something like a drop glow instead, applied using any color you want and with varying opacities. Below this is the angle setting, where you can either enter a numeric value or use the rotary control to manually set the shadow angle. The Use Global Angle comes into play when you want to link the angle set here with those used in the Inner Shadow and the Bevel and Emboss layer effects and that of any other Layer Styles layers. Deselect this option if you want to set the angles independently. You can also adjust the drop shadow angle and position by simply dragging with the cursor in the document window area. Below this are the shadow distance and blur controls.

Inner Shadow

The Inner Shadow controls are more or less identical to the Drop Shadow effect. The only difference being that this applies a shadow within the layered type or object area. The result may appear to be either that of a recessed shadow or will give a convex 3D appearance to the layer object. It all depends on the angle you choose and the size and distance of the shadow. The shadow and glow effects feature a Noise slider. At one level this will reduce the risk of banding, but the noise can also be used to add a grainy texture to your layer style.

<u>laninanin ningi</u>	Layer Style	
Styles Blending Options: L Drop Shadow Outer Glow Bevel and Embo Contour Texture Satin Color Overlay Gradient Overlay Stroke	opacity. Opacity. Angle: Distance: Choke: Size: Quality Contour: Quality Contour: Anti-	75 % ✓ Use Global Light ✓ 10 px 0 % 15 px aliased 0 0 %
	Layer Style	Layer Style
		Inner Glow

Styles	- Structure	Structure
Blending Options: Default	Blend Mode: Screen	Blend Mode: Screen
Orop Shadow	Opacity: 75 %	Opacity: 75 %
Inner Shadow	Noise: 0 %	Noise: 0 %
Outer Glow		in an an an an arrest stress of the state of
🗒 Inner Glow	● □ ● □	
Bevel and Emboss	Elements	Elements
🖳 Contour	Technique: Softer	Technique: Softer
🗇 Texture	Spread: 0 %	Source: Center Stdge
🖱 Satin	Size: 5 px	Choke:0%
Color Overlay		Size: Size: S px
🖻 Gradient Overlay	Quality	1
Pattern Overlay	Contour: 🗸 💭 Anti-aliased	Quality
Stroke	Range: 50 %	Contour: 🖉 🦳 Anti-aliased
	Jitter:	Range: 50 %

Outer Glow

Inner Glow

These both have similar controls. The Outer Glow is very much like the Drop Shadow, but is defaulted to the Screen blending mode, spreading evenly outwards from the center; you could say that the Inner Glow corresponds with the Inner Shadow effect. The glow layer effects can apply either a solid or a gradient-based glow. The Inner Glow contains options for edge and center glows. Used in conjunction with the Inner Shadow, you can achieve a very smooth 3D 'contoured' appearance with the centered Inner Glow setting. Note the Spread and Choke controls that are available with the shadow and glow effects.

Styles	Bevel and Emboss Structure	ОК
Blending Options: Default	Style: Emboss	Cancel
Inner Shadow	Technique: Smooth	New Style
m Outer Glow	Direction: O Up O Down Size: S px	V Preview
Bevel and Emboss	Soften:	
Texture		
Satin Color Overlay Gradient Overlay Pattern Overlay Stroke	Angle: 220 * 120 Jee Gloss Contour: Gloss Contour: 120 Jee 120 Jee 1	
	Highlight Mode: Screen 10 75 % Opacity: 00 75 % Shadow Mode: Multiply 00 75 %	

Bevel and Emboss

Satin

This adds a highlight and a shadow edge 180 degrees apart from each other. When you adjust the height or angle settings of the light, the two move in sync, creating an illusion of depth. There are many options here – the bevel style can be applied to create an outer bevel, an inner bevel, or pillow emboss. The embossing technique can be 'chisel hard' or 'soft'. There are some interesting Gloss Contour options in the shading section which can produce metallic-looking effects and you can also add a contour separately to the bevel edge and add an 'embossed' pattern texture to the surface.

Styles	Satin	ОК
Blending Options: Default	Blend Mode: Multiply	Cancel
Drop Shadow Inner Shadow Outer Glow Outer Glow Berel and Emboss Contour Texture Stature Statu	Opacity: Angle: Distance: Size: Contour: Anti-aliased W Invert	% New Style px px
Color Overlay Gradient Overlay Pattern Overlay Stroke		

This can add a satin type finish to the surface of the layer or type. You will want to adjust the distance and size to suit the pixel area of the layer you are applying the effect to.

Styles	Gradient Overlay Gradient	ОК
Blending Options: Default	Blend Mode: Normal	Cancel
Drop Shadow Inner Shadow Outer Glow Inner Glow Bevel and Emboss Contour	Opacity: 70 % Gradient: Reverse Style: Linear 😯 🖉 Align with Layer Angle: 105 7 Scale: 100 %	New Style
Texture Satin Color Overlay Gradient Overlay		
🗇 Pattern Overlay		

Gradient Overlay

This will add a gradient fill. Separate opacity and blend modes can be applied to create subtle combinations of coloring. Use Align with layer to center align the gradient to the middle of the layer. The scale option will enlarge or shrink the spread of the gradient. As with other effects, the settings can be adjusted by dragging in the window area.

Styles	Pattern Overlay Pattern	ОК
Blending Options: Default	Blend Mode: Normal	Cancel
Drop Shadow Inner Shadow Outer Glow Inner Clow Bevel and Emboss Contour Texture Satin Color Overlay	Opacity: Pattern: Scale: Construction Construction	New Style.
Gradient Overlay		
♥ Pattern Overlay ─ Stroke		

Pattern Overlay

Select a saved pattern from the presets. The opacity and scale sliders will modify the appearance of the overlay pattern. Use 'Link with Layer' to lock the pattern relative to the layer object.

Styles	Color Overlay	ОК
Blending Options: Default	Blend Mode: Normal	Cancel
Top Shadow Inner Shadow Outer Glow Inner Glow	Opacity: 56	New Style
Bevel and Emboss Contour Texture Satin		
Color Overlay		
⊟ Gradient Overlay ⊟ Pattern Overlay ⊟ Stroke		

Color Overlay

This Layer effect will add a color fill overlay to the layer contents. You are able to vary the opacity and change the blending mode.

Styles	Structure	ОК	
Blending Options: Default	Size:		
Drop Shadow Inner Shadow Outer Glow Inner Glow Bevel and Emboss Contour Texture Satin Color Overlay Gradient Overlay Pattern Overlay	Position: Outside 📫 Bliend Mode: Normal 🗘 Opacity: 👘 100 % Fill Type: Gradient 🐑 🕞 Reverse Style: Linear 🗘 🖉 Align with Layer Angle: 👘 90 ° Scale:	Cancel New Style	
√Stroke			

Stroke

The Stroke effect applies a stroke to the outline of the layer or text with either a color, a gradient or a pattern. The options in this dialog are similar to those in the Edit > Stroke command, except as with all layer effects, the stroke is scalable and will adapt to follow any edits or modifications made to the associated layer.

Creating Styles

Figure 15.1 When you add a new layer effect, the effect will appear in a list below the layer in the Layers palette in the same descending order that the layer effects appear in the Layer Styles dialog. Each effect has its own 'f' effect icon and the effect can be made visible or invisible by toggling the eye icon next to it in the Layers palette. Or you can hide all of the effects at once by clicking on the eye icon next to 'Effects'. When you have found an effect setting or a combination of settings which you would like to keep, you can save these as a style via the Layer Style dialog. Click on the New Style button and give the style a name and it will be appended in the Styles palette. There are several preset styles that you can load in Photoshop 7.0. The Styles palette shown opposite contains the 'Textures' Styles presets using the Large Thumbnail view setting.

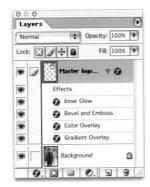

Applying layer styles to image layers

The illustrations opposite show how you can add layer effects and styles to image layers. Layer effects operate in the same way as adjustment layers do - they create a live preview of the final effect and only when you flatten down the layer are the pixels modified and does the effect become fixed. Layer effects are not scalable in the same way as the image data is. If you resize the image the Layer effect settings will not adapt, they will remain constant. If you go to the Layer menu and choose Layer Style > Scale Effects, you will have the ability to scale the effects up or down in size. The layer effect parameters in Photoshop are now large enough to suit high-resolution images. In the Layer Styles dialog you can select or deselect the global angle to be used by all the other layer effects. Although normally the effects work best when the same global angle is used throughout (the global light setting can be established in the Layer > Layer Styles menu). The Create Layers option is also in the Layer Styles menu options. This will deconstruct a layer style into its separate components. You can use this to edit individual layer elements if so desired. Layer effects and styles can be shared with other files or other layers. Select a layer that already has a style applied to it. Go to the Layer Styles submenu and choose Copy Layer Style, then select a different layer and choose Paste Layer Style from the same submenu.

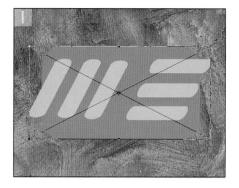

I Layer effects can be used to add glows and shadows to a type layer but Layer effects can work equally well on pixel image layers too. An EPS logo is first imported into Photoshop using the File > Place command. After resizing, hitting the Return or Enter key will rasterize the vector art as an image layer. A series of Layer effects were applied to the layer to create a new layer style.

2 In more detail, Bevel and Emboss, Inner Glow and Inner Shadow Layer styles were applied to the image layer. The global angle settings were deselected so that the Inner Glow angle was separate to the Bevel and Emboss angle. Note that the angle controls in the Bevel and Emboss dialog contain adjustments for both the lighting angle and the attitude of the light source.

3 If a layer mask is added to the layer you can then mask out portions of the layer contents. The combined layer effects in the layer style will adapt to follow the new contours and update as the layer contents change. When painting in the layer mask, the layer style adapts to follow the mask outline.

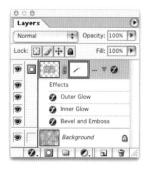

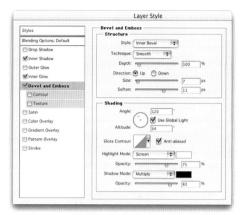

Painting effects

Take a look at the illustrations below to see how this can work. The potential is there to have three-dimensional painting brushes in Photoshop. For example, if you have an empty layer with the Drop Shadow layer effect applied to it, whenever you paint anywhere in the layer the paint strokes will automatically appear with a drop shadow attached. I quite like the effects which can be achieved using a combination of the Drop Shadow, Bevel and Emboss and Inner Glow layer effects.

Another approach you can use is to add an image texture layer, apply a layer style and then add a layer mask to hide the layer contents. As you paint on the layer mask with white, you will be revealing the layer contents and applying a layer style at the same time. The example below shows how you can create an effect which is like painting with a viscous fluid, creating a contoured edge as you paint.

I I used this weathered stone texture for this demonstration, which is really the same as the previous example but in reverse. First add an image layer containing a texture and Option/Alt-click the Add layer mask button to add a layer mask that hides all the layer contents.

2 If you paint on the layer mask with white, you will now reveal the hidden layer contents. If a Style is applied to this layer, the brush strokes will take on the characteristics of the layer style. This doodle example shows just some of the interesting possibilities. Note the Fill opacity control in the Layers palette. This performs the same function as the Advanced blending control of the same name in the Layer Options dialog (see page 334). Reducing the Fill opacity will reduce the opacity of the pixels only, without reducing the opacity of the layer style effect.

Layer effect contours

The layer effect contours in Photoshop will affect the shape of the shadows and glows for the Drop Shadow, Inner Shadow, Outer Glow and Inner Glow layer effects. The examples on this and the next page show the results of applying different contours and how this will affect the outcomes of these various layer effects. The Bevel and Emboss and the Satin layer effects are handled slightly differently. In these cases, the contour will affect the surface texture appearance of the layer effect. The Bevel and Emboss dialog refers to this type of contour being a 'Gloss Contour' and you can generate some interesting metallic textures by selecting different contour shapes. The Bevel and Emboss edge itself can be modified with a separate contour (see Bevel and Emboss dialog at the beginning of this chapter).

Figure 15.2 A Layer style was applied to a filled shape layer. The silky texture can be attributed to the use of an inverted cone contour being combined with the Satin layer effect.

I The linear contour is the default. In all these examples a Drop Shadow effect was added to the Star shape. Bevel and Emboss and Outer Glow effects were applied to the Pi shape layer. **2** The Gaussian curve contour accentuates the contrast of the layer effect edges by making the shadows and glows fall off more steeply.

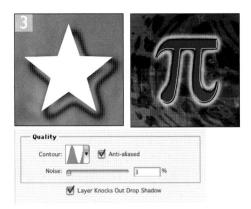

3 When applied with a slight displacement, the single ring contour can produce a subtle bevel type shadow. The Outer Glow was made with Range set to 100%.

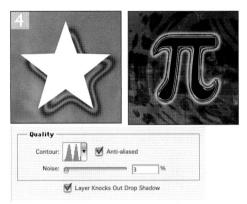

4&5 The double and triple ring shapes produce a more graphic type of layer effect. As can be seen here, the shadows look like contoured neon lights and the Bevel and Emboss resembles a chrome type of effect. The Outer Glow Range in both cases was set to 70%.

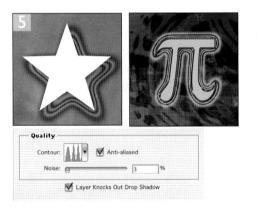

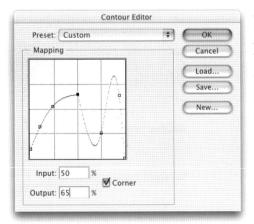

6 Click on the contour shape icon to open the Contour Editor dialog (shown opposite). Use this to load, edit and save a custom contour shape. You can create your own customized contour and save as a new contour to add to your current set. You can preview the effect the new custom contour has on the current Layer Effect. Check the Corner box to make a point an angled corner.

Transforms and alignment

Any transform you carry out can be repeated using the Edit > Transform > Again command (Command/Ctrl+Shift-T). The transform coordinate change is memorized in Photoshop, so even if other image edits are carried out in between, the Transform > Again command will remember the last used transform. When more than one layer is present, the layer order can be changed via the Layer > Arrange menu, to bring a layer forward or back in the layer stack. The full Layer menu and Layers palette shortcuts are listed back in Chapter Twelve. In addition, two or more linked layers can now be aligned in various ways via the Layer > Align Linked menu. The latter is a desirable feature for design-based work when you want to precisely align image or text layer objects in a design, although as can be seen the combination of repeat transforms and align layers provides interesting possibilities for making image patterns.

The alignment commands allow you to both distribute and align linked layers according to a number of different rules in the submenu list. To use this feature, first make sure the layers are all linked. The distribute command evenly distributes the linked layers based on either the top, vertical central, bottom, left, horizontal central or right axis. So if you have several linked layer elements and you want them to be evenly spread apart horizontally and you want the distance between the midpoints of each layer element to be equidistant, then choose Layer > Distribute Linked > Horizontal Center. If you next want the layer elements to align, then go to the Layer > Align Linked menu. How the align command centers or aligns the layers will be based on whichever of the linked layers is selected. The other layer elements will always reposition themselves around the active layer.

1&2 To demonstrate the repeat transform feature, I took this still life picture and made a mask defining the outline of the cheeses. I loaded this mask as a selection and made a copy layer of the cheeses: Layer > New > Layer Via Copy (or you could use the shortcut Command/Ctrl-J). The first single transform combined a slight reduction in size, a diagonal shift movement and an anti-clockwise rotation.

3 To repeat this transformation, I made use of the repeat transform feature, I kept duplicating the last transformed layer by dragging the last transformed layer down to the New Layer button in the Layers palette and chose Edit > Transform > Again, or the shortcut Command/ Ctrl+Shift-T.I ended up with six repeating transformed layers as shown in picture 3.To make the layers nestle one behind the other, I reversed the layer order above the background layer.

4 To complete the arrangement of the neatly stacked images falling behind each other, I activated one of the linked layers and chose New Set From Linked in the Layers palette and applied a layer mask that was based on the original mask selection to this layer set.

Photograph: Laurie Evans.

Shadow effect

This example shows how to create a lighting effect shadow. You need to prepare a precise outline selection first. Once that is made, the rest is fairly simple to accomplish. The amount of blurring applied to the first copy mask determines the extent of the glow. Try making a few attempts with different settings to judge which is the right one to use. The opposite effect of adding an outer glow (which was demonstrated in some of the previous editions of this book) is also fairly easy to achieve, but always remember that the original mask used for the technique must be very precise.

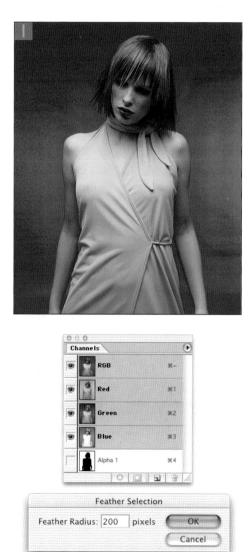

I This photograph was taken against a red background, which was some distance behind the model. Colored gels were used to provide the blue lighting, although some further Hue/Saturation adjustments were made to tweak the final colors.

2 A mask was prepared based on information existing in one or more of the color channels (see Chapter Eleven on montage techniques).The modified color channel alpha mask is shown here. I then loaded this alpha channel as a selection and applied a Select > Feather of 200 pixels.

Client: Alta Moda. Model: Melody at Storm.

4 The new alpha channel might have benefited from my adding some Gaussian noise to remove any banding which might have been introduced at the feathering stage. I loaded the duplicate channel as a selection (drag the channel down to the Make Selection button) and then clicked on the Add a new layer mask button at the bottom of the Layers palette and selected Levels. This operation added a new adjustment layer and masked it at the same time. In the Levels dialog, I adjusted the settings to darken the background areas and achieved the result shown opposite.

3 I then saved the feathered selection as a new alpha channel. I followed this by adding the original alpha channel to the duplicate. There are several ways of doing this: you could, for example, try going Image > Apply Image, select channel-4 as the source and set the blending mode to Multiply at 100%.

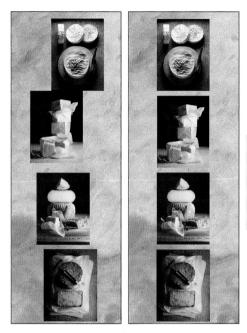

Photograph: Laurie Evans.

Rackground

0. . .

A

Figure 15.3 These linked, layered images were

Spot color channels

Photoshop is able to simulate the effect of how a spot color will reproduce in print and how a special color overlay will interplay with the underlying image. Spot colors include a wide range of industry standard colors. You use the manufacturer's printed book color guides as a reference for how a color will print and not judge this from the screen. The colors available can include those found in the CMYK gamut, but also a whole lot more that are not, including metallic 'specials'. Spot colors are used where it is important that the printed color conforms to a known standard and for the printing of small point size type and graphics in color. A four-color process mix can be used when printing larger non-serif point sizes, but not for fine type and lines as the slightest misregistration will make the edges appear fuzzy. Spot colors can be added to images as part of the graphic design or as a means of accomplishing a color not available in the CMYK gamut.

A colleague of mine once won the dubious honor of 'most out-of-gamut color of the month' award from his repro company, after presenting them with a vivid green backdrop in his RGB transparency. The image was being printed as an advert to promote his work, so they made a masked color plate, adding a spot color to the background, simulating the green in the original. Here then is an example of a spot color channel and type tool in action.

	110										1.	And in case of the	COLUMN TWO IS NOT	
	T 108	1787	Helvetica	Recting 1 and 1	Sec. 1	T	1000 Q	6.8.	Line in			11	1275	
111	Tel: 1	4.4	Helvetica	Medium	1000	ras 24 pt	- a;	Crisp	1111111	CONTRACTOR OF CO	19 D D		182	
- 11.2	 A COLUMN 				1.2	2. A.			10000	and the second s	S	0	- Coul	
113		as an excession of			101100000000				11111111111		A DOLLARS AND A	a line of the second		

I Choose New Spot Channel... from the Channels palette fly-out menu. You will see the dialog shown opposite. When you click on the Color box, this calls up the custom color dialog and you can choose from any of the installed custom colors including the Pantone[™] color selected here. Choose a solidity percentage that matches the solidity of the custom color specified. When you change the solidity of the custom color, the effect is simulated in the image preview, matching the ink characteristics. Most custom colors are opaque (100%), whilst varnish colors are translucent (0%). To produce a faint tint, lower the opacity in the spot channel. The block shown here was created by filling a marquee selection with a light gray.

2 If the spot color channel remains active and the type tool is selected, any type entered will go directly into the spot color channel.As I input the text 'Oyster Bar', it first appears cut out against the Quick mask color and after I clicked Enter, the type is rasterized as a floating selection, which can be repositioned using the move tool. Once deselected, the type is now fixed in the spot color channel.

More type is added, this time using a type layer with white text. Select the composite channel (the spot color channel is therefore now deselected) and choose a white foreground color from the color picker dialog. A new font can be chosen, or combination of fonts applied in the body of text. And as type is entered, a live preview appears in the image. A type layer is using vectors to describe the shape of the type, which will not become fixed as rasterized pixels. A file saved using the PSD or PDF formats, for example, will preserve all the vector information through to the final print stage.

Photograph: Laurie Evans.

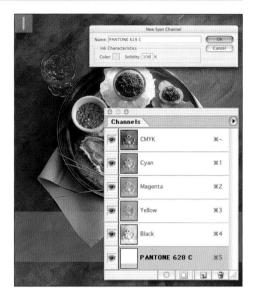

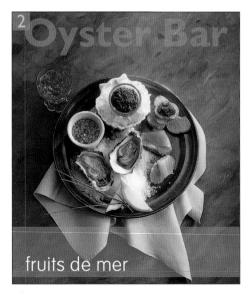

Adding type

Photoshop type is fully editable and is added to a document using vector type layers. A type layer can be rasterized or converted to a work path or shape layer. You can still place type as a selection and import EPS artwork as before (see page 399). Or you can copy and paste path outlines of logos and save these as custom shapes (see Figure 15.5). OpenType fonts and their associated features are supported by Photoshop. The text paragraph formatting, justification and hyphenation options available in the Paragraph palette work similar to the text engine found in Adobe InDesignTM. Paragraph text is created by clicking and dragging to create a paragraph box. Single line text is entered by clicking directly in the document window and can be edited at a per-character level, i.e. you can change individual character colors and font size etc. The fractional widths option in the Character palette options is normally left on - this will automatically calculate how to render the anti-aliased text using fractional widths of pixels. However, when setting small point sized type in Photoshop to be displayed on the screen, it is better to turn this option off. Photoshop will then round up the gap between individual characters to the nearest pixel distance. Small text rendered this way will be easier to read. The anti-aliasing settings provide four levels: Sharp Crisp, Strong and Smooth. With no anti-aliasing (None), font edges are likely to appear jagged. The Strong setting is suited to most graphics work. The Crisp setting is the least smooth and will probably prove useful when creating small point sized bitmapped text in Photoshop that is designed to appear on a web page. Photoshop 7.0 notably features multilingual spell checking, which can be accessed from both the Edit menu and the Character palette. The Tool presets palette is extremely useful if you wish to save your custom type and type attribute settings as a custom preset.

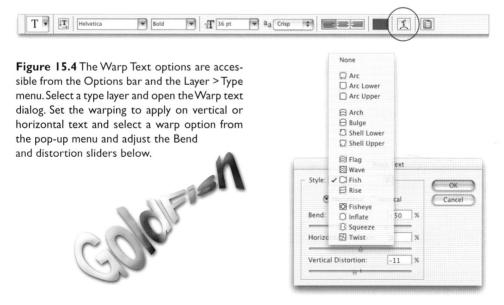

Figure 15.5 A magazine cover like this could now be designed entirely within Photoshop. The masthead was a path I copied from Illustrator and pasted into Photoshop. I then chose Edit > Define Custom Shape, to add it to the Shape presets. When saved as a Shape, I can select it at any time and add as a new shape layer and apply a Style from the Styles palette. I added a Pattern fill layer above the background, using a custom pattern, which was scaled up slightly. I then applied a couple of layer effects to the main image, to make it appear as if recessed in a card frame. I added the text on separate layers, and was able to set different point sizes and change the color of the type on a single line of text.

Vector output

The vector layer information contained in the Figure 15.5 page design can be read by a PostScript device and output the same way as vectors and type in a page layout program are normally handled. If you save a Photoshop document as a PDF, you can use the pixel compression options to reduce the file size, while the vector layer content will be preserved and will print perfectly at any resolution.

ne of the key factors attributed to Photoshop's success has been the program's support for plug-in filters. A huge industry of third-party companies has grown in response to the needs of users wanting extra features within Photoshop. John Knoll, who together with his brother Thomas Knoll originally wrote the Photoshop program, was responsible for creating many of the plug-ins that shipped with the earlier versions of Photoshop (plug-ins that still survive today). The open door development policy has enabled many independent software companies to add creative tools and functionality to the Photoshop program. In turn this ongoing development has boosted the status of Photoshop as a professional image manipulation program. Even high-end retouching systems cannot match this versatility and will rely on accessing Photoshop for its plug-in rich features.

Most filters have a dialog box interface with variable settings. The dialog previews in Photoshop 7.0 are now twice their former size, which makes it much easier to see the outcome of a filter. If you are feeling really brave and wish to experiment with the Custom Filter, you can design plug-in filter effects of your own. Some of the more sophisticated plug-ins are like applications operating within Photoshop. These have a modal dialog interface, which means that whenever the filter dialog is open, Photoshop is pushed into the background. This can usefully free up keyboard shortcuts and, as in the case of the KPT filters, have a completely different interface. With so many effects filters to choose from in Photoshop, there is plenty enough to experiment with. The danger is that you can all too easily get lost endlessly searching through all the different filter settings. There is not enough room for me to describe every filter present, but in this chapter, we shall look at a few of the ways filters can enhance an image, highlighting the more useful creative filters plus a few personal favorites.

Blur filters

The Radial blur does a very good job of creating blurred spinning motion effects. This is anything but a gimmicky filter – it has many uses, like adding movement to car wheels shot stationary in the studio. Similarly when switched to the Zoom blur setting, it does a neat impression of a zooming camera lens. The Filter dialog box offers a choice of render quality settings. This may appear quite a sluggish plug-in, but is after all carrying out a major distortion of the image. So either be very patient or opt for a lesser quality setting. The Motion blur filter is a lot faster to use and again it creates really effective sensations of blurred movement. Both the blurring angle and length of blur (defined in pixels) can be adjusted. The blurring spreads evenly in both directions along the axis of the angle set, but that need not be a problem – there is a tutorial on the Adobe CD-ROM that demonstrates how to create what are described as 'front flash' and 'rear flash' camera sync motion effects. Basically, if the blur is applied to a duplicate of a layer element and then positioned on the layer beneath, the blur can be shifted with the move tool either side as desired.

Fade command

Filter effects can be further refined by fading them after you have applied a filter. The Fade command is referred to at various places in the book (you can also fade image adjustments and brush strokes etc.). Choose Edit > Fade Filter and experiment with different blending modes. The Fade command is almost like an adjustment layer feature, but without the versatility and ability to undo later. It makes use of the fact that the previous undo version of the image is stored in the undo buffer and allows you to calculate many different blends but without the time-consuming expense of having to duplicate the layer first. Having said all that, history offers an alternative approach whereby you can do just that. If you filter an image, or make several filtrations, you can return to the original state and then paint in the future (filtered) state using the history brush or make a fill using the filtered history state (providing non-linear history has been enabled).

Smart blur

This filter blurs the image while at the same time identifying the sharp edges and preserving them. When the settings are pushed to the extremes, the effect becomes very graphic and can look rather ugly. In some ways its function mimics the Median Noise filter and is another useful tool for cleaning up noisy color channels or artificially softening skin tones to create an airbrushed look.

Noise filters

Other than the Add Noise filter, the other three filters, Despeckle, Dust & Scratches and Median, are in fact all types of noise reduction filters. The Despeckle filter is intended to remove scanning noise and artifacts which are present with all scanners to a greater or lesser degree – I have occasionally come across bad examples where the fault is more due to a poorly skilled operator. The Median filter averages out the color values of adjacent pixels, smoothing the differences between them. The minimum radius setting of 1 pixel will have quite a noticeable effect. Despeckle is like a 'gentler than 1 pixel radius' Median filter and it might get rid of the worst of the noise. I would recommend inspecting the individual color channels and applying this filter to just those channels that are badly damaged. The Dust & Scratches filter is a sort of Median filter combined with a Threshold control. The higher the radius, the more spread or smoother the effect and the higher threshold levels setting, the less effective the filter is. Dust & Scratches is not, repeat not, a filter you want to apply globally to the whole image as part of the scan preparation. Where there is an area of flat tone in a picture with lots of marks on it, make a selection of that area and apply the filter to the selection only. It is a handy alternative to spending several minutes cloning with the rubber stamp tool. Check out the tutorial in Chapter Ten where the Dust & Scratches filter is combined with the use of the history brush.

Filters for alpha channel effects

The 'Other' Filter submenu contains a collection of filters, some of which are very handy for editing alpha mask channels. I use the Maximum and Minimum filters to either choke or expand an alpha channel mask (see the example on page 414), and the High Pass filter is useful as a tool for detecting and emphasizing image areas of high contrast in preparation for converting a duplicated color channel to a mask. The Offset filter offsets the active layer or channel. You would probably want to use this filter as part of a series of steps to build a wraparound texture.

Filters can be used in Photoshop to apply a sequence of effects that can radically change the appearance of an image. On page 415, there is a step-by-step technique that demonstrates how to take a flame effect image created in KPT 5 and adapt it to produce a soft, blurred image that could potentially be included as a backdrop in a photograph. One of the masking tutorials shown in Chapter Eleven on page 319 has a swirly backdrop that was produced this way. You will notice that most of the effects filters work in RGB mode only. This is because they can have such a dramatic effect on the pixel values, and they would easily send colors way out of the CMYK gamut. So to unleash the full creative power of Photoshop plug-ins, this is a good argument for having to work in RGB mode and convert to CMYK later.

I Here in the final stages of adding a color overlay to an image on a white background, I have the color fill on a layer above the background, using a layer mask based on an alpha channel mask prepared earlier. As masks go, it's not bad but as you can see there is still a slight halo around the object where the white background shows through.

2 To get round this, I activated/highlighted the Layer Mask icon and applied the Other > Maximum filter, at a setting of I pixel. Notice the filter effectively makes the layer mask shrink very slightly and now the halo has almost completely disappeared in one easy step. You can refine the layer mask with a brush to fill in or remove any sections that are still showing. If you refer to the Spirit of St Louis tutorial in Chapter Eleven, you will find an example of how to apply further manipulating steps to refine a choked mask.

2 Another interesting KPT 5 plug-in is the Blurrrr series. Here, I applied a Spiral Weave Blurrrr to the previous FraxFlame image. The spiral weave patterns are particularly beautiful when applied to almost any original. In this example the filter is beginning to break up the recognizable pattern of the FraxFlame.

4 The final version is very soft compared to the original. I applied a Hue/Saturation adjustment to take the saturation down a little and added some noise to break up any residual banding. Steps similar to these were used to prepare the swirling backdrop which featured in the montage tutorial in Chapter Eleven.

I KPT 5 is distributed by ProCreate and complements the previous versions of Kai's PowerTools. One of my favorite KPT 5 plug-in effects is the FraxFlame.This is similar to the old Texture Explorer. You can select genetic variations of the central image and set various other parameters, affecting the outcome shapes.

3 Back in the Photoshop set of filters, I then added some Motion blur, which broke up the KPT 5 pattern even more. I chose to apply a horizontal blur with a large pixel distance.

2 I began by applying the Sketch > Graphic Pen filter. The Sketch range of filters (which with the exception of Water Paper) will always produce a monochrome image based on the current foreground color. These filters often work well if you follow the filtration with an Edit > Fade Filter command, in this case reducing the opacity to 30% with the blending mode remaining in Normal mode. I This was a shot I took a few years ago to illustrate the theme of what it would be like as a fish starved of oxygen in river water polluted by acid rain. The black and white print was chemically toned and scanned in as an RGB image (note that these creative filter effects will not work in CMYK or Indexed Color modes).

3 Next apply the Artistic > Cutout filter.

4 Afterwards, I faded the filter again. The opacity was reduced to 35% and the blending mode set to Difference. The image is darker and the highlights are lost, but this actually suits the mood of the image quite well. It is not always necessary that the levels should be expanded to fit the full tonal print range.

Opacity	<i>r</i> :	35	%	ОК	
	<u>0</u>			Cance	
Mode:	Differe	nce	\$	Previev	

Distortions and displacements

I I borrowed this sparkling sea shot as it was likely to show the displacement effect quite clearly. To displace an image, one needs to have a separate 'map' source image which can be any type of image (except Index color).

 ${\bf 2}$ I created the basis for the displacement map as a new channel in the destination water image – it would be used later to enhance the effect. I placed an Illustrator file (File > Place...) and duplicated the channel.

4 Back at the original image, I selected Filter > Distort > Displace. The options were set to Stretch to fit and Repeat edge pixels. After clicking OK, a dialog box asks you to find and select the map to be used. The lightest parts of the map produce no pixel movement, whilst the darker areas shift according to the parameters set.

5 Some extra finishing work was done to add emphasis to the displacement. The border was cut away and a couple of layers added based on the original logo placed and stored in the new channel. The blending modes were set to Screen at low opacity and Hard Light at 49% above. **3** Gaussian blur was applied to the copy channel, which was inverted, then copied and saved as a new separate 'map' image (Select > All; Edit > Copy; File > New; Edit > Paste; Layer > Flatten Image).

This last demonstration shows how to import a vector graphic from Illustrator and make a displacement map with which to apply the Displace filter. The displacement filter is capable of producing strong image distortions like the classic parabola shape described in the Adobe manual. Intuitive it is not. The effect works well with text effects and where the displacement map has been softened beforehand. Displacement maps are useful for generating texture patterns. You will find a large number of displacement maps contained on the Adobe Photoshop CD and these can be loaded to generate all types of surface texture patterns.

Liquify

While the outcome of the Displacement filter is determined by a prepared alpha mask, Liquify is in effect an interactive version of the Displacement filter. Liquify enables you to magnify, melt, smear and generally make all manner of distortions to an image and preview the outcome of the distortion in the preview window as you apply the various distorting tools. The distortion is then post-rendered at full resolution. Liquify has been improved in Photoshop 7.0 so that you can now save and load the liquify mesh. It is possible to zoom in on the image within the modal Liquify dialog. There is a new Turbulence liquify distort tool and you can also preview the liquify effect against selected views of the undistorted image.

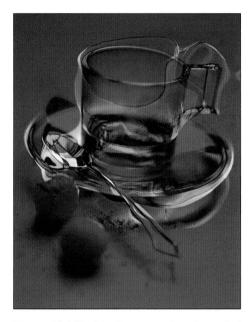

Figure 16.1 The Liquify command can be applied in various ways. In the above example 1 experimented with a Liquify distortion followed by an Edit > Fade command set to Difference blending mode.

Photograph: Laurie Evans.

Figure 16.2 Use the freeze tool to protect image areas from being distorted, or preserve the already distorted areas from any further distortions.

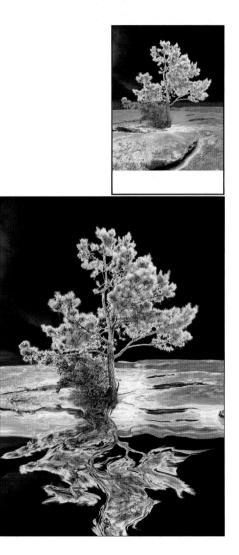

The Liquify tools explained

The Warp tool (W) provides a basic warp distortion with which you can stretch the pixels in any direction you wish. The new 🔙 Turbulence tool (A) produces random turbulent distortions. The Twirl Clockwise tool (R), as the name suggests, will twist the pixels in a clockwise direction, while the STwirl Counter Clockwise tool (L) twists the pixels in the opposite direction. A larger brush works best with these tools. The R Pucker tool (P) shrinks pixels and produces an effect which is similar to the 'Pinch' filter. Warp and Reflection distortions can sometimes benefit from 'taming'. The pucker tool is therefore ideal for correcting overdistorted areas. The log Bloat tool (B) magnifies pixels and is similar to the 'Bloat' filter. The 🗺 Shift Pixels tool (S) shifts the pixels at 90 degrees to the left of the direction in which you are dragging. When you Option/Alt-drag, the tool will shift pixels 90 degrees to the right. When you understand how the shift tool works, you can introduce some nice rippled distortions. The Reflection tool (M) is perhaps the most unwieldy of all, copying pixels from 90 degrees to the direction you are dragging and therefore acting as an inverting lens (which if you are not careful will easily rip an image apart). Fortunately, the 🜌 Reconstruct tool (E) will enable you to restore the undistorted image. If you want, you can protect areas of the image using the w Freeze tool (F). Frozen portions of the image are indicated by a Quick mask type overlay. These areas will be protected from any further liquify distortion tool actions. The Freeze mask can be selectively or wholly erased using the 🜠 Thaw tool (T). Use the 🔍 Zoom tool (Z) to magnify or zoom out and the image Hand tool (H) to scroll the preview image.

Warp tool

Pucker tool

Twirl Clockwise tool

Bloat tool

Twirl Counter Clockwise tool

Shift Pixels tool

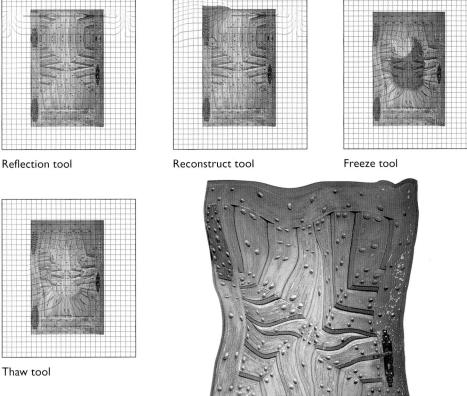

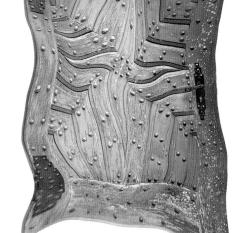

Figure 16.3 Set the brush size and pressure settings in the Tool Options section. At the bottom in View options you can display the underlying mesh grid (shown in the above illustrations). When freezing an area, you can load an alpha channel as a mask with which to protect the exact areas of the picture you don't want to distort. The reconstruction options provide different modes for reversing any distortions made. The Rigid mode provides one-click reconstruction. Stiff, Smooth and Loose provide varying speeds of continual reconstruction - the image mesh continues to unravel as you mouse down. Click on the Reconstruction button to observe the distortions undoing progressively. Use Escape or Command/Ctrl-period to halt the reconstruction at an intermediate stage. Avoid applying a second click, as this will exit the modal dialog and you will lose all your work!

The underlying mesh can be made visible in the Liquify Tool Options. The grid will give you an indication of how the warp is being applied or reconstructed and readily help you pinpoint the areas where a distortion has been applied. Liquify is a perfect tool for many types of subtle retouching such as the occasions when you might wish to gently alter the shape of someone's facial features. The View options allow you to preview the distorted version with a variable overlay of the undistorted image – this can be an overlay of all merged layers or a specific target layer.

Having the ability to zoom in on the image area within the Liquify dialog is very useful. However, the Liquify command is a very processor intensive plug-in. If you are working on a large image then it may take a long time to carry out a liquify distortion. This is where the save and load mesh options can help. If you carry out your liquify distortions on a scaled-down version of the master image, you can save the mesh as a separate file. Open up the master file later, load the mesh you saved and apply.

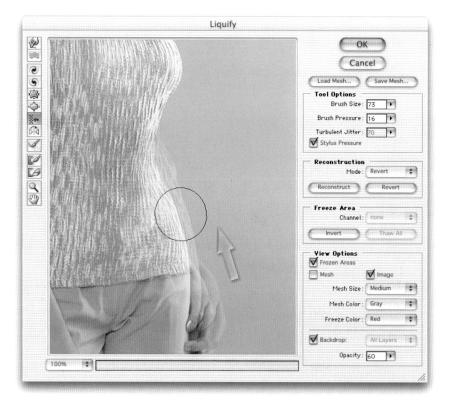

Figure 16.4 The shift pixels tool can be used to slim down waists. The pixels will be shifted to the left of the direction you drag with the tool. In this example the pixels were shifted inwards to the left as I dragged in an upward direction. If I drag downwards they would be shifted to the right. Because the Backdrop option is selected in the Preview options, you can see an overlaying preview of the undistorted version. If you have more than one layer selected, you can select a specific layer to preview your distortion against.

I In the earlier editions of this book, I used to feature a technique showing how to imitate a Polaroid film emulsion transfer. It is now easier to accomplish with the Liquify filter. The image shown here has a background layer, a tree stump image layer (with an associated adjustment layer), and above this, an independent Polaroid emulsion border layer set to Multiply blend mode.

2 I activated the tree stump image layer and chose Liquify from the Filter menu. I mainly used the Turbulence tool plus the clockwise and counterclockwise twirl tools to create the distortions that you see here. I then clicked on the Save Mesh button to save this distortion so that it could be reused.

3 I then selected Layer 2 (which was the border image in Multiply mode) and opened Liquify again. This time I clicked on the Load Mesh button and loaded the recently saved mesh, applying an identical distortion, to produce the result shown here.

Lighting and rendering

Rendering processes are normally associated with 3D design programs, yet Photoshop has hidden powers itself when it comes to rendering 3D shapes and textures. One of the most interesting of which is Lighting Effects, but let's look at some of the other rendering filters first.

Clouds and Difference Clouds

This filter generates a cloud pattern which fills the whole image or selected area based on the foreground and background colors. The cloud pattern alters each time the filter is applied, so repeated filtering (Command/Ctrl-F), for example, will produce a fresh cloudscape every time. If you hold down the Option/Alt key whilst applying the Cloud filter, the effect is magnified. The Difference Cloud filter has a cumulative effect on the image. Applying it once creates a cloud pattern based on the inverse color values. Repeating the filter produces clouds based on the original colors and so on... although after each filtration the clouds become more pronounced and contrasty.

Figure 16.5 Examples of the Render > Clouds filter (left) and the Render > Difference Clouds (right).

Lens Flare

This is another one of the render filters and a little overused perhaps, but nevertheless quite realistic when it comes to adding the effect of light shining into the lens along with the ghosting type of patterns normally associated with camera lens flare. For the purposes of illustration or adding realism to computer rendered landscapes, it is ideal. Instead of applying the lens flare directly to the background layer, I added a new layer filled with neutral gray set to Overlay mode and applied the Lens Flare filter to this layer only. This allows the option of repositioning the flare after filtering. Another approach is to apply the filter to a black fill layer in Screen blending mode.

I Option/Alt-click on the New Layer button in the Layers palette, select the Overlay blend mode and then check the Fill with Overlay Neutral color checkbox.

2 Now apply the Lens Flare filter. The position of the lens flare center point can be adjusted in the dialog preview. If you option/Alt-click in the preview box, this will call up the Precise Flare Center dialog, where you can set precise mouse coordinates for where to center the lens flare effect.

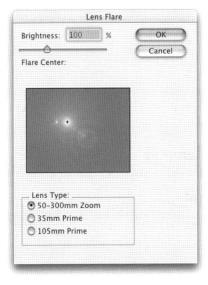

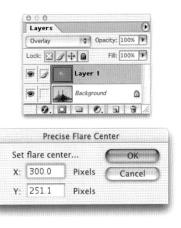

Lighting Effects

I To prepare the image, I made this grayscale bump map of a computer mouse in a mask channel (Alpha I). The dark tones represent the lower relief levels and lighter tones the peaks (although this arrangement can be reversed if you wish). To work at its best, the bump map must have really smooth tonal gradations to represent the curved surfaces. I saved an extra channel representing the outline of the mouse (Alpha 2).

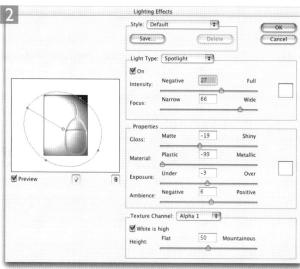

3 The resulting render as shown here takes effect in the selected area only. The image is a bit too dark, so I faded out the effect with the Edit > Fade Filter command to around 50%.

9	0	Alpha 1 Alpha 2	¥4
		Blue	₩3
		Green	¥2
		Red	H 1
F		RGB	€~

2 I loaded Alpha 2 as a selection and used the Command/Ctrl-J command to create a new layer above the background. I then chose Filter > Rendering > Lighting Effects.The texture/3D mod-

eling controls are at the bottom of the dialog box. I selected the Alpha I channel as the texture or 'bump' map for the lighting. I clicked the White is high checkbox – the slider control determines how mountainous the render should be – the 50% value worked best. I positioned the light, in this case a single spotlight, and adjusted the lighting attributes. The settings shown here were for a shiny plastic surface with a raised ambient light level.

4 After this I created another texture map. I clicked on the New Channel button in the Channels palette to create Alpha 3. I chose > Select All and selected Texture Fill from the Render menu. Any texture image can be used, but it must be a grayscale image. You will find a whole host of textures provided on the Photoshop program CD-ROM in the Textures for Lighting Effects folder inside the Goodies folder. In this example I used the Burlap texture map.

	Lighting E	ffects			
	Style: Det	fault D	Delete		OK Cancel
	🗹 On	Directiona	83	Full	
	Intensity: Focus:	Narrow	66	Wide	
	Properties Gloss:	Matte	-81	Shiny	
	Material:	Plastic	-26	Metallic	
Preview 😨 🗑	Exposure:	Under	0	Over	
	Ambience:	Negative	10	Positive	
	Texture Ch	annel: Alpł	na 3 🔹		
	White is Height:	high Flat	36 Mou	ntainous	

5 I activated the RGB channel (channel-~) and made the background layer active again (see page 127 for information about the OS_X_Keyboard_Shortcut_Fix plug-in for Mac OS X 10.2).1 then applied the Lighting Effects filter. I went down to the Texture channel section again and selected the Alpha 3 channel I had just made and as shown here used a single directional light as the lighting source using the White is high option and a mountainous setting of 35. **6** To finish off the image, the background and mouse image layer were colored separately. To add the shadow, I applied a drop shadow layer effect to the Layer I mouse layer.

This last tutorial demonstrated that Photoshop has the power to render 3D objects. Here is an exercise in which an image is created entirely within Photoshop utilizing the Texture Fill and Lighting Effects filter. Whilst Photoshop is no replacement for professional 3D design packages, there is more to the Lighting Effects filter than first meets the eye. I thought I would begin by introducing an over-the-top use of the filter that does not use photography at all, just to demonstrate its potential before showing a more typical, photographic use. The following example shows how lighting can be added to an existing studio photograph – either to add emphasis or to introduce a spotlight effect in the background. I should mention that Lighting Effects is a memory hungry plug-in. You will not always be able to use it on large files unless your computer is well equipped with RAM memory.

Pattern Maker

The Pattern Maker is another new Photoshop filter, which just like Liquify has its own modal dialog. The Pattern Maker is shown being put to use in Chapter Ten, to create a stone wall texture pattern that can be used in conjunction with the healing brush to cover up an area with a texture matching the surroundings.

Figure 16.6 The Pattern Maker dialog controls. You can generate a pattern based on either the actual image size or a tile area of specified pixel size. If you wish, the generated tiles can be offset either horizontally or vertically by a set percentage amount. Increasing the smoothness will produce better results, but take longer to process. Increasing the sample detail will preserve more recognizable detail. A lesser amount will produce more abstract results. Check the Saves Preset Pattern button at the bottom of the palette if you want to save a generated pattern to the Pattern Presets. For as long as the dialog is open, you can keep generating new presets, review their histories using the navigator buttons and delete or retain them as necessary.

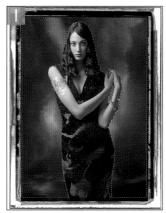

2 The Lighting Effects filter is found under the Filter > Render section. The dialog box displays the selected area in the Preview window. I selected one of the effects presets: Crossing Down. Each light can be adjusted by dragging any of the four ellipse handles or the center point. A new light can be added by clicking on the light bulb icon at the bottom. I This is a photograph taken for a Tresemme advertorial promotion. The Lighting Effects filter works well as a means of adding lighting afterwards to a photographic scene. But with a little careful control you can achieve a more realistic effect. Here, I wanted to use the Lighting Effects filter to add some spotlights to the background only. So to begin with I drew a path around the outline of the model and inside the outer border. This was converted to a selection and feathered slightly by about 2 pixels.

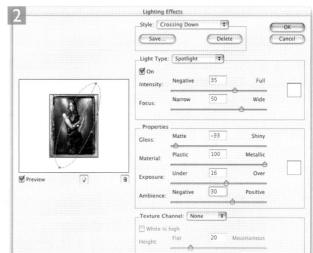

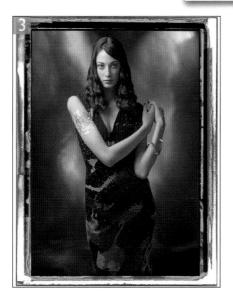

3 In this example, the two light sources are of the spotlight type. This produces an effect that is like having two fresnel spots hitting the backcloth from above. The combined controls of the Intensity and the Focus slider are like the flood/ spot wheel on a tungsten spotlight. Below that are the Properties sliders. This is where you can set the desired surface texture, to simulate a plastic matte or a shiny metallic type surface to reflect the added lighting. The Exposure slider governs the brightness of the individual lights, while the Ambience slider can be used to add a fill light to the overall scene.

Client: Tresemme/Hairdressers Journal. Model: Karen at Models One.

Syste Period Syste Period Proview Period Syste Period Proview Period Syste Period Period Period P											
Sme Deter Carcel Image: Shiry Image: Shiry Image: Shiry						Style: Def	ault			ОК)
Image: Strike						Save	Ð	Delete	D	759999999999999999999	S
Image: Strike						Light Type	Omni	100			
Image: state in the state							0				
Image: Solution of the state of the sta			,				Negative	31	Full		
Proview Image: Proview <td></td> <td></td> <td></td> <td></td> <td></td> <td>Focur</td> <td>Narrow</td> <td>69</td> <td>) Wide</td> <td></td> <td></td>						Focur	Narrow	69) Wide		
Image: Ship Image: Ship	2 4 2 4 2 4 2 4 2 4 2 4 2 4 2 4 2 4 2 4		A			rocus,					
Preview Image: Construction of the stable of the stabl				21		Properties					-
Preview Prover Prove Pr			NE			Gloss:	Matte	0	Shiny		
Preview Previe						Material:	Plastic	69	Metallic		
Ambience Negative Texture Channel: None White is high 50 Height: Flat Style: Default Style: Default Or Cancel Image: None Image: None Proview Image: None Image: None Image: None		Preview		<u></u>	8	Exposure:	Under	0	Over		
White is high Height: Flat 50 Mountainous Lighting Effects Style: Default Ight Type: Omini Ight Type: Omini Ight Type: Omini Ight Type: Omini Ight Type: Intensity: Negative State: Properties Closs: Material: Plastic Over Amblence: Negative Idit Properties Closs: Material: Plastic Over Amblence: Negative Idit Posture Channel: None White is high						Ambience:	Negative	[14]]	Positive		
White is high 50 Mountainous Height: Flat 50 Mountainous Uighting Effects Style: Default Image: Cancel Style: Default Image: Cancel Image: Cancel Light Type: Omn Image: Cancel Image: Cancel Vight Type: Omn Image: Cancel Image: Cancel Properties Closs: Narrow Image: Cancel Properties Closs: Mate On Material: Plastic Dover Image: Cancel Ambience: Negative 14 Postive Image: Cancel White is high Image: Cancel Image: Cancel Image: Cancel Image: Cancel						Texture Ch	annel: Nor				
Preview											
Style: Default Ight Type: Omni Ight Type: Omni Ight Type: Omni Ight Type: Omni Intensity: Negative Jours: Narrow Boos: Mate Intersity: Narrow Properties: Other Gloss: Mate Intersity: Narrow Material: Plastic Exposure: Under Over Material: Texture Channel: None Witht is high Image: None						Height:	Flat	50	Mountainous		
Preview Exposure: Ambience: None Texture Channel: None White is high			Focus: Properties Gloss:	Narrow Matte	69	s	Vide				
Ambience: Negative 14 Positive 4 Texture Channel: None *			Exposure	Under	0		Over				
White is high	Preview	9	Exposure.		- C	<u></u>					
White is high	Preview	3		Negative	14	Pos	itive	-			
Height: Flat 50 Mountainous	Preview	3	Ambience:			0					
	Preview	3	Ambience: 	annel: Non	e	0 1)				R	

which will in effect 'gel' the light. Lighting Effects is a very powerful imaging tool. The combinations of light sources, light coloring and texture map facility offer many more lighting opportunities.

3D Transform

I Take an object and isolate it from the background layer by defining an outline selection and making a Layer > New Layer > Via Copy. The 3D Transform filter is then chosen from the filter menu to affect this new layer only. The dialog box displays a monochrome preview of the image on the layer. Select one of the object drawing tools to surround the selected area and match its perspective. Next select the view angle tool to twist the perspective.

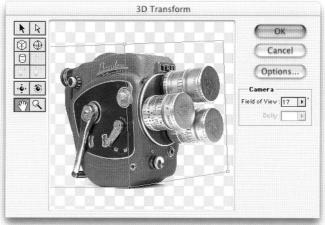

3 The cleaned-up after shot appears to show the camera as if it had been rotated toward the lens axis. Excessive 3D transforms will not work so convincingly. After all, not even Photoshop can reproduce the back of an object.

 ${\bf 2}$ When the 3D Transform has finished processing the transformation, the before image may show through from below. Here I went to the background layer and deleted them, filling these areas with white.

3D Transform

This filter effect bears some resemblance to one of the early Andromeda series of plug-in effects. The filter can be used to take an object and effectively change the perspective view relative to the remaining image. It is not an easy filter tool to master and there are restrictions on how far round you can rotate what is a '2D captured' object. The example on the previous page was done with the ciné camera on a background copy layer, where the camera was first carefully cut out.

Practical applications

People either overuse Photoshop filters and techniques or dismiss them as pure fakery and having nothing to do with photography. There is a middle line where I believe there is nothing wrong with experimenting, mixing illustration techniques and photography. When used properly, the Lighting Effects filter is an exceptionally useful Photoshop tool for generating textures, 3D objects or lighting fills. I once saw a good example of a floodlit hotel exterior where some of the outside lights were not working. The client couldn't get it together to organize replacement bulbs and the photographer had to shoot the scene as it was. Because the outside walls were not completely pitch black, there was plenty of shadow detail recorded and the Photoshop artist was able to apply the Lighting Effects filter to replicate the missing lights. He used one of the image color channels as a texture map to make the floodlighting appear more realistic and made the light source color match that of the other exterior lights.

So is it real or is it Photoshopped? Where the integrity of an image matters, such as in photojournalism, we would all prefer that photographers don't mess around with the subject matter. On a commercial shoot everything we do is all lies anyway, so who is going to care? If Photoshop can do something quickly and effectively, it makes sense to do it on the computer rather than waste time in the studio when you could be more productive and creative attending to other important things. I hope the tips and techniques demonstrated throughout have helped you understand more about the power of Photoshop as a professional quality image editor. Don't forget that the CD-ROM features some of the tutorials as movies and that there is a website for the book: <www.photoshopforphotographers.com>. This contains an FAQ section and email support links to help people who are experiencing problems running the CD-ROM movies. I hope that you find using Photoshop to be a fascinating and rewarding experience. It literally changed my life and the way I work and opened up many new avenues to explore!

ost of the photographs you see in this book were taken by myself. Some were from commissioned assignments, others are personal shots. I also asked friends and colleagues to include work too, all of whom are professional photographers. Here then is some biographical information on the other contributors whose work has been featured.

Davis Cairns

A partnership specializing in fashion accessory still-life photography with clients who include Red or Dead Ltd and Paul Smith. Davis Cairns are currently moving into more portrait and fashion-based work with an emphasis in portraying creative textiles. I have worked on all the Davis Cairns computer retouching work and a number of these commissioned and personal images were used in this book.

Email: mail@daviscairns.demon.co.uk

Julian Calder

Julian Calder's early inspiration came from the great photo stories in *Life Magazine*. He acquired his photographic education at art college and as an assistant to several London photographers. Julian is an inveterate traveler, who enjoys the discipline of working on assignments for companies and magazines. He utilizes all the technical gadgetry available in order to realize the full potential of a picture, stretching the versatility of his camera system to the utmost to capture the picture he wants.

Tel: +44(0) 20 8780 5352

Laurie Evans

Laurie Evans was born in Scotland in 1955. Having studied photography at Art School he spent two or three years as a rock and roll photographer before coming to London to seek his fortune. Transferring his interests to still life, and always a passionate cook, he quickly found that he could combine work with pleasure as he discovered the joys of food photography. He works extensively in the advertising and design industry and contributes to a broad range of magazines in the UK and abroad, and has also illustrated more than 40 cookbooks. He is married, has two sons and lives and works in London.

Tel: +44 (0)20 7284 2140 Email: Laurie@evansphoto.demon.co.uk

Thomas Fahey

Thomas Fahey, originally from Oklahoma, opened his Atlanta studio in 1990. His photography takes him from New York to Miami and occasionally overseas to London and Milan. He is a regular cover and feature photographer for *Atlanta* magazine, among others, and his pictures have appeared in numerous advertising campaigns. Formerly, Thomas trained and worked as an archival photographic printer and worked as a photojournalist. Today he enjoys a diversified client base and relies on his Mamiya RZ, Pentax 6×7, Norman light control, and an indispensible Macintosh G4 workstation.

Tel: 001 404 355 5948 Email: imagist@avana.net Website: www.thomasfahey.com

Jon Gibson-Skinner

Jon is a young photographer who lives and works in central London. Jon discovered the virtues of Adobe Photoshop 2.0 while studying for his degree at Farnham and has since embraced digital photography as well. His work as a creative crosses all boundaries from music to design and advertising. Jon is one of the founder members of LightZoo.

Tel: +44 (0)20 7402 4116 Email: jgs@dircon.co.uk Website: www.lightzoo.com

Thomas Holm

Thomas Holm from Pixl is an advertising photographer, who also provides advanced tutoring in color management, Photoshop and digital photography. Pixl has a remote custom ICC profile service available online at www.pixl.dk.

E-mail: th@pixl.dk Website: www.pixl.dk

Peter Hince

Peter Hince is an advertising photographer specializing in people/lifestyle. He works mainly on location throughout the world and is very experienced with big productions and 'round the globe' projects. He also has a unique style of underwater work and produces toned and textured black and white shots for his 'Ocean Images' collection. His work has won many advertising and photographic awards.

Tel: +44 (0)20 7386 0244 Email: peter@hince.demon.co.uk

Ian McKinnell

One of the first Macintosh owners in the UK. Ian began incorporating computer graphics for his illustration work back in the mid-eighties. He photographs mainly for editorial and design clients like *The Observer magazine*. Ian uses Photoshop and 3D package programs for nearly all his work.

Tel: +44 (0)20 7631 3017 Email: ian@mckinnell.co.uk

Eric Richmond

Eric Richmond specializes in arts publicity photography. Despite (or perhaps because of) his being American, he loves anything beginning with Royal: Royal Ballet, Royal Opera House, Royal Festival Hall, Royal Court, Royal Albert Hall. He has worked for all these venues and thinks that all arts bodies should be named in this fashion. In the past year he has traveled to Argentina to photograph tango, and Cuba to shoot a CD cover. Digital retouching is increasingly becoming a feature of his work, and like every other photographer Eric is frantically playing catchup with new technology.

Tel: +44 (0)20 8880 6909 Email: eric2001@onetel.net.uk Website: www.ericrichmond.net

Paul Webster

Paul Webster now does all his work digitally, much of it food photography for the likes of Sainsbury's. He also runs an extensive prop hire business for use by other photographers as well as his own studio in west London.

Tel: +44 (0)20 8749 0264 Email: paulsnap@dircon.co.uk

Rod Wynne-Powell

Rod Wynne-Powell, who helped with the checking into some of the technical aspects of this book, set up SOLUTIONS Photographic in 1986, and bought his first Mac in 1987.

SOLUTIONS Photographic came about because, after a period as a commercial/ industrial photographer, and later as sales manager of a London color laboratory, many calls he received began with the words: 'Rod, I've got a problem...'

His attention to detail and dogged determination led some developers to accept his offers to beta test their graphics products. This gave him the opportunity to fashion products to meet the requirements of retouchers and manipulators, which naturally gave his clients an edge against their competitors. It allowed him to offer in-depth training very early in the product lifecycle, and gain insights into the developers' future direction.

Speaking the same language as photographers has enabled him to guide others past the problems that might ensnare them when introducing them to the digital world. He offers help from the basics of Mac housekeeping, its interface, and fault diagnostics, through to the far more enjoyable aspects of teaching techniques for the productive and creative use of Photoshop as a montaging and retouching tool. His help has been valued and respected amongst his peers in the digital arena.

SOLUTIONS Photographic is now in its sixteenth year. His work is rarely credited, but lies behind many images for book jackets, report and accounts brochures, advertisements and packaging designs. His clients tend to have completely individual understandings of his services, and so he relies on most of his work by personal recommendation; the consultancy offered varies from the *ad hoc* to the retained, and he is particularly pleased with his 'flying doctor' service over the telephone, as this allows him to utilize time which might otherwise have been a tedious waste, spent inhaling exhaust fumes on the M1 or M25 car parks! His training sessions are careful to avoid 'information overload' in these increasingly technical times, but if the student can take the pace, he will continue to provide answers! Rod is much sought after for his grasp of the digital technology pitfalls. In this vein, he can be found contributing to internet lists, such as ProDIG. Also, increasingly photographers who are happier to keep shooting than retouching, find it handy to bring him into the studio to do any manipulating alongside the art director.

SOLUTIONS Photographic can be contacted by the following means: Mobile: 07836-248126 Tel: +44 (0)1582-725065 Email: solphoto@dircon.co.uk

Appendix A

Adobe ImageReady[™] 7.0

Since the release of ImageReady 2.0 with Photoshop 5.5, there has been even more integration between the two programs. Version 7.0 of ImageReady is bundled with Adobe Photoshop 7.0. This packaging primarily met the needs of web designers who use Photoshop. PSD documents created for the Web in Photoshop or ImageReady will integrate better with Adobe GoLiveTM (you can output GoLive compatible HTML code or drop PSD files directly into GoLive). I have provided information in this book on all the graphic uses of Photoshop that are relevant to photographers. Web design is really a separate skill. Nevertheless, ImageReady deserves an inclusion here because it is now an important component of the Photoshop program.

Interface

Many of the ImageReady features are common to Photoshop. For instance, you will find details of the file optimization methods have already been covered in Chapter Seven. I have chosen here to concentrate on some of the unique features contained in ImageReady rather than provide a detailed step by step guide to the whole program. Many of the ImageReady tools are identical to Photoshop and Figure A1 provides you with an overview of the Tools palette layout and the keyboard shortcuts. Options include: the ability to add image maps; toggle the visibility of image maps; a rollover preview; toggle slice visibility; and preview in a default web browser. The palettes are similar too: the Optimize and Color palettes match the features found in Photoshop's 'Save for Web' feature.

Jump to

When you click on the Jump to button at the bottom of the Tools palette you are able to switch editing a document between two different editing programs. The Jump to command from Photoshop will allow you to switch to editing in ImageReady or (if specified) any another graphics-editing program. The Jump to command in ImageReady will also allow you to switch between other HTML editing programs, such as Adobe GoLive. To specify additional programs to jump to place an alias of the application (Mac) or shortcut (PC) in the Adobe Photoshop 7.0 > Helpers > Jump To Graphics Editor folder. Place curly brackets ({}) around an application to jump to from ImageReady. In ImageReady you can choose either File > Jump to > Graphics Editor or File > Jump to > HTML Editor. The auto-updating of documents between the separate

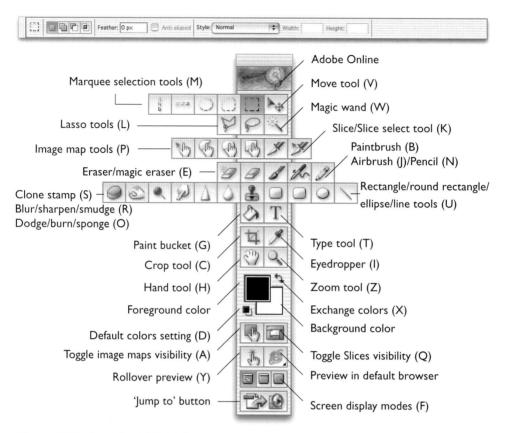

Figure A1 The ImageReady[™] 7.0 Tools palette, showing the keyboard shortcuts. The Tools palette fly-outs can be torn off and converted into stand-alone palettes.

applications now automatically happens in the background. This means that the jump tos between ImageReady and Photoshop are now therefore that much smoother and faster. The image is displayed in each program in its own document window and the window preview will be dimmed in the application which is inactive.

ImageReady layers

You can add layers in ImageReady just as you do in Photoshop. The layer features are shared between the two programs, so when you transfer a Photoshop image into ImageReady, all the layers, layer masks and layer effects will be preserved. The new Photoshop layer management and extended layer limit means that you can add as many layers as you want and organize them better using layer sets. While adjustment layers can only be edited in Photoshop, the adjustment will be previewed in ImageReady. Gradient map and fill layers can be edited though (see Styles, below). Using layers in ImageReady, you can construct a sophisticated web page with dynamic content such as rollover buttons and animations, which in turn can be linked, because the HTML code associated to the images can be generated on saving.

Figure A2 The Layers palette showing several layer effects applied to layer 2. The effects controls are located in the Layer Options palette, including the new Gradient/Pattern effect, which comes with over 50 pre-installed patterns. You can add your own customized designs. These can then be located inside the Adobe Photoshop 7\Presets\Patterns folder.

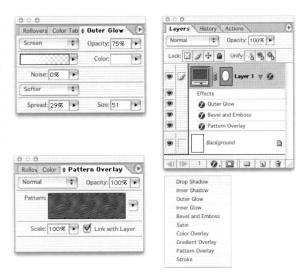

Styles

ImageReady supports all the layer effects in Photoshop and also all the vector-based features like Shape layers and vector masks. For more information on Photoshop layer effects, refer to Chapter Fifteen. To add a layer style in ImageReady, click on the effects button (•) at the bottom of the Layers palette and click on one or more of the options in the effects menu. The layer style options are displayed in the Layer Options palette. Here you will find the same controls as found in the main Photoshop program.

Single or combined layer effects can be saved as a Style, which is also a feature of Photoshop, ImageReady Styles are ideal for generating contoured 3D buttons for a website and these can be repeatedly applied to all buttons, to maintain continuity throughout the site. Preset styles are contained in the Styles palette and these can be further controlled via the Edit > Preset Manager. The examples in Figure A3 were created by making Shape layers with a type layer added above and different preset style was applied to each layer. The shape tools include a rectangle, rounded rectangle and ellipse. As with Photoshop, these tools will create a filled layer clipped by a vector mask. The shape tool Options bar allows you to modify the roundness of the rounded rectangle corners or create a fixed size shape. To apply a style, highlight a layer and double-click a style in the Styles palette, or drag the style thumbnail from

the palette to the image window – this will apply the style to the topmost layer. Or drag the style thumbnail on to a layer in the Layers palette. If you hold down the Shift key as you do so, the current layer effects will be preserved, but only if they are not duplicated by the new style.

You can create your own styles by dragging either an individual effect icon (•) or Style icon (•) from the Layers palette to the list in the Styles palette or onto the New Item button at the bottom of the Styles palette. Or you can highlight the layer in the Layers palette and click on the New Item button in the Styles palette. To name or rename a style, go to the Styles palette fly-out menu and choose Style Options... Styles can be viewed three different ways: Small List, Small Thumbnail and Large Thumbnail; all views show a swatch indicating the Style, with the smallest icons being alongside the List. Small Thumbnails is shown below in Figure A3, and Large Thumbnail shows single icons against a highlighted item in the List.

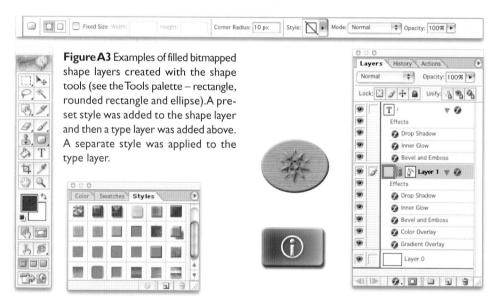

Actions

The Actions palette works the same as in Photoshop. It allows you to record a sequence of steps in ImageReady that can then be replayed on other images or used to carry out a batch action for a folder of files (the batch options are located in the Actions palette fly-out menu) and it is also possible to record playing an action within an action. There are some interesting preset actions installed with ImageReady – the flaming text example is shown here in Figure A4. But there are also actions which can be used to generate rollover and animation effects, which are discussed further on in this section.

8 0 0 3 3

Figure A4 An example of the Flaming Text action.

Image resizing

The image size dialog in ImageReady enables you to resize an image to specific pixel dimensions or as a percentage of the original size. Normally you will want to keep the Constrain Proportions option checked. The constrain options include: Width, which will constrain the proportions to the new width setting; Height, which will constrain the proportions to the new height setting; and Either, which will constrain the new size using one or other of the pixel dimensions entered. 'Either' is useful when establishing a batch action in which you wish all the images to fit within the envelope of a specific pixel size. There are two interpolation options: Jagged, which is the same as Nearest Neighbor in Photoshop and Smooth (Bicubic) interpolation.

Cropping

The crop tool is similar to the Photoshop crop tool. Use Hide (in the Options bar) when working on animations where you wish to preserve elements on other layers which move in and out of the live image area. Use the Image > Trim command to make a crop removing an outer border based on transparent pixels for instance.

Color management

When you are designing a web page you have to be conscious of the fact that visitors will be seeing your graphics under a wide variety of monitor viewing conditions. Photoshop 5.0+ handles color differently compared to previous versions of the program (see color management – Chapter Four). In particular, the RGB color you edit within Photoshop can be in one of a number of spaces. So long as an ICC profile remains attached to the file, the colors you see in Photoshop can be interpreted correctly by other ICC savvy programs. Under the View menu, choose Preview > Photoshop

compensation to see the image displayed as an ICC savvy web browser would see it. Since some browsers may not be ICC aware, it may be preferable to prepare online images in a more common-ground RGB space such as sRGB. The vast majority of Internet users will be using a PC computer and the sRGB space uses a gamma of 2.2, which is typically the gamma setting used on most Windows PC machines. Mac users should choose 'Standard Windows color' and PC users should choose 'Uncompensated color'. Then you should get a good impression of how most people will be viewing the web images you create or edit in ImageReady. If you output a file with an ICC profile embedded, then so much the better (Microsoft Internet Explorer 5.0 is ICC-aware). If you choose to incorporate a color that is non-web safe, which will make a GIF image appear badly dithered, a web safe alert icon will appear in the color picker. Click on this icon to select the nearest equivalent web safe color. I should briefly mention here a problem I experienced when I began uploading JPEG files with embedded ICC profiles. The JPEGs often got corrupted and the fault lay with the FTP software I was using to upload the files to the server. Make sure you are using the latest version of your FTP software.

Image slicing

Slicing an image is a further example of how you can use Photoshop and ImageReady in tandem to create and design dynamic web pages which will download efficiently and also produce HTML output files which can be further edited in a program like Adobe GoLive 5.0 and 6.0 upwards. Slicing makes it easy to specify what type of content will appear in a slice and how the image content in a slice shall be optimized.

Select the slice tool and you will notice the first slice (01) is assigned to the entire image. There are several ways to slice an image. Choose Slice > Divide Slice(s) – this opens a dialog box allowing you to divide an existing slice vertically or horizon-tally. This is only useful where slice symmetry is vital. When you drag with the slice tool inside the document, you are creating what is known as a 'user-slice'. As you add a user-slice, 'auto-slices' are automatically generated every time you add or edit a user-slice. User-slices can be created by dragging with the slice tool, but they can also be based on a selection, layer bounds (Layer > Create Slice From Layer), or guides (Slices > Create Slices From Guides). Note that when you create a user-slice from a layer, the slice will automatically adjust to any changes made to the layer, such as when you add an outer glow layer effect.

You can modify a slice by selecting the slice select tool and clicking on the slice you wish to edit (all slices but the active slice will appear dimmed) and using Shift-click to select multiple slices. Use the slice select tool to move a slice or resize it by dragging on one of the corner handles. A solid line border indicates that it is a user-

slice and a dotted line that it is an auto-slice. It is possible to promote auto-slices to user-slices (Slices > Promote To User-Slice). Doing so will prevent it from being altered whenever a regeneration takes place. Slices can be merged together, choose Slices > Combine Slices.

Figure A5 A window in ImageReady, which shows a layered image that has been manually divided into slices using the slice tool. Slice 8 is a user-slice which is currently active and seen with the orange colored border. While the slice visibility is switched on, all other slices appear dimmed. Click on the toggle slices visibility mode button in the Tools palette to preview the document without the slices being visible.

Slice content

The default when slicing images is to create image content slices; however, you can create no-image slices that can have text or even solid color fills. The Background Color option will fill a no-image slice with a solid color or fill the transparent areas of an image content slice. No-image slices can also be created within the Save for Web dialog in Photoshop. HTML text can be added to a no-image type content slice via the Slice palette text box. A URL web link can also be added in the Slice palette URL text box. These slice content modifications cannot be seen directly in the ImageReady document window, you will only be able to preview these in a browser or web page editing program.

Optimizing images and image slices

File optimization was discussed earlier in Chapter Seven and the same Save for Web controls are all contained in ImageReady. The only real difference is in the interface layout. The Optimize controls can be accessed at any time via the Optimize palette and the normal image window layout can be changed to show the optimized version, 2-up or 4-up displays. When working with the optimized display, the optimized version will want to regenerate a new preview after each editing action. To stop this happening you can deselect the Auto Regenerate option in the Optimize palette fly-

out menu. If you do this, after the image is modified, a small warning triangle ((a)) will appear in the bottom right corner. To manually regenerate an optimized view, click on this warning symbol. Different compression or format options can be applied to individual slices such that areas where image detail matters most, less JPEG compression is used. Linking slices allows you to share the optimization settings between linked slices, choose Link Slices from the Slices menu.

‡ Optimize	Info	\backslash		0
Settings: [Unn	amed]	+	9
JPEG	-		V 01	timized
High	1	Quality:	60	•0
Progressive		Blur:	0	1

Figure A6 The Optimize palette plus the image window set to display in 2-up mode. A warning symbol will sometimes appear in the optimized pane as you edit when the Auto Regenerate option is switched off.

Photograph: Thomas Fahey.

Image maps

If you have some previous experience with designing web pages, you will probably be familiar with the use of Image maps to designate hotspots in an image that has been incorporated into a web page design. These hotspots are used to specify an internal or external link URL. ImageReady enables you to add image map hotspots, generating the necessary HTML code – the links are entered into the Image Map palette. Image maps are therefore very much like slices, except with an image map you can create specific circular or polygon shaped hotspots, not just rectangles. Image maps can be defined using either one of the image map tools or they can be layer based. To make an image map from a layer, select the layer in the Layers palette, go to the Layer Options palette and select the image map shape type. As you change the shape of the layer, the image map will become updated.

In the Tools palette (see Figure A1) you can see all the image map tools and immediately below the foreground and background colors there is a show/hide image map visibility button, which you can use to toggle the image map display or use the keyboard shortcut (A). Image maps that have been created with one of the image map tools can be selected by using the image map selection tool. Click on an image map to select it and use the tool to reposition or drag a border handle to resize the map. Image maps can be aligned as you do with layers. Shift-click to select the image maps with the image map select tool and choose the Layer > Align Linked command and select an alignment option.

Rollovers

A rollover is a web page design feature in which an item, such as a button, will change its appearance as you perform a mouse action like mousing over, or mousing down on a designated image map hotspot or image slice area. Rollover effects contain an element of animation, which is driven by JavaScript code. Rollovers are created by using layers in conjunction with slices or image maps. It is best to begin by adding your rollover elements as separate layer elements like the example shown in Figure A7. Use the Layer-based slicing option to create the slices, as the slices will automatically adjust to compensate for any added outer shadow/outer glow layer effects you might add as a rollover effect.

Figure A7 This illustration shows a Rollover button that was created by using the 2-State button action from the Actions palette.

Each image slice starts off being in a normal state. As you add states in the Rollover palette, you store a new version of the slice or image map and can use the Layers palette to alter the appearance of the layer when it is in a new state. For example, you can add a new rollover state and by clicking the italicized (2) at the bottom of the Layers palette, add an inner glow effect, so that when the viewer mouses over the rollover button, this will initiate a glow effect. If you add a further 'Down' rollover state, this could be associated with the inner text changing color or opacity. Rollover states can be created by clicking on either the Create Rollover State or Create Laver Based Rollover State buttons in the Rollover palette. This will create a duplicate state which you can now further modify in the Layers palette. A new state is added in this version called a Selected State. This effectively makes the slice act like a Radio Button making it ideal for swapping the visibility of other layers within the stack. In ImageReadyTM 7.0, you can create a special type of Style, which will allow you to apply a combination of layer effects applied to rollover states as a rollover style. Rollovers can be previewed in the document window, by switching to the Rollover preview mode (Y) via the Tools palette (see Figure A1). This will show a preview of how the rollover behavior will respond as you navigate with the mouse in the document window. For absolute precision, you should preview the document using the Browser program. The Actions palette contains a basic '2-State button' action which can be applied to a file like the one shown in Figure A7, which will make the type layer have separate 'over' and 'down' states. Rollover state images are saved as individual files and the associated JavaScript is generated as a separate HTML file.

Animation

ImageReady can also be used to construct self-contained animated image files to go on a web page. The main limitation here is that the output file for a website will be GIF only and you will therefore be limited to a 256 color palette. However, you can export animations as Quicktime movies for use in other applications, or you can even open a Quicktime movie and edit it in ImageReady.

As with rollovers, layers play a fundamental part in the preparation of an animated sequence, so that you can easily move and modify the layer elements. The animation steps are controlled by the Animation palette. To add a frame, click on the New Frame button (you should always edit the animation frames using the original view, not optimized). You can modify various aspects of the image document such as color, layer opacity or the position of a layer for each frame. You can edit the frames afterwards by selecting them in the Animation palette and making adjustments. Shift-click to select contiguous frames, Command/Ctrl-click to select discontiguous frames.

After you have produced a sequence of frames, you can then alter the time delay between each. The tweening feature will automatically add extra in-between frames and is a simple method with which to produce smoother looking animations. Tweening can be applied to individual frames or all frames. Tweening can also be applied to specific animation layers only and/or can be applied to specific layer attributes such as layer position, opacity and layer effects. Frames can easily be reordered by dragging within the palette. They can be copied and pasted using the Animation palette fly-out menu to copy and paste frames. Click the Animation palette Play button to preview the completed animation, or use the File > Preview In Command to preview them in a web browser program.

Figure A8 Click on the New Frame button in the Animation palette to add a new frame to an animation sequence. In the Layers palette, you can alter the color, opacity, position, layer effects or add new layer elements. The optimized view (as shown here) can be used at the end to check how the file will preview when saved as a GIF file ready to upload to a website.

World Wide Web contacts list

4-Sight	www.four-sight.co.uk
ActionXchange	www.actionxchange.com
Adaptec	www.adaptec.com
Adobe	www.adobe.com
Adobe Photoshop information page	www.adobe.com/prodindex/photoshop/main.html
Adobe Photoshop discussion list	http://anna.lyris.net/photoshop/
Agfa	www.agfa.com
Alien Skin	
Andromeda	
Apple	www.apple.com
Association of Photographers	www.aophoto.co.uk
Binuscan	
British Journal of Photography	www.bjphoto.co.uk
ColorVision	
Compaq	www.compaq.co.uk
Connectix	
Contact Images	www.contact-uk.com
Daystar	www.daystar.com
Exabyte	www.exabyte.com
Extensis	
Elated Action Kits	www.elated.com/freebies/actionkits/
Formac	www.formac.com
Fractal	
Fuji	www.fujifilm.com
Fujitsu	www.fujitsu-europe.com
Gretag Macbeth	www.gretagmacbeth.com
Hermstedt Ltd	www.hermstedt.co.uk
Hitachi	www.hitachi-consumer-eu.com
Hewlett-Packard	www.hp.com
Imacon	www.imacon.dk
lomega	
Kensington	www.kensington.com
Kingston	www.kingston.com
Kodak	
Kodak Photo CD	www.kodak.com/daiHome/products/photoCD.shtml
Linotype	www.linocolor.com
LaCie	http://www.lacie.com
Martin Evening Photography	www.martinevening.com
MetaTools	

Minolta	www.minolta.de/europe.html
Mitsubishi	
Microsoft	
Nikon	www.klt.co.jp/nikon/eid/
Nik Multimedia	
Olympus	
Panasonic	
Pantone	
Philips	
Pixl/Thomas Holm	
Pixel Genius	
Polaroid	
ProDIG digital imaging discussion list	
ProRental discussion list (users of 10 MB plus digital	
Quantum	
Quark	
Radius	
RasterOps	
Ricoh	
Samsung	
Sanyo	
Scitex	,
Seagate	
Sharp	
Signum Technologies	
Sony	
Sun Microsystems	
SuperMac	
Symantec	
Taxan	
TDK	
Tektronix	
Texas Instruments	
Toshiba	
Umax	
Verbatim	
Vivitar	www.vivitarcorp.com
Wacom	
Rod Wynne-Powell	
Xerox	
Xaos Tools	
Yamaha	

Index

Symbols

16-bit color 4, 241, 382 3D Transform 431, 432 8-bit grayscale 366

A

Absolute Colorimetric rendering 93 Acrobat format (PDF) 189 notes 181 Actions 346 actions palette 149 batch Actions file naming 350 droplets 356 editing an Action 348 recording an Action 348 troubleshooting 347 Actions X Change 336 Actual pixels viewing 182 Adaptive Web palette 201 Adding a layer mask 294 Adjustment layers 150, 263, 278, 298, 358 change layer content 296 Adobe Color Engine 91 Adobe Gamma 64, 68 Adobe GoLive[™] 437 Adobe InDesign[™] 109 Adobe RGB 74, 90 Advanced color settings 87 Advanced layer blending 301 Agfa 4 Aim prints (for proofing) 111 Aligned mode cloning 244 Aligning layers 160, 388, 403, 407 Alpha channels 151, 282 AltiVec 45 Annotation tools 180 Anti-aliasing 282, 285-286 Anti-aliasing filter 17 Appending file names 127 Apple Cinema display 69 Apple RGB 74 Apply Image 406 Arbitrary map mode (curves) 235 Archiving images 116-117 Arrow heads 180 Art history brush 166, 170 Artifacts 36 ASCII encoding 188 Ask when opening 83 Assign Profile 83 Assigning shadows and highlights 214

Auto Color 227–229 Auto contrast 227–229 Auto erase (pencil) 165 Auto Levels 227–229 Auto select layer 161 Auto Select mode (move tool) 299 Auto-update documents 126 Automatic masking 322 Automation plug-ins 349

В

Background eraser 171 find edges mode 173 Background printing color 108 Banding use dither option 94 Banding (removal) 247 Barco Calibrator monitor 42, 64 Batch Actions 346, 348 Batch Rename 120 Beauty retouching 271 Bicubic interpolation 36, 126 Big data 161, 208 Binary encoding 188 Binuscan 4 Bitmapped images 4 Black and white from color 376 Black Generation 98 Black point compensation 94 Blend interior effects 301 Blend RGB colors using gamma 88 Blending mode adjustments 239 Blending modes 289 Color 270, 389 Darken 274, 275, 389, 390 Difference 292 Exclusion 293 Hue 389 Lighten 274 Linear Burn 290 Linear Dodge 291 Linear Light 292 Luminosity 219, 240, 389 Multiply 239, 319, 380, 381 Pin Light 292 Saturation 389 Screen 239, 320, 380 Vivid Light 292 Blending options 373 Blur tool 177, 269 Brown, Russell 249 Browser preview 200

Browser safe colors 202 Brush attributes 145 Brush blending modes 270 Brush controls 272 Brush dynamics 164, 272 Brush tool 145–146, 165 Brushes 145 Shape dynamics 147 Brushes palette 145, 270 Bureau output checklist 122 Burn tool 178, 278 Bus connection 45 Byte order 122

С

Cache memory 46 Cairns, Davis 433 Calder, Julian 433 Calibration bars 108 Canon EFI Fiery RIP 115 Canvas Size 207 Caption box (printing) 108 Cascading Style Sheets 199 CCD 5 CD-ROM 43, 116 Channel mixer 379 monochrome mode 376 Channels 280, 358 Channels palette 151 duplicating a channel 316 make new channel 281 make selection 281 Character palette 144, 179, 409 Chromapress 115 Cintiq input device 44 Classic Photoshop CMYK setup 94 Cleanup tool 322 Cleanup tool (Extract command) 324 Clear guides 138 Clipboard 126 Clipping groups 320 Clipping paths 122, 189, 332 Clone stamp 165, 244-247, 261-263, 330 Cloning 165, 244 Cloning alternatives dodge tool 246 Cloning selections 261 CMYK conversions 90 gamut 142 proof III proofing 104 selective color 243 separation setup 91

CMYK color management 58 CMYK proofing 112 CMYK settings 94 advanced 91 CMYK setup 95 Coated CMYK settings 80 Color Balance 229 Color Burn mode 290 Color Dodge mode 290 Color Management Modules 91 Color management off 79, 87 Color Management print settings 110 Color Matching Module 60 Color mode 293 Color negative retouching 247 Color overlays 387 Color palette 148 Color picker 126, 175, 184, 281 Color policies 77 Color proofing 108 Color sampler tool 181, 233 Color settings 76, 79 ask when pasting 78 convert to work space 78 profile mismatch 78 saving a setting 81 Color settings files 80 Color wheel 227 Colorize 225 hue/saturation 226 ColorMatch RGB 74 ColorShop 36-37 ColorSync 105 ColorSync Control Panel 68 ColorVisions 69 Compositing 319 Compression lossless 12 LZW 187 Computer mail order 44 monitor display 42 multiprocessor 45 system maintenance 54 Contact Sheet II 352 Contextual menus 155, 339 Contiguous selections 154, 173 Contour editor 402 Contours 401 Contract proofing 111 Convert to Profile 81-83, 104 Convert to profile 86, 98, 112 Convert to work space 78, 83 Copyright protection 268 Create layers 398 Create new brush 145

Crop tool 161 Cropping 205 Cross-processing 321, 383 CSI Lightjet 103 CTP (Computer to Plate) 115 Cursor display options 130 Custom brushes 146 Custom CMYK 91, 94, 108 Custom colors 408 Custom gradients 175 Customizing RGB color 89

D

Darken mode 289 Databases 117 Define brush 146 Define custom shape 410 Defringe 328 Delete file in browser 119 Delete preferences 133 Desaturate monitor colors 89 Desaturate with sponge tool 178 Device-independent color 70 Difference mode 292 Diffusion dither 130 Digimarc 124, 268 Digital cameras 24-27 image quality 21 scanning backs 23 Digital image structure of 2-4 Digitizing pad 44 Direct selection tool 307 Disk performance 48 Displacing an image 417 Dissolve mode 289 Distribute layers 160 Distribute linked layers 403, 407 Document profile 77, 135 Document size 135 Dodge tool 178, 278-279 Dot gain 84, 96, 211 Dot gain curves 97 Dots per inch 31 Droplets 356 Duotone options 369 Duotones 367 Duplicate an image state 167 Dupont Cromalin[™] 111, 115 Durst Lambda 103 DVD 117 Dynamic Color Sliders 127 Dynamic fill layers 238

E

Easter eggs 155 Edge touchup tool 322 Edit menu fade command 275, 342, 380 transform again 404 Efficiency 135 EFI Fiery RIP 115 Electronic publishing 189-192 Emulate Photoshop 4 79, 87 Epson archival inks 106 Epson inkjet printers 105 Epson print dialog 109 Erase to history 171 Eraser tool 171 Evans, Laurie 434 Exchange foreground/background 183 Exclusion mode 293 EXIF metadata 120 Export Clipboard 126 Export Transparent Image 353 eXtensible Markup Language 121 eXtensible Metadata Platform 121 Extensions (system) 45 Extract command 173, 322 smart highlighting 173 Eye-One calibrator 69 Eyedropper tool 181, 214, 248

F

Fade command 219 Fade filter 275 Fahey, Thomas 434 Ferguson, Max 104 File Browser 118-120, 122, 141 Backwards compatibilty 128 Ranking 118 File extensions 127 File formats Acrobat (pdf) 189 CompuServe GIF 196 DCS 189 EPS 151, 188 Flashpix 204 for the Web 195 GIF 127, 195 importing PDF files 192 JPEG 127, 193-195 baseline optimized 194 baseline standard 194 optimized JPEG 198 **IPEG** compression 187 Lossy GIF format 202 PDF 408 PICT 193

PNG 203 Raw Binary 127 TIFF 128, 134, 186-187 saving paths/channels 284 File menu automate 348 file Info 122 import 205 place 399, 417 preferences 126 plug-ins 133 scratch disk 133 File optimizing 443 Fill layers 148, 389 Fill opacity 400 Filter Menu KPT Blurrrr 415 Filter menu Artistic cutout 416 Blur Gaussian blur 267, 268, 275, 319, 418 Motion blur 320, 412, 415 Radial blur 412 Smart blur 412 Distort Displace 418 Extract command 322 Fade filter 412 KPT FraxFlame 415 Liquify 419 freeze tool 419 reconstruction modes 421 tool options 421 Liquify tools 420 Noise Add Noise 247, 266, 413 Despeckle 413 Dust & Scratches 250, 413 Median 268, 412 Remove dust & scratches filter 249-251 Other High pass 413 Maximum 413, 414 Minimum 413 Offset 413 Pattern Maker 259, 428 Render 3D Transform 431, 432 Clouds 424 Difference clouds 424 Lens flare 425 Lighting Effects 426, 429-430, 432 Lighting effects 428 Texture fill 427

Sketch Graphic pen 416 Solarize 373 Filters KPT 411 Fine art inkjets 105 Finger painting 124, 177, 270 FireWire[™] 43, 48 Fit image 350 Fit to screen view 136, 182 Flat panel TFT screens 42 Flatten image 334 Flextight CCD scanner 5 FM screening 33 Foreground/background 183 Fractional widths 409 Fraser, Bruce 72 Free transform 263, 304, 319 Freehand lasso tool 157 Fuji Pictrography 103 Fuzziness control 236

G

Gamma slider levels adjustment 213 Gamut 131 Gamut warning 242 **GCR 97** Gibson-Skinner, Jon 434 GIF transparency 202 Gloss contour 395 Goodies folder 368 Gradient fill 174, 387, 389-391 Gradient Map 391 Gradient tool 174, 264 transparency stops 175 Gradients 175 noise gradients 391 Graphic tablet 164 Grayscale management 84 Grayscale mode 4 Grayscale proofing on screen 369 Gretag Macbeth 69 Grid 132, 137-138 Guides 132, 333

н

Halftone factor 32 Halo effect 405 Hand tool 182 Hard Light mode 291 Healing brush 164, 251–252, 253, 254 Heidelberg 5 Hewlett Packard printers 105 Hexachrome 73 Hexadecimal web colors 148 HexWrench 73 Hide crop 208 Hiding the palettes 183 HiFi color 189 Highlight point 211 Highlighter tool 323 Hince, Peter 332, 435 History 265 memory usage 168 non-linear history 314 History brush 166, 249-251 History options 46 History palette 150 HK printer 103 Holm, Thomas 61, 434 Hot mirror filters 17 HSB color model 222 **HTML 437** Hue mode 293 Hyphenation 409

I

ICC 60 Illegal colours 142 iMac computer 41 Imacon 122 Image AXS 117 Image cache 134, 358 Image databases 117 Image interpolation 36 Image Menu Adjustments Auto Levels 227 Image menu Adjustments Arbitary map curves 374 Auto Color 227 Auto Contrast 227 Auto levels 214, 249 Brightness/Contrast 205 Channel Mixer 376, 386-387 Color Balance 370, 373 Curves 229-234, 232, 276 Desaturate 370, 372 Gradient Map 391 Hue/Saturation 222-226, 224, 249, 378 Invert 248, 277 Levels 214-218, 226 Replace Color 236 Selective Color 242 Variations 227, 229 Apply Image 317 Canvas Size 206, 207 Rotate Canvas flip horizontal 325 Image security 123-124 Image size 36

Image window 135 ImageAXS 26 ImageReady 185, 437 actions 440, 446 animation 446 auto regenerate 443 color 441 cropping 441 image maps 444 image slicing 442 layers 438 rollover styles 446 rollovers 445 shapes 439 Import from Illustrator 417 Improving performance 45 Indigo 115 Info palette 99, 142, 217, 345 Infrared technique 379 Ink Colors 95 Inkjet media 105 Installing Mac OS X 51 Interlaced GIFs 202 International Color Consortium 60 Interpolation 36, 123 Iomega ZIP disks 116 Iris printer 104 ISDN 21

J

JavaScript 185, 354, 445 Jaz disks 117 Jitter 146 Johnson Stephen 23 Jump To application 126, 184, 437 Justification (type) 409

к

Knockout blending 301 Knockout layers shallow knockout 300 Knoll brothers 411 Kodak ColorFlow 61 Photo CD 11–14 image pac 12–13 scene balance algorithm 13 sharpening 217 universal terms 13 Kodak dye-sub 111 Kodak test target 61 KPT 5 413 KPT gradient filter 349

L

Lab color mode 98 LaCie Blue screen monitor 42, 69 Lambda printer 103, 115 Lasso tool 153, 157, 374 Laye Mike 121 Layer group linked 320 Layer arrange menu 403 Layer blending options 372 Layer effect contours 401 Layer effects 148, 179, 392-395 Bevel and Emboss 395, 401 Color Overlay 397 Drop Shadow 393, 401 Gradient Overlay 396 Inner Glow 394 Inner Shadow 393 Outer Glow 394 Pattern Overlay 396 Satin 395 Stroke 397 updating slices 163 Layer linking 298 Layer locking 302 Layer masks 294, 313, 319, 389, 399 Layer menu group with previous layer 321 layer clipping groups 321 matting remove matte color 328 Layer opacity fill opacity 400 Layer options 334 Layer set blending Pass Through mode 300 Layer sets 298, 299, 361 Color coding 301 lock all layers 301 moving layers in a set 299 Layer Styles 398 Layers 287-294, 358, 403 clipping paths 332-333 Group with previous layer 314 layer mask Quick mask mode 294 removing 296 linking layers 298 masking a layer 294 Layers palette 150 new layer/copy layer 287 Leaf DCB 21 Legacy color files 85 Legacy files 86 Levels 214

Levels adjustments 210-212 threshold mode 214 Lighten mode 290 Lighting and rendering 424 Lighting Effects 426 Line tool 180 Linear Burn mode 290 Linear Dodge mode 291 Linear Light mode 292 Lines per inch 31 Linoscan 5 Linotype 4 Linotype-Hell 4 Liquify 419, 422, 423 Bloat tool 420 Freeze tool 420 Pucker tool 420 Reconstruct tool 420 Reflection tool 420 Shift Pixels tool 420, 422 Thaw tool 420 Turbulence tool 420, 423 Twirl Clockwise tool 420 Twirl Counter Clockwise tool 420 Warp tool 420 Live Picture FlashPix 204 **IVUE 204** Lock guides 138 Lock image 302 Lock image pixels 302 Lock transparency 302, 320 Lossy compression 193, 195 Luminance selection 277 Luminosity mode 293 Lysonic inks 106 LZW compression 187

Μ

Mac OS X 50-52 print center 107 Macros. See Actions Magic eraser 171, 172 Magic wand 153, 154, 285 Magnetic lasso 153, 157, 159 Magnetic pen tool 157, 179 Map GIF Colors to transparent 202 Marquee tool 153, 280 Marrutt 115 Mask channels 281 Maximize backward compatibility 128, 186 McKinnell, Ian 436 Measure tool 182, 208 Megapixels 28 Memory clearing the memory 49

Memory management 134 Merged layer cloning 244 Metadata 120, 121 Metallic layer effects 401 MetaReader[™] 122 MMX 45 Modifier keys 155, 156-157 defining selections 284 moiré patterns 266 Monitor calibration 63, 64 tonal compression 276 Monitor gamma (PC) 84 Move tool 160, 338 Multichannel mode 367 MultiPage PDF to PSD 350 Multiple layers 298 Multiple undos 166 Multiply mode 289

Ν

NAA/IPTC 122 National Air and Space Museum 311 Navigation services 186 Navigator palette 142, 182, 345-346 Neutral gray tones 101, 217 New document size 35 New guide 138 New layer based slice 163 New Mexico software 124 New spot channel 408 Nikon 5-6 Noise gradients 176, 177 Non-aligned cloning 245 Non-linear history 169 Norton Utilities 54 Numeric transform 160, 304

0

Ocean Images 332 Office environment 53 Open recent files 130 OpenType fonts 409 Optimize save for web settings 199 Optimize to file size 199, 200 Options bar 143, 152 Output guidelines 122 preferred file formats 122 Overlay mode 291 Overlays retouching with 389

Ρ

Page bleed 123 Page Setup 107, 108 Paint bucket tool 183 pattern fill mode 177 Painting cursors 130 Painting effects 400 Palette docking 139 Palette well docking 143 Palettes 138 Pantone[™] color 408 Paragraph palette 145, 179, 409 Pass through blending 301 Pasteboard editing the color 183 Patch tool 164, 255 Paths 179 convert path to a selection 307 perspective template 329 Paths palette 151 make path 282 stroke path/sub path 269 Pattern Maker 259 Pattern presets 428 Pattern stamp tool 165 PC monitor caibration 68 PCI card 48-49 PDF (Acrobat) 189 PDF Image Import 191 PDF security 191-192 Pen paths 306 drawing 306 stroking 269 subtract mode 298 Pen tool 179, 270, 306, 311, 315 adding a corner point 308 corner point 309 create shape layer mode 284 curved segment 307 direct selection tool 310 pointer 307 rubber band mode 308 straight segment 309 Pencil 165 Perceptual rendering 93 Perspective cropping 209 Photo CD interface 12 Photographic borders 380 Photomultiplier 5 Photoshop improving performance 45 memory management 47 Photoshop 4.0 limitations 86 preferences 125 Pictrograph 193 Picture package 351

Pillow emboss 395 Pin Light mode 292 Pixel doubling display option 130 Pixel Genius 122 Pixels 4, 28 Pixels per inch 31 Pixl 61, 111 Plug-ins third party 411. See also Filters Plug-ins folder preferences 133 PNG format 203 Polaroid[™] 5 Polygon lasso tool 153, 157, 262 Polygon shape tool 180 PostScript 188, 410 PostScript color management EPS options 188 PostScript printing 114-115 PostScript RIP 32 Precise flare center 425 Precise image rotation 208 Preference file 125 Preserve Embedded Profiles 77, 78, 81, 98 Preset Manager 148, 149 Presets 398 Patterns 260 Preview box 135 Primary scratch disk 54, 133 Print Center (Mac OS X) 107 Print Keys 126 Print registration marks 108 Print settings 109 Print size viewing 182 Print with Preview 107 Printers Chromapress 115 Fujix Pictrography 103 Indigo 115 inkjet 105 inkjet plotters 106 Lambda 115 laser 115 PostScript 115 Sienna/Marrutt 115 Xericon 115 Process colors 368 ProCreate 415 **Profile Mismatch** ask when pasting 81 Progressive JPEG 194, 198 Prohibit sign warnings 153 Proof Setup 94, 113, 114, 369 Proof Setup - grayscale 85 ProPhoto RGB 74 Purge history 169 Purge memory 49, 135

Q

Quadtones 367 Quick mask 183, 280, 282 Quickdraw 114

R

RAID hard drives 48 Rainbow proofer 111 RAM memory 46, 48 configuring 49 Ranking - File Browser 118 Raster Image Processing 115 Rasterized type 409 Read Me files 86 Real World Photoshop 72 Recording actions 347 Redo options 127 Refresh list tree view 118 Relative canvas size 207 Relative Colorimetric 93 Removing a matte color 328 Renaming files 120 Rendering intents 93 Repeat transforms 403 Replace color 236 Reset palette locations 140 Reset tool settings 127 Resize image 353 Resize windows to fit 182 Resolut 36 Resolution film 28 output resolution 33 pixels 28 reciprocal formula 28 terminology 31 Reveal All 161, 208 Reveal folder in desktop 119 RGB work space 89 **Ribblehead Viaduct 328** Richmond, Eric 436 Rosettes (halftone) 33 Rotate canvas arbitrary 208 Rotate image 207 Rotate thumbnails 119 Rubylith mode 294 Ruler units 131 Rulers 137, 345 Run Length Encoding compression 193

S

Saturate with sponge tool 178 Saturation mode 293 Saturation rendering 93

Save Image Pyramid 187 Save for Web GIF format 200, 201 JPEG format 198 Save palette locations 127 Saving 185-186 previews 127 Saving HTML code 199 Scaled layer effects 398 Scanning bit depth 8 drum scanners 4 dynamic range 7 flatbed 5 halftone images 267 noise 10 resolution 6-7, 33 scanners 4-7 scans from films 2 Scitex Iris printers 104 Scratch disk 46, 133 Scratch disk memory 338 Scratch disk Size 135 Scratch disk usage 168 Screen angles 33 Screen capture advice 84 Screen display modes 183 Screen mode 290 Scripting Photoshop 149 SCSI standards 48 SCSI devices 43 Select menu Color Range 155, 237, 238, 280 deselect 282 feather 286, 318 grow selection 154, 285 invert selection 334 modify border 284, 323 expand/contract 284 smooth selection 285 reselect 305 select similar 284 Selection Transforms 305 Selections 280, 282, 341 modifying 284 smoothing a selection 284 Separation options 97 Shadow point 211 Shape layer 401 Shape tool modes 180 Shapes 410 Sharpen tool 177, 269 Sharpening 217 Shift Pixels tool 422

Shortcuts 265 Show Grid 137 Show Rulers 138 Signum Technologies 124 Simulate ink black 113 Simulate paper white 113 Slice tools 164, 442 Smart highlighting (Extract command) 322 Smooth selection options 155 SMPTE-240M 75 Smudge tool 177 finger painting 270 Snap to behavior 138 Snapshot 166-167, 323, 346 Soft focus effect 275 Soft Light mode 291 Soft proofing 91, 112 Solarization curves 373 Sound annotations 181 Specular highlights 213 Spell checking 409 Sphera printer 103 Spirit of St Louis 311 Split toning 372 Sponge tool 178, 238, 279 Spot color channels 73, 151, 407 sRGB IEC-61966-2.1 74 Stochastic screening 33 Styles 148, 179, 392-395, 410 Stylus pressure options 164 SureSign 124, 268 Swatches palette 148 SWOP print settings 91 System Print 107

т

Target brightness assigning in Levels 217 Targeted CMYK printing 111 Temp files (PC) 54 Threshold mode 238 Thumbnail image cache 118 Tiffen filters 17 Timing 136 Title bar proxy icons 136 Tolerance settings 155, 285 Tonal range 2 Tool options 143 Tool presets 144, 409 Tool selection info 136 Tool switching behavior 153 Tool tips info 153 Transfer function (duotones) 367 Transfer functions 188 Transform 303

free transform 330 with the move tool 160 Transform again 305 Transform path 305 Transforms 403 Transparency 131 Transparency output 103 Transparent GIFs 202 Transparent gradients 174 Trim command 442 Tritones 367 TWAIN 10 Type 407-409 anti-aliasing 409 hide highlighting 179 warping 179 Type effects 180 Type selections 409 Type tool 179

υ

UCA 97 UCR 97 Umax scanners 4 Uncoated CMYK settings 80 Undo/redo settings 170 Units 345 Units & Rulers 131 Unsharp masking 36, 217, 221 amount 218 incremental 219 radius 220 selective channels 219, 221 threshold 220, 221 USB devices 41 Use cache for histograms 134 Use lower case extensions 196 Use Outlines for Text 190

۷

Vector effects 179 Vector masks 294, 297 based on work path 312 Vector-based programs 29 Velocity engine 45 Vertical palette docking 139 Video display 43 View menu fit to window 205 gamut warning 131, 238, 243 hide edges 238 new view 136–137 show rulers 137 Virtual memory 46 Vivid Light mode 292

W

Wacom 44 Warping text 179, 409 Web Graphics color 84 Web Graphics defaults 79 Web Photo Gallery 354 Web safe colors 184, 201 Web snap slider 202 Webster, Paul 435 WebDAV 130 Wet edge painting 165 White point 67 Window menu 341 cascade windows 137, 341 reset palette locations 140 tile windows 137, 341 Windows XP 52-53 Wizards in Photoshop 349 Work paths 282 Workgroups 130 Workspace Settings 140 Wynne-Powell, Rod 248, 436

Х

Xericon 115 XML 121 XMP (eXtensible Metadata Platform) 121

Z

ZIP compression 187 Zone optimization 197 Zoom blur 412 Zoom percentage info 135 Zoom shortcuts 265 Zoom tool 182